The Murals of Revolutionary Nicaragua, 1979–1992

The Murals of
Revolutionary
Nicaragua,
1979–1992

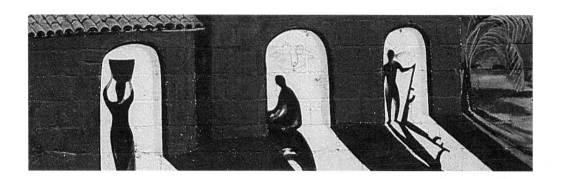

David Kunzle

University of California Press

Berkeley

Los Angeles

London

*The publisher gratefully acknowledges the generous
contribution provided by Stanley Sheinbaum,
Robin Lloyd, and the Art Book Endowment of the
Associates of the University of California Press,
which is supported by a major gift from the
Ahmanson Foundation.*

Special photographic and archival contribution
by Sergio Michilini

Research assistance by Orlando Pastora

Special photographic contribution by James Prigoff

University of California Press
Berkeley and Los Angeles, California

University of California Press, Ltd.
London, England

Library of Congress Cataloging-in-Publication Data
Kunzle, David.
The murals of revolutionary Nicaragua, 1979–1992 / David Kunzle.
p. cm.
Includes bibliographical references and index.
ISBN 0-520-08190-0 (cloth: alk. paper). — ISBN 0-520-08192-7 (pbk.:
alk. paper)
1. Mural painting and decoration, Nicaraguan. 2. Mural painting and
decoration—20th century—Nicaragua. 3. Mural painting and decoration—
Political aspects—Nicaragua. 4. Nicaragua—History—1979–1990. 5. Art
and revolutions—Nicaragua. I. Title.
ND2662.K86 1995
758′.997285053—dc20 94-49437

Printed in the United States of America
9 8 7 6 5 4 3 2 1

For Marjoyrie

Contents

Preface

Regular visits to Nicaragua since 1981, when the beginnings of a mural movement in aid of the Sandinista revolution were already visible, convinced me of the need for a book on a remarkable artistic phenomenon arising from a remarkable and courageous political experiment. The acceleration of mural production and the founding of the Mural School in the mid-1980s promised more than enough material. But by about 1988 a problem seemed to present itself: at what point, now or later, stopframe this moving picture, catch this rising tide, which showed no sign of ebbing? Then two things happened to precipitate a decision: the dramatic, wholly unexpected defeat of the Sandinistas at the polls in February 1990, and the systematic campaign for the destruction of the murals initiated by the reactionary Somocista mayor of Managua in October of that year.

This book, in documenting lost and extant murals, proclaims ulterior motives: it pleads for the preservation and restoration of the survivors, for the revival of the mural movement, and for recognition by the international community of its duty to denounce the destruction of the past and prevent destruction in the future. For this art belongs to and benefits us all. For a decade the world has looked encouragingly, critically, relentlessly at Nicaragua; let our eyes fix now on the painted walls from which Nicaraguans, their hopes still alive, gaze back at us.

This book was written and published, and will be read, in the United States, whose government has abetted the massive destruction of murals, directly in three Latin American countries (Chile, Panama, and now Nicaragua), and more indirectly in a fourth, Colombia. I appeal to citizens of the United States, in the first instance, to change a political system that abuses both people and art around the world.

Without painters there are no paintings, or books on painting; to the Nicaraguan muralists, first of all, go my thanks, especially Leonel Cerrato and Federico Matus, and above all Sergio Michilini, who over the years located people, murals, and press clippings for me; lent me numerous slides; and generally bolstered my faith in the project. With my Nicaraguan research assistant and

hermano Orlando Pastora there developed a special bond of gratitude and fraternal affection; he accompanied me on and facilitated numerous mural-hunting trips, smoothed rough paths, compensated for professorial distraction and failures of diplomacy, found murals I would otherwise have missed, persisted beyond reason, and buoyed up my spirits when they wilted in torrid heat. Inexorably, he guided me through the sanguinary infernal labyrinth of the meat market in the Mercado Oriental, to Managua's best-hidden mural.

For the provision of documentation, slides, and photographs, apart from those credited on the copyright page, I thank Dominic Allt, Lynn Anderson, Rune Andersson, Father José Arguello, Father Gabriel Rodríguez Celiz, Eva Cockcroft, Colectivo Boanerges Cerrato, Phil Danzig, the Reverend Grant Gallup, Inez Hedges, Victor Wallis, Gera Hoogland, Reinaldo Hernández, Ray Hooker, Cecelia Klein, Gloria Lachelle, Steve Lehmer, Uaininn O'Meadhra, Camilo Minero, Blair Paltridge; Nidia Taylor, who kindly showed me around Bluefields; Sister Margarita Navarro and Father Angel of the Batahola Community Center; Yvonne Sherratt; and especially Steve Kerpen of Architects and Planners in Solidarity with Nicaragua (APSNICA) in Los Angeles, who has done so much for the people of Nicaragua, and Carol Wells, whose Center for the Study of Political Graphics in Los Angeles is a primary depository and exhibition agency of Nicaraguan posters, and in whose inspiring company, along with her husband, Ted Hajjar, and Eva Cockcroft, I first discovered revolutionary Nicaragua in 1981.

My thanks also to Alan Bolt of Nixtayolero, Miguel d'Escoto, María Mercedes Alemero, Julio Madrigal, Father Uriel Molina, with his sister Elba and her daughter Elba, of the Centro Espiritual Monseñor Oscar Arnulfo Romero (CEMOAR); and to Raúl Quintanilla, Alan Barnett, Bill Callahan, and Kevin Baxter, for newspaper clippings and courier service. Valerie Gilbert and Bill Monahan, and a Visiting Fellowship at Clare Hall, Cambridge, offered some weeks of ideal space in England at critical moments of editing.

My visit to Nicaragua in 1991 was energized and enriched by Jim Prigoff, who took photographs with and for me; many of them, taken then and earlier, are used in this book and hereby gratefully acknowledged.

For help on my text, I owe much to David Craven, who corrected several errors; to Shifra Goldman, who made helpful suggestions; and to John Pitman Weber, whose caveats I gratefully heeded. My UCLA colleague Bradford Burns improved the flavor of the historical section. The typing of the manuscript was handled efficiently and gracefully by Stacy Kamehiro and Bob Stockwell; Afroditi Davos did the index; and grants from the Academic Senate of the University of California at Los Angeles rendered significant material help.

It was once again my great and good fortune to have as copy editor the panoptic Stephanie Fay, helped by Fronia Simpson, who chastened and disciplined and clarified my thinking and phrasing. Evan Camfield and Steve Renick gave valuable advice on the choice of illustrations, as did the designer of this book, Nola Burger, who is of course, with the University of California Press as a whole, responsible for its handsome appearance. Deborah Kirshman guided the whole project through with enthusiasm and tact.

Foreword

Unique in its program of a mixed economy, nonalignment, and political pluralism, the Sandinista Popular Revolution became the foundation of democracy in Nicaragua. The Sandinist National Liberation Front (FSLN), its vanguard organization, having lost the 1990 elections, peacefully handed over power to other parties, thereby setting an important democratic precedent in the 170-year history of independent Nicaragua.

Culturally the revolution meant an encounter of Nicaragua with Nicaragua, with its own deepest roots, its strongest traditions, and its most authentic forms of expression. The fathers of the land, notably Augusto César Sandino and Carlos Fonseca, previously stigmatized as bandits and terrorists, were now hailed as national heroes. The people—peasants, urban workers, and the middle class—became both subject and object of Nicaraguan history. Nicaragua began to see itself as multilingual, multiracial, and multicultural.

The high regard in which everything national, or Nicaraguan, was now held resulted in a sort of national rebirth. Dance, theater, literature, and painting; Nicaraguan music and its ⅝ time; popular art forms previously seen as mere crafts; all were now recognized for their intrinsic value. Nicaragua, a small nation immersed in the noble task of salvaging its own identity and sovereignty, became a theme and an example for both national and foreign artists.

National and international mural brigades committed themselves to spreading the good news, the revolution, the joy of knowing Nicaragua to be at last in the hands of its own sons and daughters. Although the aesthetic and technical quality of these murals varied, they emphasized the national, the autochthonous, whatever was truly Nicaraguan.

Today, many of our best murals have been erased by the anti-Sandinista fervor of Managua's neo-fascist mayor, Arnoldo Alemán. In this book is to be found the best record of their existence. Alemán's brutal, senseless attacks have been directed against the principal, the richest, the most beautiful, the most painful, and the most dynamic cultural expression of the Nicaraguan people. Alemán wants to turn back the clock, deny the rebirth of Nicaragua, deny Sandino and the revolution. As the poet and art critic Julio Valle has said, "To erase the murals is to try to erase the

beauty, the flights of fancy and magic released by the liberation and utopic dreams of our people."

This book is an important act of international solidarity, which arrives at a critical moment. It will serve future generations by recording a vital aspect of the single most important social and political event of the 1980s. I hope it can help defend the remaining murals physically as well as morally, and that, as testimony to the achievement of the immediate past, it will inspire new waves of mural activity in the future.

The Sandinista popular revolution, which so obsessed two presidents of the United States, brought out the worst in those pathologically afraid of any attempts to turn our planet into a more brotherly and sisterly place; but it also brought out the very best in Nicaragua, and solidarity with Nicaragua.

Miguel d'Escoto Brockman
Formerly Foreign Minister in the Sandinista Government

Managua 1993

A Suspended Dialogue:
The Revolution and the Visual Arts in Nicaragua

Like so many of the Nicaraguan people after 1979, I am proud to be an active part of a social process that was building its cultural identity in an open, democratic, popular, and anti-imperialist manner—a process that demanded then and still demands active engagement and strong solidarity.

As an artist I belong to the generation that matured under the U.S.-backed Somoza dictatorship and rooted itself in a culture of resistance to that dictatorship. There arose in the 1960s and 1970s progressive urban groups like Ventana, Praxis, and Gradas, and the liberation theology centered on the parish of Solentiname by the poet-priest Ernesto Cardenal. Even then we tried to bring together high art and popular culture, intellectuals and people in a dynamic capable of enriching the lives and culture of the Nicaraguan people and of establishing new parameters for the socialist experience as a whole.

Beginning in 1979 we embarked on the making of a new visual language within the framework of a popular-based revolution, one that was immediately besieged by the U.S. government. Our new identity required us to look critically at both our past and our present situation. The revolution of 1979 gave us the right to freedom of expression, experimentation, and recovery of the heritage taken from us throughout five hundred years of colonialism and neocolonialism. We also valued the new developments made by vanguard artists in the West. We knew that there was always a Third World within the First World, just as there was always a First World within our Third World. We looked in a newly liberated way at the Eurocentric nature of much contemporary art. We did not want to be an appendix or a benign tumor on these so-called international centers of the arts, nor did we intend to "other-ize" ourselves, as the Cuban critic Gerardo Mosquera has brilliantly put it, or to serve the demands of the Western art transnationals for ethnic touristic curiosities. We wanted and began to shape a new visual language that was national and yet also international. Our models were the painter Armando Morales and the poets Rubén Darío, Ernesto Cardenal, and Carlos Martínez Rivas, who had already thoroughly immersed themselves in

contemporaneous expression. They had affirmed our national self-identity in a new plurality of ways.

So we began to build a visual language embracing many dialects through a continuous dialogue—a dialogue that engaged everyone and everything. This dialogical process dovetailed social commitment and visual experimentation. We had emerged from a very restrictive tradition that hierarchized the arts in a highly undemocratic way. In the visual arts as practiced before the revolution (and now again with the new UNO [National Organized Union] government), oil painting was practically the only important art form. The 1980s, however, brought about a great diversification of forms: billboards, murals, posters, graphics, festival decoration, crafts, music, videos, mixed media; and also diversification within oil painting itself. We did all of this while fighting a war, a battle that continues now in other ways, which, being nonmilitary, are perhaps harder to deal with.

In February 1990 an amazing thing happened. The U.S. government surprised the world—and itself—by winning the Nicaraguan elections. And the Nicaraguan people set their "utopian" vision to one side. This had happened before. In the middle of the last century we even had a North American, a freebooter called William Walker, install himself forcibly as president. From 1934 to 1979, the United States ruled through the Somoza dictatorship. Finally, in the revolutionary triumph of 1979, the Nicaraguan people reclaimed national dignity and sovereignty.

Then immediately, under Ronald Reagan and George Bush, the contra war, a so-called low-intensity war of high-intensity cruelty, began to destroy the incipient revolution. Washington's war was repudiated not only in Nicaragua and by many in the United States itself but worldwide: in 1986 the International Court of Justice in The Hague, in a historic decision, ratified Nicaragua's complaint by ordering that the U.S. government pay an indemnity of $17 billion to cover just *part* of the immense damage it had caused our country. The new UNO government, in its neocolonialist cowardice, has now withdrawn the claim for damages, in order to further the so-called new friendship between our nations. As a result of this "new friendship," our national debt is approaching $15 billion, and 64 percent of our national workforce is un- or underemployed.

The supposed "universal triumph of capitalism" threatens to reduce the dramatic reality of our Third World nations to an "accident of history," to a "sociological joke," in the words of the rector of Nicaragua's National Autonomous University (UNAN). The new Nicaraguan culture is framed by the "death of communism" so recently and triumphantly announced by President Bush and by the airborne genocide perpetrated in Iraq in 1991. (We had a taste of that too in the early 1930s, when the U.S. air force attacked Sandino in the Segovias and, more recently, in the 1970s, when the U.S.-supplied and -supported Somoza air force bombed our cities.) Back in 1905 Rubén Darío asked, "Will we all be Yankees?" This is for us to answer.

How can we now theorize about a project that has not only been officially discontinued but also harassed and largely undermined—except in the notable cases of Estelí and León, where the

FSLN won the 1990 elections and has maintained its programs of the 1980s at the local level? Our friend Margaret Randall [a U.S. writer on women and revolution in Latin America] has said that memory is identity, which is why we must continue to talk about Nicaragua and its cultural legacy for popular democracy. We must sharpen the struggle against official erasure of memory.

As soon as the FSLN took power in July 1979 it assumed the greatest and most important cultural task ever to have been accomplished in our country: the 1980 National Literacy Crusade (which won the Kruskaya award of UNESCO in 1981). This tremendous dialogical program reduced the illiteracy rate, in a matter of months, from about 50 to 12 percent, in a process that engaged almost the entire population of the country. In the capital city of Managua, Alejandro Canales was inspired by this unique historical phenomenon to paint one of the best murals of the revolution: his *Homenaje a la Mujer* (Homage to Woman; see no. 8), dedicated to women and the literacy campaign (the majority of whose *brigadistas* were female).

Less than a year after UNO's "democratic victory" the illiteracy rate rose sharply (25 percent according to official government data), owing to the semiprivatization of the school system, which leaves around 120,000 Nicaraguan children untaught. Arnoldo Alemán, mayor of Managua, one of the most picturesque and reactionary figures of the new government, chose to obliterate the Canales mural—one of the most conspicuous commemorations of the literacy campaign. Alemán's aim was to destroy the "capital of mural painting," as Kent Johnson had called it. Books were burned too, those by Nicaragua's most acclaimed writers such as Ernesto Cardenal, Sergio Ramírez, Gioconda Belli, and Omar Cabezas. Galleries and exhibitions were censored, popular monuments to our martyrs and heroes were destroyed. Immediately after the creation of the new Institute of Culture in 1990, all the programs for popular culture were abandoned, because they threatened to reawaken the energy of the masses. What we have today is the most dismal trivialization of art and culture. In 1991 *La Prensa*, the UNO newspaper, declared the Miss Nicaragua beauty pageant the most important cultural event of the year, such as is "possible only in a real democracy."

The roles played by the National Union of Plastic Artists (UNAP) and by the National School of Plastic Arts (ENAP), meanwhile, reveal the same apathy and confusion that pervade most of the cultural organizations once linked to the FSLN through the Sandinista Association of Cultural Workers (ASTC) and the Ministry of Culture, especially in Managua. Members of UNAP, after inscribing angry graffiti on the walls whitewashed by the Managua mayor and later deciding to bring a lawsuit against him (which they might have won), suddenly dropped everything and sat down with him to negotiate compensation. Yet to date nothing has happened.

Most of the artists' unions have been co-opted and debilitated. In this way they have paradoxically legitimized the vandalism and censorship of the new government. Just recently the Union of Visual Artists organized, in collaboration with the Institute of Culture, an exhibition of young Nicaraguan painters, which was to travel across the United States. How pathetically this venture

ended: after opening in Maryland, the show was immediately canceled when officials of the Nicaraguan embassy in Washington realized that most of the participating artists had links to the Sandinistas.

Today, with the independence of the art workers' unions undermined, with their links to popular organizations and the FSLN weakened, artists find themselves in desperate economic straits (the "politics of hunger," we call it). The emphasis of the new government on private art for personal gain has led to the isolation of many artists from that sense of shared social experience of the 1980s; and this has noticeably affected the quality of work being produced. Now it is the gallery owners and dealers who are organized.

On the positive side, alternative, largely self-sufficient cultural groups have now emerged, or continue, which preserve the social consciousness of the 1980s: in the theater, the Justo Rufino Garay group, Alan Bolt's Nixtayolero, Guachipilín, and the Danza Contemporanea; in the popular arts, Mecate; in the visual arts, Artefacto and the Union of Painters and Artisans of Solentiname; in the mass media, Radio La Primerísima. In these groups, we have started to analyze our predicament. We have openly assessed the cultural policies, good and bad, of the revolution, and the virtual abandonment since 1990 of the cultural sector by the FSLN, which is itself undergoing a major (and very necessary) identity crisis; and we are coming to terms with the virtual disappearance of international solidarity in the cultural arena.

We know for certain that the revolution is still alive. We might have lost an election, but we will never lose the dignity that we acquired at such cost: more than fifty thousand deaths up to July 1979, perhaps as many in the contra war since. For as Ernesto Cardenal has said, "The new government may remove the images of Sandino from the walls, the ramparts, the electric posts, but not from the heart of the people. Because Sandino lives."

And as it is written on the walls:
SANDINO VIVE Y LA LUCHA SIGUE [Sandino lives and the struggle continues]

Raúl Quintanilla
Artist, formerly Director, National School of Plastic Arts,
and formerly Director, Museum of Contemporary Art, Managua

Managua–Chicago–New York–Managua, February–March 1992

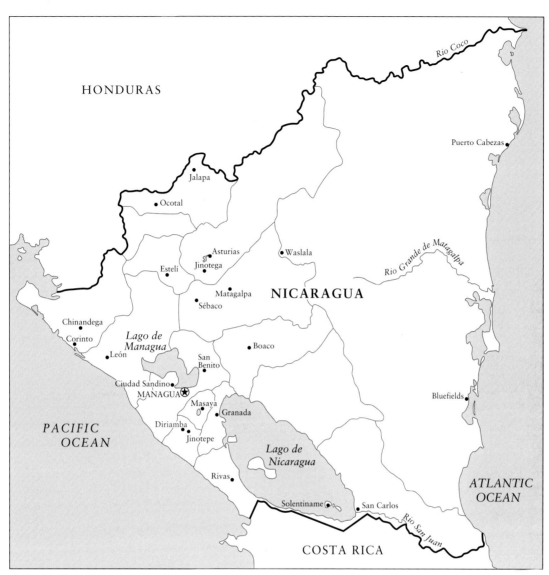

Nicaragua, with sites of murals.

Introduction

The United States and Nicaragua: A History of Hostility

Perhaps no other nation in this hemisphere—not Mexico, not Cuba—has been so consistently abused by the United States.

Carlos Fuentes

The enmity that existed in the 1980s between the United States, the most powerful nation in the world, and Sandinista Nicaragua, one of the poorest, was rooted in history and in fundamental differences of social vision.[1] The governments of Ronald Reagan and George Bush engaged in the most massive peacetime arms buildup of U.S. history and the redistribution of wealth in favor of the rich, undermining national education, health, social welfare, labor rights, and civil liberties. Nicaragua, by contrast, from 1979 made radical moves to enfranchise the poor, build a free national educational and health system, promote social welfare and labor unions, give land to the landless, and encourage popular democracy. Washington characterized this enterprise as a Marxist tyranny and waged war against it.

The sad history of United States–Nicaragua relations is now written in a number of excellent books and articles,[2] but the salient facts have been so obscured by Cold War rhetoric and the disinformation of the U.S. government-military-media complex that a brief review is in order here. Nicaragua passed from the hegemony of Spanish colonialism to the hegemony of U.S. imperialism. In the mid-nineteenth century a North American adventurer called William Walker installed himself by force of arms as president, declared English the official language, tried to reintroduce slavery, and attempted to have the country annexed to the United States. He failed, because he fell afoul of the competing economic interests of the American millionaire Cornelius Vanderbilt, who built across Nicaragua a transportation route to link the east coast of the United States and California (see no. 68).

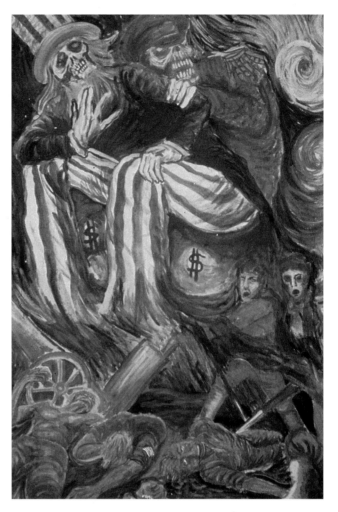

Detail from a mural by Spanish artists in Ocotal, to commemorate the U.S. aerial bombing attack of 1926 (now destroyed; no. 237).

As a convenient trans-isthmian crossing route, as a promising site for a canal (before one was built in Panama), and as a source of valuable agricultural exports, Nicaragua gradually came under U.S. economic control and policing. To establish political hegemony, by the turn of the century the United States was interfering directly, arming factions deemed favorable to U.S. interests. When this proved insufficient, U.S. marines invaded in 1909 to overthrow the nationalist president José Santos Zelaya. With only brief respites, Nicaragua remained under U.S. military occupation until 1933, when the marines were forced out after a bitter guerrilla struggle led by Augusto César Sandino. A generation later Sandino became the rallying cry of the insurrection named after him, and in the 1980s the presiding genius of the Sandinista mural movement.

The commander of the 1912 invasion, Marine Corps legend General Smedley Butler, explained in a retirement speech U.S. purposes in the southern hemisphere: "The record of racketeering is long. I helped make Mexico safe for American oil interests in 1914. I helped make Haiti and Cuba safe and profitable for our bankers. I helped rape half a dozen Central American republics. I

Seal of Sandino, used in the 1930s as an official seal by the guerrilla chief; also known as *corta de chaleco* (the vest cut), a form of killing associated with Sandino's general Pedro Altamirano. The recumbent figure is a U.S. marine, whom the seal is supposed to warn.

Child with Molotov cocktail at the ready, at a barricade. Children participated effectively in the struggle against Somoza and were often wantonly killed. Detail from a mural, now destroyed, at the Managua airport (no. 15).

helped purify Nicaragua for the international banking house of Brown Brothers in 1909–17."[3]

In February 1934, after attending a celebration banquet with the Nicaraguan president Juan Bautista Sacasa, the victorious Sandino and several of his followers were assassinated, with the connivance of the U.S. ambassador and on orders from Anastasio Somoza García, who had been installed by the marines, before their departure, as head of the National Guard, or Guardia, the country's army. This Somoza and his two sons ruled Nicaragua for forty-three years, on the avowed principle "I'll give this country peace, if I have to shoot every other man to get it."[4] The Somozas stayed in power by means of unwavering servility to the United States. As President Roosevelt put it, in a phrase now notorious, "He's a son of a bitch. But he's *our* son of a bitch."

The Somoza family amassed enormous wealth, treating Nicaragua as their private hacienda. A "rough inventory" listed over 140 names of the companies they owned (not counting their share in at least 43 U.S.-dominated transnationals), whose holdings, by the end of their reign, amounted to over half the national economy. The Somozas suppressed opposition, manipulated elections, and

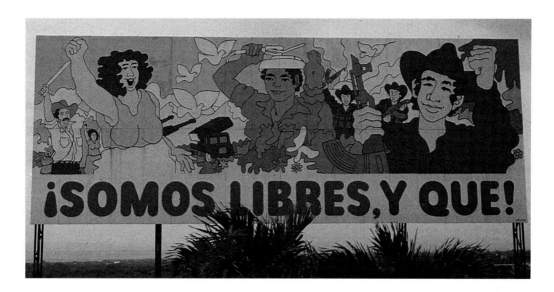

"We Are Free, and How!" Billboard, Managua, 1986.

profited handsomely from the foreign aid that poured in after the greatest national disaster of Nicaragua's history, the earthquake of 1972. One of the murals (no. 68) shows Somoza sucking the profits from earthquake reconstruction as if it were blood to his heart. And indeed one of his businesses was a blood bank, which provided 15 percent of the world's plasma supply, most of it going to the United States, to a profit of $12 million a year: "Somoza, bleeding his own people, had turned his own country into the ultimate family business."[5]

Meanwhile another, social, earthquake was rumbling. The spirit of Sandino was rekindled by a group, founded formally in 1961, called the Sandinista National Liberation Front (in Spanish, Frente Sandinista de Liberación Nacional, or FSLN). The new Sandinistas, under the leadership of Carlos Fonseca (killed in battle in 1976), launched a political and guerrilla struggle. After many vicissitudes, and at horrendous cost in lives (up to 50,000) and property (Somoza bombed his cities from the air), they finally triumphed on 19 July 1979. Anastasio Somoza Debayle had fled to Miami two days before, taking with him the caskets of his father and brother and as much of the national treasury as he could lay his hands on. He left the country bankrupt and devastated.

The Sandinists' victory was aided by sympathetic neighboring countries (notably Mexico, Panama, and Costa Rica), effectively preventing the United States from organizing an invasion. To keep up the flow of arms to Somoza's by-now thoroughly discredited National Guard, President Carter used Israeli surrogates. Recognizing Anastasio Somoza personally as a lost cause, the Carter administration tried to the very end to install a form of "Somocismo without Somoza." This would be the aim with the contra war, and it is still the aim of an important faction of the new Nicaraguan government.

As with Cuba in 1959–60, the revolutionaries' appeals to the United States for aid fell on deaf,

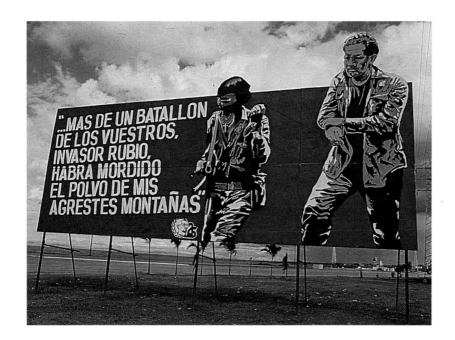

"More than One Batallion of Yours, Fair-haired Invader, Will Bite the Dust of My Rugged Mountains." Nicaraguan soldier brings in Eugene Hasenfus, a U.S. citizen shot down and captured while providing supplies to the contras. The United States denied responsibility. Hasenfus was soon released unharmed, in a futile gesture of goodwill. Note the Catholic cross around the Nicaraguan's neck. Billboard, Managua, 1986.

indeed hostile, ears; and the Sandinistas turned to the socialist bloc, notably the Soviet Union and Cuba, for help. On taking office in January 1981, President Reagan turned the cause of getting rid of the Sandinista government into a personal crusade. Reagan used every diplomatic pressure, economic embargo, and, above all, a U.S.-trained and -armed terrorist army. This was composed of mercenaries, numbering up to twenty-five thousand, drawn from the Nicaraguan exile community (ex–National Guard); Cuban exiles; and adventurers of other nationalities, including "death squad assassins, torturers and killers from around the world."[6] They were dubbed "contras," for "counterrevolutionaries," and were paid (at the officer and organizer level) handsome salaries by the CIA. By the mid-1980s the contras were getting over $200 million annually, or the equivalent of one-third of the Nicaraguan national budget.[7] The economic and human damage they did was immense: the economic cost by about 1990 was put at $17 billion, with 43,000 Nicaraguans killed, wounded, or kidnapped; 22,500 dead on both sides (by June 1987—this toll is now estimated at around 30,000)—a percentage equal to 1.8 million of the U.S. population, or more than the combined battlefield deaths of the American Revolution, the War of 1812, the Civil War, World Wars I and II, and the Korean and Vietnam wars.[8]

The contra war was so blatantly a violation of international law that Nicaragua sued in the International Court of Justice at The Hague. The judgment, rendered in June 1986, condemning the United States to pay massive damages, was so little regarded in that country, by the government and media alike, that Reagan was able to authorize immediately afterward another $100 million for the same cause. Proclaiming "I am a contra too," Reagan went so far as to call the terrorist band Freedom Fighters (in Spanish, *Paladínes de la Libertad*), "the moral equivalent of our Founding Fathers" and comparable to the French Resistance and even Winston Churchill. The accounts of

atrocities committed by the contras, particularly against "soft targets"—they preferred to attack undefended schools, health clinics, and cooperatives—make appalling reading.[9] The murals avoid these subjects, deeming them beyond the pale of aesthetic viability, unpaintable as well as unspeakable. But they were well publicized in the U.S. alternative press, while the government and major media concealed them.

When, in the mid-1980s, Congress (through the Boland amendment) finally balked at financing the contras, who were unable to win a single military victory against the Sandinista army (this was considered their major and overriding failing) or to hold a square foot of Nicaraguan soil, the Reagan administration circumvented the Congress by secret means. The discovery of these means led to the Iran-Contra scandal, whose labyrinthine thread leads to the principal officials of the U.S. government and into a further maze of lies and deceit. The international character of this conspiracy may be viewed as the sinister contrapart to the global solidarity on behalf of the revolution to which the murals testify. The Iran-Contra scandal is a central example of the "state-sponsored terrorism" that has marked U.S. foreign policy continuously and globally since World War II.[10] The arming of the contras, which was not only in contravention of Congress but also, according to opinion polls, always against the popular will in the United States, involved the sale of arms to Iran via Israel, with funding from Saudi Arabia and special "targets of opportunity" like the Sultan of Brunei, and the diversion of monies via Swiss banks to the contras, with the help of Communist China and Taiwan, which shipped arms to the contras through Canadian dealers and Portugal. Singapore and South Africa were also heavily involved.[11]

When it became apparent that the contras could not overthrow the Sandinistas directly and had become a serious public-relations liability, the Reagan government continued to support them as a means of slowly bleeding the Nicaraguans to death—or surrender, which is more or less what happened in the elections organized and lost by the Sandinistas in 1990; the Nicaraguans voted for their stomachs, survival, and an end to the war. The winning UNO coalition (Unión Nacional Oppositora; when in government, called Unión Nacional Organizada) benefited electorally from $12 million given directly to them, as well as $600,000 given covertly and illegally by the CIA.

"In the American continent, there is no regime more barbaric and bloody, no regime that violates human rights in a manner more constant and permanent than the Sandinista regime."[12] This was just one of the accusations endlessly repeated by Washington in its systematic, obsessive campaign to demonize the Sandinistas. Father Miguel d'Escoto, Foreign Minister of Nicaragua, a Roman Catholic (Maryknoll) priest, spoke of Reagan's "incredible capacity for lying [which] reveals something like a case of diabolical possession."[13] Let us briefly review and respond to these accusations, to which murals respond best of all.

1. "The Sandinistas are 'barbaric and bloody,' worse than Somoza." It is impossible to deny that the Somoza dynasty was one of the very worst tyrannies, as well as longest-lasting, in the history of twentieth-century Latin America. Without admitting any guilt for supporting the

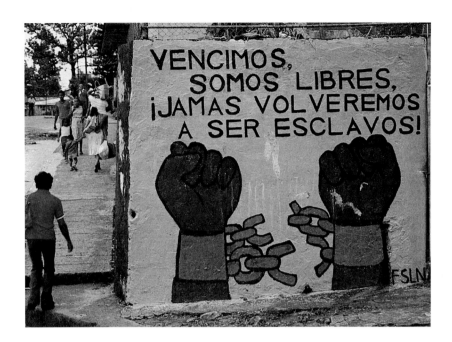

"We Won, We Are Free, We Will Never Be Slaves Again!" Mural, Bluefields, 1981 (no. 134).

Somozas, the U.S. government and media affixed the label "tyranny" (often preceded by "Marxist" and even on occasion "Stalinist") to the revolutionary regime that succeeded them. And yet, the Sandinistas, after suffering atrociously under Somoza and after some initial uncontrolled and uncontrollable "popular executions" of the worst Somocista criminals and the jailing of others after trial, proved remarkably humane and generous in their treatment of their former enemies.[14] This was attested by international human-rights organizations, which pointed out that such treatment compared favorably with what happened in the occupied territories of Europe after liberation from the Nazis in World War II. The Sandinistas abolished the death penalty, arbitrary arrest, disappearances, and torture; humanized the jails; and opened the country to reporters, even those known to have no sympathy for them or the truth. Later, captured contras were quickly released, and all those who surrendered with their arms were amnestied, no questions asked.

2. "The Sandinistas suppress human rights, civil liberties, and political pluralism." International observers, including respected international human-rights organizations, agreed that the degree of personal civil and political liberty in Nicaragua was greater than in most Latin American countries. The periodic closure of *La Prensa*, the U.S.-supported newspaper, while generally regretted, was compared favorably in the foreign and alternative U.S. press with the closing down of dissident voices by democracies in wartime. Never could the United States or Britain have allowed an organ of Nazi ideology funded from Germany to operate openly in the country during World War II. Indeed, the attitude of the Sandinista government to vocal dissidents compares very favorably with that of the United States in 1941, when one hundred thousand Japanese Americans were interned, although they had

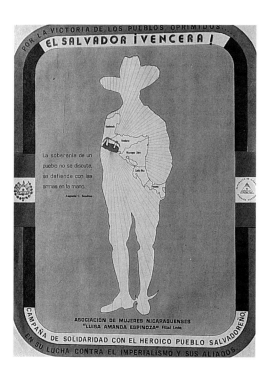

"For the Victory of Oppressed Peoples . . . El Salvador Will Win!" and "The Sovereignty of a People Is Not a Matter for Discussion; It Is to Be Defended with Arms in Hand (Augusto C. Sandino)." Luisa Amanda Espinoza Women's Association (AMNLAE) poster, circa 1981, for the Solidarity Campaign for the Heroic Salvadoran People in Their Struggle against Imperialism and Its Allies. Nicaragua's aid to El Salvador was largely moral and political.

voiced no opposition at all, not to speak of the postwar, peacetime McCarthyite purges. Comparisons with other Central American countries, notably El Salvador and Guatemala, where the opposition press has been totally and violently suppressed, and where U.S.-supported death squads operated with impunity, cast Nicaragua in a light so rosy that the media apparently had to call it Red.

As to political pluralism: even small political parties, spanning the extremes of left and right, are represented in the Nicaraguan Assembly, by a proportional voting system that is generally agreed to favor breadth of viewpoint. Seven political parties participated in the 1984 elections after the United States persuaded an opposition bloc to boycott them. Twenty-one parties participated in the 1990 elections. In the United States, some consider the monolithic two-party system a mask for a one-party system; and the connivance of a Democrat-controlled Congress with the Republican president's Nicaragua policy lends substance to this view. In Nicaragua the voter turnout was around 75 percent; in the United States it has been recently around 50 percent, with the figure down to 37 percent in the 1986 midterm elections. In 1990 the Sandinistas handed over power peacefully and gracefully.

3. "The Sandinistas export revolution, seek to subvert their neighbors, and send arms to the Salvadoran rebels." The Nicaraguan government admitted that soon after the Triumph in 1980 some enthusiasts had, without their approval, slipped small quantities of arms across the border to El Salvador. But this soon stopped, as CIA reports confirmed, even as Reagan persisted in his accusations. It is true, however, that Sandinista Nicaragua gave *moral* sup-

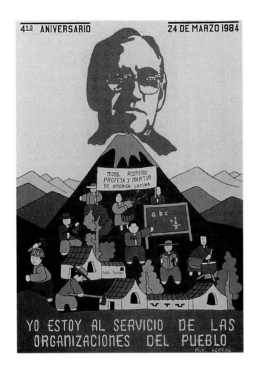

"Monseñor Romero, Prophet and Martyr of Latin America" and "I Stand at the Service of the Organizations of the People." Romero's portrait surmounts a volcano with scenes, depicted in Salvadoran folk style, of schooling, production, and construction. Poster published in 1980 for the fourth anniversary of the murder of El Salvador's archbishop by U.S.-supported death squads.

port to the Salvadoran rebels and denounced the atrocities committed by the Salvadoran army death squads, whose principals had trained at the U.S. army's School of the Americas, Fort Benning, Georgia (see nos. 36, 57, and 113).

4. "The Sandinistas maintain a large army in order to threaten their neighbors." It is important to understand the arms depicted in the murals either as those used during the insurrection or as those embodying the spirit of self-defense against contra aggression and the ever-present possibility of full-scale invasion from the United States. (Contingency plans for this had been in place since 1980.) The Sandinistas never verbally threatened or made an aggressive move, either against neighboring Honduras, although this country was virtually a military base for launching the contras upon Nicaragua, or against Costa Rica, which was also used for a time as a base for cross-border raids and was being pressured by the United States into hostility with its erstwhile friends.

Nicaragua, in short, stood accused of maintaining the means to defend itself. The need for a large army to contain the contras resulted in a very unpopular military conscription and the diversion of resources from much needed social programs. Seven percent of the government expenditure in 1980, defense later accounted for over 50 percent. This increase is of course what the United States intended. Army and militia did indeed constitute a "people in arms"; but what tyranny, communist or otherwise, has ever armed the very people it is suppressing?

The further accusation that Nicaragua threatened Mexico, and even the United States,

indicates only the level of desperation, absurdity, and paranoia attained by U.S.-government rhetoric. Meanwhile, Nicaragua was the only Central American country to accept the Contadora Treaty proposals barring arms imports and foreign military advisors.[15]

5. "Nicaragua is a Soviet-Cuban puppet." Who objected that Nicaragua was a U.S. puppet under Somoza? True, having been rejected by the United States and its allies, Nicaragua turned, as Cuba had done before, to the Soviet Union and its allies; the progressive withdrawal of Soviet-bloc aid since about 1988 has severely harmed the Nicaraguan economy, as it has Cuba's. In the tireless refrain of Ernesto Cardenal, "We do not aim to be a second Cuba, we want to be *a* [or *our*] Nicaragua."[16] The Sandinistas proclaimed neutrality in a situation where the United States made neutrality in practice impossible. While gladly accepting aid from anywhere, Nicaragua's revolution remained Sandinist, national, and unique, as the murals testify.

6. "The Sandinistas ruined the country economically." In the first five years after the revolution the gross domestic product *increased* by 4.4 percent, double the rate of increase for Latin America as a whole, and well beyond that of any single country. Export production increased 11 percent, compared with the 19 percent decrease in Central America as a whole.[17] The decline that set in after the mid-1980s can, according to an opponent of the Sandinistas, be attributed chiefly to the contra war, and then to the international economic crisis, the contraction of the Central American Common Market, decapitalization by the business sectors, and government errors.

7. "The Sandinista government engages in drug trafficking." The Iran-Contra scandal proved U.S.-government agencies guilty of this very charge. The same day Reagan made the accusation against the Sandinistas (16 March 1986), the *San Francisco Examiner* carried a lengthy story of how a U.S.-based cocaine ring was helping finance the contras. Evidence that the Sandinistas themselves ran drugs was never offered. In reality, Nicaragua was one of the few Latin American countries *not* involved in the drug traffic.[18]

8. "The Sandinistas enacted far-reaching reforms in education, health, social welfare and land-ownership, and worker control. They helped workers, women, and peasants organize themselves to improve their lot. They did all this in such a way as to make U.S. allies in the region, who do the reverse, look bad. This 'threat of a good example' might have destabilizing effects elsewhere, even in the United States itself, which incorporates a restive 'Third World' population." Touché.

There is no such thing as the pro-contra or anti-Sandinista mural, inside or outside Nicaragua, but photographs were, naturally, pressed into service by the mass media. We may dismiss, as unlikely to reach the wider public, contra posters that obscenely parody appeals to aid children in the Third

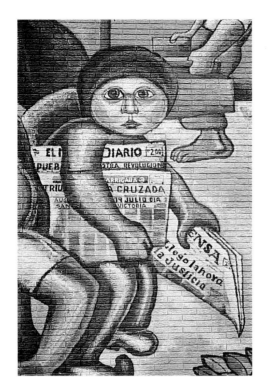

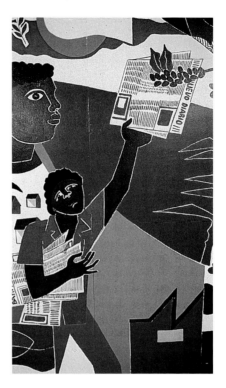

Child selling the three Nicaraguan daily newspapers in the street; above him, a bootblack. Detail from a mural by César Caracas, circa 1981 (no. 124).

Child selling the two Nicaraguan pro-Sandinista newspapers. Detail from a mural by Alejandro Canales (no. 112).

World ("Only 53¢ a day will support a Nicaraguan Freedom Fighter," with the photograph of a heavily armed, half-naked Rambo-like warrior), and the *Freedom Fighters Handbook*, published under CIA auspices, detailing techniques for economic sabotage in comic-book format (another contra manual openly recommended selective assassination).

"Nicaragua has the freest print media in Central America."[19] In the 1980s the press war was probably more open, ruthless, and polarized than anywhere in the world. There were two pro-government newspapers: the official FSLN daily *Barricada* and *El Nuevo Diario*, the latter more independent in editorial policy and more exciting in style.[20] Both papers, but especially *El Nuevo Diario*, while still sympathetic to Sandinism, have now degenerated into sensationalism. Then there was, and is, *La Prensa*. These papers contended vociferously for the popular will and were too conspicuous a feature of Managua street life, carried and cried by the children of the poor, not to show up in the murals.

La Prensa, the pro-U.S., pro-contra newspaper funded by the United States, was permitted to flourish in Nicaragua, with some interruptions due to closure by the government but with absolute freedom during the recent election campaign. It adopted the tactics tested successfully by the

CIA-funded *Mercurio* in Chile, which helped sabotage the popularly elected Allende government in 1973. These tactics included a form of journalistic psychological terrorism, blazoning headlines and photographs of terrible private crimes, natural disasters, bizarre sensations and miracles, all formatted to implicate the Sandinista government in general, both obviously and subliminally, and to make traditional Catholics in particular see it as antireligion.[21] I have detailed elsewhere the pattern of misinformation, provocation, and lying adopted by *La Prensa* in the early years of the revolution,[22] with its liberal use of photographic deceptions. We will observe shortly its attitude to the destruction of murals.

The U.S. mainstream press, like *La Prensa*, operates by slogans, lies, half-truths, and the simple omission of inconvenient information, which by means of sheer repetition take on the status of unquestionable truth.[23] This has been documented with icy irony and impeccable exactitude by Noam Chomsky, particularly with respect to Central America, and in a broader fashion by Michael Parenti, in *Inventing Reality* and other works. The role of photographs in the U.S. press, while it has not received due attention with respect to Nicaragua in the eighties,[24] may be pinpointed in a few admittedly crude but not exceptional examples.

A photograph published in *Time* magazine (2 August 1982), showing a line of figures applauding and with raised fists, is captioned "Sandinista leaders, including Ortega . . . celebrate in Moscow." The picture was in fact taken in Managua at the 19 July celebrations two weeks before, as the fragment of billboard behind them—in a more modernist style than one associates with the Soviet Union—would have given reason to suspect.[25]

A photograph run originally in the French conservative newspaper *Le Figaro*, purporting to show an alleged massacre of Miskito Indians by the Sandinista army in December 1982, was touted by Secretary of State Alexander Haig as evidence of Sandinista genocide in a region under attack by the contras.[26] The photograph was quickly proven to show the burning of bodies by the Red Cross after a 1978 massacre in Estelí by the Somoza National Guard. (*Le Figaro* furthered the incrimination and fabrication by printing a smaller picture of Sandinista militia next to that of the burning bodies.)

Shortly after the Sandinista victory, Susan Meiselas made and circulated a photograph identified as "Distributing free meat and milk, Matagalpa, July 1979." *Business Week* ran the photograph in its 24 January 1983 issue over a caption saying, in effect, "Nicaraguans line up for food rations."[27] Such are the tactics of the American "free press."

Writing History, Rewriting History, Erasing History

In the decade of Sandinista rule following the Triumph of the Nicaraguan revolution in 1979, close to three hundred murals were created in a tiny, poor country of three million or so inhabitants. These murals offer a history of the past, recent and more distant, and a projection of a better future promised by the revolution. This happier future was thwarted by the U.S.-sponsored contra

war against the Sandinista government and the Nicaraguan people and by the counterrevolution that won at the polls in 1990 with the UNO opposition alliance.

Several of the very best, oldest, and most centrally placed murals have been painted over, obliterated; none are now safe, despite the law passed by the Sandinista government just before leaving office, declaring as many murals (and martyr monuments) as they could name to be historic patrimony, and therefore untouchable. The murals are a narrative of a revolutionary convulsion the very memory of which the new government wishes to wipe out. The historiographical and educational significance of the murals, in a country where competing (electronic) media are underdeveloped, cannot be overestimated. They are, to be sure, not neutral—what art is? They celebrate the insurrection and revolutionary reconstruction. They are self-image and self-education, popular autobiography. They are extensions of the great literacy campaign, which turned "all Nicaragua into a school," as the phrase went; they are the blackboards of the people.

The new UNO Minister of Education, Humberto Belli, a U.S. citizen with proven CIA connections whose appointment flouts Nicaraguan law, has called on teachers to "exorcise" the schools of "all the evil taught during ten years of revolution."[28] Somocistas, many of them unqualified, have replaced Sandinista teachers, hundreds of whom have been summarily fired. The U.S. Agency for International Development has spent $6 million to replace innovative Sandinista textbooks (a new batch donated by Norway was pulped and burned). Supposedly depoliticized, the new civics textbook opens with the Ten Commandments and calls divorce a "disgrace" and abortion "murder." In the chapter on national heroes it fails even to mention Augusto César Sandino and Carlos Fonseca, the presiding geniuses of the murals. The world history textbook tells that U.S. interventions, of which there have been dozens in Latin America, were intended to bring "peace and stability." The fourth grade *History of Nicaragua* contains elementary errors of fact (such as that World War II ended in 1944) and calls the contra war (created, financed, propelled wholly by Washington) a civil war resulting from an indigenous, legitimate peasant insurrection, against which the Sandinista government arrayed a vast, useless(!), and wasteful army. The major Sandinista social and educational achievements, of which the murals speak so vividly, are passed over in silence, or belittled: all the Sandinistas really did was to bankrupt the economy and to create a Cuban-style tyranny worse than Somoza's. The Centers for Popular Culture, which under the Sandinistas laid the basis for a national and democratic culture, including the mural movement, are deemed a failure because of the Nicaraguans' obstinately "low level of culture." Most astonishing of all in this farrago of deprecation and disinformation is the claim that President Carter, not the Sandinistas, toppled Somoza![29] The very word *revolution* is generally taboo in the new educational order, since it has favorable connotations in Nicaragua. In the murals, it is a talisman.

Prelude to Destruction The ideological battle engaged on this fundamental level, as well as through the U.S.-supported press (primarily *La Prensa*, TV, and radio),[30] is complemented by sporadic attacks on public monuments, designed to demoralize further an already dispirited

people. The UNO government was elected in February 1990 by a people with a knife at their throats, after a decade-long war of attrition and atrocity, whose end seemed possible only with a change of government. Many people were tired of the war, with its military conscription, the deepening economic deprivation, and, to be sure, signs of corruption within the Sandinista government.

The UNO government was quick to show and use its claws to savage the symbols of Sandinismo. The huge stone letters *FSLN* on the Motostepe hillside near Managua, visible from afar and a landmark for a decade, were changed to read *FIN* (end of Sandinism), then removed altogether. The mayor promised to replace them with a twenty-meter-high statue of the Virgin Mary.[31] The flame over the tomb of FSLN founder and martyr Carlos Fonseca was extinguished; later (November 1991) the monument itself was bombed.[32] A bonfire of books by Sandinista authors was organized by the director of the municipal library in León, on 4 July 1990. Portraits of revolutionary heroes were removed from the airport and ministries, to be replaced by photographs of President Violeta Chamorro. The very name of Sandino was removed from Augusto Sandino International Airport.

By July 1990 a mural at the airport by the Panamanian Felicia Santizo Brigade (see no. 15), showing an insurrection at the barricades, of the kind that led to the 19 July 1979 revolution, was painted out—the first such major victim, unnoticed by the press. When I arrived in Managua that month, in the first mural I encountered (on which I had worked myself a few years before; no. 81), I saw how the face of a small boy carrying the FSLN flag had been carefully peeled off. Faces in other murals proved to have had their eyes poked out—an old act of superstition common to iconoclastic outbursts throughout history. Sandinista martyrs in little monuments such as are scattered all over the country began to be decapitated and otherwise mutilated. Also in July the mayor made his first attack on the dignity of the popular former president, Daniel Ortega, ordering that the protective wall around his house be demolished. The painters immediately converged upon the principal wall threatened, which was decorated with what they called the *Mural de la Dignidad* (no. 77), a series of designs (none of them political) by a dozen different artists, now covering close to a hundred meters, intended to protect Ortega both magically and physically. In 1993 great quantities of paint were issued by the Ministry of Education to schools all over Nicaragua, with orders to use it to obliterate any murals on school premises (most of which had been painted by the children themselves).

The Campaign of Obliteration and the Response of the Press Early in the morning on Thursday, 25 October 1990, the painter Cecilia Herrera happened to be passing along the Avenida Bolívar when she saw workmen beginning to paint over the mural there. She alerted artists at the Praxis Gallery and the author of the mural, the Chilean Victor Canifrú, who immediately went on the radio to denounce the action. By the time he arrived at the site, the mural was half gone, but he was able to document photographically the destruction of his masterpiece. It was three-quarters

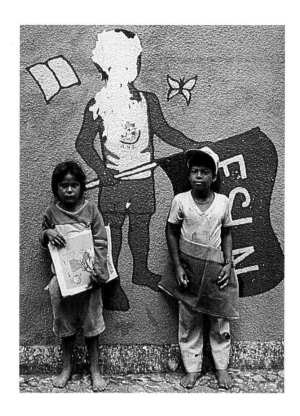

Vandalism, 1990. Detail from
Chicano Solidarity mural (no. 81),
Managua.

gone by the time a deputation of artists could be gathered to confront Arnoldo Alemán, the mayor of Managua, who disclaimed responsibility. (As a result, it seems, of regular police intervention, one-quarter survived until the end of 1991, when the whole wall was painted in gray and white stripes.) The mayor is cited as one of the triumvirate (with Alfredo César, president of the National Assembly, and Virgilio Godoy, vice president of the republic) seeking to overthrow Chamorro and replace her with a further-right government totally subservient to the United States.[33] Alemán, a judge under Somoza, is described in the title of a recent article as "up to the ears in corruption"; in 1994 he was charged with misappropriation of funds, fraud, and embezzlement.[34]

The next day the large, beautiful murals by Alejandro Canales (*Homage to Woman*, no. 8) and Leonel Cerrato (*The Meeting*, no. 6) on the service building in the Luis Alfonso Velásquez Park near Avenida Bolívar succumbed to the paint roller. The work by Canales was extinguished in the full gaze of Sandinista TV cameras and a platoon of organized artists from the National Union of Plastic Artists (UNAP). There ensued a "pitched battle" between the unarmed painters and some thirty civilians carrying shotguns and pistols, goons sent from the mayor's office. One of them aimed a gun at a painter, and the painters responded by throwing paint over the enemy.[35] The president's office condemned the action, and the president's press and information director, Danilo Lacayo, hurried to the scene to prevent, he said, further destruction; in vain, he ordered a worker to stop.[36] As soon as the wall was completely painted out, a Sandinista video camera recorded the painting of (short-lived) defiant slogans over it. Faced with protest from individuals

The United States as Death.
Detail from *The Supreme Dream
of Bolívar*, by Victor Canifrú
(no. 3), Managua.

and groups and in the press, the mayor called a meeting of the artists, apologized, labeled the whole thing an error due to maintenance workers' misinterpreting an order to erase political *pintas* (party and electoral graffiti) as an order to obliterate *pinturas* (paintings). He offered compensation. Within two or three weeks the artists submitted a budget of $50,000, the cost of replacing or indemnifying the murals; rejected contemptuously by the mayor, this was subsequently much lowered, but to no avail. The mayor's response was to paint out the last, also large, mural remaining in the Luis Alfonso Velásquez Park, the joint work of the primitivists Julie Aguirre, Manuel García, and Hilda Vogl (no. 7) and to add another coat of paint to cover a mural already erased.

This obliteration of a mural in the primitivist style, which is embedded in the Nicaraguan national cultural identity, should have served as a rallying point for the Nicaraguan art community, but in fact it precipitated a serious enmity. Manuel García, responsible for only a fifth of the mural, gave the mayor to understand that it was all his and undertook to repaint the whole building himself, on top of his colleagues' erased work, for an appropriate fee. His offer, which was ignored, earned him the contempt of his fellow painters and much denunciation, public and private.[37] Having defected to the UNO government, he now publicly scorns the Sandinistas who did so much to promote him in the 1980s.[38]

It was *El Nuevo Diario*, the independent pro-Sandinista paper, that mounted a fierce defense of the artists. The first editorial (27 October), under the headline "A Paranoid Action" (Una acción paranoica), roundly blamed the Chamorro government and the president herself, who, having only a week earlier declared in Venezuela that America in the twenty-first century must realize the "dream of Bolívar," had now destroyed (allowed to be destroyed) the painter's version of that dream.

> In only six months since taking power, the bourgeois counterrevolutionary government of Violeta Chamorro has had the "virtue" to reveal nakedly and shamelessly its ultramontane, neofascist, and vulgar nature, its absolute disdain not only for the elementary sense of people's rights, but also for the abc of culture, for the least consideration of universal values. . . . It was the President herself who gave the order to the troglodyte Arnoldo Alemán who obeyed enthusiastically, with the savage joy of the paranoid. His attitude is akin to that of the Spanish fascist general whose motto was "Death to Intelligence! Long Live Death!"

An opinion piece in the same paper the following day, under the heading "Satánico crimen medieval," accused Alemán of *lèse-patria* and crimes against universal culture, committed by this "homunculus" of UNO (Alemán is very short in stature), a "mongoloid" who manifests the severest form of Down syndrome. He is like a culture-destroying conquistador who obeys, not Spain, but U.S. imperialism, Cardinal Obando, and his H-UNO (Hun) government. His atrocity against art is likened to those against human life recently committed by the contras in Nicaragua. According to *Barricada*, the official organ of the FSLN, under the headline "Alemán ["German" in Spanish] in the steps of Hitler" (Alemán tras los pasos de Hitler), Alemán was worse than Hitler, who preferred to steal rather than to destroy art.

The following weekend *Nuevo Amanecer Cultural*, the cultural supplement of *El Nuevo Diario*, in an issue commemorating the Day of the Dead (3 November), mourned the Death of Art in Nicaragua over five of its eight folio pages, with a half page given to a mural by Canales painted just before his death, in Germany ironically, and deemed "inerasable" (it has since been built over); the mural shows a U.S.-made tank ripping through a wall.

The destruction of the murals violated the constitution, chapter 4, articles 126, 127, and 128, relating to the protection of Nicaraguan culture, and law 90, respecting the preservation of historic patrimony and specifically citing the murals in question, as well as article 30 protecting freedom of expression. But the pro-UNO, pro-U.S. *Prensa*, always quick to accuse the Sandinistas of breaking laws, did not report the incident at all, except, a week later, to exculpate the administration, whitewash the whitewashing, and blame the workers for misinterpreting orders.[39] Alemán could have passed the buck, not downward to his workers, but upward to the United States, where he had, allegedly, been encouraged to solicit donations of paint for just such a purpose. Fuller O'Brien, a San Francisco–based company, donated paint specifically "to obliterate Sandanista

[*sic*] propaganda."[40] It is true that some walls of Managua that had been covered with electoral graffiti were painted out to present a clean face to the king of Spain when he was in Nicaragua on an official visit—but this was done well after the murals were destroyed.

Months later the mayor, in an interview,[41] defended himself along familiar lines, adding, with breathtaking hypocrisy, that he himself was an art lover with a large collection of paintings, including examples by some of the very artists whose murals he had destroyed. (This collection, Nicaraguan artists say, came into his possession in the most dubious circumstances.)

The line given by *La Prensa*, the newspaper so admired by the mainstream media in the United States as a defender of liberty, is worth examining with respect to the mural destruction. Under headlines phrased to avoid emphasizing the idea of destruction, the newspaper reported that the mayor had set up a committee to investigate the "error," and cited his determination, voiced over the radio, to "continue to transform Managua" (by destroying more murals?), to fire the workers responsible, who were probably "infiltrado por el frentismo" (infiltrated by the Front)—in other words, put up to do the dirty work by the Sandinistas as a provocation! The op-ed piece ends on the happy note that the attacks on Alemán are increasing his popularity.[42] A week later, reporting under the deceitful headline "Agreement to Reconstruct Murals" that Leonel Cerrato and Manuel García (one of the primitivists victimized) had demanded $100,000 for restoration (double the actual figure, given me by Leonel Cerrato; see p. 16), *La Prensa* offered the outright lie that the painters *themselves* recognized that the mural had been obliterated by mistake.[43]

The political significance of the timing of Alemán's action did not pass unnoticed:[44] he chose the very moment when the president was out of the country, receiving the Order of Bolívar in Venezuela (the Venezuelan embassy also protested the destruction of the Avenida Bolívar mural), and when the debate over *concertación* (social pact, or reconciliation between the government and FSLN) had reached a delicate stage, a debate that was taking place in the Olof Palme Center only hundreds of meters from the site of the destroyed murals. Alemán's idea was to exhibit to the world the impotence of the government, which was certainly embarrassed but never formally denounced Alemán's actions, and to drive a wedge between it and the hitherto cooperative Sandinistas: in a word, to torpedo the government.[45]

Alemán's quest to stand forth as a man of action, as a prelude to a bid for the presidency, is manifested in certain cosmetic changes to the city of Managua, in which the theme of clean-up is paramount—"it is like putting makeup on leprosy," says the muralist Janet Pavone. Signs claiming "Alcaldía cumple" (the mayor gets things done) are everywhere; and he has had the government place a special four-dollar tax on Nicaraguans leaving the country at the airport, so that (as the Italian-Nicaraguan muralist Sergio Michilini put it) "we painters have to pay for the destruction of our own murals." The only official response of the government, through Gladys Ramírez, the director of the new Institute of Culture (replacing the old Ministry of Culture), who declared herself administratively incapable of stopping Alemán,[46] was deemed "sad" and "timid." A sinister construction was put on her offer to set up a "commission to judge the real value of the works that

should constitute the historic patrimony,"[47]—as if the murals just destroyed had no "real value" and did not belong to that patrimony. And it was noted that not a single voice from the ranks of non- or anti-Sandinista writers was raised against the destruction,[48] neither that of Pablo Antonio Cuadra, one of Nicaragua's best-known poets of the older generation (but also an editor of *La Prensa*), nor, more surprisingly, that of Jorge Eduardo Arellano, author of the only art-history survey of Nicaragua.[49]

Historically, anger against iconoclasts is based on the sense that destroying an art object is tantamount to killing a living organism. In this instance it was animated by the premature death earlier in 1990 of one of the best painters victimized, Alejandro Canales. A concert ("mural of songs") in homage to the artist was organized for 30 October by the popular Sandinista troubadours Carlos Mejía Godoy and Los de Palacagüina, just back from a three-month tour of Europe. The destruction of his mural was a posthumous censorship and another, civil, death.[50]

The terms of abuse heaped on the mayor have to do not only with the contempt and hatred for him and his actions personally but also with such grief as is felt at the death, in atrocious circumstances, of a friend. Hence Alemán as "worse than a pyromaniac," experiencing like "Nero" the thrill of the flames and the pleasure of the "torturer and inquisitor" (Torquemada is named), watching his victims suffer, "die without dying," with his satisfaction actually increased by the cries of pain (i.e., the protests of Canales's friends). Hence the resort to animal similes, always regrettable to those who know that animals do not act in a "beastly" human fashion, and hence the view that Alemán is not beneath judgment merely because he is subhuman, but might be condemned like the domestic animals solemnly sentenced by medieval courts. "Perhaps in the most sordid and filthy corner of some macondian forest one might encounter so consciously repulsive a creature."[51] Such language, descending to the scatological as well, strikes emotional roots deeper, perhaps, than all the allusions to fascism and Hitler.

The vandal's hand was stayed for the time being, but there were soon signs of his returning to the attack. In a children's park with deteriorating equipment the mayor chose to extinguish a mural featuring Sandino's boots and spurs, doves, and children at play, using black paint "as if to portray the antiart and antipeople spirit of the mayor." Within days the wall was sporting the words "Alemán: Progeny of Evil. Like This Wall, so Is Your Conscience," followed by a swastika and MUERTE AL SOMO卐ISMO (with another swastika replacing the C).[52] In another "error," a bust of Ho Chi Minh was destroyed, allegedly as an accidental result of drainage renewal, and a bust of the pro-Sandinista Panamanian General Omar Torrijos was removed.[53] In Granada, as part of a campaign to "clean up the city" for the Columbian quincentenary celebrations, the mayor had murals destroyed because they were painted "by Russians." One of these murals, which was photographed for the press as it was being destroyed (no. 170), was by North Americans and Nicaraguans.[54]

In March 1991 Sandinista martyrs were eliminated from the new currency. In August the Museum of Literacy was closed. In February 1992 Alemán ordered the obliteration of a prominent

Christian mural that, virtually without reference to Sandinism or revolution, showed a Christ figure demanding the liberation of the poor and the oppressed (no. 17). The list of offenses to monuments and murals goes on, too long to detail.[55]

The legislative proposal to revoke law 91 of 5 April 1990, which confirms the naming of schools, barrios, communities, streets, plazas, parks, factories, sport centers, and all kinds of public buildings after heroes and martyrs of the revolution, was passed in an "openly illegal" manner in September 1991.[56] To preserve this valuable, historic nomenclature, which is under threat of extinction, I have wherever possible given the Sandinista name of the building where a mural is located.

Apart from some publicity generated in Italy by Sergio Michilini, the founder of the Mural School in Managua, little attention has been paid in the international press to the destruction of the murals, despite plans to bring the matter to the attention of the United Nations, through UNESCO. (There is a relevant precedent: in 1973 the United Nations voted overwhelmingly—with only the United States and Taiwan abstaining—to condemn the book burning in Chile. And books are not unique; they are replaceable.) If the Sandinistas had destroyed a single mural of their opposition, the U.S. media would have orchestrated a global outcry, as they did every time *La Prensa* was shut down. Instead, they ignore or condone the vandalism of the UNO government.[57] My own efforts to get letters of protest into the national art and newspaper press failed completely.

And the vandals struck yet again. In the early morning hours of Monday, 28 December 1992, a group of six armed men arrived at the Children's Library in Luis Alfonso Velásquez Park, claiming they were under orders from Humberto Belli, Minister of Education. After threatening the caretaker with bodily harm, in less than an hour they painted over the various small walls constituting the facade of the building, leaving intact only the signature—as it were, a hit list for the future. The crime went unnoticed in the press for a week; only on 4 January did *El Nuevo Diario* break the story under the headline "Alemán in New Act of Cultural Terrorism." The nongovernment dailies then and during the following days threw the blame on Alemán once more (the Children's Library as a building came under his mayoral purview). Alemán once again denied the action, as did Humberto Belli, who was particularly vigorous in denouncing this *bochornoso* (degrading) act. Both officials counterattacked with the allegation that this was an *autogolpe*, that is, that the Sandinistas were destroying their own monument to make their enemies look bad; they demanded that the authors of the crime be investigated and punished. Alemán, boasting once again of his own art collection, was all for keeping intact "this militarist, Tolteca culture" the "frentistas" (members of the FSLN) had bequeathed, "so that people can see who they were." (The Children's Library murals, like most of those destroyed earlier, were virtually untouched by militarism.)[58]

While the Institute of Culture once more remained silent, the Director General of Culture and Tourism denounced the action as a crime against childhood as well as culture; and the voices of artists and writers were joined by those of the Luis Alfonso Velásquez Children's Association and the Nicaraguan Coordinating Committee of Nongovernmental Organizations Working for Chil-

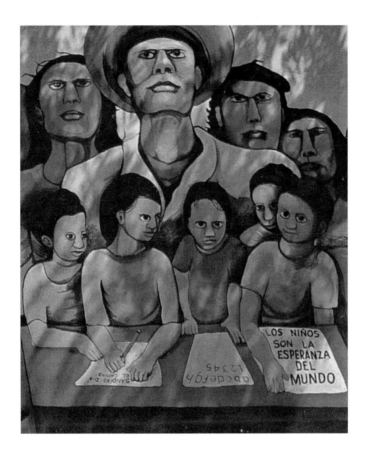

"Sandino Is the Way" and "Children Are the Hope of the World" (Jose Martí). Painting on panel, probably by the Felicia Santizo Brigade of Panama. Location unknown.

dren (CONDENI), who described the vandalism as a violation of the rights of children. The ironic coincidence was noted that it took place on Holy Innocents Day, when Herod massacred the infants.[59] The embassy of Austria, which had donated the library, eventually delivered a note of protest.

The dozen or so lamentations printed in the press constituted the only response. Thus the artist Raúl Quintanilla bitterly rebuked artists, writers, and their unions for resting content with a press release and then quietly painting "little paintings for our galleries and their depolarization [i.e., reconciliation] projects."[60] Six weeks later the destruction was again in the newspapers, but on a happier occasion, the cleaning, varnishing, and reconstitution of murals in the Parque de las Madres (Mothers' Park).[61]

Meanwhile, the mayor remains well armed, with supposedly twenty-four thousand gallons of cover-up paint at the ready.[62]

The First Internationalists: The Felicia Santizo Brigade of Panama The murals in Luis Alfonso Velásquez Park, centrally located, large in scale, by five major Nicaraguan artists were the launching pad of the Nicaraguan mural movement. But they were not the first revolutionary murals in the country. Chronological priority goes to a single very militant but short-lived mural by Róger

Pérez de la Rocha and others (no. 83) and above all to the Felicia Santizo Brigade of Panama.

The story of the first muralistic expression of solidarity with Nicaragua from the outside grows directly out of the political and military solidarity shown by Panama at the climax of the struggle against Somoza. In the 1970s the Felicia Santizo Brigade was formed by the brothers Virgilio and Ignacio ("Cáncer") Ortega, who took the name from their grandfather's sister, a teacher and leftist militant who died in Cuba. Inspired by the Ramona Parra Brigades in Chile (1970–73), they began to paint murals all over Panama, particularly on army bases, with the official encouragement of the Torrijos (1968–81) and Noriega (1983–89) governments. The themes of the murals were national-ist, Marxist, and anti-imperialist—pro-Palestine, pro-Sandinista. By the time of the brutal invasion by the United States in December 1989, the Felicia Santizo Brigade had done about sixty murals. A systematic campaign of destruction after the invasion eliminated almost all of them, and many large movable paintings "mysteriously" disappeared.[63] Cáncer Ortega was caught painting a mural at an air force base and was jailed.

In September 1979, within two months of the Triumph, arrangements were made for the brigade to paint in Nicaragua by José de Jesús ("Chu Chu") Martínez, a Nicaraguan who had become a naturalized Panamanian, a bodyguard of President Omar Torrijos, a polymath cultural figure, and a friend of the FSLN intellectual and political leaders Tomás Borge and Ernesto Cardenal; he mediated in the exchange of FSLN prisoners for hostages after the assault on Managua's National Palace in 1978.

The painting brigade followed in the footsteps of another, guerrilla, band from Panama, the Victoriano Lorenzo Brigade, which had fought for the FSLN on the southern front. It was logical that the Felicia Santizo Brigade would have its entrée into Nicaragua via the FSLN army, and that they should have done most of their work in army and police bases. It is also logical that their themes—in consultation with local sponsors and residents—should be militant and military, focusing on the hard physical facts of the insurrection, which was still fresh in the minds of all. The weapons in the Felicia Santizo murals (see, for example, nos. 76, 109, 110) are copied exactly from those actually used. Virgilio tells how nervous he was when some youngster (FSLN combat-ants were, famously, often very young) would pose with a rifle pointing directly at him.

The brigade consisted, initially, of Virgilio Ortega (principal designer) and Elpidio Mora; later, Virgilio's brother Ignacio ("Cáncer") arrived, and Marx Malek; always there were Nicaraguan assistants. Days were spent painting; nights were spent making music, for Virgilio is an accom-plished drummer and Cáncer a guitarist and singer. Sometimes the music mediated the next project—a Nicaraguan and fellow musician, for instance, would ask for a mural in his barrio. The spontaneous and intimate manner in which the brigade's first mural was painted—it was also the first revolutionary mural in Nicaragua (September 1979, now lost)—is instructive: "We arrived, Elpidio Mora and I, in Managua with a message for Rosario Murillo [head of the Artists' Union]. We failed to find her, but we managed to spend that night in a post of the popular militia in Barrio

Bolonia. We had brought our materials and made a proposal to the head of the post that we paint a mural; he accepted, so that the day we arrived in Nicaragua, we were already painting our first mural."[64]

Mural Ephemeral, Advertisement Resurgent Having suffered almost total obliteration in a Panama "liberated" by the United States, the Felicia Santizo Brigade can look to a Nicaragua where some of their work has survived remarkably well, especially that painted indoors. An external mural has been the subject of a recent, reverent restoration (no. 156), which one hopes will prove an example for the treatment of deteriorating murals generally. Other murals by the brigade have faded beyond recognition, have fallen off the wall, have (in the case of panels) been put into storage, or have been accidentally lost; one, as noted, in the airport (no. 15), was deliberately destroyed by the new government. The various fates that have befallen the dozen or so Panamanian murals are emblematic of the future of all the revolutionary murals in Nicaragua.

Time, climate, war, neglect: nature and mankind have combined over centuries and millennia to wipe out most of the wall paintings in history. But here we are looking at one small country, and a mere decade during which so much has been lost. The loss is ironically timed, since it fell in the years the world was preparing to celebrate/deplore Columbus's discovery/invasion of the New World, which resulted in all manner of cultural genocide. In a sense, time has stood still: no more than in Columbus's time is it regarded as wrong to destroy the art, the symbols, the dignity of the political enemy of the moment.

This said, it must be recognized that some murals, especially at the beginning, were painted without adequate technical knowledge and preparation. Artists were resigned to the evanescence of this art, scorched by the sun, beaten by the rain, undermined by humidity and mold. Even in the United States, where the climate in many cities is less deleterious and technical knowledge advanced, external murals done in recent years are failing. Sandinista Nicaragua, like the more developed countries, has also neglected its murals and has carelessly built over them. In one notorious instance, first fruit of the new Mural School (see below), splendidly decorated walls were casually pulled down by a Sandinista agency itself (at the Women's Association National Headquarters, no. 108), to the anguish of the authors. In another instance (no. 16), the mural was blocked by a latrine. There is a paradox the mural movement worldwide will recognize as its own: art on walls, so much more permanent-seeming a support than the canvas and stretchers of an easel painting, is less resistant to changing circumstance. Easel paintings can hide—from human enemies, as well as from sun and rain. Walls cannot.

In 1992 I inquired of several of the staff in the very hotel in which I was staying what had happened to the mural behind the swimming pool painted in 1988 by Danish volunteers (no. 25). Each remembered the mural, but none could say when, how, and why it had been painted over. The story is the same with other murals—long before Alemán started his campaign.

The planting of trees and bushes, the erection of fencing, and the parking of automobiles constitute casual visual obstacles testifying to carelessness, negligence, and indifference, popular and official. Murals in the streets of Nicaragua, like those in most countries of the West, are hostages to a philistine indifference to immediate surroundings, to an aesthetic blindness, to a contempt for visual hygiene that tolerates the worst in architecture, commercial billboards, and street litter. In cities characterized, above all, by poverty of housing (if such a word can be used at all for dreadful makeshift hovels), and with even the wealthier sectors bereft of conventional visual comforts such as interesting architecture and flowering trees and parks (private flower gardens scarcely exist at all to public view) one comes upon the murals like oases of color in a desert.

But the thirst for color is not universal. The first time many Sandinista leaders knew there were murals in Nicaragua was when Alemán began to destroy them. "The Right values our work more than the Left. The enemy, by attacking it, at least recognizes its power and importance." This from a leading muralist, Janet Pavone, who went on to recount how, when inaugurating the new medical center in Estelí, the president of the republic gave his speech directly in front of huge murals specially completed for the occasion (nos. 157–163), without mentioning them at all. The muralist afterward asked him what he thought of them. "What murals?" he replied. Even Comandante Tomás Borge, an art lover as well as a poet and key government minister, was able to speak at length in praise of the new Luis Alfonso Velásquez Park without mentioning the murals, far and away its most original and remarkable feature.[65]

If mural paintings are so vulnerable in the face of urban development, then legislation can at least impede their destruction. Politically motivated violence against murals, of which the United States has suffered and continues to suffer instances,[66] is all the more disquieting for its being the symbolic counterpart, in Nicaragua, of the most horrendous violence against people: that of Somocismo, of contra and recontra (revived contras). Art celebrating the pleasures of peace, the dignity of woman, the hopes of children, and the reunion of families in a children's park has been the object of murderous hatred, such as has been vented upon pacifist principles and people everywhere and at all times. By contrast, the regime that sponsored those murals, having taken power by an armed insurrection, has proven, by international consensus, nonviolent and generous to its enemies.

Triumphant Sandinistas toppled the equestrian statue of Somoza amid popular rejoicing; but there was no popular support for the obliteration in stealth of the murals. No one had revered the equestrian statue—originally done for and of Mussolini, with a head of Somoza added—as a work of art; but its remains have been preserved in a museum, as a historic document (as one hopes statues of Lenin, now disappearing from public places all over the ex–Soviet Union, will be preserved). The surviving equine rump figures as a symbol of tyranny in a mural (no. 205).

How does the UNO government imagine the visual environment of a Nicaragua "rescued" from Sandinista "tyranny"? What new artistic policy is now being offered? A dismally familiar and aesthetically degraded commercial one. Miami is now the model, the true cultural capital of

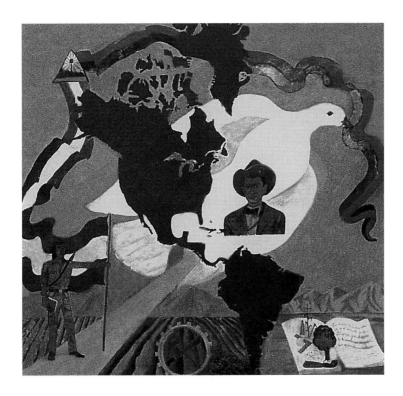

The light of Sandino illuminates the Americas: a literacy worker and the dove of peace carry the Nicaraguan and Sandinista flags. Mural on a school in Managua; photo 1981.

Nicaragua. All the old revolutionary and public-service billboards are gone, swallowed by a forest of commercial advertisement sprouting up everywhere in Managua—even obscuring famous viewpoints—as a veneer of petty enterprise fueled from the United States spreads over generalized and deepening poverty. "This is the culture of repossession, easy profit and brandished opulence in the face of so much poverty and loss."[67]

Paint of any kind was scarcely available in the 1980s and had to be imported by the artists themselves; now commercial paint stores are everywhere, and there are materials and money (or loans) to make shop signs, to paint factory and office walls—but not for murals. The barefoot children who used to press newspapers on motorists stopped at traffic lights now sell goods dumped by U.S. manufacturers or their subsidiaries; in July 1991 primarily two articles, both symbolic, were being pushed: "tummy trimmers," a slimming gadget functioning as an obscene joke on a hungry people, unless understood as aimed only at those returning fat from Miami; and TV antennae, for better reception of the de-Sandinized, sanitized consumerist electronic images now swamping the consciousness the murals had tried to raise. Even the Sandinista dailies are now swollen to twice their original size with commercial ads.

Searching for so-often-elusive murals in Nicaragua, which lacks the telephones, signage, maps, street names, and house numbers we in the United States take for granted, was like a journey into a recent past upon which a fog of amnesia had suddenly descended. One anecdote: acting on a tip about a mural in Niquinihomo, the birthplace of Sandino where in 1981 I had visited a small museum in his memory, we find ourselves, after much asking, confronted by the only mural

anyone knew of: on a recreation center, a huge figure of Mickey Mouse, signed *Claudio Sandino.* A relative? And the Sandino museum was closed.

It may be that Mickey Mouse got elected, but the dominant public imagery of the region (Carazo) was large-scale, carefully executed electoral portraits of Daniel Ortega by the indefatigable Marvin Campos—most of them since defaced by ugly blotches of black engine oil.

Revolutionary Mural Themes

Mural art is ideology, education, history, daily life, beauty, conflict, action, even violence.

Leonor Martínez de Rocha, director, National Museum

It is a matter of definition that "revolutionary art" reflects and promotes the aims and achievements of a revolution. The murals of revolutionary Nicaragua hew closely and consistently to a nationalist, militant, Sandinista perception of history. They are lived experience, both factual and idealized, often prosaic and literal, relatively unconcerned with abstractions, theory or "aesthetics"—though some are quite beautiful. They are above all very Nicaraguan, and neither in theme nor style (see below) do they much depend on past models of socialist or revolutionary art, although the idea that art, too, should join in a revolution has a solid tradition in the nineteenth and twentieth centuries and is anchored in the incomparable Mexican precedent.

The Insurrection Both the Mexican and Cuban revolutions took power by popular insurrection, but the art that followed, at some remove in time, is not so obsessively insurrectional as the Nicaraguan murals, which were made in the years—indeed, started in the months—immediately following the Triumph.

It is the drama of the fighting at the street barricades and in the towns that dominates, rather than the protracted guerrilla war in the countryside: the use of small arms against planes and tanks, raw physical courage against machines, naked heroism of bare or semibare bodies against an enemy left largely invisible (nos. 76, 108, 109, 259). There are some references to Sandino's own struggle against visible U.S. marines (no. 233 and the various representations of the Seal of Sandino motif), but the emphasis is overwhelmingly on the latest struggle, with just the occasional brutal view of Somoza's National Guard. The contras appear only once, on an army base where I was not allowed to photograph (no. 184; they are coded as spooks in no. 106).

I wanted to reproduce that mural here, if only for its exceptionality. I might have been wrong, for the omission of the gory specifics of Sandinista martyrology,[68] with the exception of this example, is significant. That martyrology is, at most, generalized in a large bloody blot (no. 68). For a country steeped in the Catholic tradition, with its rich iconography of the sufferings of the saints and martyrs (some of them very exotic), the muralists' refusal to dwell upon the latter-day tortures

inflicted by Somoza and the contras is remarkable and makes an ideological point. Traditional martyr iconography, from Christ down through the centuries has taught the duty and virtue of submission and suffering, even to the very worst. Sandinism, by contrast, preaches resistance.

Traditional Christian martyr iconography has also served to bury the massive suffering of the Indian natives under certain signal, individual sacrificial acts credited to modern missionary saints. The extraordinary 1992 mural painted in the remote and inaccessible village of Waslala brings that tradition suddenly back to its point of origin, reverses it, hangs it by the feet. A large external wall of the church is dedicated to the martyrdom of anonymous Indians at the hands of Christian conquistadores and the justification of the Indian's resistance to them (nos. 269–270). The parish priest who sponsored these murals, located in a village much harassed by contras, was himself twice kidnapped and tortured; an Italian artist who in 1988 was designated to do the murals was forced to flee. In these circumstances, it is impossible not to see the crimes against the Indians as forerunners of those committed by the most "Christian" persecutors of Sandinistas (the contras, like Somoza, hid behind a cloak of Christianity). The struggle of today has mandated a reevaluation of the older ones, and the Indians, here as in other murals (e.g., no. 93), become models for the defense of popular sovereignty in the present. Several quincentenary-influenced murals done in 1992 use the conquest martyrology as a concealed metaphor, perhaps, for that of the revolution; at this point, to openly emphasize such a connection might appear divisive.

The paving stones shaped like pieces of a jigsaw puzzle that recur, with iconic insistence, in the murals (e.g., nos. 97, 103) to signify "barricade" carry their own freight of contradictory associations. These are the stones made in cement factories owned by Somoza; the profits from their use in public-works projects filled the family coffers, especially after the earthquake of 1972. The revolutionaries turned the stones into agencies of liberation, and the muralists used them as functioning symbols of resistance to tyranny. Called *adoquínes* in Spanish, the stones gave the name to an international harvest brigade (Los Adoquínes) in 1985.

Power to the People Predominantly figural, with bodies, gestures, and attitudes ranging from the monumental to the miniature, the murals foreground the idea of ordinary people taking power into their own hands. They are organized in the murals as they were in reality, the representatives of masses gathered spontaneously under the flags of Nicaragua (blue and white) and Sandinismo (black and red), paired, intertwined, and fused to express the symbiosis of nation and revolution (e.g. no. 80).

The military stance of the rebels merges with the defiant assertion of independence and self-governance by unarmed peasants and workers, for whom liberation is an ongoing struggle. Despite the inclusion of verbal slogans taken from real-life street demonstrations and the chants that opened and closed political meetings (a custom disapproved of by people in power such as Vice President Sergio Ramírez), the idea of conformity to party dogma is not manifest. Nor are authority figures from the present (heroes and models are dead; see below). The murals do not present

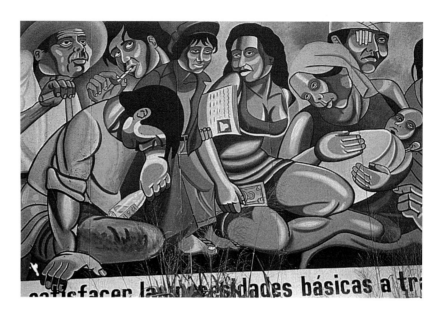

"Social Welfare. Communal Solutions to Social Problems. Satisfy Basic Needs through Productive and Organized Work, Sharing Social Achievements." Left half of a Ministry of Social Welfare billboard, showing the old, unhealthy, Nicaragua; right half shows the new, healthy, people. Managua, circa 1981.

themselves as authoritarian or dogmatic, although the FSLN, as a party, certainly suffered from these tendencies, as members now generally admit. Sandinist doctrine, if not dogma, is present in the murals by popular consensus.

The "ideology" of the murals is neither subtle nor ambiguous. It is simple, direct, unnuanced, and celebratory rather than denunciatory. No one doubts who is the enemy, or what is his fell purpose; but the eagle, the death's-head, or the actual soldiers of American imperialism are used sparingly, more as required by an actual historical moment than as a rhetorical foil to the virtues of Sandinismo.

A Better Society: Sandinista Social Programs Somocismo, when shown at all, figures as military atrocity and bloody repression; specific social ills are not alluded to. In an exception to this rule, hand-painted billboards and posters rather than a mural, they appear juxtaposed with their healthy equivalents under Sandinismo. The dire "medieval" warning against the consequences of alcoholism, which by all accounts is now much on the increase, was painted (for an Alcoholics Anonymous center in Managua) at the very moment, early in 1990, when a prostrate Nicaragua surrendered to the United States and the new regime (no. 66). Otherwise, the murals are overwhelmingly positive, looking forward to a better life, improved health, a world of play, not poverty, for children, who run with kites (no. 205) rather than sell newspapers or black boots (no. 124). It is a life socialized by organizing the various traditional popular sectors: workers, peasants, Christians, women, youth. The insistence, again and again, on children, in school or (more often) at play, illustrates the axiom, proclaimed by the public art of Allende's Chile, that in an egalitarian society children are the only privileged sector.

I cannot do justice to the multiplicity of social themes addressed by the murals, which must be left to speak for themselves through reproduction and description. One anomaly, however, may be

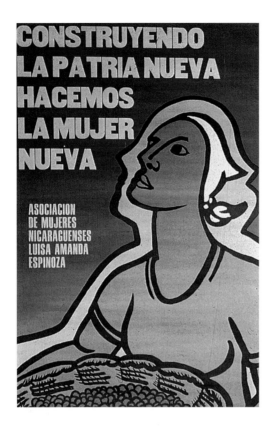
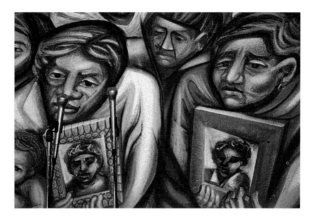
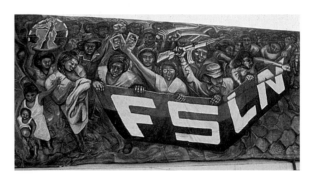

(*Left*) "Building the New Fatherland, We Make the New Woman." Poster by the Luisa Amanda Espinoza Women's Association (AMNLAE), circa 1981. (*Top, right*) Mothers bearing the portraits of their martyred children. Detail from no. 107. (*Above, right*) "FSLN" (Sandinista National Liberation Front). Banner hung on the old cathedral and elsewhere, circa 1984, designed by members of the David Alfaro Siqueiros National School of Public and Monumental Art (ENAPUM-DAS). Women brandish photos of their sons, killed or kidnapped by the contras.

noted. although the murals speak combatively and eloquently of the life, work, desires, and achievements of women (especially, as one would expect, in the many murals sponsored by women's organizations and executed partially or chiefly by women, who were often feminists from the United States), there are very few portraits of individual female martyrs from the insurrectionary period—no Luisa Amanda Espinoza (after whom the national women's organization, AMNLAE, was named), no Blanca Aráuz (wife of Sandino), no Arlen Siú.[69] The pantheon of heroes, like that of the Sandinista directorate, is all male. The toll of female civilian deaths in the contra war is encapsulated in the figure of Mary Barreda in the Church of Santa María de los Angeles in Managua (no. 106); female protest and female suffering are best conveyed by the group of mothers of heroes and martyrs in the same location (no. 107), and in a manta where they brandish like weapons the photographs of their sons killed or captured by the contras. And recently a team led by a young Nicaraguan woman created, at last, a female pantheon (no. 75; cf. no. 231).

Certain crucial feminist issues, such as abortion rights, though openly debated and part of

the agenda for a new constitution, were simply too divisive to be included in the murals, as was the idea of equal rights as such, in this in some ways still traditional and Catholic society. The willingness of women to bear arms, however, shows forcefully in the murals. One photo-derived motif in particular, the "armed Mother and Child," recurs in an iconic fashion (nos. 9, 70, 181, 244), and the "contradictory" virtues of breast-feeding are proclaimed in several places, in images that (given the erotic primacy of the female breast in Western art) seem deliberately anti-erotic (nos. 108, 261). That very Nicaraguan icon of the armed mother and child that recurs in our murals, empowers an ancient and sacred but essentially submissive Christian image, and naturalizes and nurtures the very idea of revolutionary struggle; the posters of women guerrillas from other countries, from El Salvador to Vietnam, have sought to do likewise, but without the baby they do not have the same force.

The poster and billboard design reproduced on page 28 posits a Nicaragua determined to eradicate prostitution, alcoholism, drug addiction, malnutrition, hunger, child labor, and disease. All of these are now returning in force. According to UNICEF data, Nicaragua now heads Latin America in infant mortality, infant malnutrition, and illiteracy; 40 percent of the population live in extreme poverty.[70] The happy future, the sentimental utopia visualized at the end of the León mural (no. 205), has been postponed. Nicaragua now has the highest per capita debt in the world.

Murals in hospitals, naturally, depict Sandinista ideals of universal and free health care. The new government, as it cuts health programs and makes people pay for services and medicines or go without, should be embarrassed by the murals in León (no. 202) and Estelí (nos. 160–162). It claims Nicaragua is too poor for free health care. (The United States, by contrast, is apparently too rich for it.) In 1988 the government invested $57 per person per year in health; today it invests $17. Unlike the high-tech medical visions of the Mexican muralists Rivera and Siqueiros, the Sandinista medical model seeks to recover traditional herbal cures (no. 162). The special role assigned in the murals to the handicapped (nos. 21, 119, 141, 163) is part of a new global consciousness but is especially appropriate to a country where tens of thousands have been maimed by war. A mural called *Bikes Not Bombs*, which came to my attention too late for inclusion in the catalogue, shows how "civilization" has evolved toward ever more efficient ways of killing and disabling. The mural was done by a British group in 1990 for the Organization of Revolutionary Disabled Bicycle Workshop near the Cementerio Oriental.

An Economy Producing Happiness, Too The murals of the new Nicaragua do not, on the whole, envision a future of industrial growth and technological advance like that represented in murals of the 1930s in the United States and Mexico, although mechanization is desirable (no. 260). Nor do the Nicaraguan painters imagine a truly diversified economy, although scientific and technical education (nos. 1, 120) is a necessity. Nicaragua is seen, with a touch of romanticism perhaps, as continuing its traditional dependence on agricultural export crops, particularly the mainstays, coffee and cotton, which historically, like the gold that was once plentiful, have been so attractive

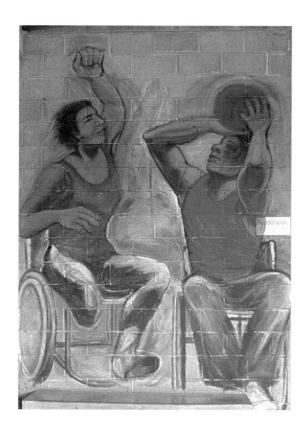

Boys in wheelchairs playing basketball. Mural in Medical Center, Estelí (no. 163).

to outsiders and thus the curse of the country's existence. The painters' simplifications, explicable on practical and aesthetic grounds (coffee and cotton picking are picturesque and easily recognizable) are not, however, congruent with Sandinista plans to diversify and industrialize the Nicaraguan economy, to make it less dependent on Western markets and capital by opening it up to Scandinavia and the East European bloc. Contrast, however, number 68 with any of the numerous depictions of happy cultivation (e.g. nos. 65, 80). The difference is between coffee and cotton production (up to 1979, as it was in the nineteenth century) for the profit of U.S. capitalists and a production *process*, wherever the market outlets may be, for human happiness and the profit of the worker-producers.

The hands that affectionately mingle with the succulent-looking red coffee berries and the fluffy white cotton bolls (which, pretty as they look, actually tear up the hands of the pickers) engage in a ritual that keeps Nicaragua in thrall to foreign capital; so much coffee goes to export that locally one is reduced to drinking Nescafé. Likewise the juice from plentiful, delicious local fruit is never as freely available as omnipotent Coke (called *gaseosa*—the word alone is enough to turn the stomach). And the United States consumes half the coffee sold in the world.[71]

The peasant of the new Nicaragua, as depicted in murals, is the beneficiary of the sweeping Sandinista land reform (now threatened under Chamorro), one who works on his or her own lot or (more likely) in a cooperative and does not feel exploited by anyone. Is this the traditional

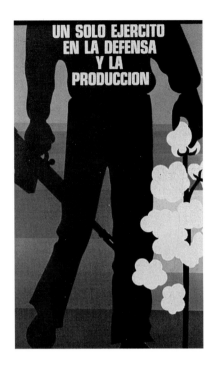

(*Above*) "A Single Army in Defense and Production." Poster by the Department of Propaganda and Political Education of the FSLN, March 1981. The regular army and, later, conscripts often helped in the cotton (here) and coffee harvests.

(*Above, right*) "We'll Break Their Chains and Set Them Free. Literacy Is Liberation" appears on the English-language edition of this poster for the National Literacy Crusade on the Atlantic coast, published in the Mesquito (here), Sumu, and Rama languages, as well as in Spanish. The original attempt to bring literacy to the Atlantic coast in Spanish alone was recognized as a serious error, later corrected.

(*Right*) "Let's Teach Our Brothers. Let's Help Each Other." National Literacy Crusade poster for the Atlantic coast, 1980.

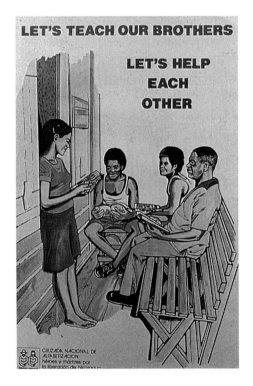

idealized "happy worker" of socialist realism? Partly, but in a more casual, intimate form, not rhetorically idealized, not heroic, though heroic many were, under contra attack. The idea of simply producing *more*, which underlies so much government-sponsored socialist realist art, subserves the idea of producing *well*, that is, harmoniously.

Industrial development, according to the murals, would be at a modest technical level. Nuclear high-tech is condemned outright as a capitalist abyss (nos. 32, 235); low-tech economic development appropriate to Third World desires for self-sufficiency is illustrated in background landscapes (for instance, potable water in no. 79 and electrification in no. 31), and as the primary theme of number 176, which proposes environmentally friendly forestry and crafts deriving from it. Skyscrapers in the murals tend to be an evil omen (no. 235).

Culture Is Revolution, Revolution Is Culture As Ernesto Cardenal, the poet, priest, Minister of Culture, great moneyless Maecenas, and tireless propagator of Nicaraguan revolutionary cultural values to the world outside, has said again and again: The revolution is a work of art. "Culture is the revolution, and the revolution is culture. There is no separation."[72]

The Nicaraguan "democratization of culture" has seemed exemplary and has invited analysis in a sophisticated and complex framework of Marxist theory.[73] It was real, if short-lived, and is now in suspense if not outright retrogression. By 1988 there were as many as twenty-eight Centers for Popular Culture throughout the country.[74] These were the facilitators of murals, as well as of poetry and pottery workshops, dance and theater festivals. The key concept, never encompassed by statist theories of socialist realism, is that culture should be made by and not for the masses. In the United States, "popular culture," from movies to pop music to comic strips, is notoriously of corporate rather than truly popular manufacture. The mixed sponsorship of Nicaraguan murals, by mass-based popular organizations able to develop amateur gifts rather than professionalism, has encouraged the evolution of a limited thematic but unlimited stylistic diversity. Any mural celebrates itself as a mural; in Nicaragua murals celebrate a newfound artistic literacy, a new flourishing—in the face of the corporate mass culture that afflicts the Third World more harshly than it does the First—of traditional music, dance, folklore, theater, and crafts (nos. 31, 116, 146, 147) that had been suppressed under Somoza. The writing of poetry, that national obsession, is hard to visualize effectively in a mural, but the idea of poetry as a major (perhaps the principal) vehicle of revolutionary culture is emphasized in the murals that cite the titles of, and lines from, the works of prominent poet-revolutionaries, such as Tomás Borge's celebrated cryptic characterization of Carlos Fonseca: he who rendered the dawn "no longer merely a tempting dream" (i.e., but achievable—"cuando el amanecer dejó de ser una tentación").[75] The basic literary text was called "Amanecer del pueblo" (Dawn of the People). In the murals, dawns are everywhere in the symbolic role of rebirth.

"Nicaragua today is like a great school, where everyone is teaching and learning," said the Sandinista Minister of Education, Fernando Cardenal. The instrument of literacy and then of all

(*Right*) "The Call Is Literacy!" Wall Painting, Managua, 1980.

(*Below*) "Literacy and Production: Two Goals of Our Revolutionary Process, Which Will Forge the New Man in the Liberated Fatherland." National Literacy Crusade Poster, 1980.

(*Below, right*) "Literacy to Raise Production!" National Literacy Crusade poster, 1980.

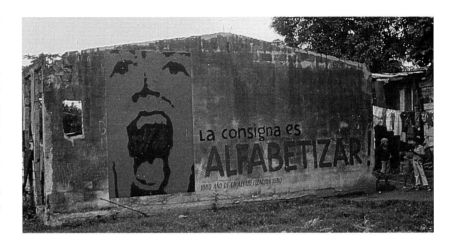

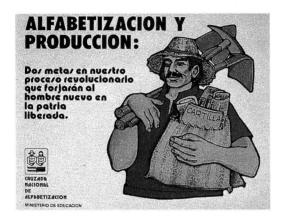

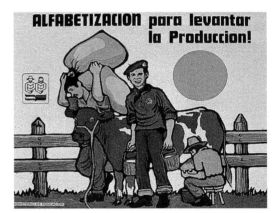

democratization efforts was the world-renowned Cruzada de Alfabetización (National Literacy Crusade), a mobilization involving one hundred thousand students, teachers, and other volunteers and enjoying international support, which brought illiteracy nationwide down from 50 percent to an estimated 12 percent and won a prize from the United Nations. The Literacy Crusade is the most often reiterated theme of the murals, both as primary subject (no. 223) and as a motif culminating the revolutionary narrative (no. 68); it was the first cultural and social triumph of the Sandinistas. It did not hide its political dimension and purpose (it was conducted according to Paulo Freire's system of learning based on, and integrated into, real-life experience, now widely accepted among Third World educators), which condemned it in the eyes of the reactionaries. Within four years of Sandinista rule, the education budget went up from 1.4 percent to 12 percent of the national budget. School enrollment doubled in the ten years from 1978 to 1988.

Newly literate viewers of the murals see themselves, their own persons and lives depicted, their moment of dignity, and their transformation from passive to active voice. They are encouraged by the texts (poetic citations, political slogans) to practice reading, the skills for which are constantly undermined by the radio and TV culture (in Nicaragua the poor cannot even afford newspapers)

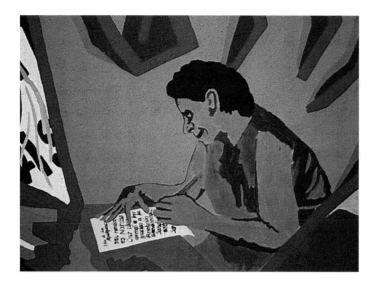

Woman writing: "Literacy Day. My name is Narcisa Cruz López. I learned to read thanks to the Sandinista Revolution. Sand[ino] yesterday, Sa[ndino today, Sandino tomorrow]" (detail from no. 121).

Monument to the National Literacy Crusade volunteer, who raises a book as if it were the Sacrament at mass. Matagalpa, circa 1980.

and, latterly, cuts made by the new government in adult education programs. A Letelier Brigade mural (no. 12; see also no. 216) makes the book the equal of the hammer and rifle in a not uncommon trinity of symbols linking instruments of knowledge, production, and defense. And the final word is with the paintbrush, massively creating human form and beauty. The new, culturally/politically educated and integrated man/woman, such as was imagined by that great visionary Che Guevara, stands as a challenge to the future.

The Sandinista Pantheon The Sandinistas observe a rule that the Cuban revolution established to avoid the cult of personality encouraged under Stalin, Mao, and Kim Il Sung: no public portraits of living heroes, only martyrs of the past. Nonetheless, portraits of Fidel Castro, by popular demand, have always abounded in Cuba, and he is inevitably shown as the protagonist of historical iconography. In Nicaragua there is just one surviving founder-member of the FSLN, former Interior Minister Tomás Borge, who appeared only on the occasional billboard, in the company of other founder-members, who were all killed in action.

Lacking portraits of living comandantes and the raison d'être for them in specific military engagements, which are scarcely ever depicted, the Sandinista pantheon consists of Nicaraguan martyrs, plus some international heroes painted by artists from the heroes' own countries. The trio of classic international figures—Marx, Lenin, and Che—is a rarity (no. 109). Time and again, we

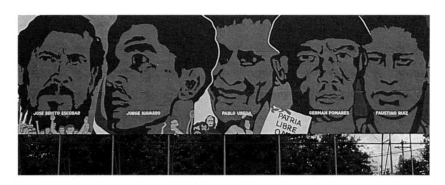

Portraits of five heroes and martyrs of the insurrection. The paper at bottom right reads, "Free Fatherland or (Death)." Billboard for the 19 July celebrations, Plaza 19 Julio, 1984.

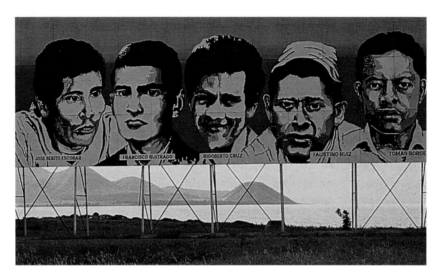

Portraits of five founders of the FSLN in the 1960s; only Tomás Borge, right, survives. Billboard overlooking Lake Managua, 1987.

see Augusto César Sandino (d. 1934) in the murals and in every imaginable medium and location, and, somewhat less often, Carlos Fonseca (d. 1976), who, like Che in Cuba, unites the roles of theorist, guerrilla, leader, and personal model. This puts Sandino, relatively, in the role of José Martí, *pater patriae* of the Cuban revolution from an earlier age and, along with Che, by far the favorite hero of Cuban iconography. Rigoberto López Pérez, the poet who assassinated the older Somoza in 1956, comes next in popularity, followed by Germán Pomares Ordoñez, known as "El Danto" (the tapir), a man of very humble origin, with whom the poor naturally identified.

Sandino and Fonseca preside mainly as facial portraits or busts, never as figures in action, as history will otherwise remember them. Sandino's face is often brooding, old beyond his years, haloed by his characteristic hat; Fonseca, in his glasses and Che-like moustache and beard, is the visionary peering with pale blue eyes (very unusual for a Nicaraguan) beyond us into the future. In no case has it been considered necessary to label the figure of any of the dozen or so Nicaraguan martyrs represented; one is expected to recognize them even in the crudest rendering.

According to the murals, the insurrection was the work of an anonymous "people"; it was also, misleadingly, an urban, "Somoza-stone" barricade affair. There is, however, a popular martyrs'

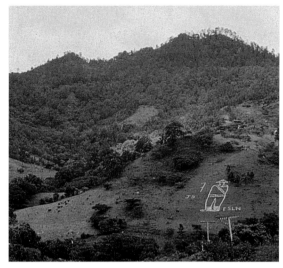

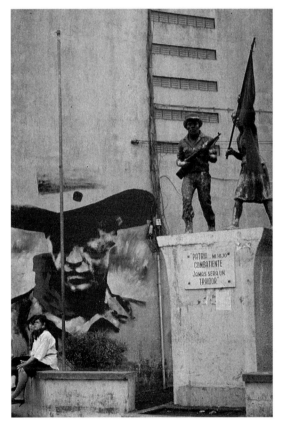

(*Top, left*) From 1979 to 1988 Sandino was the "patron saint" of the old Managua cathedral, ruined and in disuse since the 1972 earthquake.

(*Top, right*) Landscape near Estelí, with the silhouette of Sandino picked out in whitewashed stones, signed *JS* (for Sandinista Youth) and *FSLN*; 7 is for the seventh anniversary of the Triumph (1986).

(*Left*) Painted portrait of Sandino broods beside sculpture by Florencio Arthola with a plaque reading "Fatherland—My Son Will Never Be a Traitor."

(*Above*) This woman lost her son in the insurrection. Stencil, Managua, 1981.

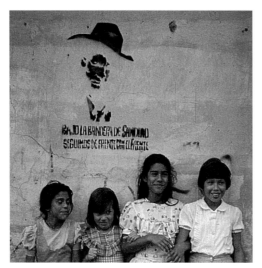

(*Top, left*) The familiar contours of Sandino drawn in wire, over a marker for a Sandinista defense committee named after a martyr. Managua, photo 1987.

(*Top, right*) Sandino is frequently paired with FSLN leader and theorist Carlos Fonseca. Stencil, Managua, 1986.

(*Above*) The children gather under a stenciled portrait of Sandino with the slogan "Under the Flag of Sandino We Forge Ahead with the Front." Managua, photo 1986.

(*Above, right*) The silhouette of Sandino is everywhere.

The crudest scrawl is capable of evoking the familiar silhouette of Sandino. 1986.

gallery in a very different medium, scattered all over the country: many of the fifty thousand who died in the years leading up to the Triumph, and some of the thirty thousand who have died since, victims of the contras, are memorialized in modest, moving, small sculptural monuments. Some of these now looked neglected, and others have suffered destruction or mutilation.

Internationalism

That which is international always *helps us to understand and evaluate better that which is national.*

Julio Cortázar

A unique symbiosis exists between the Nicaraguans and non-Nicaraguans in the creation of the revolutionary mural.[76] This domain in particular reflects the international scope of the aid and volunteer programs pervading the entire economic and cultural fabric of the country. Probably no revolution in history has attracted such widespread and varied outside support. Examples of past revolutions relying on outside help are, to be sure, not lacking. The first modern popular national revolution against the first modern imperialist power, Spain, by what became in the sixteenth and seventeenth century the Dutch republic, enjoyed the support of France and England. The amazing school of painting that developed in the newborn nation drew heavily on Italian art, if not Italian painters. In this hemisphere, the revolt of the British colonies in the New World was supported by France.

My own vantage point, as a non-Nicaraguan, may explain, if not justify, my emphasis on the international contribution at this point, but it should always be understood that "internationalists" (the word is preferred in Nicaragua and by the volunteers themselves to "foreigners") rarely

worked in isolation but rather in more or less close collaboration with Nicaraguans, who were not only sponsors but also, as a rule, fellow executants and sources of ideas, if not of actual design components.

The extent and success of this collaboration renders the Nicaraguan mural phenomenon unique: the Mexican murals were done mainly by Mexicans;[77] the mural renaissance in the United States is the domain of North American artists; and the European mural renaissance of the past generation has likewise been the work of nationals working in their countries. But in Nicaragua, over half the murals were initiated, designed, directed, and partially executed by non-Nicaraguan Sandinistas, that is, by sympathizers with the Nicaraguan revolution from around the world—Latin America, North America, and Europe. These volunteers brought with them not only their skills and energy but also, for the most part, essential materials: brushes, paint, even paper for sketching, things in short supply or simply unavailable in Nicaragua. And they came willing to learn from the Nicaraguan sociopolitical and artistic process as they participated in it. Several artists—Sergio Michilini, Daniel Pulido, the Boanerges Cerrato Collective—arriving initially to paint a mural or to learn to paint murals, decided to make Nicaragua their permanent home.

Internationalist painters are not paid; neither are the Nicaraguans, by any U.S. definition of the term. Their rewards are strictly moral. They range from professional artists arriving with the express intent of doing a mural to volunteers with other specialties and primary concerns who come to Nicaragua in the first instance to help with a coffee cooperative, to build a school, to set up a clinic. Sometimes they are part of a broadly cultural brigade (as with Boston-based Arts for a New Nicaragua). The mural itself may function as a signature on a project, the origin of which might otherwise be forgotten; hence the sometimes lengthy inscriptions and salutations (nos. 144, 173, 232 are good examples). These embody a kind of social (nonfinancial) contract between people and entities whose names historians would normally seek in archives. (The contras declared any foreigner working in development projects an enemy. At least twenty-four internationalists from many different countries laid down their lives, victims of the contras. They included more than ten Cubans and a young engineer from the United States, Ben Linder, who is charmingly and poetically commemorated in nos. 72–74, 165.[78])

International support, minimal in the days of Sandino, was a substantial force in the Sandinista victory of 1979. The amount of foreign aid—skills and materials—that came to Nicaragua in the first ten years of the revolution is apparently beyond computation, since so much was people-to-people, from one small (sometime very small) solidarity organization to a particular clinic, school, or co-op. In 1989 the number of solidarity groups worldwide was estimated at 2,500, with 1,000 in the United States.[79] The geographic distribution of this aid, by donor country, gives the following very rough estimated proportion: a third from the advanced capitalist countries (United States, Canada, Western Europe), a third from the (former) socialist countries of Eastern Europe, including the Soviet Union (this aid, of course, was governmental), and a third from the Third World,

including Latin America. Thousands of individuals arrived in Nicaragua both in connection with this aid and independent of it.[80]

In the United States it is estimated that during the decade a total of $250 million was donated to Nicaragua by U.S. citizens, through solidarity organizations such as Nicaragua Network and Quest for Peace, in material aid alone (that is, not counting the value of contributed services in Nicaragua).[81] If one adds the value of time and money spent by solidarity organizations and their hundreds of thousands of supporters mobilizing opinion against contra aid, people from the United States actually outspent their own government in lobbying efforts, which may account in part for that government's failure to swing public opinion in its favor. With demonstrations in the United States numbering up to one hundred thousand people in one place at one time, "the scale of domestic dissidence was greater and it was more broadly based than at comparable stages of the Indochina wars. The Reagan administration was therefore unable to carry out the Kennedy-Johnson transition from state terrorism to direct aggression."[82] The harassment of critics and dissidents, while never reaching the scale of the Vietnam War era, constituted a massive assault on civil liberties: solidarity organizations for Central America (chiefly Nicaragua and El Salvador) were threatened, and their staffs were arrested, fined, imprisoned. The Vietnam veteran Brian Willson lost his legs in Concord, California, when a train carrying weapons for Central America deliberately ran over him; a worker in Los Angeles for the Committee in Solidarity with the People of El Salvador (CISPES) was kidnapped, terrorized, and tortured. Much of this governmental terrorism was carried out in league with Central American death squads; none of it was reported in the major press.[83] As in the Vietnam War era, artists in many major cities organized themselves as a separate group, launching a far-flung Artists Call against Intervention in Central America, with posters, exhibitions, and related activities.

While economic aid to Nicaragua came largely from the socialist bloc, "mural aid" did not. The twenty foreign countries whose citizens painted murals in Nicaragua are almost all in the West: in North America, Latin America, and Western Europe; none are in Eastern Europe. And no muralists, until very recently, came from Cuba, which helped massively in the domains of health and education (2,000 people)[84] and in military defense and has a highly developed artistic tradition. (Governments in the socialist world, like governments everywhere, put their priorities elsewhere.)

My purpose here is to measure internationalism as diffused through the murals, but the concept is neatly encapsulated in a single fledgling institution, the Julio Cortázar Museum of Contemporary Art, which was inaugurated in December 1982. It was named after one of its chief instigators, the Argentinean writer based in France.[85] It was promoted and directed by the Chilean exile Carmen Waugh and has attracted donations from all over the world, on the model of the Museum of Solidarity with Chile created under Allende in Chile, which garnered worldwide donations until it was looted and closed down under Pinochet. At present housed in an old, pretty building opposite Telcor (telecommunications center) in downtown Managua, the museum currently

"You and Your New Positions" ("positions" in such cartoons has political connotations as well). Cartoon by Róger Sánchez from *Humor Erótico* (Managua: Vanguardia, 1986).

"Halt or I shoot!" Cartoon by Róger Sánchez from *Barricada* 1984 (also published in *Dos de Cal, Una de Arena, Muñequitos*, vol. 3 [Managua: Editorial El Amanecer, n.d.]). Cf. "The U.S. may be the only country that is officially and publicly committed to wholesale international terrorism as a standard policy instrument" (Noam Chomsky, Z *Magazine*, May 1993, p. 23).

holds about thirteen hundred works, over half of which are from Latin America and Spain, including major official donations from Cuba and Venezuela, but with relatively few works from the United States—about twenty—and none at all from the former Soviet bloc. Preview exhibitions were held in Paris and Madrid in 1981–82. The present government has sought unsuccessfully to seize the collection.[86]

Another artistic institution that incarnated the spirit of international solidarity with Nicaragua was the *Semana Cómica*. This popular humorous and satirical weekly was notorious for its tongue-in-cheek (or -crotch) use of erotic photographs filched from *Playboy*-type U.S. magazines (a predilection that caused the FSLN government to suspend it briefly).[87] It also used an array of cartoons volunteered from sources all over the world, including comic strips by the Argentineans Fontanarrosa and Quino and by José Palomo, a Chilean who, from 1973, lived in exile in Mexico. Meanwhile, the core concept and political line of the magazine, which was subtitled *Semanario de Humor, Marxismo, Sexo y Violencia*, remained thoroughly Nicaraguan, and Sandinista. The editor and author of much of the text and the ongoing "Humor Erótico" cartoon series (a minor

celebrity in its own right) was the arch-Nicaraguan Róger Sánchez Flores, political cartoonist of *Barricada*, the official Sandinista daily. His premature natural death at age thirty-one coincided exactly with the premature unnatural death of some of the best murals.[88] The magazine did not survive him for long.

Through *Barricada Internacional*, the English-language weekly (then bi-weekly) digest of the Sandinista daily, *Barricada*, Róger reached an international audience,[89] and an international audience reached Nicaragua. Never has a socialist revolution had a better advocate in the United States; written in an engaging, vivid, and self-critical manner which we do not associate with an official socialist medium, *Barricada Internacional* was a bulwark against the barrage of disinformation put out by the mainstream press in the United States. The English edition of *Envío*, published by the Universidad Centroamericana in Managua and distributed by the Central American Historical Institute in Washington, D.C., is another source of relatively impartial information on Nicaragua, expertly and brightly written.

Gallery paintings and cartoons made outside the country have found a home in Nicaragua. The "donation" of murals is a more integrated process, involving a deeper and more lasting commitment, usually as part of a group solidarity effort built over time. The individual or small group artistic-aid project resulting in a mural is often a spin-off (or add-on) of other economic- or educational-aid projects by larger solidarity organizations. Sometimes artistic aid is simply easier and cheaper to give than other kinds. The materials involved—paint and paintbrushes—are hand carried and inexpensive compared with high-tech machinery. It was not so hard for inconspicuous people and groups to slip through the embargo net, and the murals may be considered artistic and ideological contraband, along with small-scale economic contraband—labor, materials—smuggled piecemeal through the myriad efforts of hundreds of solidarity organizations in the United States and Canada. A list of the names alone makes picturesque reading: CAPP Street Foundation, the Presbyterian Hunger Program, the Fund for Tomorrow—to cite just a trio from Ridenour's *Yankee Sandinistas*.[90] These organizations are expressions of long-standing scholarly, academic, ideological, religious, sentimental, and ethnic ties to Latin American popular struggles.

The Mural School and Popular Church Patronage

After the twin impulses from the Panamanians and Luis Alfonso Velásquez Park, murals by Nicaraguans and internationalists began appearing all over Nicaragua. The sense that Nicaragua was the place where a socially conscious mural movement had real meaning touched an Italian artist, Sergio Michilini, who founded the Mural School. Michilini, of Busto Arsizio, Varese, a product of the sixties ideological youth revolution, conceived and brought to Managua in 1982–85 a complete mural school: a vision, a program, instructors (fellow Italians), financing from powerful Italian solidarity organizations, paints, scaffolding, and other necessary materials. In Nicaragua he found a fertile ground of cooperation in the Ministry of Culture, among progressive priests, and

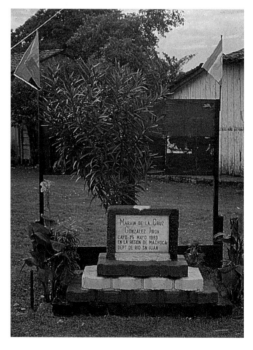

Five martyr monuments. Countless monuments of all shapes and sizes are scattered over Nicaragua, dedicated to some of the fifty thousand victims of the insurrection and the tens of thousands of victims of the contras. Many of these monuments are now neglected or mutilated, or have been removed.

(*Above*) The bust of the martyr Aristides Huerta is now decapitated.

(*Above, right*) Martyr monument to Fernando Salgada Díaz. Some monuments, such as this one, serve to name roads.

(*Right*) Martyr monument to Marvín de la Cruz González Jirón.

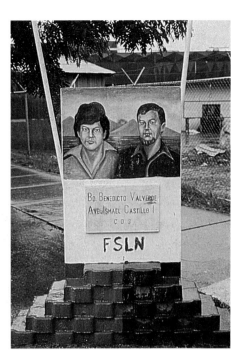

Martyr monument.

Martyr monument to Benedicto
Valverde and Ismael Castillo.

among certain Nicaraguan artists. He has now settled in the country with his Nicaraguan *compañera*, an architect, and their daughter

The first such state-sponsored specialized school in the world (the Taller Siqueiros, or Siqueiros Workshop, in Cuernavaca was no longer active in the 1980s), the Mural School was given as its full name the David Alfaro Siqueiros National School of Monumental and Public Art (Escuela Nacional de Arte Público y Monumental David Alfaro Siqueiros, or ENAPUM-DAS). While emphasizing mural painting, it included in its curriculum and practice sculpture-painting (*escultura-pintura*), clay and cement work in high relief, and mosaics, the natural-color stones for which are found in Nicaragua. Conceived shortly after Michilini's arrival in 1982, the Mural School officially opened its doors in 1985, with Leonel Cerrato as director, to students both Nicaraguan and foreign (from seven different countries), and survived until 1988–89, when government funding for the arts was radically cut. The school was housed in modest, specially enlarged premises adjoining the Ministry of Culture, an ex-Somocista hacienda known as El Retiro, now serving the Ministry of Sports, which the new government considers more important than art.

The announcement in the fall of 1991 that it was to be turned into a riding school elicited in the press a storm of angry and satirical letters, one of which suggested that commemoration of the original (public art) function of the place be combined with the new purpose by erecting a

Somoza-style equestrian statue to—should it be Arnoldo Alemán, or perhaps Ronald Reagan? The students of the National School of Plastic Arts presently learning sculpture there have done so to the rumbling of earth-moving machines nearby; but the actual demolition of the Mural School buildings has been stayed by fear of offending the Italian embassy.

In the three years of its existence, the school trained many of the muralists currently most active, notably the Nicaraguan Federico Matus and members of the Colectivo Boanerges Cerrato in Estelí. Its success was patent, but it always had its detractors and was subtly undermined by Sandinista art officials who preferred portable easel and commercially viable gallery art to public art. The principal enemy on the official side was Quinche Ybarro, head of Arts Education (Departamento de Enseñanza Artistica), who held the purse strings and illegally starved it of funds. (His destructive role is covertly commemorated in the Michilini mural no. 31). The school also suffered from certain internal divisions. After its demise, it was savagely and stupidly attacked by the new (UNO-appointed) head of the School of Plastic Arts, a painter trained in Florence, Italy, as guilty of "destructivism, anti-culture," and a waste of human and material resources.[91]

The formation of the school went hand-in-hand with the most ambitious practical application: the sixteen-part cycle in the Church of Santa María de los Angeles in the poor Managua barrio of Riguero, inaugurated in July 1985, the same day as the Mural School. The cycle achieved international renown and attracted visitors from abroad.[92] One cannot help fearing, however, that it, too, is imperiled, since its original sponsor, Father Uriel Molina, was fired from his post in January 1990, and a new priest, not enamored of the murals' content, was installed. After the demise of the school, on 19 September 1989, twelve Nicaraguan muralists, meeting in the Praxis Gallery, constituted themselves as a sociopolitically motivated Unión de Artistas Público-Monumentales (Union of Artists in Public and Monumental Art).[93] But this group seems to exist only on paper, and the more active association of muralists at present is a diffuse international one calling itself TALAMURO (Taller Latinoamericano de Muralistas, or Latin American Workshop of Mural Painters), of which Michilini is coordinator.

To compensate for the loss of the school and to maintain the impetus of the mural movement, Michilini initiated a scheme even larger in scale than the church cycle, with murals by other Italians, Nicaraguans, and internationalists (twenty artists from ten different countries, seven of them in Latin America, are represented at the time of writing), mainly in Latin America, in the Monseñor Oscar Arnulfo Romero Spiritual Center (CEMOAR), a retreat, study, and conference center near Managua (nos. 29–51).

The complex mural scheme, designed to integrate and bring human scale to alienating and fragmented modernist architecture, will comprise dozens (50–60) of murals, internal and external, large and small, on the theme of Five Hundred Years of Popular, Black, and Indigenous Resistance (since the arrival of Columbus)—a counterquincentenary celebration, inaugurated in 1992. The CEMOAR and Riguero church projects, both sponsored by the Italian Third World development organization Asociacion de Cooperacion Rural Agraria (ACRA) and Father Uriel

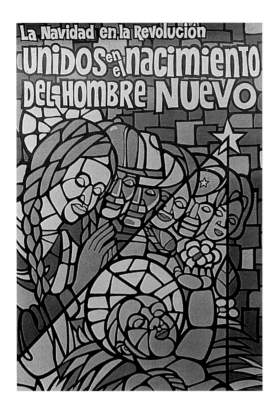

"Christmas in the Revolution. United in the Birth of the New Man." Poster by the Ministry of Social Welfare, 19 July 1980.

"David against Goliath." Luis Alfonso Velásquez faces Somocista brute force. Detail from no. 97.

Molina, the former Riguero parish priest, testify vividly to the creative collaboration of Christians united in liberation theology and to the fusion of Christianity and Marxism. It seems as if the official church's response to these murals is the enormous, pretentious new cathedral Cardinal Miguel Obando y Bravo is having built, after the design of a Mexican architect and with funds from a U.S. contra supporter and pizza millionaire.

Cardinal Obando, the U.S.-funded *Prensa* newspapers, and religious conservatives have generally railed against the Riguero church cycle as a "profanation of the temple" and want it destroyed, or at least removed, for its incorporation of the "Sandinista Saints" Sandino and Fonseca, the Spanish revolutionary priest Gaspar García Laviana, and Luis Alfonso Velásquez, the famous ten-year-old martyr who figures as David confronting the Goliath of Somocismo and, as it were, little Nicaragua confronting the U.S. giant. The resurrected Christ is incarnated as a youthful Nicaraguan peasant. The resurrection, achieved through revolution, is, according to Ernesto Cardenal, that of the Nicaraguan church and of Nicaragua itself. The Riguero cycle, an homage to the pictorial dynamic of Michilini's modified neo-Siqueiresque style, and the more diverse CEMOAR project recall the historic mural tradition of Italy as well as the more recent one of Mexico;

together, under the auspices of the Antonio Valdivieso Ecumenical Center, they revive the ancient tradition of ecclesiastical art sponsorship, which Mexican muralists, who were largely anticlerical, did without.

The CEMOAR project is complex and ambitious, an attempt at "plastic integration" in the tradition, says Michilini in his publicity brochures,[94] of Beato Angelico in the San Marco convent in Florence, Antonio Gaudí in Parque Güell in Barcelona, Diego Rivera in the Chapingo Chapel, and Siqueiros in the Polyforum, the last two in Mexico City. The big difference, however, is that the CEMOAR project, rather than being the work of a single personality, like the antecedents listed above, consists of contributions from numerous different artists working in their own personal style. (Tied in later years to his desk job as coordinator of the solidarity organization ACRA [Associazione di Cooperazione Rurale in Africa e America Latina], Michilini was removed from the temptation of filling more of the CEMOAR spaces himself; he has now returned to muralism.)

"Plastic integration," in Siqueiros's view, is the means by which a mural tries to break through its traditional role as enhancer of (at best, window through) a single, flat, autonomous wall or segment of wall. Siqueiros sought to exploit surrounding space and physically involve the spectator by using polyangular perspective and by optically abolishing angles (see nos. 93, 214). The process has its analogue in the socialist idea of fostering popular and international participation in building the new order.[95]

The complex of buildings constituting the Romero Center, a former Somocista dwelling built in the going "cosmopolitan functionalist" style, with its repetitive, boxlike spaces, is prima facie highly resistant to any pictorial effort toward integration. Its location eleven kilometers outside Managua, moreover, makes it relatively inaccessible. The idea of coupling artistic activity with a re-created Mural School is in abeyance. Even before 1990, and increasingly since, the center has seemed isolated from the popular struggle. It has not exactly flourished as a nexus for international liberation theology (it is now available to any organization for whatever purpose), nor can it, remote from any population center, attract local support (the Church of Santa María de los Angeles, by contrast, is in the middle of a poor, populous barrio in the heart of Managua). It is as if the mural movement, like primitive Christianity or the insurrectionary idea itself, were seeking refuge in the hills, awaiting more propitious times, in a "repliegue tactico," or tactical retreat, from the danger of destruction.

Michilini intends the CEMOAR to be Nicaragua's "first integrated and collective work of art." "Integrated" but not "collective" is the characteristic of antecedents (including those Michilini lists) in the tradition of mural schemes. For Michilini, quoting Siqueiros, "integrated" means a unitary art, the simultaneous creation of architecture, painting, lighting, and so forth—a total and indivisible vision. Given pre-existing buildings, the vagaries of funding (now much diminished), and the random timetable of invitations to, and the acceptance and availability of, artists (who must work virtually for free) and the multiplicity of personal styles they bring to the project, "collectivity" can hardly contribute to "unity"—the very opposite. Add the diversity of media

already in place: sculpture, ceramic, mosaic, and painting (with tapestry announced as a desideratum) and the placement of spaces, most of which divide rather than connect, and the result is a mural museum or mural gallery (a "mural solidarity museum," perhaps) rather than a "plastic integration." A piece of ceramic sculpture, rescued from a "sculptural-pictorial" mural now destroyed (no. 108) is a reminder, no more, of a favorite Siqueiros combination not thus far represented.

If circumstances prohibit that a work by so many artists from different countries practicing different idioms (and media) be integrated as the Church of Santa María de los Angeles is integrated—spatially and plastically, under the authority of a single artistic personality—any integration or unity is ideological. Paradoxically, the least ideological of the CEMOAR paintings, by a Cuban artist, is the exception, which does attempt a certain plastic integration: in a narrow, awkward passageway, architectural forms wrap around and up adjacent walls and ceiling with optical finesse so as to involve surrounding space and compel movement on the part of the spectator, as Siqueiros demanded (no. 30).

Michilini himself preserved a traditional, frontal, single viewpoint in his two paintings in the CEMOAR, as did his fellow Italian Aurelio Ceccarelli. Both refer here to European rather than Mexican traditions: Aurelio C. (as he prefers to be called) to the Italian quattrocento with his masked religious-sacrificial symbolism, stylized postures, and tightly painted flesh of figures trapped in a surrealist nightmare (no. 32), and Michilini to the Italian Renaissance equestrian portrait, with this Christian *guerrillero* on muleback, as imperturbable as a condottiere on his horse, in a thematic context inspired by the *Good Government* of Ambrogio Lorenzetti, the fourteenth-century Sienese painter (no. 31). In his *Crucifixion* (no. 37) Michilini refers, by contrast, to a very different tradition, that of the German Renaissance (or late Gothic), in the brutally contorted limbs of the thieves and the gentle, unheroic face of Jesus.

The Jesuit-funded Central American University (UCA) has sponsored, by way of contrast, if not as a corrective to the Sandinista militance of the Church of Santa María de los Angeles, the sweetly bland but rather touching (Fra Angelical) murals by the Spanish priest Maximino Cerezo Barreda with their Salvadoran (thus less controversial) martyrs (no. 113). This and the same artist's poster series, mantas, and biblical illustrations project a Christ of the poor, if not of revolution.

The forthrightness and clarity of the fusion of revolution and Christianity in the Church of Santa María de los Angeles contrast also with the ambiguity (which may be deliberate) of Victor Canifrú's Christ on the cross in the Antonio Valdivieso Center (no. 28). Seen in an extreme foreshortening reminiscent of Salvador Dalí's famous *Christ of Saint John of the Cross* in Glasgow, Jesus' haloed head radiates in a brilliant pun on the total eclipse of the sun that took place while the artist conceived the mural (11 July 1991). Does this allude to the (temporary) eclipse of Sandinist Christianity? Or to an essentially meaningless natural phenomenon greeted with superstitious (unconscious, unenlightened) amazement by the populace, who crane their necks at all angles to catch it.

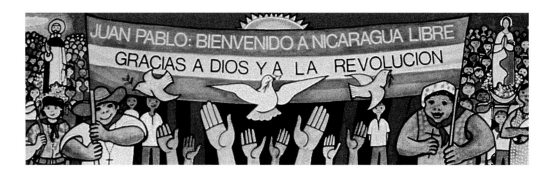

"John Paul: Welcome to Free Nicaragua. Thanks to God and the Revolution." Banner by Father Maximino Cerezo Barreda to greet the pope in 1983; the pope, however, rejected the revolution and refused to say a prayer for the martyrs, causing a furor.

Nicaragua's revolution is recognized as the first socialist revolution in which Christianity has played a major role, and the need to combine the old religious and the new, socially conscious, iconography (mitigating the latter by preserving the former), is well exemplified in the Waslala church decorations (nos. 262–270). Without being explicitly Sandinista, the east and west interior walls show the new Nicaragua at work: school, health clinic, sewing cooperative, agricultural labor. To the local bishop, a conservative from the United States, these innocent-seeming themes were wrong for a church, so the parish priest, Father Enrique Blandón, compensated for them by ordering a traditional Via Crucis (Stations of the Cross) along the side walls. But the really astonishing subject at Waslala is the exterior one already referred to (nos. 269, 270): here Christianity condemns its own history of oppression. Other murals done in 1992 (nos. 217, 221) have since taken up the quincentenary theme of the cruelty of the "Christian" conquest. These "gentle and shy" native people in western Nicaragua (to quote Columbus's first letter of 1492), whose initial friendliness the muralists portray (nos. 242, 244), were subject to a massacre the extent of which was unique—99 percent of the population, from over a million down to less than ten thousand in just sixty years.[96]

The Luis Alfonso Velásquez Park and Other Managua Murals

The Mural School mobilized progressive sectors of the Catholic church aligned with the revolution and the poor. It was characteristic of the young revolutionary government, which included several priests, that the first major public construction work should be a park for the children of the poor, named after Luis Alfonso Velásquez, himself of a poor family (for more biography see no. 9). The park occupies what was the heart, the elite downtown, of the city of Managua before the 1972 earthquake. In 1980 it was given over to the pleasure of the people, with trees, spectacular murals at

either end (now destroyed), and rudimentary playground equipment, which gave color and cheer to a large blighted area ringed with hulking ruins once squatted in, and now reoccupied by, the homeless, who under the Sandinistas had begun to find better accommodations.

Here, on a service building, which, being windowless, seemed to have no function other than to display mural paintings, were united three examples of indigenous Nicaraguan style: one naive-realistic, by the former director of the Mural School Leonel Cerrato, representing the reunion of the revolutionaries with their families after the Triumph of 19 July 1979; another by three artists—Julie Aguirre, Manuel García, and Hilda Vogl—merging almost indistinguishable primitivist styles, to depict daily life and new hopes in Nicaraguan villages today; and the third by Alejandro Canales, on the theme of women and children playing in the park. To all of these we shall have occasion to return.

At the other, western, end of the park, separated from it by a military base (this too has its significance and symbolism), ran the mural of the Avenida Bolívar, the longest (at one hundred meters) and in some sense the most publicly accessible of all Nicaraguan murals, and certainly the one most photographed by visitors and the international press, for it lay on a major thoroughfare linking the Intercontinental Hotel to the Rubén Darío National Theater, the lake, and the east-west arterial road. Sponsored by the army, untitled until destroyed (as described above) and then christened *The Dream of Bolívar*, it was painted by a Chilean couple living in exile in Nicaragua, semi–art professionals better known in Nicaragua as singers, under the names Victor (Canifrú) and Alejandra (Acuña). With stylistic reminiscences of the plangent Ramona Parra Brigade (BRP) style, which illuminated the Chile of Salvador Allende (1970–73),[97] it suffered the fate of all the Chilean murals destroyed by Pinochet.

Canifrú had landed from the frying pan of one mural-hating government into the fire of another. The *Dream of Bolívar* mural was his finest work, done when the Nicaraguan revolution was in its early phase and still offered the purest inspiration. It was an epic that situated the revolution as the culmination of a whole Latin American history of struggle for freedom, with Simon Bolívar as the pivot. History seemed to be rushing pell-mell forward through the centuries, suddenly catalyzed in a frenzy of garish colors and overlapping and intersecting forms. Individual heroes, the "people," arms, and weapons; flags, crosses, masks; wind-torn hair, shouting and thrusting heads; horses, death: all were impaled upon each other as if time and space were running out. Paint did in fact run out; so now has time. This is Siqueiros confused by Expressionism, and a tangle of other modernist influence, including that of the Cuban poster. The mural flowed in the very rhythm of revolution, impetuous, unreflective, disorganized, and energized.

Another mural bordering the park, less monumental but full of charm (it was destroyed in December 1992), was added in 1984 by Miranda Bergman and Marilyn Lindstrom, artists from the San Francisco Bay area. They and Nicaraguan assistants decorated the multiple faces of a small children's library with the theme of children at play, building the blocks of a better future and learning to read (no. 9). Cheerful and innocent in spirit, artfully simple—even naive—in style but

with a distinctly clever rebuilding of a wall corner, this mural seemed the least deserving of the political revanchism that caused its destruction.

Another cluster of murals emerged in Managua's elite commercial center near the Plaza España, also at the hands of internationalists: three large, closely abutting works (to which more were to be added), one by the same San Francisco Bay artists, also with Nicaraguan help, for the wall of the Teachers' Union headquarters, on the theme of schooling and literacy, featuring a magnificent tree of knowledge, life, and hope (no. 80); another by Chicanos and Latinos from Southern California showing the plight of Central American refugees in the United States and celebrating Chicano culture as well as the Nicaraguan revolution (no. 81); and the third by the Salvadoran refugee Camilo Minero (since expelled) about El Salvador and its popular heroes (no. 82).

Like the three adjoining murals of the Luis Alfonso Velásquez Park, this trio offers contrasting styles, this time all from abroad: the artfully naive and naturalistically allegorical in the conventional perspective of a simple landscape (Teachers' Union); the sophisticated articulation of incisively contoured motifs, in bright, flat colors—that is, poster graphic style—connected in autonomous spaces (Chicano); and plain-spoken monumental serial forms lightly touched by modernist distortion (Salvadoran).

Literacy is also the major theme of murals executed in Managua near Masaya by Chilean exiles and others now living in the United States, including the sons of Orlando Letelier, after whom they named their brigade (he was assassinated in Washington, D.C., in 1977 by CIA-trained Cuban-exile and Chilean death squads).[98] Like Canifrú, the Orlando Letelier Brigade used a style designed to recall that of the Chilean Ramona Parra Brigades (nos. 12, 223), but more sedate in rhythm and with greater clarity of design. These, with Canifrú's, are Nicaragua's contribution to a virtually worldwide diaspora of Chilean exile murals since 1973, all bearing the hallmarks of the original Ramona Parra Brigade style.

Mexico, which despite a framework of general economic submissiveness to the United States has always shown itself capable of autonomous political and diplomatic gestures, is the one country officially represented in the murals. In the National Palace in Managua, the Canadian-born Mexican Arnold Belkin (d. 1992) painted a commanding triptych, as he called it, with the Mexican and Nicaraguan revolutionary heroes Zapata and Sandino, cast as the new Prometheuses stealing the fires (in this case, of revolution) from the gods (of capitalism).

With the Italian murals, Belkin's stands as a model of spectacular and highly sophisticated professionalism that is hardly typical of the Nicaraguan mural movement as a whole. *The Prometheans* is a work painted (in airbrush) with dazzling dexterity. The perfectly tuned, tightly controlled volumes are in contrast to a certain philosophical ambiguity or abstruseness, which most people, especially in Nicaragua, would be unlikely to fathom. The partial flaying of the principal figures, Zapata and Sandino, which is not new to Belkin's art, carries an array of potential meanings, to judge by the various critical testimonies and the artist's own explanations. Likewise the robotic figures. Apart from the flayed and the robotic, there are idealized, stylized forms (notably

Arnold Belkin finishing his mural
in the National Palace (no. 1).

in the right segment, the New Nicaragua), and various degrees and kinds of photographic treatment that range from the blank silhouette, via the faded, monochromic news photo, to the sharply defined portrait. This virtuosity, applied to the very bright, contrasting color scheme, is a visual feast; what it means is another matter.

The broad intention and relevance to the Nicaraguan revolution, at least, are not in doubt in Belkin's murals, unlike those of his compatriot the Russian-born Vlady (son of Victor Serge, he uses only this name), done under the same sponsorship on the opposing walls. Vlady's murals, in this monumental space, are oddly less interesting, although interestingly odd, with their surreal fantasy untouched by particularity of time and place.

Estelí and León

In the 1990 elections the two major cities of Estelí and León, unlike Managua, both returned Sandinista municipal administrations, so that murals there are protected, and conditions are good for future work. The spark of the mural movement was ignited in Estelí by an international group, in residence since about 1985, calling themselves the Colectivo Boanerges Cerrato, after an artist who died in 1990 at the age of twenty-seven, considered a brilliant young painter (he was a brother of the muralist Leonel Cerrato). The core group is a trio, two women, one from the United States (Janet Pavone) and the other from Argentina (Cecilia Herrera), and a man from Great Britain (Daniel Hopewell); their work is monumentally conceived, aggressively figural, and carefully documented. They have already done a dozen murals in Estelí and elsewhere. The collective is particularly committed to making murals with children.

Each member of the trio works on occasion independently, but together they blend with no apparent effort in a harmonious style. The collective is capable of different stylistic modes: on the

army barracks wall (nos. 150, 151) the sweeping gestures and movements of a few figures fill a great space with an energy that seems to burst the frame. In the Medical Center (nos. 157–163) the compositions are more centered and the forms generally more quiet, though still massive. In the long, low mural opposite the Social Security Building (no. 166) the construction of space through changing viewpoints and backgrounds and a perspective tilting through a multiplicity of motifs become subject matter in themselves. In the carpentry workshop of Ciudad Sandino (no. 141) the Boanerges Cerrato Collective has exploited the angles and windows of a small building in a "plastic integration" learned at the Mural School, where the trio first met.

Another notable contribution to muralism in Estelí is that of Roberto Delgado, a Chicano from Los Angeles, California, who has painted "martyr galleries" in translucent color imbrications (nos. 154, 155). The individual features of the martyrs, remotely based on photographs, are over- and underlaid with patterns tending to pure coloristic abstraction. This treatment raises them from the personal to the historical, from the portrait to the ideal, from the mortal to the eternal.

After Managua and Estelí, the city in Nicaragua most decorated with murals is León, which has a Plaza 23 de Julio enclosed on two sides by a patchwork of five different murals, the work of Nicaraguans, the Mural School, North Americans, and others (nos. 206–210). The historic, dominating, war-damaged, lugubrious cathedral (built in a style known as "earthquake baroque") is now offset by a huge shimmering mural partially circumscribing a nearby plaza dedicated to revolutionary martyrs of León, the first city liberated from Somoza. The mural, designed and painted jointly by two artists from Hamburg, Germany (sister city of León), and four Nicaraguans, traces the history of Nicaragua in a panoramic, surreal, and desertlike space (no. 205). Symbols of historic events (Spanish Conquest, Walker's invasion, U.S. invasion, the assassination of Somoza) lie stranded in historical spaces distinctly marked but, qua landscape, presented as an arid continuum—a record, as it were, of momentous history that failed to change anything, until the 1979 revolution at the very end of the mural, when real people (children) appear and hope (the kite) beckons.

In León a young Colombian refugee, Daniel Pulido, has initiated a scheme for Ten Murals for León, to commemorate the 1992 quincentennial. In a style touched by both Siqueiros and Orozco and, like Michilini, evincing open, flowing brushwork combined with monumental form, he has delved deep into Nicaraguan folklore (no. 196) as well as the revolution (nos. 192–194). From Michilini he has learned the meaning of "plastic integration" and in a very cramped patio played greatly different scales against each other and painted against real architecture. Of late Pulido has been much in demand in the Netherlands and Germany (most recently, in Düsseldorf), where he has had opportunities denied him in Nicaragua.

In 1991 a new, youthful autodidact group emerged, calling itself Grupo Artistico Contraste.[99] They have worked in Britain and on military bases in Nicaragua, and in Managua and Matagalpa they have done spectacular murals commemorating sacrifices by women (nos. 75, 231). They

successfully combine on the same surface two different styles—realistic for the portraits, sweetly idealized and strongly symbolic for the rest—and may, furthermore, be introducing a significant new trend of the (post-Sandinista) 1990s toward a humanistic but not specifically Sandinista (or indeed militant) iconography.

Other European Contributions

The Nicaraguan mural movement is part of a global renaissance of art on public walls. The considerable U.S. contribution in Nicaragua (artists from the United States constitute the largest single non-Nicaraguan group) can be partially explained by the continuing vitality of the mural movement in the United States, beginning in the late 1960s. Itself much indebted to Mexico, the U.S. movement is socially concerned and aware of Third World, especially Latin American, struggles and is readily exported (or re-imported). Scandinavia, by contrast, is without an indigenous popular mural movement but has contributed in many ways to Nicaraguan culture and its institutional development, including help with the National Theater, the National Library, art galleries, and a major conference center named after a great socialist and internationalist, the assassinated Swedish prime minister, Olof Palme (see no. 31). The few murals done in Nicaragua (most of them destroyed) by a Danish group, themselves virtually the only muralists in their own country; a large satirical world map on canvas (now missing) by Swedes that was originally part of a diplomatic exchange; and a very recent addition, a mural by the same Swedish group in the CEMOAR, are insufficient reminders of the considerable Scandinavian tradition of aid to the Third World.

France, which gave much support in the domains of education and the media (partly through UNESCO), is scarcely present in the Nicaraguan mural movement. The French contribution actually flows in reverse: the French solidarity movement has given opportunities to Nicaraguan muralists, notably Leonel Cerrato, to work in France, where he has executed far more murals than at home.

The Dutch, likewise, who were extraordinarily hospitable in the 1970s and 1980s to murals by exiled Chileans, have invited Daniel Pulido and others from Nicaragua to paint murals in Holland. Austrians, too, have sponsored Nicaraguan murals in their own country and have financed the new cultural center in Estelí, as well as libraries and publications. But in Nicaragua itself there are no murals by Austrian or Dutch painters (a small Dutch one was quickly painted over, no. 235).

Exception should be made for the participation of León-based Gera Hoogland from Utrecht, an occasional muralist active primarily as the coordinator of cultural projects for the extensive Dutch sister-city system (18 cities are so allied). The special Dutch role in aiding Nicaraguan culture can be measured financially (in 1980–82, when 6 million cordovas were given—ten times the individual donation averaged by the other major European countries)[100] and morally: Tomás Borge made a speech in the Netherlands, in which he said how perfectly that country embodied the idea that

"BROTHER/SISTERHOOD. AMSTER-DAMANAGUA 1984." Logo of sister-city office in Managua, now painted over. Is Amsterdam the only European capital city that dared to establish a sister-city relationship with Nicaragua?

solidarity is the affection of peoples (Solidaridad es la ternura de los pueblos, a phrase often quoted in the murals and originating with the poet Gioconda Belli).[101] In a delicate, and very Dutch, gesture, the Dutch named a new tulip variety after Ernesto Cardenal.

Some murals, such as the huge one in León, mentioned above, by Germans from Hamburg (no. 205), are the direct result of sister-city projects, which have sought to institutionalize, solidify, and ramify the linking arms of solidarity in a global way.[102] A fine mural in Estelí by the international Colectivo Boanerges Cerrato pays homage to the sister-city concept on what was then the project premises but is now occupied by hostile UNO government officials (no. 167). To them, the murals are an embarrassment, or at best incomprehensible. They expect aid to come from mighty Washington, not places like Delft, Evry, and San Feliu de Llobregat.

Nicaragua's artistic contacts with the world outside depend much on chance, individual enthusiasm, serendipitous encounter. It is nonetheless not entirely accidental that the country that has the most governmentally institutionalized and politically oriented mural tradition of this century, Mexico, is the one that has given Nicaragua its only government-to-government mural (no. 1). No less significant is the contrary case of Chile, where socially conscious mural work was systematically driven out by the Pinochet tyranny, to strike roots in a diaspora of defiance and hope, in Europe (Holland, as noted, and elsewhere), in the United States—and in Nicaragua.

The invitations to Nicaraguan muralists to apply their skills in West European countries has, no doubt, helped maintain the image of the revolution abroad, as well as helping individual artists

who have been barely able to survive, especially since 1990, in Nicaragua.[103] But it is unfortunate, from the perspective of one who, like Michilini, wants a mural movement to become domesticated in Nicaragua itself that the solidarity organizations prepared to raise large sums to bring Nicaraguan artists halfway around the world are unwilling to sponsor murals or mural activity in general in Nicaragua. In his constant struggle to keep his CEMOAR mural project afloat (nos. 29–51), Michilini sees this disinclination as a form of left imperialism: by rich countries with a long history of not just seizing valuable economic resources but also enticing the finest human resources (artists, scientists) out of their native country. Since popular (community) mural painting nowhere offers real economic rewards, this is likely to remain a true "borrowing," rather than a permanent extraction. It is no accident that seven countries from Latin America, hitherto proportionately underrepresented in Nicaraguan mural painting generally, are represented in the CEMOAR project. Western Europe and especially the United States, hitherto dominant among internationalists, have dropped out of the picture, reflecting the precipitous fall in nongovernmental aid overall from that quarter. In an encouraging development, however, an organization in Illinois called the Peoria Area Peace Network began in 1993 to raise material donations to revive mural painting in Nicaragua.

Locales, Sponsors, Processes, Critical Neglect

The range of locales on which murals are painted—government buildings, schools, churches, military bases, factories, union halls, hospitals, and youth, community, and cultural centers, even a prison—indicate how deeply the mural movement has permeated the social fabric. The processes involved in the execution of the painting are equally varied, since the collaboration necessary for each mural takes a different form. In the first instance it is a union of individual artists, local workers, and inhabitants, who are often organized into an association or unit from one of the mass organizations set up by the Sandinistas for women, youth, co-ops, and so on. The Ministry of Culture and to a lesser extent the Sandinista Association of Cultural Workers (ASTC, or the Union of Artists taken in the broadest sense), approve, make connections, and facilitate, but seldom initiate or fund.

The Ministry of Culture, founded by the Sandinistas under the poet-priest Ernesto Cardenal, did much to encourage mural ventures, even if with its scarce funds it could not finance them; as a mechanism of liaison, it worked jointly and sometimes in apparent rivalry (and friction) with the ASTC. Certain elements of the ASTC sought to undermine the Mural School, out of sectarian envy and ingrained elitist aesthetic prejudice. One noted muralist characterized the ASTC opposition as a "terrible war" involving the destruction of art work. When in 1985 the school first publicly displayed its visual founding charter, the cycle in the Church of Santa María de los Angeles, not a single representative of the ASTC was present; the occasion was effectively boycotted by the only artists' union in the country, and the tension, or division, has persisted to this day.

Artists were also conspicuously absent from the quincentennial inauguration of the CEMOAR murals in 1992.

Despite these tensions, the two organizations, the Ministry of Culture and ASTC, both contributed to a climate propitious to the democratization of culture we have noted, and to its internationalization. But the ministry was dissolved in 1988, and funding for the arts was cut in half in February 1989, with a layoff of 250 subsidized cultural workers.[104] Four hundred jobs were eliminated at a stroke, including those at the Mural School. The ministry and ASTC were replaced by an Institute of Culture.

In the smaller towns, the buildings housing the Popular Center for Culture (CPC), often taking over an abandoned Somocista dwelling, were the first candidates for murals. The buildings are now vulnerable to reappropriation by the new government, thus putting the murals at risk. The centers, by their very inclusive, nonhierarchical nature, tended to obliterate distinctions between professional and amateur, which the murals also transcend, as they sought to incorporate and give rein to the ideas of untrained volunteers.

The Ministry of Culture took under its wing the Mural School. This served as a counterweight to the School for Plastic Arts, which then (and today, a fortiori) encompassed a traditional, private-consumption, commercial-market philosophy of art making. The same philosophy was, up to a point, espoused by the head of ASTC, Rosario Murillo, a poet and the wife of President Daniel Ortega. She never showed herself particularly sympathetic to the mural movement, which she implicitly identified with pamphlets, clenched fists, raised guns, and bad art,[105] while the association mouthpiece she edited, *Ventana* (a weekly cultural supplement, now defunct, to the official Sandinista daily *Barricada*), admired in the United States for its "resolutely unprejudiced and non-tendentious editorial policy,"[106] did its best to ignore the whole phenomenon. So, more surprisingly, did *Nicaráuac*, published by the Ministry of Culture.[107] *El Nuevo Amanecer* (like its parent *El Nuevo Diario*) did rather better, with the occasional notice of new murals as they were inaugurated. The only history of Nicaraguan painting, in its updated 1990 edition, does not even mention the murals.[108]

This neglect on the part of Nicaragua's cultural periodicals cannot be accidental, and if we regard art journals as major "sponsors" of art, (co-)determining, as they do in most countries, distribution, reception, and (up to a point) creation, as well as individual reputation, it is remarkable how well the muralists have managed without critical attention. One might even argue that critical neglect has profited the mural movement, has allowed it to develop more spontaneously, unfettered by doctrine, dogma, and other criteria spawned by writing about art. The failure even to notice, in a bare-bones journalistic sense, is, however, bizarre. Even the *Los Angeles Times*, not known for its sympathy for popular movements, gives adequate coverage of local murals.[109] Small photographs of mural fragments tend to show up in the Nicaraguan press simply as space fillers.

Apart from its role in engendering a receptive atmosphere for the arts, the practical control exercised by any "official body" seems slight, given the received stereotype of socialist cultural

centralization and revolutionary claims to politicize culture. Culture has been politicized, to be sure, but by spontaneous combustion. Vice President Sergio Ramírez, an internationally known writer, has said, "Freedom is our artistic policy," and, like Cardenal, his concept of culture—as of revolution—is anything but doctrinaire. Cardenal quotes his mentor, Thomas Merton: "The rule is to have no rules." Thus, says Cardenal, "Our cultural policy is to have no cultural policy." The murals cannot be said to emanate from, much less be directed by the Ministry of Culture, the ASTC, or even a local Popular Center for Culture. They are, as largely in the United States but not in Mexico—where a national government body such as the Secretariat of Education played a critical financial and organizational role—very much the initiative of individual artists, working loosely in cooperation with existing mass and cultural organizations. (In the United States, where the latter are lacking, the cooperation is with local business and government.) "He who pays the piper calls the tune." Being largely unpaid, the pipers are free of interference from above and the censorship that tends to dog public art paid for with public funds.[110]

The Sandinista army may be cited for its remarkable success in sponsoring poetry workshops; "the Israeli army exports military advisers; ours can teach your soldiers how to write poetry," a Nicaraguan army official told me. But the Ejercito Popular Sandinista (Popular Sandinist army, now barred from such cultural activities) also sponsored murals, on military bases (nos. 3, 128, 129, 150) and elsewhere, and its officers have actually introduced artists from abroad. There is a parallel here with socialist Vietnam, where the army was and remains a major organizer of culture. It is hard to imagine the military forgoing control over a mural on army premises, and one hears, un-surprised, how a colonel exercised his veto over an idea artists wanted to include (in Estelí, nos. 150, 151). But he did so in an unexpected way: he wanted a nonmilitaristic mural, with no overt attacks on, or even references to, U.S. imperialism, whose usual symbol, the eagle, he considered an outworn cliché; he would not allow its wings to bear a design of the U.S. flag.

Whoever the sponsor, content is mutually agreed upon, not dictated from above; style is left entirely to the discretion of the artists. A short, sharp debate, in the early years of the revolution, over the merits of a social(ist) realist style as the preferred revolutionary style ended (as in Cuba in the early 1960s) in complete victory for eclecticism.[111] Aesthetic questions arise, not in the context of orthodoxy or dogma, but out of fear that the Mural School, named after Siqueiros, the most politically dogmatic of artists, by the sheer force of example and the institutional support it received, might willy-nilly come to exercise hegemony. There is a critical consensus in Nicaragua that the little public monumental sculpture that exists, which has tended to follow archaic socialist realist lines (especially the huge, centrally located monument to the heroic guerrilla, jocularly known as the Incredible Hulk), has not been successful.

The "advanced" nations tend to impose their own criteria on the Third World. A village lacking running water does not necessarily want to sacrifice the important social ritual of washing clothes in the river or to break the tradition of living close to farmyard animals, whatever the objections of foreign experts. (Steve Kerpen of APSNICA tells this story: stressing the importance of the

(*Right*) Hero portrait of Edgard (La Gata) Munguía, by university students. León, circa 1980.

(*Far right*) Hero portrait of Dean Padgett (Comandante Pedro), 1951–1979. "He Fell for the Liberation of Nicaragua." Managua, circa 1981.

women's ritual of washing clothes in the river, a Nicaraguan villager asks how clothes are washed in the U.S. "Oh, we usually just throw them into a machine—a big metal box that does the job automatically." "Big metal box? How do you get such a thing down to the river in the first place?")

Internationalist painters, as well as experts in economic development, health, or housing, have reason to be wary of offending and ignoring local sensibilities; they seek advice and elicit themes the local people want to see, even invite specific design ideas and active help in the execution; these can usefully be offered by quite unskilled people. In the hospital of León (no. 202), the naive thoughts of both young and old were harmonized into a complex, overall design. The work was directed by the principal artist, Eva Cockcroft, an experienced professional from New York, one of whose chief concerns was the democratic representation of the dozen or so participants, many of them children as young as twelve and all but two from the local Popular Center for Culture. Having shared the experience from beginning to end, I can testify to the alchemy which went into such a mural, the multifarious, half-formed visual ideas jelling finally into something approaching artistic gold.

The mural shows a male doctor and female nurse. Cockcroft, a feminist, wanted to reverse the roles, to make the mural more "progressive." Her convictions on the matter were, however, overruled, on the grounds that although women doctors certainly exist in Nicaragua (by the mid-1980s, over half the new medical students were women),[112] "the doctor" there is still male. In another instance, the Nicaraguans' sense of the imperatives of an armed self-defense posture overruled the pacifist sensibilities of certain internationalists (not the Panamanians!), who were uncomfortable with too much weaponry.

Differences of attitude, to be expected in people of such disparate political and cultural backgrounds, came sharply to the fore in the process of creating what must stand as one of the most

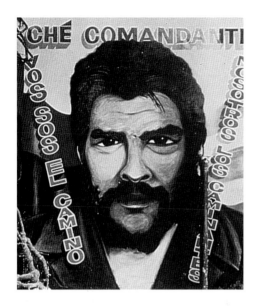

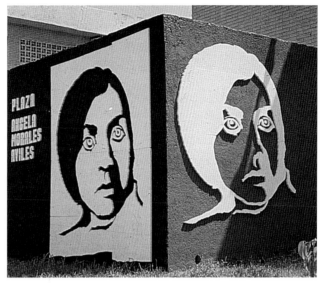

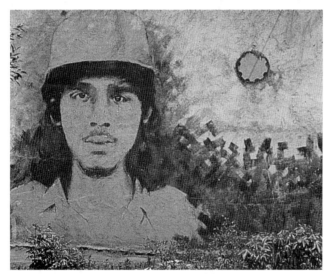

(*Above, left*) Hero portrait of Che Guevara: "Ché Commandante, You Are the Way, We Are the Wayfarers." Mural by Mike Alewitz, Estelí (no. 153).

(*Above*) Hero portrait of Angela Morales Avilés. Cutout of styrofoam, Ministry of Education, Managua, 1980–90.

(*Left*) Hero portrait of (?) Emil Cabezas, León.

original and successful, as well as the largest, single mural of all, already mentioned above (no. 205). According to the Germans involved,[113] they were "hard and direct" (*hart und direkt*) in discussion, critical, aggressive, and, moreover, divided among themselves, whereas the Nicaraguans were more polite and reserved, conflicting traits that often led to misunderstandings compounded by the difference in language. The Nicaraguans wanted to stress the positive and to include the utopian, an attitude that prevailed in the final segment of the León mural; it also figured in the mural painted as a counterpart by the same artists in Hamburg, Germany. The inauguration of the two murals in their respective cities also offered a striking contrast: in León, both officials and a throng of people were present; in Hamburg, both officials and media coverage were missing.

The content and execution of Belkin's work in the National Palace were determined solely by the artist; this was a rare case when a single authorship asserted itself in the traditional (Italian renaissance, 20th-century Mexican) manner. But in the Church of Santa María de los Angeles, the overall direction by a single powerful artistic personality left room for much collaboration at all levels, from subject matter derived from discussions with the residents of the barrio, led by their priest, through execution, harmonized and finalized by Michilini himself. The whole process came about by consensus, but not without a struggle; several completely painted panels were rejected and redesigned from scratch.

Collaboration and Credits　Most murals are carefully credited in a manner I have tried to reproduce exactly in the catalogue. In the credit lines the principal artists appear first, but their names are often closely followed by a more or less lengthy list of assistants, who would have helped execute any large mural project in history but are now lost from the record. In the United States the special collaboration to which the mural lends itself has answered demands for a more democratic, less individualistic, less elitist art practice. The U.S. mural movement may be described as an exercise in grass-roots democracy on the margins of the macropolitical system. But in Nicaragua the new art practice has a parallel in the political practice of the Sandinista revolution, which was made by massive participation and run by a group of comandantes who did not seek individual recognition or encourage a cult of personality (Edén Pastora, who did, quit). The crediting of the assistant "proletariat," which has become customary also in the United States, is a historical novelty. A shift is perceptible even in the short decade of Sandinista murals: the tendency in the early 1980s to sign with collective brigade-name-only signatures or even to choose anonymity has yielded to a more detailed roster of participants, although the number of names listed is far from that on the Great Wall of Los Angeles (Tujunga Wash), California, whole segments of which are devoted to the names of the mural painters. Such emphatic crediting of individuals serves to reinforce the role of the mural process as de-alienation, as therapeutic socialization, summertime painting to keep kids out of gangs and off drugs, and to give them self-respect. Such a purpose is not wholly foreign to the Nicaraguan mural movement, where endemic unemployment, underemployment, and poverty take their toll on the individual's sense of self-worth.

The contrast in this, as in other respects, with the Chilean Allende-period mural, is striking: no individual names were used by the members of the Ramona Parra Brigades (which was just as well when Pinochet ordered the murals destroyed), and the whole process was experienced as an exercise in communal activity, in which individuals were harnessed to a simple agreed-upon style, with prearranged tasks allotted in an assembly-line division of labor. The Chilean murals, moreover, were not designed to last, as the Nicaraguans want theirs to do; processes, styles, and techniques reflect these differences.

Murals, Graffiti, Billboards, Posters, and Other Visual Arts

Nicaragua is known as the land of poets, and its revolution as the revolution of poets. "In Nicaragua," its former president has said, "everybody is considered to be a poet until he proves to the contrary."[114] The literature of this little country, especially poetry, stimulated by the Nicaraguan founder of Latin American poetic modernism, Rubén Darío, has achieved an international renown, both in the original and in translation, as a form of national and political expression. Ernesto Cardenal's work has been translated into almost twenty different languages. Writers achieving excellence in the realm of the novel and the historical narrative (Sergio Ramírez, translated into fourteen different languages; Omar Cabezas, whose *Fire from the Mountain* reached best-seller status in the United States; Tomás Borge) is a more recent phenomenon and has its counterpart in the mural movement, which is also essentially narrative, aspiring to epic, but speaking a visual language usually more prosaic than poetic.

Graffiti One of the most ubiquitous, bizarre, and truly popular literary addictions of Nicaraguans is also public and visual: graffiti (*pintas*). Every village and every town is scrawled over. Originally, the graffiti bravely declared and stimulated individual resistance to Somoza. In the film *Under Fire*, as in some of the murals (nos. 174, 182), one can see how crudely daubed and sprayed houses served to mobilize people, defy the enemy, stake out liberated territory. The graffitoed walls were the cry of an otherwise voiceless people, the voice of the silenced taking the walls by assault, throwing up the ramparts of revolution. "The enemy was dislodged from our walls before he was dislodged from his barracks," says Omar Cabezas, himself once a graffitist, in a monograph, called *The Insurrection of the Walls*, honoring the political graffiti phenomenon. At first (1965–68) the "voice of the catacombs," they were destined to become "the Sandinista stethoscope on the political heart of the people."[115]

The aesthetic of the graffito in Nicaragua is more literary and verbal than visual (unlike the sophisticated spray-can art in the United States). The citations from Sandino and the Sandinista poets are axioms politicized, defiance maxim-ized, war cries muralized. These same literary citations show up on banners carried in marches and are carefully inscribed on banners and elsewhere within the murals. Numbers 91 and 207 represent a conscious junction of political graffiti and mural.

The addiction to political graffiti—some, in their pristine pre-Triumph phase are piously preserved in the National Autonomous University, mingled with assorted murals and *pintas*-cum-murals—is so widespread in Nicaragua that it is impossible not to see graffiti as the precursors of mural painting proper. Sandino started as a name, became a hat, then a stenciled silhouette, finally a fully painted face and figure. The famous Stetson hat survives on the walls as a kind of logo, in the absence of an instantly recognizable formula for the face such as Che Guevara acquired after his death. FSLN was a dirty scrawled four-letter word before becoming a reality in

the minds of the masses, and then a mural program. Graffiti reign supreme because there is no spray-can art, which is a popular intermediate art process between graffiti and mural painting, but which depoliticizes and aestheticizes the graffito principle.[116]

The graffito impulse continued unabated under Sandinista rule, ranging from simple exhortation and crude insult to the poetic, aphoristic, and humorous. The *pintas* were overwhelmingly political, polemical, and Sandinista. Managua in the aftermath of the 1990 election was saturated with graffiti and mural slogans; for the first time, Sandinista verbiage was contested, and weakly it seemed, by the opposition. But the real kill of contra war spoke louder at the polling booth than the rhetorical overkill of graffitoed wall.

That the Nicaraguan murals have never been graffitoed over, as they would have been elsewhere in the world, especially in the United States, is surely a sign of popular respect for them, whatever one's political persuasion. The immediate response to the Managua mayor's painting over of the murals was a series of denunciatory and defiant *pintas* over the overpaint, which the government also painted over. The Avenida Bolívar mural, originally painted on part of a wall dedicated to graffiti and slogans, thus returned to its original usage.

In the United States, the functional relationship between graffiti and murals is conflictive, or at best competitive; murals are designed to discourage and cover over graffiti, and in revenge gang graffitists sometimes turn their spray cans on the murals (if on their turf), often almost obliterating them. The Nicaraguans abstain not only from graffitoing murals but also from interfering with the slogans of enemy or rival political parties. The graffiti were welcomed, it seems, as a healthy sign of an individualistic democracy and real party pluralism rather than feared as antisocial anarchism, or as a form of gang warfare and gang appropriation, as in the United States. In Los Angeles, California, the graffito is a means of individual or clan empowerment by lower-class, disempowered people; in Managua, it is a means of cross-class, national empowerment.

Significantly, there were never any pro-contra graffiti, despite U.S. efforts to promote them, an index of the lack of popular support for the contras.[117] Conservative billboards, subject to graffito correction or conversion in the United States (the graffiti of re-appropriation) have occasionally been added to in Nicaragua; religious hoardings, always conspicuous under FSLN rule, underwent this simple tactic (To "There Is Only One God," for instance, "The God of the Poor" was added).

Billboards and Posters With billboards (*rótulos*) the crossover to mural painting is apparent more in the themes than in the style. Large, invariably hand painted, the new Sandinista billboards, in frames formerly used for corporate advertising, symbolically appropriated formerly commercial ideological space to the Sandinista public message.

Much Sandinista government public service and political exhortation reached the people in this fashion, most impressively in consecutive series such as were pioneered in Cuba and appeared

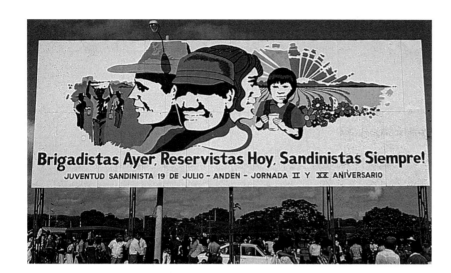

"Brigadistas [i.e., literacy volunteers] Yesterday, Reservists Today. Sandinistas Always!" Billboard, Plaza 19 Julio, for 19 July 1981 celebrations.

in Nicaragua in the early 1980s as part of the annual national celebrations of 19 July. The "Cuban style" (an essentially graphic style using vanguard posterlike linear simplifications and flat colors) was visible in the prize-winning *rótulos* for 19 July 1981 but is little evident in murals, except perhaps in the Chicano mural (no. 81). The visits of artists and designers from Cuba, a country distinguished for its public (billboard and poster, rather than mural) art, left scant traces in the sister republic of Nicaragua.

The posters (*afiches*), very numerous in the early years of the revolution and eagerly snapped up by internationalists, tapered off in quality and quantity from the mid-1980s, owing largely to a lack of materials. They have been much used for exhibitions and educational and solidarity work, such as fund-raising, in the United States, where artists and organizations, in turn, have produced a large number of posters on behalf of the Nicaraguan revolution.

The Nicaraguan Sandinista posters, which number in the hundreds, were produced by professionals of varying degrees of skill and training for the different governmental agencies and for popular organizations set up by the FSLN. Some examples of where they (and the *rótulos*) overlap thematically with the murals, for instance in the literacy campaign or in propagating the role of women and Christians in the revolution, are reproduced here. The striking series by Leoncio Sáenz on the theme Insurrección Evangélica, done for the popular church and distributed through the Antonio Valdivieso Center, gave a revolutionary, if not specifically Sandinista, tilt to traditionally Christian iconography. Billboards and posters reveal as little as the murals do any sense that one style is more appropriate or "revolutionary" than any other; every type of graphic mode serves as grist for the mill, and, as with the murals, the variations in quality are striking.

Another public art form that should not be omitted, because of its links with folk traditions as well as its satirical force, is the carnival float. Such floats were constructed to mark the revolutionary festivals of 17–19 July during the early 1980s, before the war took its toll of people's energy and

resources. Ingenuity made up for lack of materials. Conservative and counterrevolutionary enemies were favorite targets, and a prize was given to the local organization that created the best design.

The Question of Style: Nicaraguan Eclecticism

The Nicaraguan mural seems casually eclectic in style. It does not recognize that there can or should be a single "revolutionary style." It relies on spontaneity and happenstance, being unwilling to privilege the quick, flat-patterned painting technique aiming for instant comprehension that developed in Chile. Like the eclecticism of mural movements in Europe and the United States, Nicaraguan eclecticism (or ecumenism) derives from a stylistic anarchy among so many individual contributions. To be sure, in Nicaragua there is little conscious effort at personal stylistic differentiation, as happens in capitalist countries and societies where artists work in a highly competitive market. The major stylistic restriction, which inhibits nonfigurative, abstract, socially neutral, or merely picturesque designs, is in reality one of content.

Primitivism The only widely practiced style that could, at the moment, claim a Nicaraguan national identity, is the primitivist, which has gained a firm foothold in the national and international markets. This style, or family of styles, upon which certain individuals have placed a spectacular personal stamp, producing "imagery of dazzling, jewel-like luminosity,"[118] lends itself to small-format easel painting, which is manageable by the untrained and self-taught artist and relatively easy to sell.

Its first application to the mural was monumental, spectacular, and symbolically collaborative (no. 7). This mural in the Luis Alfonso Velásquez Park by three major primitivist artists (which was destroyed, as noted above) stood for a decade as an example of how the painstaking, cumulative, piecemeal method of composition central to primitivist painting could be successfully magnified, and how sensuality, joie-de-vivre, and richness of color could be preserved on a large scale. Yet the idea has not caught on as much as might have been expected, although more or less primitivist murals are to be found everywhere, and there are signs of a revival in the 1990s (e.g., no. 74), with a shift from militant to folkloric subject matter. It remains true, however, that relatively few of the many good primitivist painters have seen murals as a real outlet, if only because, unlike easel work, they cannot be sold.

The small primitivist wall paintings surviving in San Carlos take their style from nearby Solentiname, the island where Ernesto Cardenal founded an arts community in the sixties (poetry, painting, crafts) that became the fountainhead of the primitivist style. The courage of the poets and painters of the Solentiname area was manifested in their daring assault on the Somoza army barracks at San Carlos in October 1977, which was represented by painters who participated in the action (no. 250).[119] The area was then thoroughly bombed by Somoza.

Prize-winning carnival float, 17 July 1981. The *Prensa* newspaper, popularly known as the "Prencia," with its allegiance to the United States (VOA = Voice of America), was a favorite target at this time; on several occasions the government closed it down.

The name and aura of Solentiname have been spread by books of reproductions published in the United States and Germany, some in conjunction with the poetry that also originated there. Such publications and the work of German solidarity groups who helped build community centers on the island are motivated by a conviction that the idyllic vision of Solentiname is born of, and is a service to, the revolution.

It is perhaps symbolic and certainly regrettable that a large Nicaraguan primitivist mural envisioning the insurrection by a lakeside, once on a soap-factory wall in Granada, should have been painted over with a more modern(ist) design by a U.S. brigade (nos. 173, 174). The visiting Chilean Orlando Letelier Brigade, by incorporating a pre-existing primitivist design (no. 223), showed more respect: both for the style and for the factory workers who had used it. The primitivist style lends itself to historical narration, as we see in the Solentiname example (no. 258), as well as to the political adaptation of traditional religious stories: a Sandinizing of the Passion, for instance, shows Somoza and his National Guard as Pilate and Christ's torturers ("Que muera Cristo, es comunista!"). This and other compositions have been disseminated on an international scale.[120] The primitivist easel paintings are typically more utopian than politicized, although their popularity among city dwellers must certainly have to do with the alternative (if not the opposition) they present to consumerist, commercial, urban, and imported values, now again resurgent. The primitivist vision tends to the Edenic and tranquil, favoring color-saturated jungle landscapes that usually dominate the little human figures, similar to the beginnings of European landscape

Crucifixion, with Che Guevara as a naked Christ, National Guardsmen as Roman soldiers, and Nicaraguans in the role of the Holy Women. Part of a Via Crucis de Solentiname series published by Peter Hammer Verlag, from a painting by R. Arellano.

painting in the sixteenth and seventeenth centuries. The heavenly paradise of Adam and Eve in Northern Renaissance painting was seen as a mixture of ideal and real (German or Netherlandish) landscape, a joyful discovery of the visually tangible, and a quest for the return of innocence. Likewise, but more so, the paradise of the Nicaraguan primitivists is both nostalgia and hope, "each leaf [etc.] . . . painted with the joy of one who for the first time in life and in the world is exercising national sovereignty, baptizing, naming things, and possessing them in the very act of naming them. . . . To make an inventory of paradise today is to enjoy revolution, creation."[121] The depiction of nature in the murals, even when not primitivist in character or intensity, shares this feeling.

There can be no doubt about the political significance of certain landscape features common to primitivist painting and murals. Volcanoes in Latin American poetry generally stand for social eruption (in no. 24, a volcano literally spouts the paving stones of insurrection); they serve as a national emblem on bank notes and official badges. Mountains, as in Omar Cabezas's *Fire from the Mountain*, represent proletarianization and existential challenge, at once consuming and protective. And the ever-present dawn, as in the famous phrase applied by Tomás Borge to Carlos Fonseca, "was no longer merely a tempting dream" (dejó de ser una tentación; see text at note 75). This dawn illuminates a new Nicaragua, ushers in a new day, a new era of social justice.

"I Swear before the Fatherland and History that My Sword Shall Defend National Dignity and Shall Be the Redemption of the Oppressed" [signed] A. C. Sandino. "Nicaragua Is Now Free, Our Liberation Is War to the Death against Undernourishment and Sickness." Health Ministry poster, circa 1981.

The international success of the primitivist style and its status abroad as the image of Nicaragua may be measured, apart from the incalculable trade in originals, by its predominance in greeting-card and poster-sized reproductions.[122] Insofar as it plays on the same tourist aesthetic as comparable primitivist paintings from Haiti (where we find a cottage industry perpetuating a vision of that long-suffering country, which may be even poorer than Nicaragua, as happily backward and innocent of aspiration for change), Nicaraguan primitivism is certainly at odds with the mural movement. In neighboring El Salvador, the primitivist painting style is actually taught as an option at the academy; but neither it nor associated crafts demonstrably depict the revolutionary struggle in that country. The Chilean *arpilleras* (small, crudely stitched but brightly colored patchwork on burlap), by contrast, which are also primitivist in their very different medium, were firmly locked into protest against the Pinochet dictatorship.

What concerns us here is the question of a *style* with national status that validates a range of primitive, naive and pseudo-naive, unsophisticated, unschooled modes, and allows them to develop unashamedly in the murals, as well as in Nicaraguan easel painting. The quiet dignity of the essentially modest and self-effacing primitivist painting is, moreover, a healthy corrective of tendencies toward rhetorical excess in many of the murals.

Among the different primitivisms in the murals, one may distinguish between the "true primitiv-

ism" of Manuel García, who makes a virtue of clumsiness, and the "sophisticated primitivism" of Canales, whose massive rhythms have a Giottesque presence, or Leoncio Sáenz, with his crisp, perfectly controlled contours derived from a modernist stylization of pre-Columbian designs.

Western taste for the primitive, whose history goes back to ancient times, has always drawn on a biological attraction to youth over maturity, to promise over achievement, to the naive and innocent over the "corruption" of the pragmatic. Can we accordingly say that primitivist styles are appropriate to a Nicaragua that had a youthful naive vision—naive because the chances of making a socialist revolution in the teeth of U.S. hostility and a world dominated by capitalism were, from the onset, slim? The Nicaraguan revolution was without a doubt biologically youthful (fought by adolescents, managed by men in their twenties and thirties) and full of promise, if not achievement, of a better life. A parallel case is that of Chile: the naive, deliberately childlike effect of the best Allende government posters and the child's-cutout-book effect of the Ramona Parra Brigade murals correspond to the self-image of the Chilean of an adolescent at last growing out of juvenile colonial dependence.[123] Cuban art, too, though not at all "primitive" like that of Nicaragua and Chile, has a youthful exuberance. The older (former) socialist countries like the Soviet Union are (in their official art at any rate) left with a monopoly of the mature and senescent.

Modernist Eclecticism: Mexican and pre-Columbian Models The modernist tradition in painting entered Nicaragua soon after World War II, primarily through the efforts of Rodrigo Peñalba, after whom a brigade composed of Mural School artists was named. A group of painters who shared aesthetic (modernist) and political (anti-Somoza) values came together in 1963 under the name Praxis. From among the original and post-Praxis groups, an arresting and commercially successful tendency emerged, combining abstract form and impastoed surface. Rough textures and dark colors have been interpreted as evocative of the rough and tragic aspect of Nicaraguan history.[124] These formal characteristics have not perceptibly affected the murals. Those who painted murals before the revolution (except for Leoncio Sáenz) have not practiced the medium since, and the surge of mural painting has not tempted the easel painters.[125] Individuals who have done both murals and easel paintings tend to maintain distinct styles, abstract for easel, more figurative for the murals. (There are also painters who practice both primitivist and more abstract styles.) This separation helps to explain why mural styles in Nicaragua derive from specifically international mural traditions rather than from the modernism of Nicaraguan easel painting.

As there are varying degrees of knowing artlessness and practiced naivete among mural painters, Nicaraguan and internationalist, so there are varying degrees of receptivity to the twentieth-century heritage of mural and vanguard art styles. Siqueiros, arguably the most vanguardist of the Mexican muralists, is the powerful agent behind the more dynamic and "plastic-integrative" work of the Mural School (Michilini, Matus), as well as the anatomical distortions, exaggerated foreshortenings, and rhetorical stridency of the Panamanian brigade, among others. (Rivera shows up also in the encyclopedia of natural forms covering the apsidal ceiling of Santa María de los

Angeles, no. 107). Siqueiros, via the Mural School, taught Daniel Pulido and the Colectivo Boanerges Cerrato how to enliven a planar composition with optical tricks and to invite spectator participation. Artists at the CEMOAR have undertaken the challenging task of linking and integrating, in the spirit of Siqueiros, a complex of small, uninviting walls lacking in organic relationship. Siqueiros's style, probably more than that of any other single painter, has been absorbed into the mural vernacular worldwide. But Mexico is present in Nicaragua, above all, in the belief that a revolution is visually manifested in murals rather than posters, a belief rejected by both Soviet and Cuban models.

The Mexican mural movement is of course much more than just Siqueiros, and more than the acknowledged era of the Tres Grandes (Rivera, Orozco, Siqueiros). Much has happened since. It is ironic, but fitting, that the Mexican Vlady—working in the National Palace opposite (opposing) his compatriot Belkin, who belongs to the politicized tradition of Rivera and Siqueiros—should declare himself both in support of the Nicaraguan revolution and (as he has always declared himself in Mexico) in opposition to political art. His weird *Heresies* on the wall of the National Palace are indeed a heresy—aesthetically. "I defend the right of the artists to be disrespectful of the Revolution."[126] But is he "disrespectful"? Irrelevant, rather; real disrespect could get you into trouble, as the frequently censored *Prensa* knew, and as certain Sandinista cultural workers, such as the playwright and theatrical director Alan Bolt, discovered (whose theatrical critique of FSLN agricultural policies brought dire threats of forcible silencing upon him).

The Mexican mural is experienced as problematic for Nicaraguan artists; it is too powerful, too obviously the model, and too Mexican (Mexico was seen as a country long sunk in counterrevolutionary economic dependence on the United States). In terms of industrial development and political temper, Mexico and Nicaragua are poles apart. It seems symbolic that the very first post-Triumph mural in Nicaragua (no. 83) should have been superimposed on one begun by a well-known Mexican artist, whose understanding of the Nicaraguan situation was deemed defective by his Nicaraguan colleagues, who painted over his work.

Nicaraguans are particularly critical of Belkin's mural in the National Palace as being too cold and mechanical. The highly sophisticated airbrush technique, the abstruse philosophical implications of the flayed anatomies place this apart from all other murals, a high-tech masterpiece in a low-tech aesthetic and economic environment. Even the unmechanical, creative translation of the Mexican mural style by the Mural School is suspected of embodying, willy-nilly, a potential dogma capable of mandating "styles, aesthetic idioms, and ready-made solutions" not suited to a "truly Nicaraguan" approach.[127] It is doubtful, however, that many Nicaraguan muralists are concerned with what might constitute a truly Nicaraguan approach, except in terms of content; indeed, the very concept is perceived as restrictive. The possibility that the sophisticated, authoritative example of the Mural School might set a standard caused anxiety, and in his current project at the CEMOAR Michilini has determined to allow the wide array of participants to work freely in national and international styles.

"Evangelical Insurrection." Poster
by Leoncio Sáenz, circa 1985.

Pre-Columbian art was an essential catalyst of the Mexican mural renaissance, especially in the work of Diego Rivera; for him it was like African art to Picasso, but it released him from rather than into cubism. Nicaragua, where the visual remains of pre-Columbian civilizations are slight, relative to the glories surviving in Mexico and Guatemala, and sculptural (petroglyphic; see no. 205) rather than painted, has incorporated into its murals ancient gods and pre-Columbian decorative motifs as an affirmation of ancient, independent *Nicaraguanidad* (nos. 92, 181, 224), that is, an identity reaching back beyond the Spanish conquest and surviving despite all efforts to exterminate it. But more important, perhaps, than these allusions is the vision of indigenous leaders actively challenging the invader, as an inspiration for contemporary resistance to imperialism (nos. 3, 93, 150; contrast no. 242).

In Nicaragua as in other parts of Latin America, the indigenous styles survive best in modern handicrafts, and it is no accident that the muralist most addicted to pre-Columbian stylizations, Leoncio Sáenz, has preferred folkloric to political themes in his murals, although he has also done many militant posters.[128]

His vision of a pre-Columbian civilization flourishing within the Spanish era has a panoramic scope reminiscent (with much simplification) of Rivera's *Marketplace of Tenochtitlán* in the National Palace of Mexico City. Sáenz's painting, one of very few public mural-sized works surviving from before the revolution,[129] idealizes the Nicaraguan Indian, the Spanish settler, and the kind of commercial transaction that in practice doomed the former and enriched the latter. The gross inequality of the exchange—cheap cloth for gold—is also masked in one of the very few

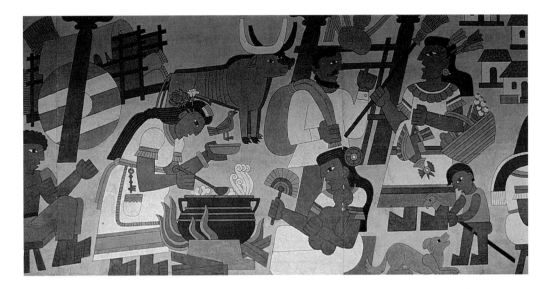

Colonial-period market, with barter between a native Nicaraguan woman, holding a chicken, and a bearded Spanish settler. Detail from a painting on panel of 1977 by Leoncio Sáenz, now in the Olof Palme Center, Managua.

official non-Sandinist murals of recent years (no. 242).

Sáenz's mural celebrating the Güegüense (no. 116; cf. nos. 146, 147) shows a form of popular theater regarded as Ur-Nicaraguan: a dance put on by Indians to amuse the Spaniards, but with words spoken in mockery of them and in local languages incomprehensible to them. The Güegüense, a favorite mural motif, uses masks stereotyping the masters' blond, blue-eyed, pretty-little-mouth-and-moustache look. The insurrectionaries used these masks to hide their faces in battle; in the murals (e.g., nos. 3, 103) they appear as a symbol at once of militant defiance and of an ancient, pre-Columbian cultural heritage.

The contours favored by the late Alejandro Canales, pre-Columbian in the transcendent spirit, if not the form, of their stylization, translate easily into the *tapices* (wall hangings made of colored rope or yarn) for which the town of Masaya is famous. Canales's ethereal airborne figures in the Luis Alfonso Velásquez Park mural (no. 8), which elevate to an ontological level the quotidian theme of mothers and children at play, are transpositions of ancient goddesses, obesity monumentalized, poeticized. But the concrete task of celebrating telecommunications (no. 10) or social services (no. 112) seems to have tied his hands. Canales died before he could settle into a satisfactory mural style, but a sense of the specialness, and "Nicaraguanity," of his contribution is attested by Daniel Pulido and the German Klaus Klinger, who, as I write, are painting a wall in Düsseldorf that will reconstitute part of the built-over Canales mural in that town. Klinger was one of the participants in the Hamburg-León mural (no. 205).

Is there a typically Nicaraguan mural style? That of Leonel Cerrato could be one. Its "Nic-

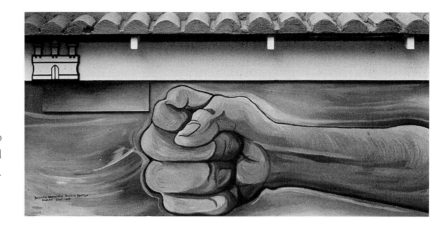

Signature of the Felicia Santizo
Brigade, Panama (detail
of no. 109).

araguanity" depends on a blend of simplified, rather awkward figure structure with quite sophisti-
cated compositional rhythms and soft, sensitive coloring. Cerrato also, alone among muralists,
attempts a rough textural effect, such as some easel painters cultivate, resulting from his mixing
the pigment in the wet cement, as in true fresco technique, which, despite the experiments of the
Mural School, has not otherwise been practiced, except by Vlady in the National Palace. Cerrato's
best mural is, alas, now painted over (the artist has repeated it, one-fifth the original size, in the
CEMOAR); but seen in a raking light, his revolutionaries return to haunt us (or their destroyer,
the mayor of Managua) as ghostly outlines.

By contrast with Cerrato's essential modesty of style, and the lyricism of Sáenz and Canales, the
Felicia Santizo Brigade of Panama erupts like a furious wind from the south. Beside it, much
revolutionary art of Nicaragua looks understated, sober, and tranquil. The Panamanian signature
is virtually a parody of the socialist-realist stereotypical raised fist: huge, swollen, spasmically
clenched, white-at-knuckle, attached to arms plunging through space—this is the traditional
symbol of the heroic and defiant still indispensable to political art worldwide, become super-
rhetorical, frenetic, and surreal (nos. 109, 110, 233). Bereft of space, background, and context, save
that of military and militant emergency, the bodies of the revolutionaries are like the fists tightly
clenched, braced against and bursting the frame, claustrophobically close and often savage in
expression. This is the insurrection of an angry part-Indian peasantry, as dark in complexion as in
demeanor, built into a barricade of human flesh and desperation, breaking occasionally to engage
in an exemplary merciless execution of a white U.S. marine or National Guard soldier, who gets
his throat cut (no. 76). Their struggle is allegorical, primeval, epic, mythic.

There is a crass, nightmarish energy to all this, and if the term "surreal" fits, it does so evoking
aspects of Latin American literature. "Surreal" in its original art-movement sense fits the manner
of Aurelio Ceccarelli, whose compositions have a dream (or nightmare) -like quality, with figures
rendered in a Dalíesque academic perfection of surface; painted, to adapt Dalí's own words, with
an "anti-imperialist fury of precision."[130] Fantasy and humor, other characteristics highly devel-

oped in the literature of the hemisphere, are generally missing from the murals; exceptionally, one finds them in the work of the North American Mike Alewitz for his special audience in the Children's Hospital mural (no. 60; cf. no. 165) and, in a simplified form, in the work of the Danish Syntese (nos. 24, 257). The alliance of fantasy and eroticism in a work had to await the belated arrival of the Cuban Aldo Soler (no. 38), while eroticism in its pure and classic form is limited to a single figure, Michilini's lovely Afro-Caribbean dancer from Nicaragua's Atlantic coast (no. 31).

Nicaraguan eclecticism is artistic, social, political, economic; it is that of a society "open, relaxed, self-confident."[131] This characterization, dating from 1985, may no longer be as true as it was, but the openness to different styles, and people, remains. The receptivity of Nicaragua has been remarkable; the country has welcomed from all over the world "people who paint" (rather than mere painters—Karl Marx's distinction), to make common cause with their own painting people, in the creation of a new culture and in defense of a revolution.

Notes

1. The epigraph to this introduction is quoted in Burns 1987, p. 16.
2. Apart from those works cited subsequently, I recommend Robert Dallek, *Ronald Reagan: The Politics of Symbolism* (Cambridge, Mass.: Harvard University Press, 1984).
3. Abridged from Sklar 1988, pp. 1–2.
4. Sklar 1988, p. 5.
5. See Peter Davis, "Where Is Nicaragua?" *Nation*, 28 January 1984, p. 78. The "rough inventory" is from Ríus [Eduardo del Río], *Nicaragua for Beginners* (New York: Writers and Readers, 1984), pp. 92–95.
6. Chomsky 1988, p. 40.
7. Burns 1987, p. 28.
8. Sklar 1988, p. 393. Kent Norsworthy, *Nicaragua: A Country Guide* (Albuquerque: Inter-Hemispheric Resource Center, 1989), pp. 59f. has similar figures.
9. Readers with strong stomachs may turn to Noam Chomsky, *Turning the Tide: U.S. Intervention in Central America and the Struggle for Peace* (Boston: South End, 1985), pp. 10–11.
10. The phrase, used by the former CIA director Stansfield Turner in testimony before Congress in April 1985, figures normatively with respect to the United States in the writings of Noam Chomsky; see Chomsky 1988, p. 27.
11. Chomsky 1988, p. 40.
12. See the government statement dated 10 December 1986, cited in Chomsky 1988, p. 101.
13. Burns 1987, p. 41. The accusations that follow in my text are laid out in Burns.
14. See the remarkable self-critical testimony of the Sandinista leader Tomás Borge in Borge 1981, pp. 88–110.
15. Chomsky 1988, p. 120.

16. Cardenal repeated the phrase in many places, among them an interview recorded by Kavery Dutta and Obie Benz in their documentary film *Americas in Transition* (1981). Cardenal used both "a" and "our."

17. Chomsky 1988, p. 52.

18. Chomsky 1988, pp. 186–87; Sklar 1988, p. 281; and Burns 1987, p. 40.

19. Francisco Goldman, "Sad Tales of *La Libertad de Prensa*: Reading the Newspapers of Central America," in *Harper's*, August 1988, p. 61.

20. See Kunzle 1984.

21. See Fred Landis, "CIA Media Operations in Chile, Jamaica, and Nicaragua," *Covert Information Action Bulletin*, no. 16 (March 1982): 32–43.

22. See Kunzle 1984.

23. See the new periodical *Lies of Our Times*.

24. In the manner, let us say, of Howard Friel, "Covert Propaganda in *Time* and *Newsweek*," *Covert Action Information Bulletin*, no. 21 (Spring 1984): 14–23; or Robin Andersen, "Images of War: Photojournalism, Ideology, and Central America," *Latin American Perspectives* 16, no. 2 (Spring 1989): 96–114.

25. The photograph, uncropped, clearly shows that the billboard is a portrait of the Sandinista hero Rigoberto López Pérez (Black 1988, p. 146).

26. Richard L. Harris and Carlos M. Vilas, eds., *Nicaragua: A Revolution under Siege* (London: Zed, 1985), p. 185. The photograph was originally run in *Newsweek*, 2 October 1978, correctly identified (Black 1988, pp. 147–48).

27. Black 1988, p. 145.

28. "The New Exorcist," *Barricada Internacional*, 8 September 1990, p. 21, and September 1991, p. 34; Alexander Cockburn, "The P.C. Crusade in Nicaragua," *Nation*, 10 June 1991, p. 762.

29. Germán J. Romero V., *Historia de Nicaragua*, fourth-grade textbook (Managua: Ministerio de Educación, 1991).

30. Sandinista TV was of course taken over by the new government. But even under the Sandinistas radio was foreign dominated and counterrevolutionary, with a "veritable torrent of foreign radio signals penetrating its [i.e., Nicaragua's] borders. This ideological war of ideas against Nicaragua is as incessant and damaging to morale as the military raids by the CIA-supported counterrevolutionaries" (Howard Hedrick, "The Radio War against Nicaragua," in *Communicating in Popular Nicaragua*, ed. A. Mattelart [New York: International General, 1986], p. 70).

31. *Barricada Internacional*, 14 July 1990, p. 16.

32. For the mayor's responsibility, and the trashing and looting of his office in revenge, see Donna Vukelich, "Tomb-Trashing Ignites Nicaragua Powder Keg," *Guardian* (New York), 4 December 1991, p. 11.

33. *Barricada Internacional*, September 1991, p. 7.

34. *Barricada Internacional*, February 1993, p. 19.

35. Gabriela Selser, "Culture of Hate," *Barricada Internacional*, 17 November 1991, pp. 7–8.

36. *Barricada*, 27 October 1990.

37. Interviews with various artists; and Julie Aguirre, "Vuelve al ataque a artistas," *El Nuevo Diario*, 4 January 1991.

38. *La Prensa Centroamericana* (Miami), 19 June 1992, p. 8.

39. *La Prensa*, 2 and 3 November 1990.

40. Newsletter, dated November 1990, published by South North Communication Network on behalf of *Barricada Internacional*.

41. *El Semanario*, 30 May to 5 June 1991.

42. Julio César Armas, "Arnoldo Alemán defiende . . . ," *La Prensa*, 2 November 1990.

43. *La Prensa*, 7 November 1990.

44. "Por qué Alemán hace lo que quiere," *El Nuevo Diario*, 1 November 1990; see also "Condena unánime a Alcalde Alemán," ibid., 27 October.

45. Sofía Montenegro, "Desagravio a un pintor ausente," *Gente* (supplement to *Barricada*), 2 November 1990.

46. *Barricada*, 27 October 1990.

47. Montenegro, "Desagravio."

48. Raúl Quintanilla, "La unidad del sector cultural," *Barricada*, 11 November 1990; he had counted twenty-six articles, all by Sandinistas, denouncing the destruction.

49. *Pintura y Escultura en Nicaragua*, Boletín Nicaragüense de Bibliografía y Documentación, no. 20 (Managua: Biblioteca Banco Central de Nicaragua, 1977).

50. Montenegro, "Desagravio."

51. "Razones de peso para juzgar a culturicida," *El Nuevo Diario*, 9 November 1990. "Macondian" refers to Macondo, a place imagined by Gabriel García Marquéz in *One Hundred Years of Solitude*.

52. *Barricada*, 17 July 1991, p. 2.

53. *Barricada Internacional*, June 1991, p. 31.

54. *Barricada*, 18 August 1991; and Remo Mazzacurati, "Los alcaldes bárbaros de Nicaragua," *El Nuevo Diario*, 29 August 1991.

55. A list, by no means complete, is given by Daniel Pulido, "Abril/90–Marzo/92: Guerra particular contra la memoria colectiva," *El Andamio* 5, no. 6 (January–July 1992): 5–7.

 Besides Alemán, others share responsibility for the destruction: Noel Palacios, Denis Silva, and William Somarriba, respectively director, subdirector, and team head (*jefe de cuadrilla*) of the Empresa de Mantenimiento y Ornato Municipal (Municipal Maintenance and Improvement Service).

56. "UNO castiga a los muertos," *El Nuevo Diario*, 12 September 1991.

57. A typical U.S. treatment was that of the *Los Angeles Times* (11 June 1991, p. H-6). A feature article (appearing many months after the event, which is presented as recent), entitled "Art in Nicaragua:

The Paintbrush Battles," dealt with the vandalism in an offhand, ambiguous, and factually inaccurate manner. Confusing the Canales and Canifrú murals throughout the text and captions (a detail from the Canifrú, showing Death wrapped in a U.S. flag, is reproduced in color with an attribution to Canales) and showing no knowledge of the extent of the destruction (only one, not four, major mural victims is discussed), the writer effectively condones the governmental vandalism as part of a battle between two rival political factions with opposing and equally legitimate tactics and views on art: art that is "free" as against art that is politically committed, which a "free" government, like that of the UNO, opposed to all government support for art, should feel free to destroy. The fantasy the writer invents (or believes) for what happened conjures up a childish tit-for-tat graffito wargame: "Working mostly at night, one anonymous group of 'artists' covers Canales's bright colors with whitewash. Then, in the morning followers of the late Sandinista artist gather and try to restore the mural and its political symbolism." When I pointed out the bias of the article directly to the writer, who is actually quite sympathetic to the Sandinistas, he responded, "Well, that's the only way I could get the thing printed."

Worse yet, an article published nearer to the event (Christine Toomey, "Sandinistas Sing a Capitalist Song," *Sunday Times* [London], 2 December 1990) implies that the Sandinistas themselves, in their headlong rush to renounce their former ideology and to embrace capitalism, *themselves* painted over the murals.

58. *Barricada*, 6 January 1993.

59. *El Nuevo Diario*, 7 January 1993.

60. "Se repitió la barbarie," *Barricada*, 6 January 1993

61. "Brigada contra el muralicidio," *El Nuevo Diario*, 17 February 1993; and *Barricada*, 22 February 1993, p. 1b.

62. "MED y Alcaldía niegan . . . ," *El Nuevo Diario*, 6 January 1993.

63. Interview with Virgilio Ortega, July 1991. In a letter from the artist to Sergio Michilini dated 26 July 1991, he laments "the death of the majority of the murals I fathered here in Panama. Some died a natural death, but most were murdered before and after the invasion."

64. From a statement written for me by Virgilio Ortega.

65. Borge 1986, p. 162.

66. For a recent example, see *Community Murals* (San Francisco, Spring 1987): 14. The most infamous example is of course Nelson Rockefeller's destruction of a huge Diego Rivera 1933 mural *Man at the Crossroads* in Rockefeller Center, New York, because it contained a small portrait of Lenin (see Antonio Rodríguez, *A History of Mexican Mural Painting* [New York: Putnam's, 1969], p. 270). An example from Mexico: Arnold Belkin's *It Rests with Our Generation to Decide,* for the Centro Pedagógico Infantil, Mexico City, was destroyed within months of its completion, by government order and for ideological reasons (see Shifra Goldman, *Contemporary Mexican Painting in a Time of Change* [Austin: University of Texas Press, 1981], pp. 86–87).

67. Margaret Randall, "Nicaragua's Culture Grays," *Guardian Weekly* (New York), Winter 1991, p. S-5.

68. For a brief taste, try Borge 1981, pp. 84–87.

69. A large portrait of her was one of the designs rejected from the cycle in the Church of Santa María de los Angeles. Arlen Siú may be represented on a placard in a mural (no. 148). She appears, belatedly, in no. 75.

70. *Envío* 12, no. 145 (August 1993): 25.

71. Eduardo Galeano, *Open Veins of Latin America* (New York: Monthly Review, 1973), p. 114.

72. Quoted in Craven 1989, p. 298.

73. Craven 1989, p. 298.

74. Craven 1990, p. 112.

75. "Carlos, el amanecer ya no es una tentación" is the title of the eulogy to Fonseca that Borge wrote in 1979.

76. The epigraph to this section is quoted in Ashton 1988, p. 38b.

77. A few U.S. artists did work in Mexico, and (as is well known) the three great Mexicans painted murals in the United States.

78. See the funeral eulogy for him pronounced by President Ortega (Sklar 1988, p. 357; and *Barricada Internacional*, November 1991, p. 23). An unobtrusive little monument to Ben Linder in the children's Parque Carmen in Managua, consisting of an antique single bicycle wheel set in a round concrete base in the middle of a cycle track, has the following words obscurely scratched into it: "Ben, podrán matar todas las flores, peró nunca detendrán tu primavera: (Ben, they can kill all the flowers, but they will never stop your springtime). His tombstone is inscribed "The light he lit will shine forever."

79. According to Carlos Ugalde, attending the International Solidarity Encounter, Managua, July 1989.

80. On 10 July 1986 *Barricada* put the number of internationalists in Nicaragua at 500 and that for NGOs (nongovernmental organizations) at 50. The figure for individuals rises, depending on the source, to as high as 4,000 (surely an exaggeration). By 1984 an estimated total of 3,000 U.S. citizens had helped in the harvest, plus hundreds more from Europe (Ron Ridenour, *Yankee Sandinistas* [Willimantic, Conn.: Curbstone, 1986], pp. 33, 157; other figures are given in Jeff Jones, ed., *Brigadista: Harvest and War in Nicaragua* [New York: Praeger, 1986], p. xxvii). The 1,500 U.S. citizens cited by Sklar 1988 (p. 357) as currently helping in Nicaragua (1987–88) seems a reliable estimate. See also Melissa Everett, *Bearing Witness, Building Bridges: Interviews with North Americans Living and Working in Nicaragua* (Philadelphia: New Society, 1986).

According to a hostile source using figures apparently derived from President Ortega himself and Planning Minister Alejandro Martínez (Pranay Gupte, "Daniel Ortega's New Friends," *Forbes*, 22 August 1988, pp. 38–40), the Soviet bloc provided 47 percent of Nicaraguan imports in

1987, 40 percent in 1988. Countries cited as particularly prominent in aid to Nicaragua are Canada, Belgium, Spain, Italy, West Germany, Mexico, and Japan, with Sweden and Italy singled out as "high" on the list of development aid ($60 and $50 million respectively). The number of "foreign visitors" is put by Gupte at 100,000, at least 40 percent of whom came from the United States, including many "fellow travelling and gullible 'revolutionary tourists'—a.k.a. 'sandinistas.'"

81. This figure comes from Father Bill Callahan of Quest for Peace in Hyattsville, Md.

82. Chomsky 1988, p. 6.

83. Sklar 1988, pp. 352–55.

84. Ridenour, p. 158.

85. Cortázar discusses the museum in his *Nicaragua tan violentemente dulce* (Mexico City: Katún, 1984), pp. 74–76.

86. Interview with Auxiliadora d'Enveda of the museum staff, July 1990.

87. The circumstances, in which a very poorly reproduced intimate pose was coupled with a reference to female Sandinista militance, are detailed in Kunzle, forthcoming, in *Kunstgeschichte Richtung radikale Historizität* (Essays in honor of Karl Werckmeister, working title), ed. Joan Weinstein, where the content and history of the magazine are fully analyzed.

88. Both misfortunes were announced in the November 1990 issue of *Barricada Internacional*. This periodical was published weekly from 1981 to July 1987, bi-weekly through 1988, and then irregularly.

89. Róger's political cartoons were published in album form by the Association of U.S. International-ists residing in Nicaragua, and by *Barricada* under the title *Dos de Cal, Una de Arena, Muñequitos*. The preface to the third volume (Editorial El Amanecer, 1986) speaks of the cartoons as published in "fifteen languages."

90. Ridenour, p. 38.

91. Hugo Palma, "Los barbaros del siglo XX," *La Prensa*, 23 May 1990.

92. Cf. Kunzle 1989 for a description of the genesis, content, and patronage of the cycle and the critical reaction to it.

93. The signators were Rommel Beteta, Leonel Cerrato (coordinator), Nohelia Cerrato, Oman Díaz, Pablo Hernández, Cecilia Herrera, Daniel Hopewell, Camilo Minero, Soraya Moncada, Janet Pavone, Daniel Pulido, and Ignacio Zuñiga. The charter is reproduced in *El Andamio* [The Scaffold] 2, no. 4 (December 1989–February 1990): 7. This publication, starting in November 1987, hand produced in Nicaragua in the cheapest possible form, is dedicated entirely to the mural movement, in association with the occasional periodical of the same name, more professionally printed in Milan, Italy, in Italian, with the subtitle *Bollettino del Laboratorio Latino-Americano di Muralismo e Integrazione Plastica in Italia*.

94. "Presentazione," *Centro Espiritual Monseñor Oscar Arnulfo Romero, Proyecto de Integración Plas-tica del Conjunto Arquitectónico*, January 1987 (a 33-page duplicated typescript), pp. 4 and 32. See

also Linde Rivera, "Integrated Art, People's Art," *Barricada Internacional*, 3 December 1987, p. 24, translated from *Nuevo Amanecer Cultural*, 14 November 1987.

95. A manifesto pinned for many years on the Mural School bulletin board, adapting the Communist Manifesto of Karl Marx and substituting "plastic integration" for "communism," summoned international public art workers of the world to unite in the name of plastic integration (Kunzle 1989, p. 53).

96. David Stannard, "Genocide in the Americas," *Nation*, 19 October 1992, p. 430; and Hans Koning, "The Legacy of Columbus," *Crossroads*, October 1992, p. 2.

97. Kunzle 1978.

98. Francisco (now living in Los Angeles), José, and Juan Pablo Letelier; the Chilean exiles René Castro (now in San Francisco) and José Labarca; the Chicano Roque Hernández (now in Los Angeles) and the Turkish-American Beyhan Cagri. For their work on Casa Nicaragua in San Francisco to celebrate the Triumph in 1979, see Barnett 1984, p. 263.

99. Composed of Jaime Eduardo Castillo, William Hernández, José Nuñez, Rosa Oviedo, and Pablo Téllez.

100. *Hacía una Politica Cultural de la Revolución Popular Sandinista* (Managua: Ministerio de Cultura, 1982), pp. 306–20.

101. Tomás Borge, *El Axioma de la Esperanza* (Bilbao: Desclae de Brouwer, 1984), p. 97.

102. The work and extent of the sister-city network may be judged from the article and listing published in *Popol-Na* (Managua) 1, no. 2 (July–September 1992): 15–18, and no. 3 (October–December 1992): 17–20. The nineteen countries participating are headed, numerically (i.e., according to the number of projects without taking account of size or duration, but including both governmental and nongovernmental works), by the United States, with 127; followed by Spain, 87; Germany, 73; Italy, 33; France and England, 26; Sweden, 21; and Holland, 20.

 For an eloquent series of photographs contrasting two vastly different "sister" communities, Puerto Cabezas, Nicaragua, and Burlington, Vermont, see Dan Higgins, intro., *Sister Cities: Side by Side* (Burlington, Vt.: Green Valley Film and Art, 1988).

103. In 1992 no fewer than eighteen murals were done in Germany, twelve in the Netherlands, and several in Italy, all in commemoration of the invasion quincentenary and dealing critically with Euro–Latin American relations, by thirteen Nicaraguan muralists: Noel Calero (with Grupo Diriangén), Leonel Cerrato, Rafael Flores, Cecilia Herrera, Reinaldo Hernández, Olga Maradiaga, Federico Matus, Carlos Montenegro, Janet Pavone, Daniel Pulido, Claudia Rocha, Augusto Silva, Danelia Sandoval.

104. *Nuevo Amanecer Cultural*, 11 March 1989; *Barricada Internacional*, 25 March 1989, p. 24; and Craven 1990, p. 116.

105. "When we talk about revolutionary art, we are not talking about pamphlets, the clenched fist, or a raised gun. We are talking about art of quality . . . bad art is bad for the revolution" (Rosario

Murillo, quoted in Craven 1989, p. 7).

106. Ashton 1988, p. 38a. Aside from ignoring opportunities to celebrate the inauguration of murals, something the press did generally, articles in *Ventana* offer a perversely exclusive focus on the easel painting of some of the major muralists. For example, interviews with Leonel Cerrato (27 August 1988) and Manuel García (13 January 1990), whose inspiration by "Granach," "Pieter Grcueghel the Elder," and "Snuegel," affected, apparently, only his easel work, and the homage to Alejandro Canales in *Nuevo Amanecer Cultural* (17 March 1990) likewise ignored the master's mural achievement. The October 1990 destruction of murals did not even merit a mention in *Ventana* at the time.

107. *Nicaráuac* (14 issues, 1980–87), edited, to be sure, by writers but very well illustrated by leading Nicaraguan artists, had no article dedicated to the new murals, never reproduced them, and barely mentioned them even in passing.

108. Jorge Eduardo Arellano, *Historia de la Pintura Nicaragüense* (Managua, 1990). Arellano is a member of the National Council on Culture, and director of the National Library.

109. For example, Nancy Kapitanoff, "City's Rancho Park Area Enriched . . ." (with an Eva Cockcroft mural), *Los Angeles Times*, Calendar, 6 December, 1992, p. 92.

110. For instances of civic sponsorship that requires the exclusion of politics (mural painting as social "cooling out"), see Rolston 1991, pp. 63f.; and Barnett 1984, pp. 431–34; for problems arising from consultation with local residents, Rolston 1991, pp. 55f.

111. See Craven 1989, pp. 8–9, 44–45.

112. Burns 1987, p. 6.

113. "Hamburg-Leon, ein Interview," *IKA*, no. 41 (February 1991): 19.

114. The poet Daniel Ortega, quoted by Salman Rushdie, *The Jaguar Smile* (London: Pan Books, 1987), pp. 35–36. The axiom may originate with the poet José Coronel Urtecho.

115. *La Insurrección de las Paredes: Pintas y Graffiti de Nicaragua*, intro. Sergio Ramírez, texts Omar Cabezas and Dora María Téllez (Managua: Editorial Nueva Nicaragua, 1984), p. 21.

116. Spray-can art has become one of the most striking and perhaps the most international of popular art forms. See Henry Chalfant and James Prigoff, *Spraycan Art* (New York: Thames and Hudson, 1987).

117. The U.S. government donated 3,432 gallons of paint to paint pro-contra graffiti and then could not find anyone to do the work (Craven 1989, p. 232).

118. Betty Laduke, *Compañeras: Women, Art, and Social Change in Latin America* (San Francisco: City Lights, 1985), p. 17.

119. Julio Valle Castillo, "Los primitivistas de Nicaragua o el inventario del paraíso," *Nicaráuac* 13 (April 1986): 169.

120. See, for instance, Ernesto Cardenal, *Unser Land mit den Menschen, die wir lieben, Gedichte* (Wuppertal: Hammer, 1980), and *Heimweh nach der Zukunft* (Wuppertal: Hammer, 1981); see also Philip Scharper and Sally Scharper, eds., *The Gospel in Art by the Peasants of Solentiname*

(New York: Orbis, 1984). Two series of posters published by the Peter Hammer Verlag in Wuppertal, Germany, are in the primitivist style and include a Sandinized Passion. Of the twenty cards available from the Quixote Center/Quest for Peace in Hyattsville, Md., over half are primitivist, as are all the cards published by the Nicaraguan Solidarity Campaign in London.

121. Castillo, "Los primitivistas," p. 174.

122. See note 120.

123. See Kunzle 1978.

124. See Ashton 1988; Craven 1989; and John Weber, "Sandinista Arts: Report from Managua," *New Art Examiner*, October 1985, p. 44 (Spanish version in the Los Angeles newspaper *La Opinión*, 29 September 1985, pp. 4–6).

125. Among the fifteen painters in *Pintura Contemporánea de Nicaragua* (Managua: Editorial Nueva Nicaragua, Ediciones Monimbó Managua, n.d.), only two (Leoncio Sáenz and Manuel García) have also done murals; the proportion is about the same in the exhibition catalogue *Nicaraguan Contemporary Art* (Frostburg, Md.: Frostburg State University, 1991).

126. *Ventana*, 27 June 1987.

127. Luis Morales Alonso, "Reflections on Muralism," *Ventana*, 23 November 1985, as translated in *Community Murals* (Summer 1986): 10.

128. See Julio Valle Castillo, "Leoncio Sáenz o nuestro tlahcuilo [i.e., painter of codices]," *Nicaráuac* 3 (December 1980): 31–52, 177–79.

129. This extensive series of panels done in 1978, originally for a supermarket in Managua, is now beautifully displayed in the Olof Palme Center of that city.

130. Dalí's aim was for his art "to materialize the images of concrete irrationality with the most imperialist fury of precision," as quoted in Simon Wilson, *Salvador Dali* (London: Tate Gallery, 1980), p. 20.

131. John Weber, *Community Murals* (Spring 1985): 12.

Catalogue

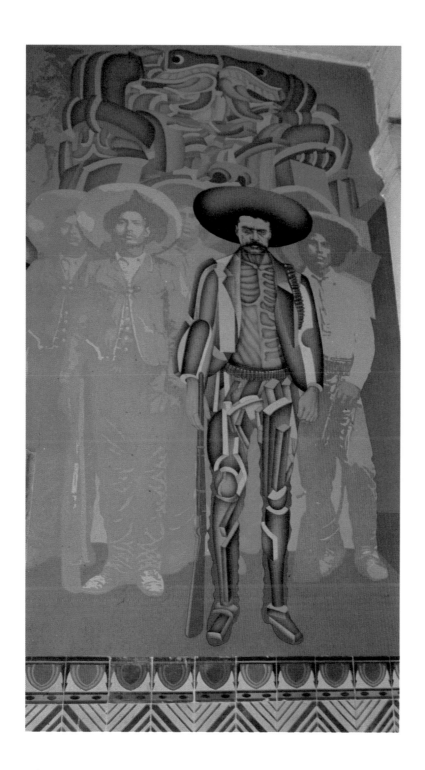

1A

Arnold Belkin, *The Prometheans:*
Zapata, generals, and (*above*)
Coatlicue. Managua, National
Palace.

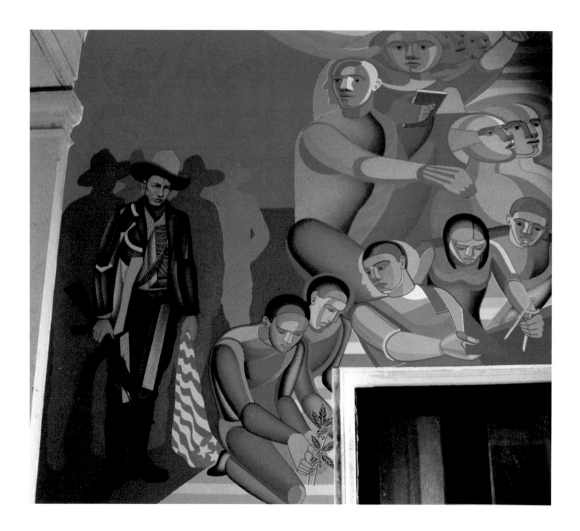

1B

(*Above*) Arnold Belkin,
The Prometheans: Sandino and
the New Men in Nicaragua.
Managua, National Palace.

3A

(*Opposite, top of page*) Victor
Canifrú, *The Supreme Dream of
Bolívar:* the first inhabitants.
Managua, Avenida Bolívar.

3B

(*Opposite, midpage*) Victor
Canifrú, *The Supreme Dream of
Bolívar:* resistance to Invasion.
Managua, Avenida Bolívar.

3C

(*Opposite*) Victor Canifrú, *The
Supreme Dream of Bolívar:*
imposition of Christianity
and bloodshed. Managua,
Avenida Bolívar.

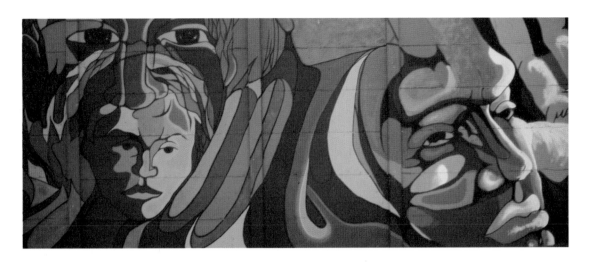

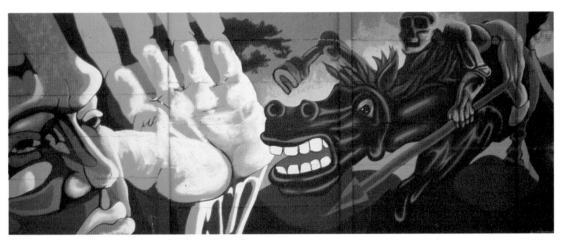

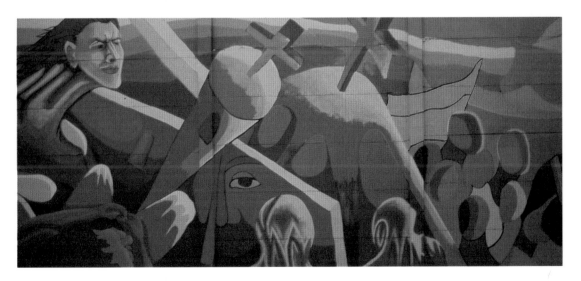

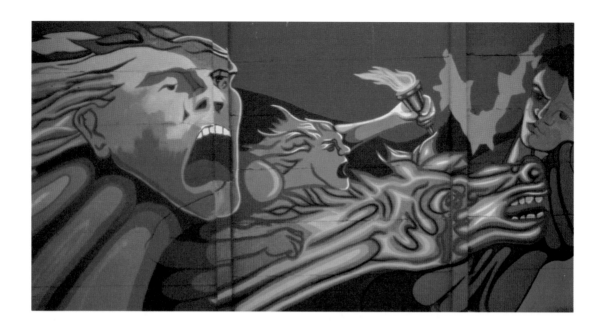

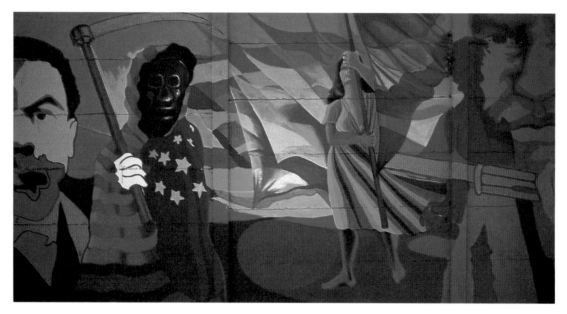

3D

(*Top*) Victor Canifrú, *The Supreme Dream of Bolívar*: cry and Horse of Liberation. Managua, Avenida Bolívar.

3E

(*Above*) Victor Canifrú, *The Supreme Dream of Bolívar*: Rubén Darío; United States as Death; flags of Independence; face of Sandino imagined old. Managua, Avenida Bolívar.

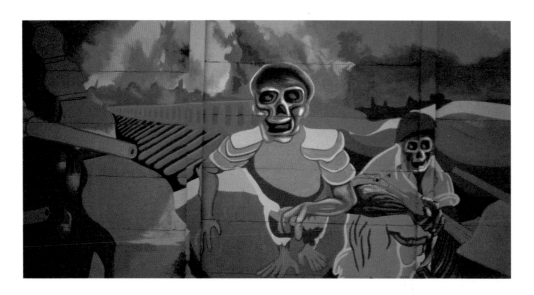

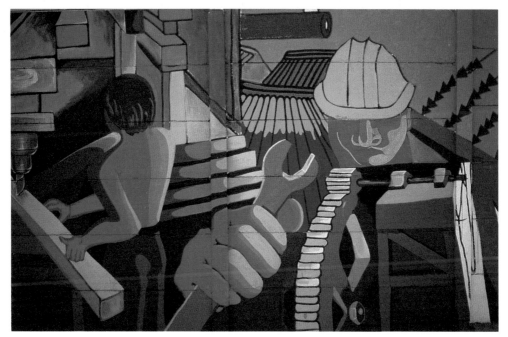

3F

(*Top*) Victor Canifrú, *The Supreme Dream of Bolívar*: Somoza's National Guard fights the insurrection. Managua, Avenida Bolívar.

3G

(*Above*) Victor Canifrú, *The Supreme Dream of Bolívar*: building the New Nicaragua after the Revolution. Managua, Avenida Bolívar.

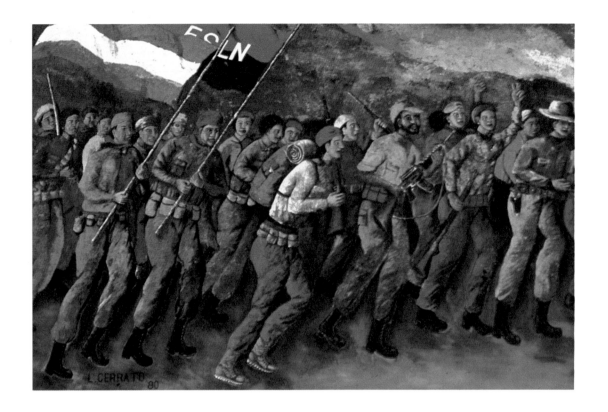

6A–C

Leonel Cerrato, The meeting of
the revolutionaries with their
families after the Triumph.
Managua, Luis Alfonso
Velásquez Park.

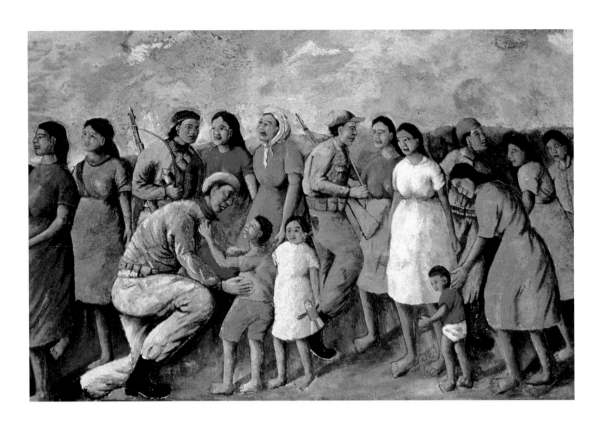

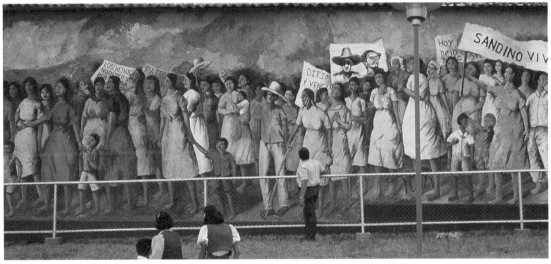

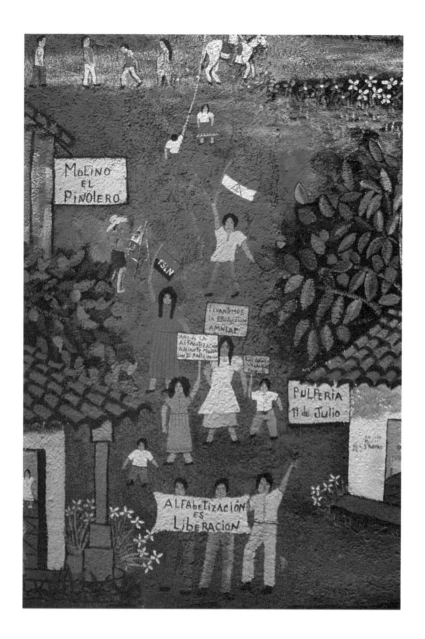

7A

(*Above*) Julie Aguirre, Village life. Managua, Luis Alfonso Velásquez Park.

7B

(*Opposite, top of page*) Hilda Vogl, Village life: peasant hut (portrait of Sandino on wall) and baseball game. Managua, Luis Alfonso Velásquez Park.

7C

(*Opposite*) Hilda Vogl, Village life: playing baseball, playing with bull. Managua, Luis Alfonso Velásquez Park.

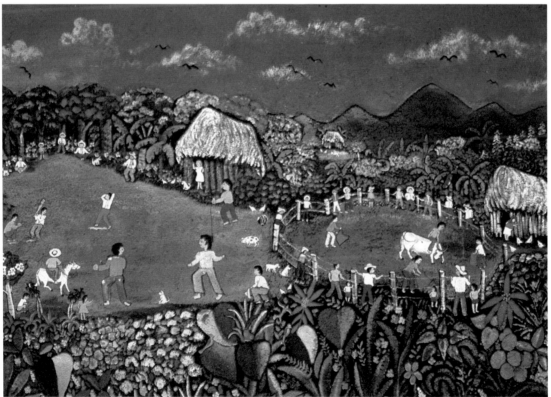

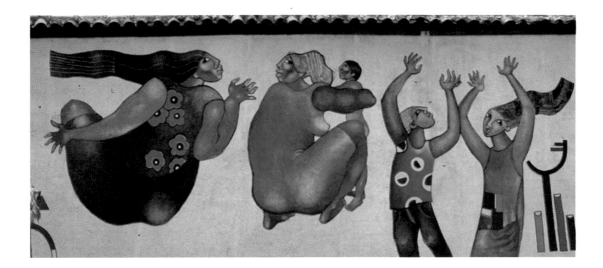

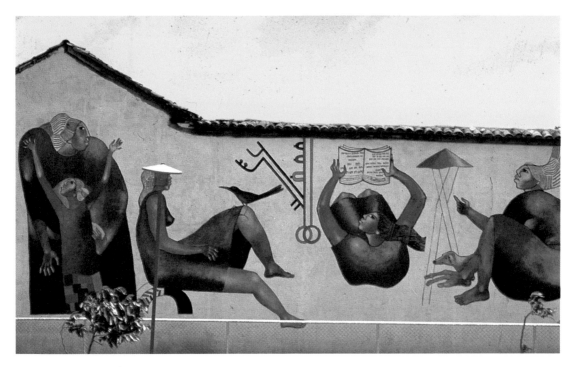

8A

(*Top*) Alejandro Canales, *Homage to Woman*: women conversing, children playing. Managua, Luis Alfonso Velásquez Park.

8B

(*Above*) Alejandro Canales, *Homage to Woman*: women at rest, one learning to read. Managua, Luis Alfonso Velásquez Park.

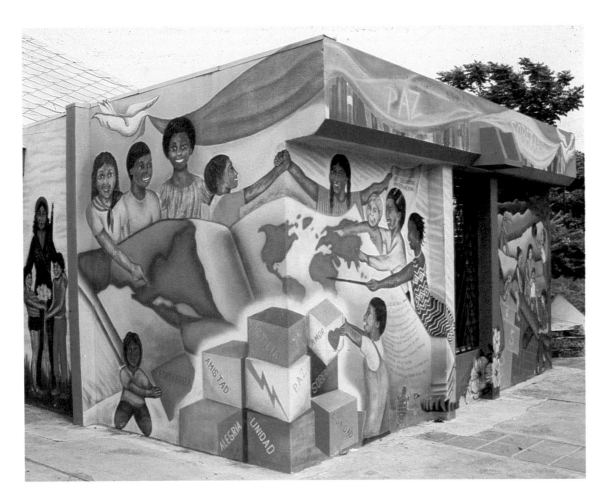

9A

(*Above*) Miranda Bergman,
Marilyn Lindstrom, and assistants,
(*far left*) Woman with gun
embracing children with flower;
(*center*) learning about and
building a new world based on
hope, friendship, etc.; (*far right*)
children on a seesaw. Managua,
Luis Alfonso Velásquez Park,
Children's Library.

9B

(*Left*) Detail of 9A: child
and biography of Luis
Alfonso Velásquez.

12A

(*Above*) Orlando Letelier
Brigade, The new culture.
Managua, Ministry of
Construction.

18A

(*Opposite*) Boanerges Cerrato
Collective, The birth of the New
Man. Managua, Batahola
Community Center.

18B

(*Opposite*) Detail of 18A: among
the peasant Magi bringing gifts are
Carlos Fonseca and Che Guevara
(*above*), Sandino and Archbishop
Romero (*below*).

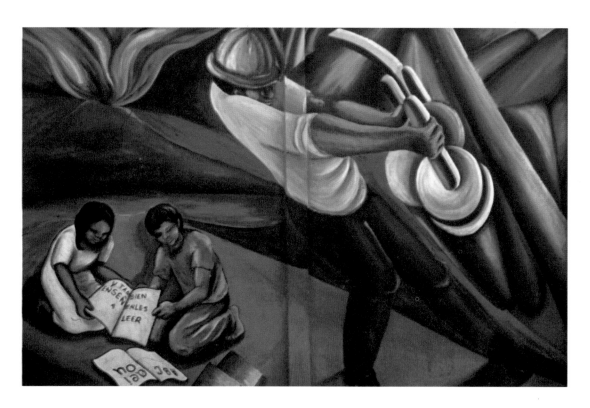

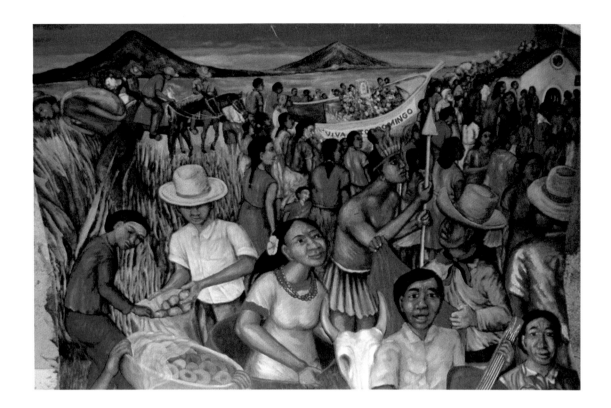

20A

(*Opposite, top of page*) Boanerges
Cerrato Collective, "And teach
them also to read"; volcano;
industry. Managua, Batahola
Community Center.

29A

(*Above*) Leonel Cerrato, *The
Festival of Santo Domingo.* The
Monseñor Oscar Arnulfo Romero
Spiritual Center, near Managua.

23

(*Opposite*) Aldo Soler, *Milflores.*
Managua, Verde Sonrisa
Children's Center.

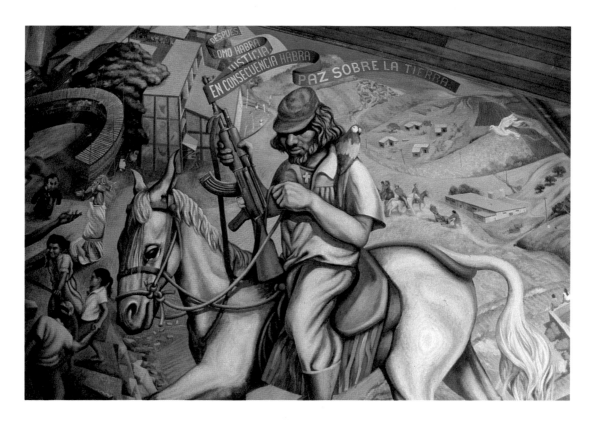

31A

(*Above*) Sergio Michilini, *Good Government*: detail of the Christian peasant/knight. The Monseñor Oscar Arnulfo Romero Spiritual Center, near Managua.

31B

(*Right*) Sergio Michilini, *Good Government*: detail of the dancer and children playing. The Monseñor Oscar Arnulfo Romero Spiritual Center, near Managua.

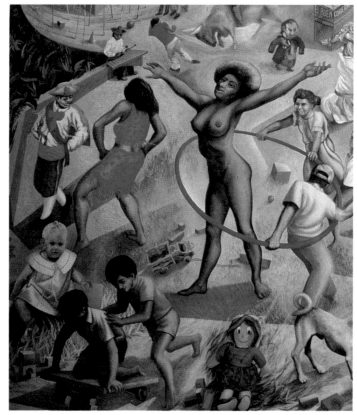

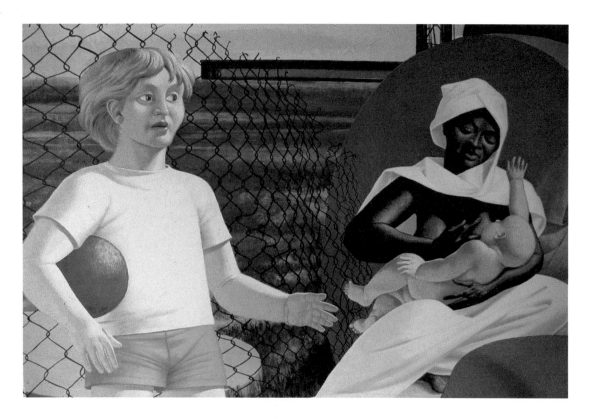

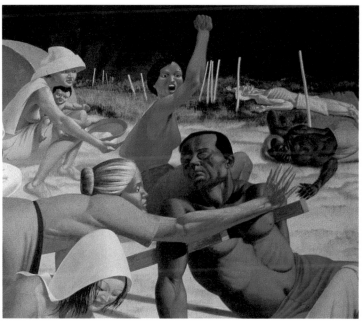

32A

(*Above*) Aurelio Ceccarelli, *Bad Government*: detail of white boy and woman suckling infant. The Monseñor Oscar Arnulfo Romero Spiritual Center, near Managua.

32B

(*Left*) Aurelio Ceccarelli, *Bad Government*: detail of the victims, suffering and protest. The Monseñor Oscar Arnulfo Romero Spiritual Center, near Managua.

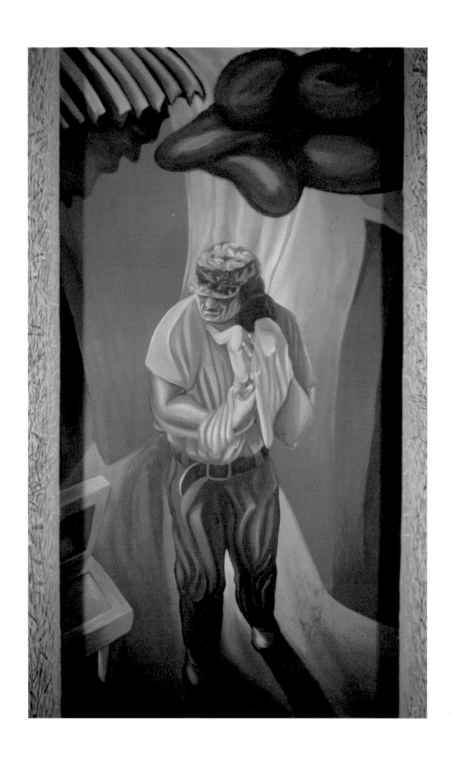

35

Daniel Pulido, *Birth of the
New Man*. The Monseñor
Oscar Arnulfo Romero
Spiritual Center, near
Managua.

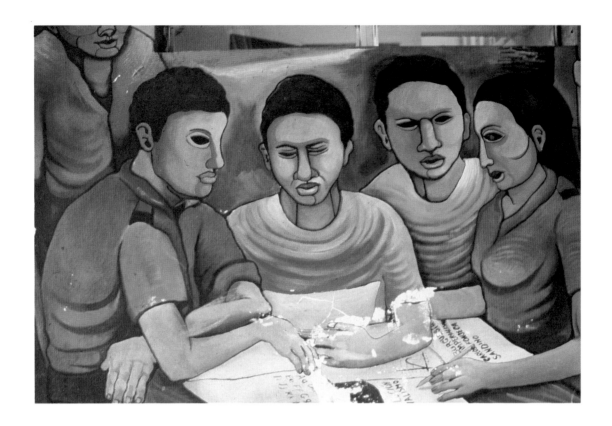

53A

Felicia Santizo Brigade of
Panama, Police teaching peasants
to read. Managua, Police School.

60A

(*Top*) Mike Alewitz, Elephant with tusks colored in black, green, and gold of African National Congress; tree held by fingers of Earth. Managua, Children's Hospital.

60B

(*Above*) Detail: fishes with books by Marx and Malcolm X.

60C

(*Top*) Detail: Lenin fishing,
with birds.

60D

(*Above*) Detail: rhinoceros and
bird; hand of Earth.

61A

(*Above*) Guerrero (Mexico),
Natives resist the Conquest.
Managua, Tecnisa
Garment Factory.

61B

(*Opposite, top of page*) Guerrero
(Mexico), Sandino resists the
United States. Managua, Tecnisa
Garment Factory.

66A

(*Opposite*) Ricardo Morales and
Martín Espinoza, The challenge,
with figures of social degeneration.
Managua, Mercado Oriental,
Alcoholics Anonymous Center.

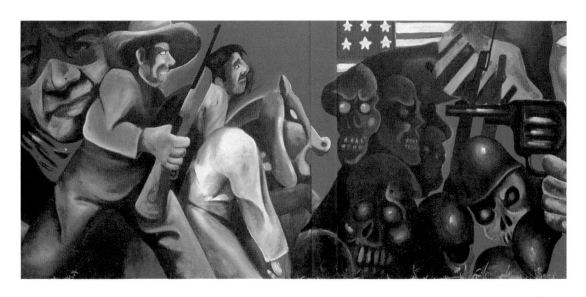

68A

(*Above*) History of Nicaragua, detail: enslavement and killing of the Indians. Present location unknown.

68B

(*Opposite, top of page*) History of Nicaragua, detail: "Democracy"; Rigoberto López Pérez assassinates Anastasio Somoza I. Present location unknown.

68C

(*Opposite*) History of Nicaragua, detail: the Somoza reign of terror; insurrection of the FSLN; portrait of Carlos Fonseca with political manual. Present location unknown.

69

(*Above*) Mexican artist, Nicaraguan artisans at work. Managua, Roberto Huembes market.

76A

(*Opposite, top left*) Felicia Santizo Brigade of Panama, Insurrection. Managua, Nicaráo Community Center.

76B

(*Opposite, top right*) Felicia Santizo Brigade of Panama, Insurrection. Managua, Nicaráo Community Center.

80

(*Opposite*) Juana Alicia, Miranda Bergman, and assistants, *Dawn*, with the tree of knowledge, life, and hope; demonstration; agriculture; and music. Managua, Parque de las Madres, Teachers' Union and Móngalo School building.

MOVIMIENTO CON LA REVOLUCIÓN

81A

(*Above*) Southern California Chicano brigade, *Chicano Solidarity with Nicaragua*: common ancestors, Chicana women, Nicaraguan girl. Managua, Parque de las Madres.

82A

(*Opposite, top of page*) Camilo Minero, Salvadoran Solidarity with Nicaragua: Salvadoran people, with ancestral types. Managua, Parque de las Madres.

83A

(*Opposite*) Róger Pérez de la Rocha and others, Sandino, with Nicaraguans. Managua, "El Chipote" military base.

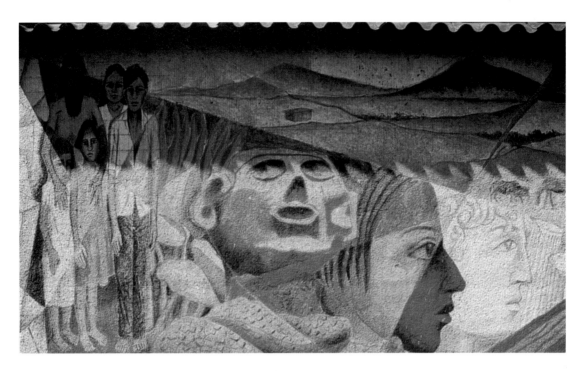

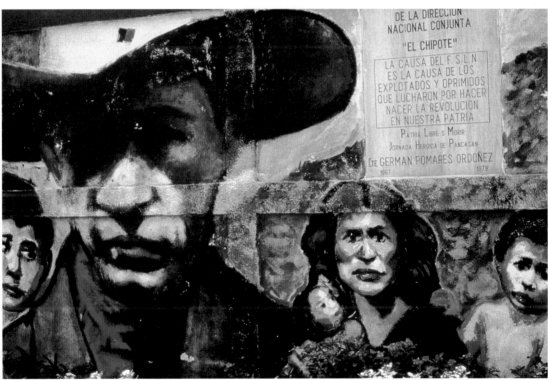

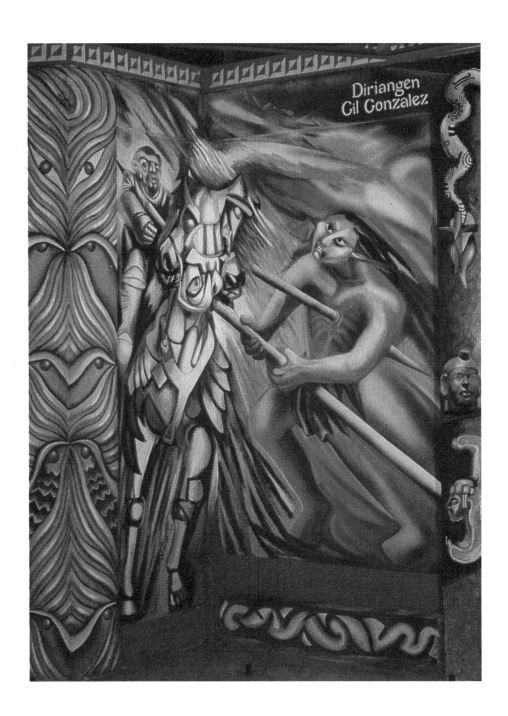

93A

Sergio Michilini and Mural
School (ENAPUM-DAS),
Indigenous leader Diriangén
fights conquistador Gil González,
who resembles Anastasio
Somoza II. Managua, Church of
Santa María de los Angeles.

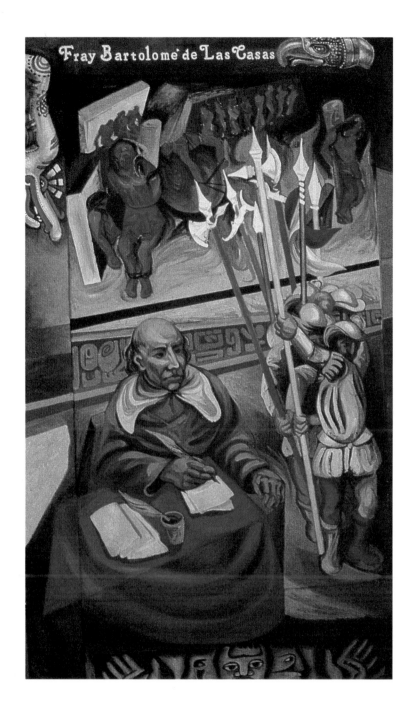

94A

Sergio Michilini and Mural
School (ENAPUM-DAS),
Bartholomé de las Casas, defender
of the indigenous. Managua,
Church of Santa María de
los Angeles.

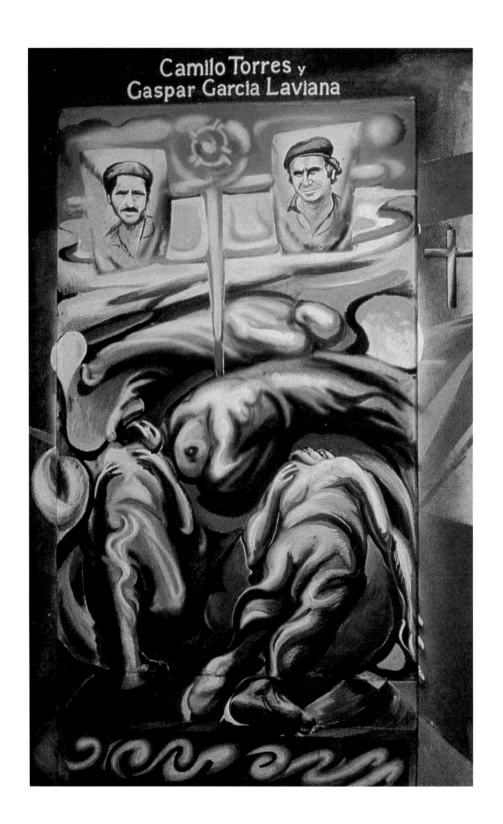

Camilo Torres y
Gaspar Garcia Laviana

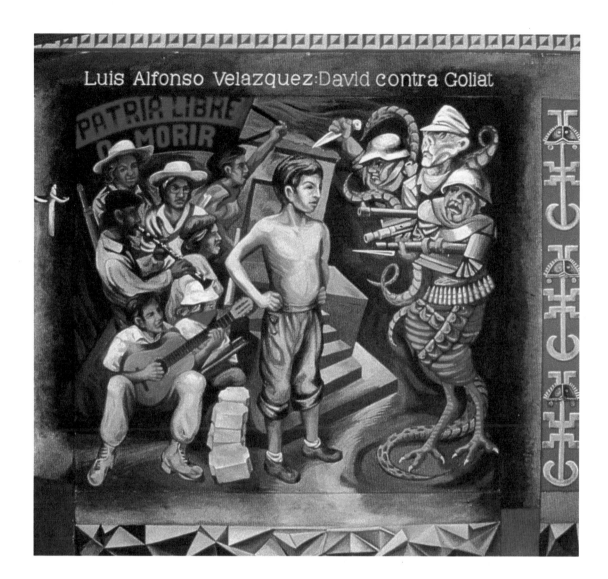

96A

(*Opposite*) Sergio Michilini and
Mural School (ENAPUM-DAS),
Colombian priest Camilo Torres
and Spanish-Nicaraguan priest
Gaspar García Laviana, with
corpses of other victims. Managua,
Church of Santa María de
los Angeles.

97

(*Above*) Sergio Michilini and
Mural School (ENAPUM-DAS),
David (i.e. Luis Alfonso
Velásquez) and Goliath.
Managua, Church of Santa María
de los Angeles.

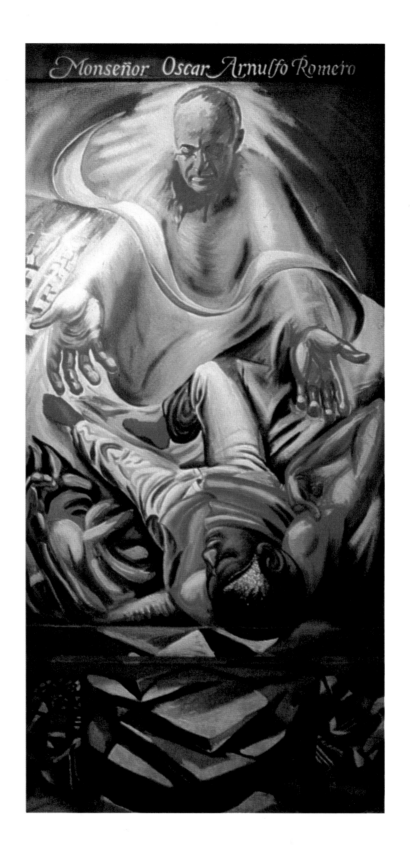

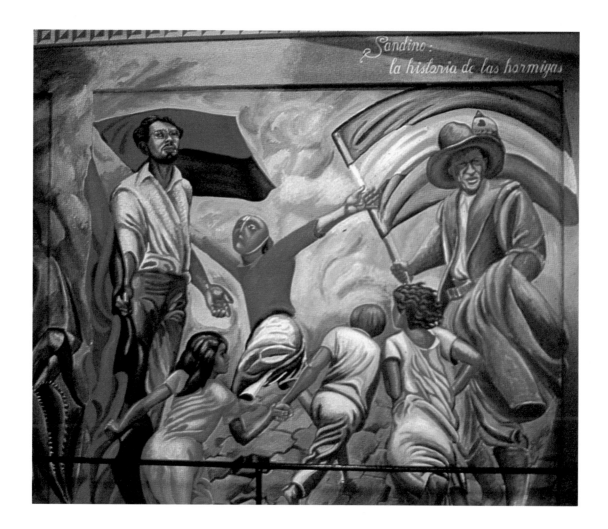

101A

(*Opposite*) Sergio Michilini and
Mural School (ENAPUM-DAS),
Archbishop Oscar Arnulfo
Romero of El Salvador, with
victim. Managua, Church of
Santa María de los Angeles.

103

(*Above*) Sergio Michilini and
Mural School (ENAPUM-DAS),
The Story of the Ants: Carlos
Fonseca and Sandino. Managua,
Church of Santa María de
los Angeles.

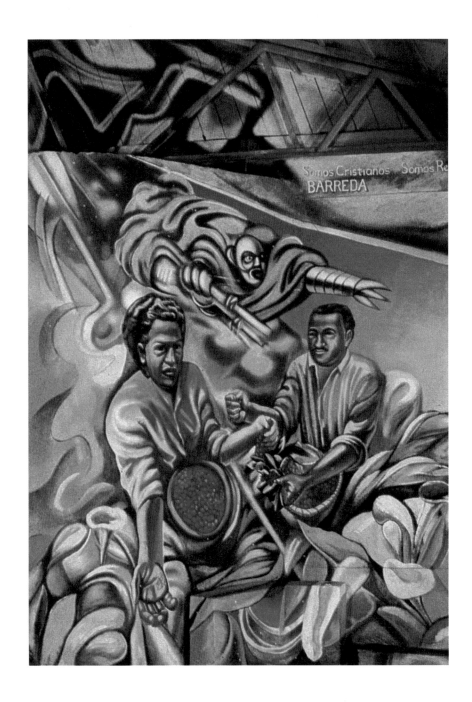

106

Sergio Michilini and Mural
School (ENAPUM-DAS), The
Barreda couple (murdered by the
contras), picking coffee: "We are
Christians, we are revolution-
aries." Managua, Church of Santa
María de los Angeles.

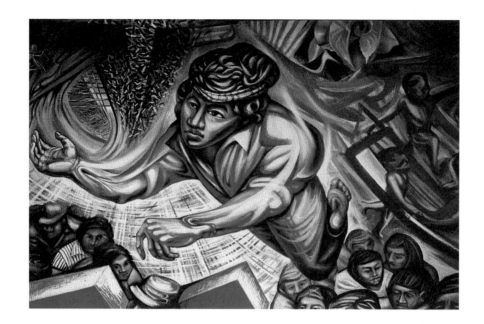

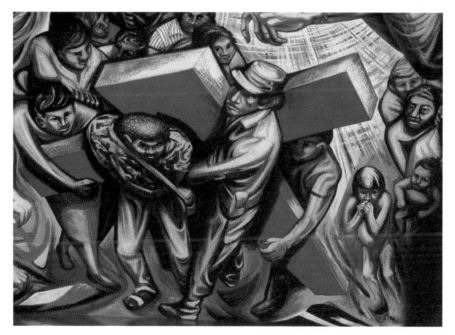

107A

(*Top*) Sergio Michilini and Mural
School (ENAPUM-DAS),
Resurrecting Nicaraguan peasant
Christ. Managua, Church of
Santa María de los Angeles.

107B

(*Above*) Sergio Michilini and
Mural School (ENAPUM-DAS),
Nicaraguan soldiers and peasants
carry the Cross. Managua, Church
of Santa María de los Angeles.

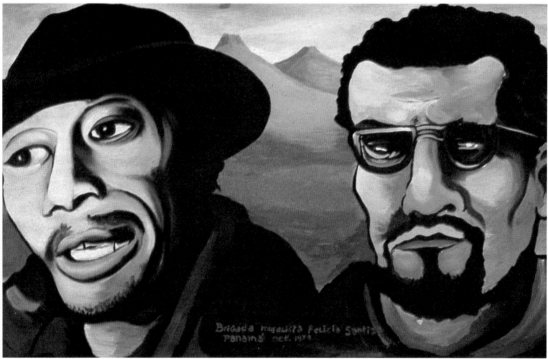

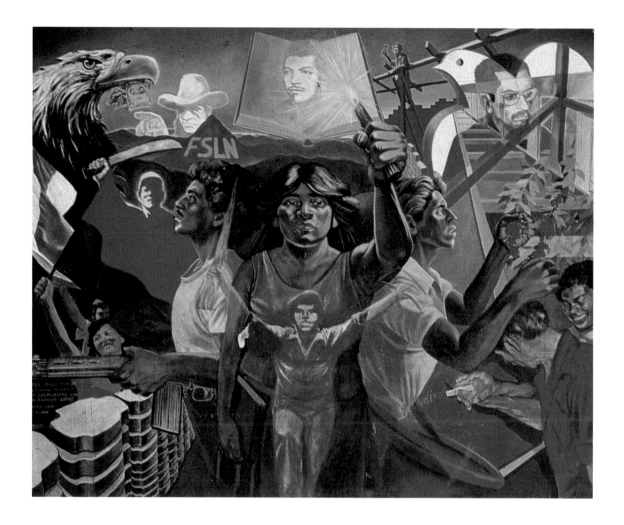

107C

(*Opposite, top of page*) Sergio Michilini and Mural School (ENAPUM-DAS), Church ceiling: the abundance of nature. Managua, Church of Santa María de los Angeles.

109A

(*Opposite*) Felicia Santizo Brigade of Panama, The Barricade, detail: Germán Pomares and Carlos Fonseca. Managua, Santa Ana, barracks.

111

(*Above*) David Fichter, The Light of Revolution. Managua, Rigoberto López Pérez School.

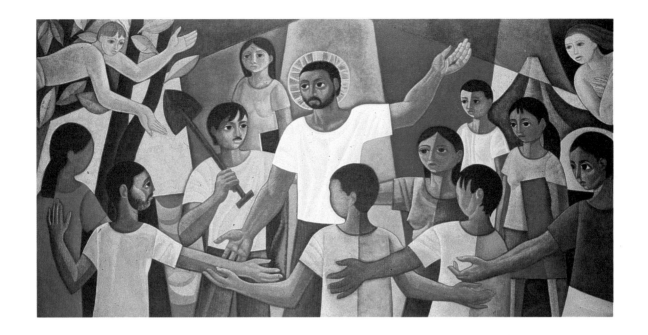

114A

(*Above*) Maximino Cerezo
Barreda, Christ with the people.
Managua, Central American
University, chapel.

116

(*Opposite*) Leoncio Sáenz,
El Güegüense. Managua,
dance school.

135

(*Opposite, below*) Literacy
billboard in Bluefields,
Atlantic Coast.

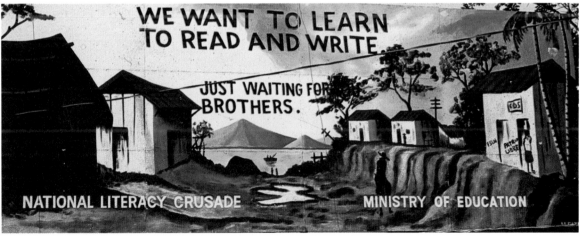

146

Arts for the New Nicaragua,
Güegüense dancers. Diriamba,
Casa de Cultura.

148A

(*Top*) Artifact, Women's Solidarity:
women organized; the market.
Diriamba, Womens' Association
(AMNLAE).

148B

(*Above*) Artifact, Women's
Solidarity: the market; women
airborne, people picking coffee.
Diriamba, Womens' Association
(AMNLAE).

150A

(*Top*) Boanerges Cerrato
Collective, Girls and doves. Estelí,
army base.

151A

(*Above*) Boanerges Cerrato
Collective, Germán Pomares,
Carlos Fonseca, and Sandino.
Estelí, army base.

151B

(*Top*) Boanerges Cerrato
Collective, Doves defy bloody-
taloned eagle. Estelí, army base.

151C

(*Above*) Boanerges Cerrato
Collective, Warrior with flag.
Estelí, army base.

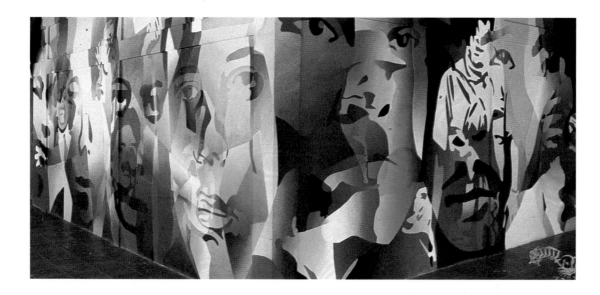

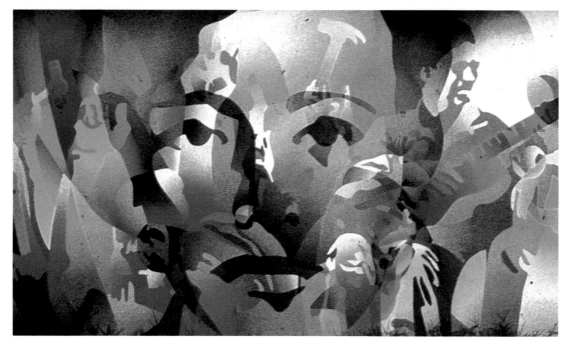

154A

(*Top*) Roberto Delgado, Local martyrs. Estelí, Christian Base Community.

155A

(*Above*) Roberto Delgado, Martyr gallery. Estelí, Popular Center for Culture.

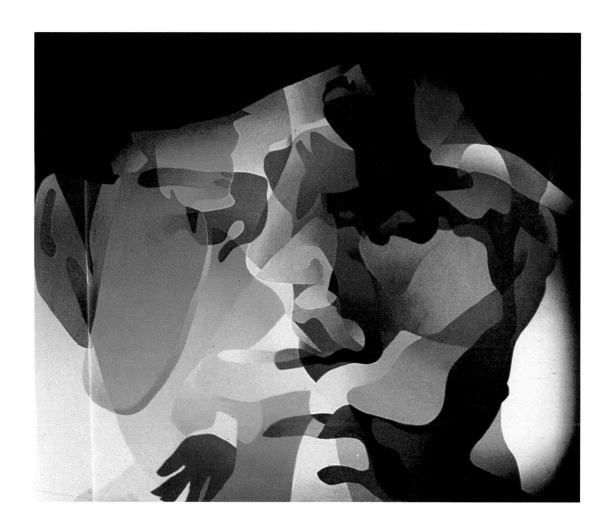

155B

Roberto Delgado, Martyr portraits.
Estelí, Popular Center for Culture.

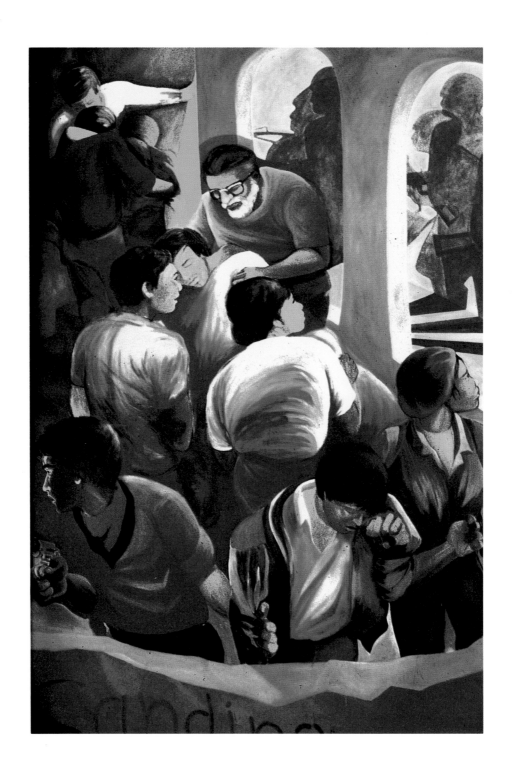

158

Boanerges Cerrato Collective, Dr.
Dávila Bolaños treating wounded
guerrillas. Estelí, Medical Center.

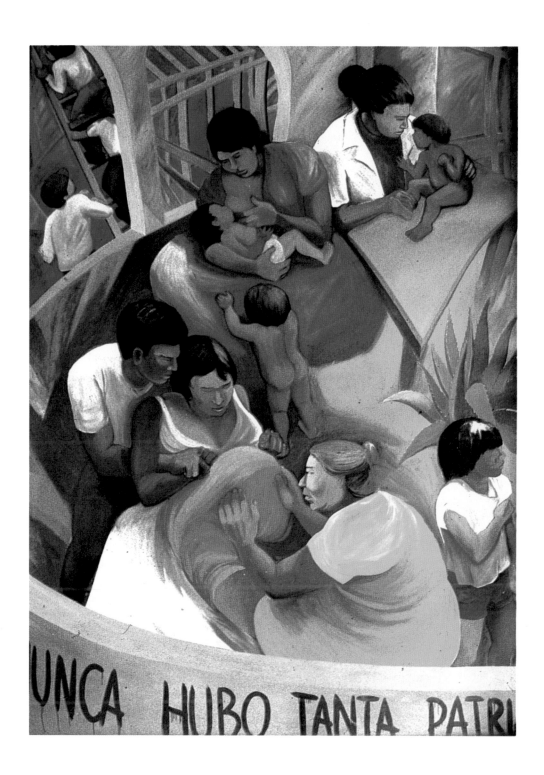

161

Boanerges Cerrato Collective,
Childcare. Estelí, Medical Center.

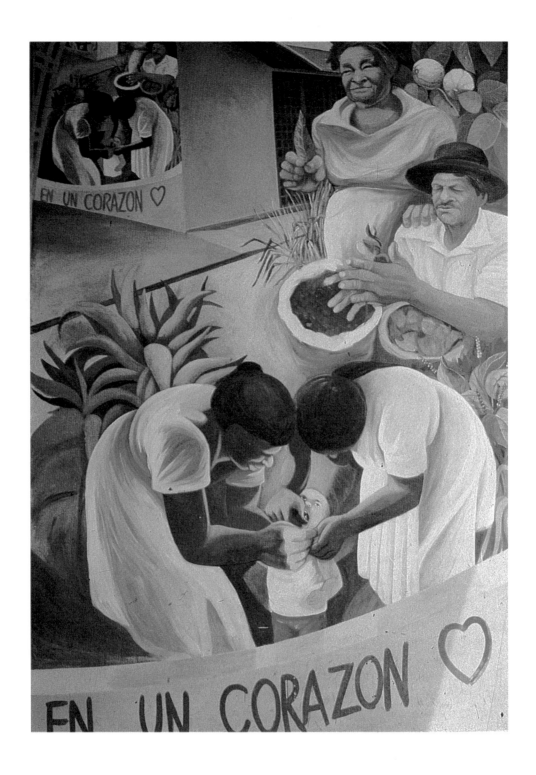

162

Boanerges Cerrato Collective,
Vaccination and herbal cures.
Estelí, Medical Center.

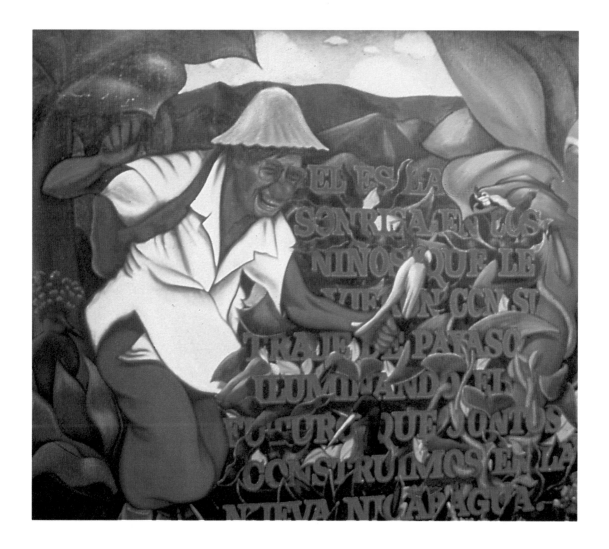

165

Mike Alewitz, U.S. martyr Ben
Linder ("He is the smile in the
children"). Estelí, former
language school.

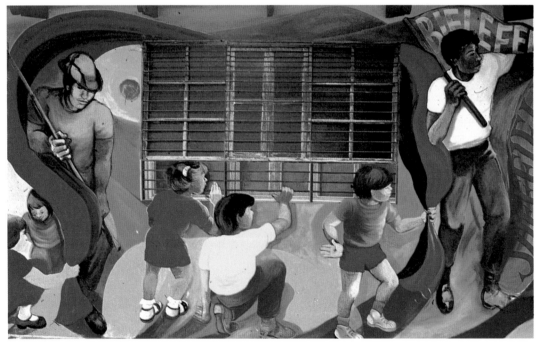

167A

(*Top*) Boanerges Cerrato
Collective, Children playing.
Estelí, sister-city office.

167B

(*Above*) Boanerges Cerrato
Collective, Children at window.
Estelí, sister-city office.

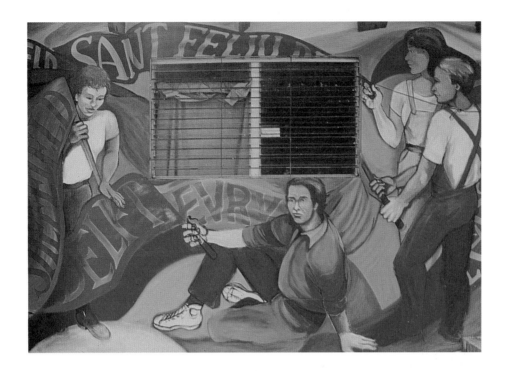

167C

(*Top*) Boanerges Cerrato
Collective, People holding flags
for towns in solidarity with Estelí.
Estelí, sister-city office.

175A

(*Above*) Daniel Hopewell, Detail:
the ice cream vendor. Jalapa,
children's library.

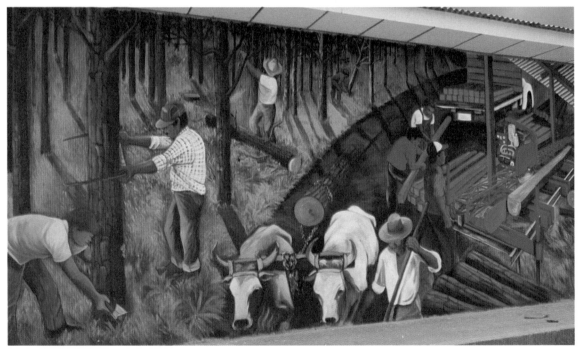

176A

(*Top*) Daniel Hopewell, Planting trees. Jalapa, Reforestation Project.

176B

(*Above*) Daniel Hopewell, Harvesting, processing trees. Jalapa, Reforestation Project.

180A

(*Top*) Felicia Santizo Brigade of Panama, Detail: figure with mallet. Jinotega, Revolutionary Command Post.

180B

(*Above*) Felicia Santizo Brigade of Panama, Detail: fists. Jinotega, Revolutionary Command Post.

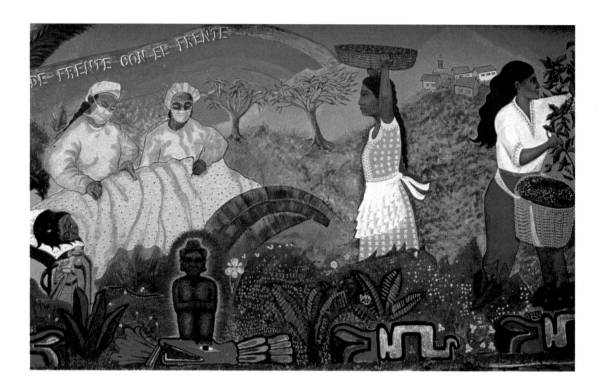

181A

Nicaraguan and U.S. artists,
Medical procedure; women
harvesting coffee. Jinotepe,
Women's Association (AMNLAE).

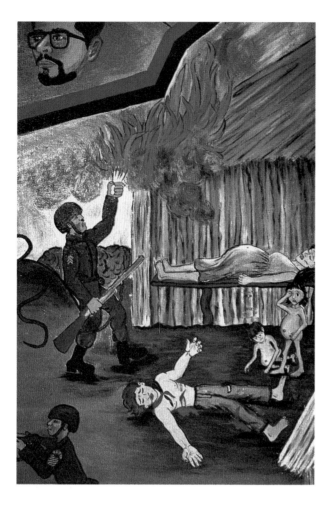

199A

(*Left*) Detail: National Guard
at work. León, Labor
Union Headquarters.

199B

(*Below*) Defeat of Uncle Sam
and A. Somoza II. León, Labor
Union Headquarters.

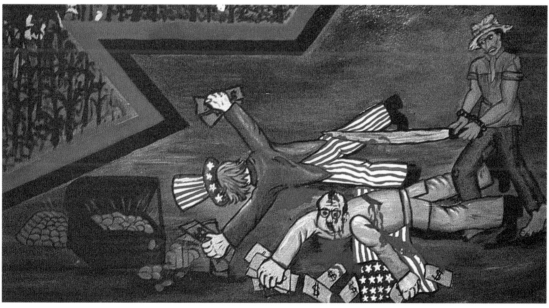

205A

(*Above*) Nissen and Klinger (Hamburg); Flores, Gutiérrez, Tovar, and Pineda (León), *Our Land Is Made of Courage and Glory*: history of Nicaragua, pre-Columbian sculptures. León, Plaza Héroes y Mártires.

205B

(*Opposite, top of page*) Nissen and Klinger (Hamburg); Flores, Gutiérrez, Tovar, and Pineda (León), *Our Land Is Made of Courage and Glory*: cannon of Walker invasion, map of U.S. invasion of 1912, and photograph of President Benjamin Zeledón; shadow of Sandino. León, Plaza Héroes y Mártires.

205C

(*Opposite*) Nissen and Klinger (Hamburg); Flores, Gutiérrez, Tovar, and Pineda (León), *Our Land Is Made of Courage and Glory*: detail of pistol, violin stem, and last letter of R. López Pérez, assassin of Anastasio Somoza I. León, Plaza Héroes y Mártires.

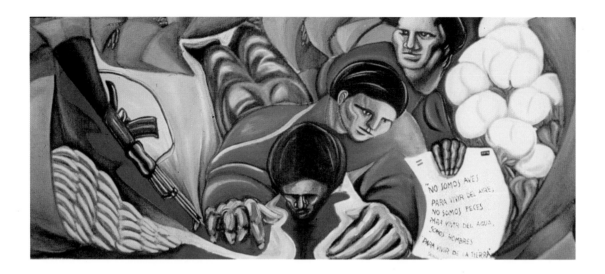

212

(*Top*) Daniel Pulido, Bananas, cotton, bloody victim. León, Agrofishery school.

251–252

(*Above*) Nicaraguans shooting down plane with Hasenfus; schooling in landscape. San Carlos, riverfront.

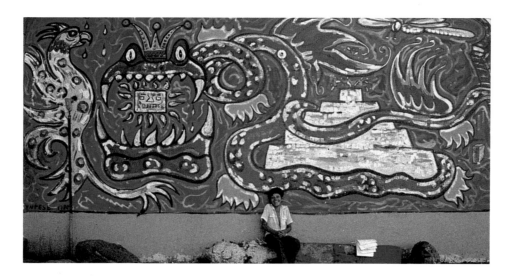

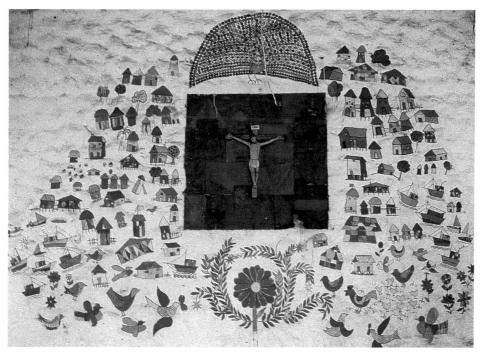

257

(*Top*) Syntese (Denmark), Eagle
and (Viking) dragon, with
(pre-Columbian) pyramid.
Sébaco, School.

258

(*Above*) Crucifixion, with
decorations. Solentiname, church.

259A

(*Above*) Federico Matus, with Reinaldo Hernández, The workers' struggle against imperialism. Tipitapa, chemical factory.

259B

(*Right*) Federico Matus, with Reinaldo Hernández, Women hoeing, man cutting weeds. Tipitapa, chemical factory.

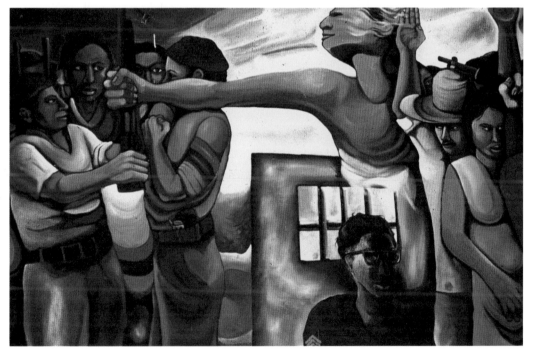

260A

(*Top*) Felicia Santizo Brigade of
Panama, Torture. Tipitapa, jail.

260B

(*Above*) Felicia Santizo Brigade of
Panama, Out of the darkness of
oppression, the light of rebellion.
Tipitapa, jail.

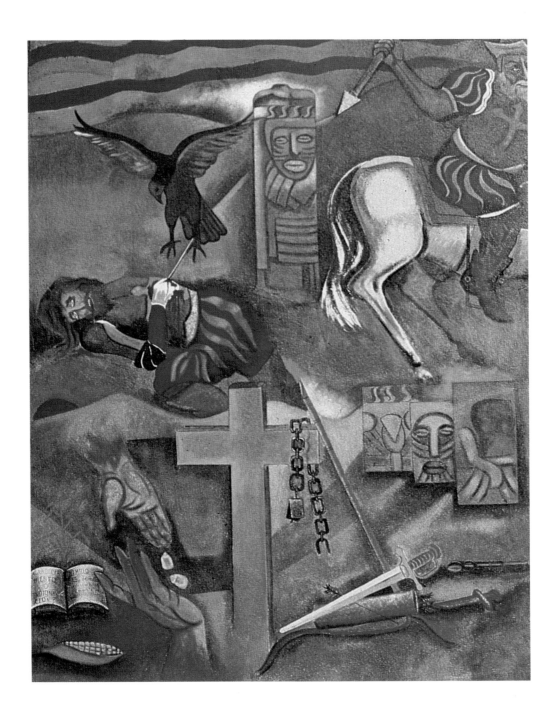

270A

Francisco Pantoja,
Conquistadores; maize to the
world; an end to religious
oppression and war. Waslala,
Church of the Immaculate
Conception, exterior.

Note to Catalogue

This catalogue lists all accessible murals of sufficient size and quality, including some not reproduced and many now destroyed. Together with the usual catalogue data: location, title (or major theme), authors, sponsors, date, rough dimensions (height precedes width in meters), and literature, I have included a minimal description (usually moving from left to right) to aid in identifying persons and motifs, with the briefest historical notes where appropriate. This will aid in "reading" the reproductions (capital letters in descriptions indicate color plates, lowercase, black and white photographs) and provide a verbal record, at least, of those murals and parts of murals which for reasons of space cannot be reproduced here, or have had to be reproduced very small.

I have transcribed and (except where cognates make the meaning clear) translate here both the inscriptions in the murals and the credit lines, making only minor changes (adding, for example, punctuation and diacritical marks, which are often omitted by the artists). The title of a mural is italicized when it is given on the mural itself or in a literary source; themes or other guides to content are given in roman type.

Locations, which determine catalogue sequence, are given according to custom in Nicaragua, which does not generally have, or use, street names or house numbers. The "exact address" in Managua takes picturesque but, for us, rather cumbersome and archaic forms such as "from the rotunda in Bello Horizonte three blocks to the south and one and a half blocks down" (where I lived on my first visit in 1981). (The address of ACRA, the mural-supportive Italian solidarity organization, is Del Restaurante Caporal 1 cuadra arriba y 8 cuadras al lago, Casa U-19, Barrio Las Brisas [for mailing, use also "Apto 1545, Correo Central, Managua"].) Carretera Sur is the main road running south out of Managua.

The catalogue sequence starts with the capital city center (or downtown—Managua really has no center) and continues alphabetically with the Managua suburbs, an order occasionally super-

seded by the name of a major institution (a university, for example) at or near which a mural is located. Outside the Managua area murals are listed under the name of the town or nearest town, again in alphabetical order.

I have traveled over much, but not all, of Nicaragua in search of murals, usually following a lead. Casual, serendipitous encounters with murals convince me that there are many I have missed, in Managua and outside. I have not recorded here a small number of the murals listed in the Nicaraguan murals bulletin (*El Andamio* 2, no. 4) that are located in remote towns and villages, some of them identified there as no longer in existence. Undoubtedly, a "mural reflex" was deeply and widely manifest in Nicaragua during the 1980s, but I do not believe that I have missed many major works.

A special word is in order for the inaccessible Atlantic Coast region, where security risks impeded visits between my first visit there in 1981 and my final one in 1993; the hurricane of 1988 destroyed most public art. This region, with its starkly differing history and traditions, has not on the whole been receptive to murals, which have not been used as a primary means of artistic and political expression.

I have omitted murals lacking socio-political content and done in commercial locations (notably restaurants) and, more regretfully, murals designed and executed by children.

National Palace, interior, above principal staircase, at entrance to former Chamber of Deputies

1 *Los Prometeos*, a triptych. *Left bay* (A, b): Mexican revolutionary Emiliano Zapata; behind Zapata, his generals; *above*, ancient Mexican goddesses Nahuatl (life) and Coatlicue (death); *to left*, machinoid fallen figure; *above*, Prometheus bound; *in background, top*, photo-derived procession of *soldaderos* of Zapata. *Center bay* (b): Prometheus bringing fire and breaking his bonds and those of recumbent figure to his right, below; other figures marching to their liberation, below and to the left of Prometheus. *Right bay* (B): Sandino with gun and U.S. flag (captured from U.S. marine and sent by Sandino to Frankfurt Peace Congress, 1933); silhouette of his generals behind him and photo-derived rendering of revolutionaries entering Managua in triumph, 19 July 1979; *to right*, the New Men (including a woman) planting coffee, drafting, and moving forward.

Plaque left of central door reads (*under title*): "Auditorio 22 de Agosto. Mural de Arnold Belkin de México para Nicaragua en ocasión LXXV aniversario de la revolución Mexicana 1910–1985. Managua 18 de Julio de 1987." *Plaque to right of door reads:* "Auditorio 22 de Agosto. El 22 de Agosto de 1978 el 'Comando Muerte al Somocismo Carlos Fonseca Amador' se toma por asalto el Palacio Nacional. En este sitio se encontraban sesionando los miembros de la cámara de diputados de la dictadura entre los cuales estaban connotados representantes del somocismo. Tras 45 horas de negociaciones se logró obtener la libertad de los miembros del F.S.L.N. que se encontraban presos en las carceles del somocismo. Jornada XXV aniversario de la fundación del F.S.L.N. y X aniversario de la caída en combate de Carlos Fonseca Amador" (Auditorium 22 August. On 22 August 1978 the "Carlos Fonseca Amador Death to Somocism" commando unit took the National Palace by assault. In this room the members of the Chamber of Deputies of the Dictatorship were in session, among them notable representatives of Somocism. After forty-five hours of negotiation, the members of the FSLN imprisoned in jails of Somocism were set free. Twenty-fifth anniversary of the foundation of the FSLN and tenth anniversary of the death in combat of Carlos Fonseca Amador).

The flaying of the body to reveal the "inner landscape" of the soul, with connotations of pre-Columbian sacrifice and Christian resurrection imagery, has been traced in Belkin's art to his *War and Peace* series of 1963 (Goldman 83–88). In the Managua mural, the flayed anatomy of Zapata and Sandino is, according to the artist, a metaphor for human vulnerability, a reminder of the flesh-and-blood nature heroes tend to lose when they are mythicized. It also represents social oppositions, including that between conflict and order (Tanner 7–8).

1a

1b

2

The robotic figures, raised here to an acme of volumetric mechanical perfection vis-à-vis Belkin's earlier, more linear, treatment of the robotized human body, have a "metaphysical" meaning that seems largely negative. In the left sector, compare the mechanical figure lying prostrate, "perhaps another Prometheus bound . . . and a fallen statue, the downfall of the old order" (Tanner 7–8), with the anatomically defined figure in bondage struggling heroically and pathetically in the manner of Michelangelo's *Dying Slave*.

A comparison with Belkin's paintings from the *Che Guevara* series (1975; donated by the artist in 1979 to the Managua Museum of Contemporary Art) further complicates the meaning of these robotic figures. In *The Final Anatomy Lesson*, which parodies the famous Rembrandt painting,

a photographically real Che Guevara plays the role of Dr. Tulp, anatomizing the dismembered, robotic corpse of imperialism while Che's fellow revolutionaries look on, like Rembrandt's surgeons. Another painting in the series (Abrahan Díaz González collection, San Juan, Puerto Rico) portrays a reversal, with a robotic professor of anatomy presiding over the photographically real corpse of Che.

By the Mexican Arnold Belkin (d. 1992), with the assistance of the Mexican David Leonardo; sponsored by the Mexican government to commemorate the seventy-fifth anniversary of the Mexican Revolution, July 1987.

Painted area approx. 42 sq. m.; painted with airbrush.

Lit.: *Barricada Internacional*, 18 June 1987, 14–15; Arnold Belkin, *Nueva York, 1971–1975: Cartas contra la amnesía, Textos, 1965–1985* (Mexico City: Domes, 1986), pls. 27–36, pp. 222 and 227; Andres de Luna, *Arnold Belkin*, Los Creadores y las Artes, México D.F., UNAM, 1987 (for flayed Zapata series 1978, and Coatlicue 1980, see pp. 28, 51, 53, and 57); Porfirio García Romano, "Ernesto 'Che' Guevara ye la lección final de anatomia del 'Doctor' Belkin," *Nuevo Amanecer Cultural* (Managua), 5 December 1992, 8; Shifra Goldman, *Contemporary Mexican Painting in a Time of Change* (Austin: University of Texas Press, 1981); Lauri Rose Tanner, "Arnold Belkin's New Mural in Managua," *Community Murals* 12 (Winter 1987): 7–8; *Ventana*, 1 August 1987, 10–11.

National Palace, interior, surrounding principal entrance

2 *Herejías* (Heresies). *Left wall:* Exotic warrior figure, faces running on legs; biped hand pointing threateningly at warrior. *Center, over entrance:* Inscription "Mirar el volcán desde arriba" (Look at the volcano from above), crowd of people, confused blotches and cloudlike shapes. *Right wall:* Thrice-life-size shamanic figures conjuring serpents and other evil (?) spirits.

Inscribed, bottom left: " 'Arte es heregía [*sic*]' Tomacito [Tomás Borge]. Preparó el muro Francisco Sanches Zarate, de Mexico." Inscribed, bottom right: "A cada persona de este pueblo de cuya revolución esperamos tanto. Vlady 16 Julio 1987." ("Art is heresy" Tomacito. Francisco Sanches Zarate of Mexico prepared the wall. [Dedicated] to every person in this country from whose revolution we hope for so much. [Painted by] Vlady 16 July 1987.) See Tomás Borge, "Arte como Heregía," *Nicaráuac* 4 (January–March 1981): 111–19.

Side walls both 8 x 2.5 m., painted in true fresco.

Lit.: *Ventana*, 27 (June 1987): 6.

Avenida Bolívar, wall of Retaguardia (rearguard) of Ejército Popular Sandinista (EPS; Sandinista Popular Army), third military region

3 *The Supreme Dream of Bolívar.* (A, a) The first inhabitants; hand raised against the Spanish invader, on horseback and (b) arriving in ships; (B) native resistance (man with pink head is a white sympathizer); (C) the church imposes its ideology; (D) cry and horse of liberty in second wave of liberation (green and blue landscape symbolizes indigenous purity); (c) second wave of liberation (Indians, horse's head), (d) bust portrait of Bolívar; Bolívar again, cry of liberty, with horse; (e) indigenous faces, José Martí with Bolívar above, Rubén Darío; (E) Death clothed in a U.S. flag; flags of independence, (g) face of Sandino imagined old; FSLN insurrection, with FSLN masks; National Guard with death's heads, before flaming city; (F) rebels behind barricade, face of Rigoberto López Pérez in background; (h) more rebels charging right, face behind (nostrils and eye delineated) intended as Carlos Fonseca; (i) triumphal renaissance of ideals of Bolívar, whose portrait hovers among Nicaraguan and FSLN flags; hand releasing dove of peace; (j) Sandinista flags in Plaza Revolución (cathedral visible with cupola); (G) defense; industry revives; the future; in a garden, "Vitruvian man" (based on well-known drawing by Leonardo da Vinci of naked male with arms and legs out-stretched to touch circumference of circle in which he is inscribed).

3a

3b

3c

3d

3e

3f

3g

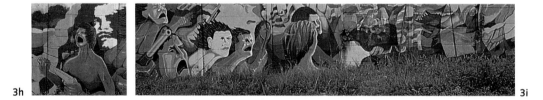

3h

3i

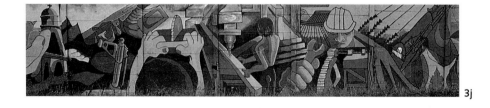

3j

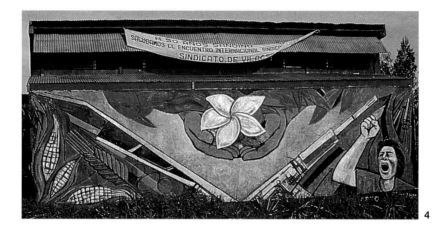

4

5

Inscribed, below, center: "Del pueblo chileno al pueblo Nicaragüense." A marble tablet was later added in front of the mural: "Al pueblo de Nicaragua del pueblo Chileno. P.C. [Partido Comunista de Chile]."

By Victor Canifrú with the help of Alejandra Acuña Moya (both are Chilean exiles) and passing children, for two hundredth anniversary of the birth of Bolívar. Sponsored by an army captain who had been in Chile during Allende period and by the Venezuelan embassy.

March–July 1983. 2.5 x 100 m. All but first quarter destroyed 1990; remainder destroyed 1991.

Lit.: Pérez Díaz, pp. 16–17 (harshly negative review; incorporated into Michilini p. 32); *Geo* (German ed.), no. 11 (November 1984), with color reproductions of three segments in progress.

Avenida Bolívar (opposite no. 3)

4 Composition in three triangles. *Left:* Corn and agriculture; *center:* hands holding *sacuanjoche* (national flower); *right:* figure with raised fist flanked by rifles. By the Mexican Alfonso Villanueva, with Genaro Lugo, Orlando Sobalvarro and Xavier Orozco. About 1980. 3 x 10 m.

Avenida Bolívar (opposite no. 3)

5 Three women, in red, blue, and yellow, picking coffee. By Alejandro Canales. About 1982. 3 x 11 m.

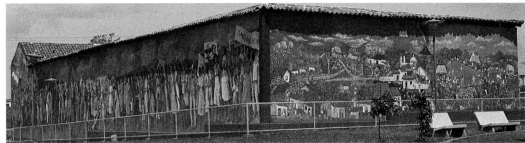

6a–7a

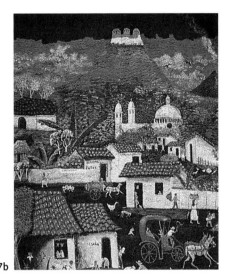

7b

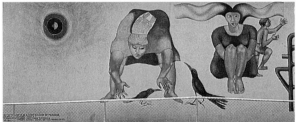

8a

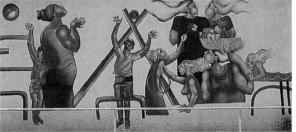

8b

Luis Alfonso Velásquez Park, east end, three murals on Empresa de Mantenimiento y Ornato Municipal (Municipal Maintenance and Improvement Service) building

6 *El Encuentro* (The Meeting), *north wall:* (A, B) Return of the revolutionaries from countryside and mountains to their families after the Triumph; women (C) bear signs saying "Los heroe[s] no dijieron [*sic*] [que morían] por [la pat]ria . . . [sino que murier]on," "Patria Libre," "Dijim[os] y vencim[os]," "Hoy e[l amanecer] dejó d[e ser una] t[ent]ación," and "Sandino vive," as well as portraits of Sandino and Carlos Fonseca (The heroes said, not that they were dying for the fatherland [i.e. boastfully], but that they were [simply] dying; Free Fatherland; We

said so, and we won; Today the dawn ceased to be merely a tempting dream; Sandino lives).

Signed "L[eonel] Cerrato '80."

3 x 38 m. Obliterated November 1990.

7 Scenes from peasant life, in primitivist style, *west wall:* Details of village life, and (A) street with demonstration in favor of literacy campaign, and artist painting; (b) village street with coach; (B) hut with poster of Sandino, animals, children relieving themselves, and (C) children playing baseball and playing with bull.

Continuous design by three different artists, who signed over the portions for which they were responsible: *left*, [Julie] "Aguirre 80" (A); *center*, "Manuel García 80" (b); and *right*, "Hilda Vogl 80" (B, C).

3 x 12 m. Obliterated November 1990.

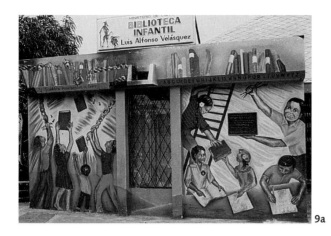

9a

9b

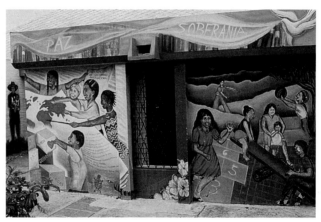

9c

9d

8 *Homage to Woman, south wall*: (A) Mothers and children, symbolizing fertility, playing and learning to read. Writing exercise book (B) includes the motto "Las masas hicieron la Revolución" (The masses made the revolution).

Signed "Projecto: Junta de Reconstrucción de Managua. Diseño Alejandro Canales, Colaboraron Genaro Lugo, David Espinoza, Freddy Juárez, Romel Beteta, María Gallo 1980." Numbers 6–8 sponsored by the government.

3 x 38 m. Obliterated November 1990.

Lit.: *Community Murals* (Winter 1985): 10, and (Spring 1983): 27–29; Pérez Díaz, pp. 18–21.

Luis Alfonso Velásquez Park, Biblioteca Infantil (Children's library; donated by Austrian solidarity group), on Plaza Centro América Monseñor Romero

9 *Los Niños son el jardín de la revolución* (Children are the garden of the revolution). *Left facade wall* (A, a): " 'Y Tambien enseñenles a leer . . .' Carlos Fonseca" (And teach them also to read) is inscribed below a shelf of books, the chain around which is broken by the children below; *at right*, children reading, writing, and climbing a ladder to the shelf of books; *left of entrance* (b): Sandino full length, with a baby in his arms, an unusual representation, designed to promote male participation in child rearing; *right of entrance* (c): mother, with a gun over her shoulder, protecting children holding *sacuanjoche* flowers; *wall to right of entrance, and right facade wall* (d): children of varying complexions point to maps of

Nicaragua and the world. One holds up a "Declaration of International Solidarity"; others stack building blocks, whose corners coincide with the corner of the building (they are marked Hope, Friendship, Joy, Justice, Unity, Love, Sovereignty, and Dignity); *at right*, children at play.

Text (B) summarizes the life of the child after whom the park is named: "Luis Alfonso Velásquez Flores (Grasshopper) was a proletarian child. At the age of seven he was a distinguished child leader in the FSLN and founder of the Primary School Movement (MEP). He organized meetings in the barrios, takeovers of schools and universities. His struggle was for the joy of all children, to give them schools, hospitals, parks, and above all happiness. At ten years of age he was foully assassinated by the genocidal dictatorship, 29 April 1979." A banner marked Peace and Sovereignty runs over the painted shelf of books along the roofline.

Signed, to left of armed mother with children, below title, in Spanish: "Painted by North American artists in solidarity with the people of Nicaragua, Miranda Bergman, Marilyn Lindstrom, with the help of the Ministry of Culture, Association of Sandinista Children, Children's Library Luis Alfonso Velásquez Flores, School of Plastic Arts," followed by fifteen names.

On a set of cards published in Minneapolis, Minnesota, the work is credited to the two principals listed above and to Jane Norling and Odilia Rodríguez. The title is taken from a speech of Tomás Borge (1986, p. 116).

December 1983–January 1984, total 3 x 22 m., on five wall faces. By July 1990, the name of Luis Alfonso Velásquez was partly scratched out, as also (by 1987) the eyes of the children on the seesaw. All but credit list obliterated 28 December 1992.

Lit.: *Community Murals* (Spring 1984): 4; Pérez Díaz, pp. 17–18.

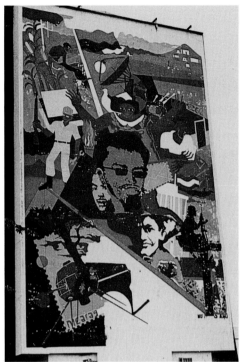

10

Telcor (Telecommunications) Building

10 *Below:* Postage stamp with satellite, Rigoberto López Pérez, Carlos Fonseca, Sandino, worker on telephone pole, with rifle; *above:* worker with gun and wrench, coffee harvest, FSLN flag, satellite dish, dove, woman with arms raised (post office worker?), male post office worker, defense, Nicaraguan flag.

By Alejandro Canales.

1985. Left unfinished because of problems with wall surface, lack of paint, death of sponsor (Telcor director), and finally death of artist. By June 1992, very faded and about one-quarter of paint surface gone.

Wall of barracks, opposite Olof Palme Center, three murals

11 National Guard dying; Barricades; Culture. Each 2.5 x 2 m.

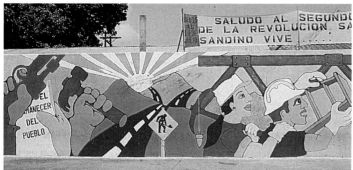

12a

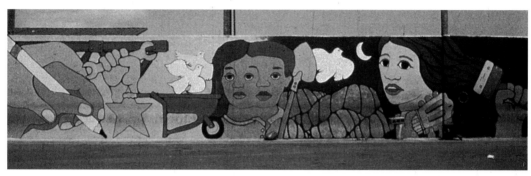

12b

Ministry of Construction, near National Stadium,
wall facing street, divided by entrance

12 *Left:* Nicaraguan and FSLN flags, Germán
Pomares, Sandino; (a) hands holding rifle, and
"Dawn of the People" book; dawn; construction
of roadway and bridge; *right* (b): one hand guid-
ing another to write, wrench, star, doves, wheel-
barrow, "the new woman and man" (conjoined),
spade, and woman with guitar, (A) her hair flow-
ing into paintbrush.

Signed with the logo of the Orlando Letelier Bri-
gade. Sponsored by the Ministry of Culture.

July 1980. 2.5 x 40 m. Very faded by 1990.

Acahualinca

Escuela Modesto Bejarano (school, supported by Sweden, Netherlands, and France), entrance courtyard

13 Six-thousand-year-old footprints as preserved in Huellas de Acahualinca museum nearby; Nicaraguan petroglyphs; women market vendors; people creating a park in a trash-filled wasteland by planting trees; background of erupting volcanoes (the ancient footprints were probably left after an eruption); lakeside, stylized volcanoes and sun.

Signed, lower right, "Martes 15 Dic. 1992. Diseño Augusto Silva. Participaron: Omar, Jaime, Jairo, Reynolds, Hamilton, Norman, Jeannete, Rebeca, Reynaldo Macis, Michel."

2.5 x 16 m.

Defense Area opposite Airport

14 Dove-airplane in Nicaraguan skies protects people and production. By Victor Canifrú. Destroyed about 1986.

Airport Terminal

15 At the barricade, a crowd of militants, among them a dozen boys, with stones, Molotov cocktails, guns, catapult, raised fist; *behind,*

FSLN flag. Signed, lower right, "Brigada Muralista Felicia Santizo Panamá. S.P.C. Policía Sandinista III-80." Painted March 1980. 3 x 6 m. Destroyed about June 1990 (see figure p. 3).

Altagracias

Escuela Primaria José María Villaseca (named for the founder of the Josephine Missionary Order, which supports the school), outside, corridor

16 *To left:* Moon, Sandino, five volcanoes (Nicaraguan national emblem); workers armed with gun and machete; hand holding handmade grenade; chains; paving blocks; cob of corn, open hand; *to right:* tank ripping through national flag; gun; FSLN flag, giant face of Carlos Fonseca (very blue-eyed), with pile of books.

Signed, bottom left, "A Vega Calera 1980." 2 x 16 m. Very faded.

Parque para niños William Díaz (Children's park, built by locals and finished with the help of CARE Canada)

17 A Christ figure releasing a dove and crying "Lleva la Buena Nueva a los Pobres, renueven la tierra, liberen a los oprimidos" (Carry the good news to the poor, renew the earth, liberate the oppressed); figures laboring; chain; hand clenching stick; FSLN flag; "Por qué me llaman Senor y no

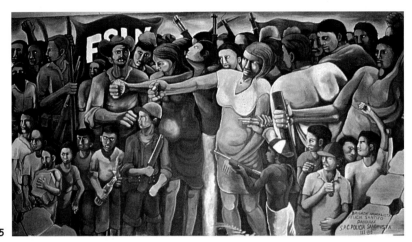

15

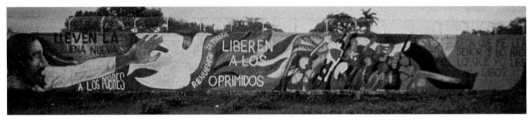

17

hacen lo que les digo" (Why do they call me Lord, and do not what I say).

Signed with five sets of initials and "Pentecostes 81." Painted by "350 hands" of barrio and church community, including internationalists, for Pentecost (Whitsun) 1981, to design of Maximino Cerezo Barreda.

3 x 26 m. Destroyed 17 February 1992 by Mayor Alemán. Afterward the wall was graffitoed: "Aquí estaba el mural cristiano que mandó a borrar el alcalde. Este parque lo hizo el barrio en 1980. ¿Por qué lo inauguran ahora?" (Here was [painted] the Christian mural that the mayor ordered destroyed. The barrio [people] did it in 1980 [*sic*]. Why is it inaugurated now?).

Lit.: "Cronica de un muralicidio anunciado," *Nuevo Amanecer Cultural* (Managua), 29 February 1992, 4–5.

Batahola

Centro Cultural Eroes y Mártires de Batahola (Community Center)

18 *El Nuevo Amanecer* (The New Dawn), *in assembly hall* (also used for saying mass): (A) Local people, including children and women and Latin American heroes—(B) Che Guevara, Carlos Fonseca, Sandino, and Oscar Romero—encircle a Christ-like baby aureoled in golden straw, carrying offerings of fruit and vegetables. Female figures float above, one bearing corn; coffee plants and pickers far right and left.

By the artists who formed the Colectivo Boanerges Cerrato (Boanerges died while painting here).

Executed October–November 1988; inaugurated 4 December 1988. 5 x 20 m.

Lit.: Three details published as picture cards by Pueblo to People, Houston, Texas.

19

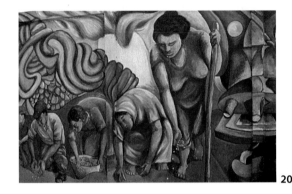

20a

20b

19 Three remaining walls of assembly hall: *Paradise*, with animals; *Fall*, with mushroom cloud encircled by *pájaros negros* (black birds, shaped like spy planes); Hurricane Joan; erupting volcanoes with falling (U.S.) eagle; overhead an angry-looking Sandino(?); *Recovery*, with schoolroom; hospital scene.

By "children of all ages," according to director of mural, Daniel Hopewell (Colectivo Boanerges Cerrato).

About 1988. 3 x 25 m.

Escuela Primaria Carlos Fonseca, Exterior wall

20 (a) Sowing; (b) industrial machinery, figure holding immense *sacuanjoche*; (A) children holding book marked "Y tambien enseñenles a leer" (And teach them also to read—Carlos Fonseca), and alphabet book; worker manipulating heavy machinery.

Signed, to right, "Para el barrio Batahola Norte del Colectivo Boanerges Cerrato." By Boanerges

Cerrato, Leonel Cerrato, Daniel Hopewell, Janet Pavone, Daniel Pulido (design), and Cecelia Salaverri (all of ENAPUM-DAS).

About 1987. Repainted with new designs by Colectivo Boanerges Cerrato in 1988.

Centro de Protección Infantil Rolando Carazo (Center for abandoned, orphaned, and handicapped children, financed by Manos Unidas de España), 7.5 km. Carretera Sur

21 Exterior wall, facing road: Children playing, protected by woman in white who extends over them a long black and red banner; boy in wheelchair; *sacuanjoche*.

Signed "Para el barrio Batahola Norte del Colectivo Boanerges Cerrato." Sponsored by INSSBI (Instituto National de Seguro Social y Bienestar, social security organization).

June–August 1988. 3 x 50 m. When the UNO government prohibited the display of party symbols on public buildings, orphanage workers painted the red of the banner over in white.

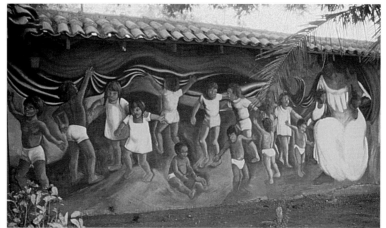

21

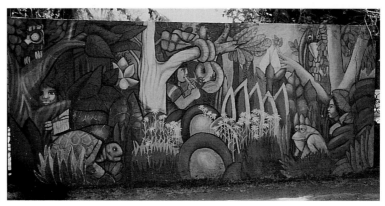

22

22 *Inside center:* Four murals on one wall, including one representing children and animals in a jungle landscape. By Colectivo Boanerges Cerrato, circa 1987. 2 x 4, 2 x 2, 2 x 7, 2 x 4 m. All destroyed 1992 as a result of reprivatization of property.

Bello Horizonte

Fundación La Verde Sonrisa (The Green Smile), ecologically oriented children's foundation founded by Tomás Borge, near Pio X Church

23 *Milflores* (Flowers): Birds, palm leaf, corn, dragonfly. Signed, bottom left, " 'Milflores' Aldo Soler, Luis Miguel Valdéz, Managua 1992 Talamuro." 1.5 x 5 m., pedimental shape.

Biblioteca Nacional (National Library)

Interior, various walls

24 Animal fantasy, including (a) eagle transfixed by arrow; (b) volcano spewing forth paving stones; serpent twisting from volcano; (c) humanoid and dragonfly. By Syntese (Denmark). 1988.

El Carmen

Hotelito, patio, behind swimming pool

25 Jungle mammals, tropical fish, birds. Signed, below left, "Per Johan Svendsen & Flemming Vincent, Syntese [Denmark] 1988." 3 x 15 m. Destroyed by 1990.

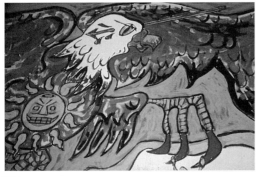

24a

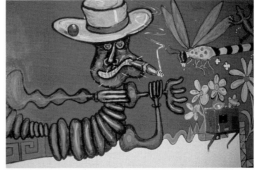

24c

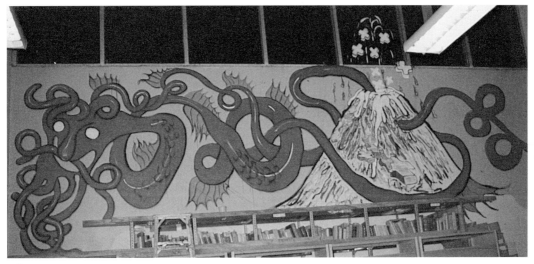

24b

25

Hotelito Zulema ("de los Cubanos," near El Carmen church), patio

26 Portraits of Patricio Argüello Ryan, Nicaraguan Sandinista and internationalist who died in struggle for Palestine; Aracely Pérez-Daría, Mexican who died in combat in León, June 1979; Farabundo Martí (see also no. 82); Carlos Ulloa, Nicaraguan pilot who defected from Somoza airforce and was killed at U.S. Bay of Pigs invasion, Cuba, April 1961; Ernesto Che Guevara.

Signed, left, "Toscano 83" (Cuban).

2 x 3 m.

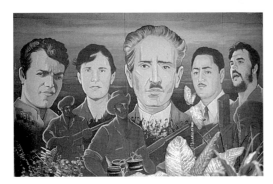

26

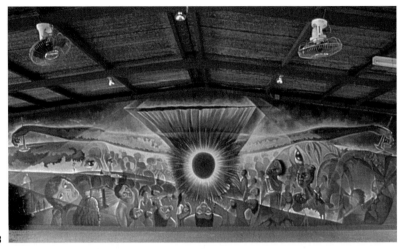

28

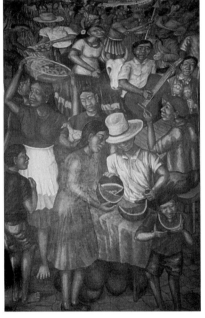

29a

30

Centro de Desarollo Infantil Valerie Anne Briehl, Carretera Sur (Child development center)

27 Doves, close-up of children's faces, children standing and playing, mother and child enclosed in huge cupped hands. By Camilo Minero, 1989. 5 x 20 m.

Centro Ecumenico Antonio Valdivieso

Auditorium

28 *La Crucificción Cotidian de América Latina* (The Daily Crucifixion of Latin America): Jesus on the cross, seen from above, as in Salvador Dalí's *Christ of Saint John of the Cross*, in Glasgow City Art Gallery, his head and halo like an eclipsed sun (as on July 11, 1991), with a large crowd of people looking up. By Victor Canifrú. July 1991. 2.5 x 6 m. A set of four picture cards were published by the Centro Valdivieso.

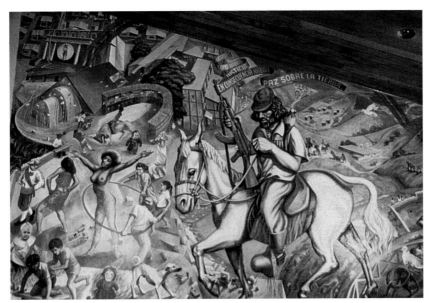

31a

Centro Espiritual Monseñor Oscar Arnulfo Romero, Carretera Sur 11 km.

On the inside and outside walls of this ecumenical conference center a plan is in progress for fifty to sixty murals centering, in principle, on the theme Five Hundred Years of Indigenous, Black, and Popular Resistance (i.e., to the new world capitalist order). These murals are designed to counter the conventional quincentenary celebrations in 1992 of the landing of Columbus in America. The center also contains mural ceramics, children's murals, and a large freestanding sculpture by the Swiss Barbara Roth.

Entrance, interior

29 *Fiestas de Santo Domingo de Guzmán.* Above (A): theatrical, musical, and religious festival; *below* (a): market scene, with melon seller. Signed, bottom left, "L[eonel] Cerrato J. Nic 91." 4 x 2 m. Curved surface.

Passageway outside conference room

30 Anthropomorphic architectural fantasy. Signature of Luis Miguel Valdéz (Cuba), "V. 92 Managua—Talamuro—Cuba. De la Serie 'La Siempre Habana: El Mestizaje.'" 1.5 x 6 m. Runs over wall and ceiling.

Conference Room

31 *El Buen Gobierno Obrero Campesino.* (Good Government [of] Workers and Peasants) around bullring: (A) Christian peasant/knight, riding mule, parrot on shoulder, carrying rifle from whose barrel unfurls a long banner saying "Despues como habrá justicia, en consecuencia habrá paz sobre la tierra" (Afterward, because there will be justice, there will be peace on earth); (B) brown and blond children playing (the blond is the artist's Nicaraguan-born daughter with her toys); traditional (Masaya) dance, opposite nude (Atlantic Coast) female in hula hoop; Enana Cabezón and Gigantona (festival figures); bull sport in a stadium; Olof Palme Center; Managua cathedral with portrait of Sandino; and (*above bullring*) new Mural School. A ghost enters the school from the right, and a windowpane at the bottom is marked, in letters scarcely legible from below, "Fué una gran utopia en la revolución y terminó con Quinche Ybarro" (It was a great utopia in the revolution and ended with Quinche Ybarro)—a reference to one of the enemies of the school; behind rider, peaceful hillside, dove of peace; figures pulling pig (as in Lorenzetti), erecting telephone or electricity poles. The work, according to the artist, was freely inspired by the *Good Government* fresco (1337–

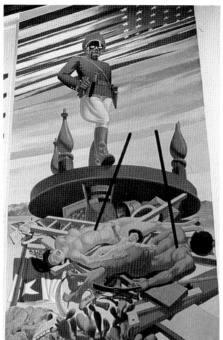

32a

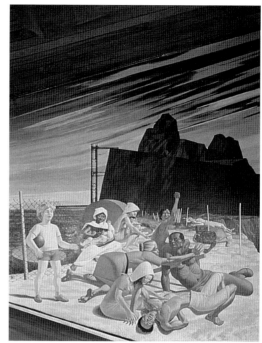

32b

39) of Ambrogio Lorenzetti and the equestrian portrait *Guidoriccio da Fogliano* (1328) by Simone Martini, both in the Palazzo Pubblico, Siena.

Signed, bottom right, "Michilini 1987, obreros y campesinos."

5 x 3.5 m.

Conference room (opposite no. 31)

32 *El Mal Gobierno* (Bad Government), *from right to left:* (a) Chilean dictator Augusto Pinochet below U.S. flag, standing on overturned table (representing democracy), under which lie naked bodies transfixed with poles, one a female, face up over a cross, her slit throat weeping tears; a naked child beside her, arms outstretched, Christ-like; and a male, lying facedown over tools, including a "communist" machete (for hammer and sickle) arrangement, and religious symbols (three nails and ladder of Crucifixion); Chilean flag; books by Farabundo Martí, Che Guevara, Pablo Neruda, Rubén Darío, Ernesto Cardenal, and Fidel Castro. *To left:* the Nazi death-camp motto "Arbeit macht frei" (Work sets you free) in

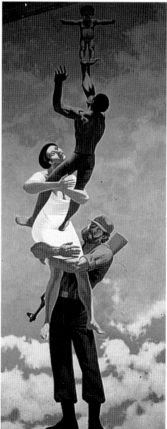

33

34

36

seven languages, in a zigzag. *Further left (same wall)*: (b) stripes of flag above Pinochet continue across the sky, which stretches over a stark landscape: (A) a northern European (blond), presumably bourgeois boy, standing by a fence that separates him from a (nuclear?) desert, observes (B) starving, succoring, begging, breast-feeding, and angrily defiant people near a chasm.

By Aurelio Ceccarelli. 1987. 5 x 3.5 m.

Salón Romero

33 Pyramid of the new life: armed militiaman raises woman supporting Atlantic coast youth, who balances an infant on his upstretched hand. By Aurelio Ceccarelli. 1987. 4 x 1.5 m.

34 Sandino as a boy, standing on severed tree trunks, with a live tree behind. By Aurelio Ceccarelli. 1987. 4 x 2 m.

35 *Birth of the New Man.* Man in militiaman's cap pressing an infant to his breast. By Daniel Pulido. About 1987. 4 x 2 m.

36 Salvadoran martyrs, all identified, surround Archbishop Romero, arms uplifted. *Left side*: portraits of Father Ignacio Ellacuría, S.J.; Father Juan Ramón Moreno Pardo, S.J.; Father Segundo Montes Mozo, S.J.; Father Armando López Quintana, S.J.; *center, below archbishop:* El Indio Ama, Farabundo Martí, Mélida Amaya Montes (comandante Ana María; see also no. 82), Rafael Aguinada Carranza, Febe Elizabeth Velázquez; *right side*: Father Ignacio Martín Barr, S.J.; Father Joaquín López y López, S.J.; and Celina Maricet Ramos and Elva Julia Ramos (the Jesuits' cook and her daughter). The six Jesuits, their cook, and her daughter were assassinated in November 1989 (see also no. 113).

Signed, to left of Romero, "[Camilo] Minero 1992."

Auditorium

37 Crucifixion, with the two thieves, one hooded as in modern torture, two Marys (Mary Magdalene wears Palestinian colors, according to the artist as homage to the suffering of Palestinians), and Nicodemus(?). Informally called by the

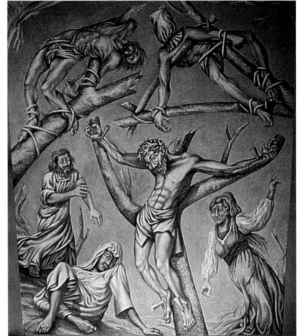

37b

37a

artist "Crucifixion in Central America; or, The Triumph of Neo-Liberalism." Signed, in roundel above, "Talamuro 1989." By Sergio Michilini, assisted by Nohelia Cerrato. 2.5 x 3.5 m.

Dormitory building, interior corridors

38 Female torsos on three walls, bound in ribbons of light, one with a pink *sacuanjoche* in place of a head. Signed, bottom left, "Aldo Soler 92 Cuba." Airbrush, 2.5 x .5, 1.5 x .5, 2.5 x 2.5 m.

39 Anthropomorphic vases. Signed, bottom right, "Vicente C[errato] Nic 92." 2 x 1.5 m.

40 Landscape with Indian warriors and an armless Spaniard, on three walls and ceiling. Labeled nearby "Victor Canifrú Chile 1992." 2 x 5, 2 x 5 m. (less doors), 1.5 x 1.5.

Exterior Walls, near entrance of Conference Building

41 Sandino and women washing by river; horsemen of his "Little Crazy Army," as his followers were called. Signed, bottom right, "L[eonel] Cerrato S." 1992. 3.5 x 5 m. Mosaic.

42 *Panamá, Diciembre de 1989.* Bare-chested figure grasping Panamanian flag, bowed under and chained to a beam inscribed "20 xii 1989" (20 December 1989, date of U.S. invasion); slain Panamanians, burning building (reference to the bombing of the barrio of Chorrillo); death's head in U.S. soldier's helmet; fence with sign "[NO]T Trespa[ss], Military, U.S. Government"; woman combatant with shirt inscribed "Batalló[n] Rosa L[andecho]"; male combatants (Rosa Landecho died in combat in an uprising against the United States in 1964).

Signed, bottom left, "Viyiyo Santizo [Panamanian Virgilio Ortega] x [October] 91."

2 x 3 m.

38

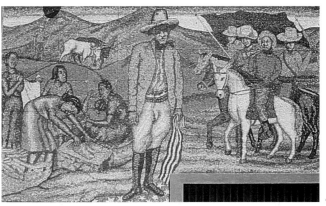

41

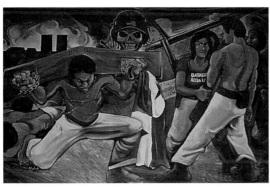

42

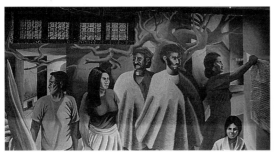

43

Exterior and back walls of Conference Building

43 Colombian liberation. Colombian flag; five three-quarter-length figures: man in plain gray T-shirt labeled below "Simón Bolívar"; woman in green top labeled "Manuela Sáenz" (1793/97–1856, known as "liberator of the Liberator," i.e., Bolívar); man in clerical collar wearing a yellow poncho, "Camilo Torres Restrepo" (1929–1966, a Colombian sociologist, revolutionary, and priest killed in combat, scc no. 96); frowning figure in white shirt and yellow poncho, labeled "José Antonio Galán"; woman pulling down notice to right, "Manuela Beltrán."

Winding in and out of doorway and branches of tree (of time), full length of mural: "Una nueva . . . arrasadora utopia de la vida donde nadie pueda decidir por otros hasta la forma de morir, don[de] de veras sea cierto el amor y sea posib[le] la felicidad y las estirpes condenadas a cien años de soledad tengan por fin y para siempre una segunda oportunidad sobre la tier[ra]." (A new overwhelming utopia of life where nobody can make decisions for others, down to the form of death, where love shall be truly certain and happiness possible, and the races condemned to

44

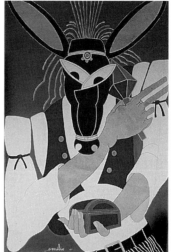

45

46

one hundred years of solitude shall enjoy at last
and forever a second opportunity on earth—
Gabriel García Marquéz, Nobel Prize accep-
tance speech).

The poster being pulled down, dated 30 Janu-
ary 1782, reproduces the sentence of death, with
details of disposition of limbs, declaration of in-
famy upon family, and so forth, to be inflicted
upon José Antonio Galán, a Colombian revolu-
tionary, leader of the popular "comuneros" revolt.
Manuela Beltrán, shown pulling down the poster,
was a tobacco worker arrested and executed for
pulling down posters announcing a cut in
workers' wages, one of the incidents that sparked
the revolt.

Signed, bottom right, "Colaboraron en este mural
Doña Elba Elbita, Edgar Emimio, Moritza,
Stella Marisol, Isabel, Francisco y Maximo.
Talamuro—Nicaragua. Daniel Pulido / 91."

3 x 6 m.

44 Sweden and America. *Counter-clockwise,
from top right:* Dragon, curled to form map of
Sweden, inscribed with Norwegian runes saying,
"After a long journey Leif Eriksson discovered a
new land, and this land he called Vinlandia—
Anders [Svensson, brigade member] wrote this";
Viking ship approaching Greenland; "Vinlandia,"

50

with birds (symbolizing Indians) meeting the Vikings; northeastern coast of North America; round Indian shield, with Indian artifacts; poster for American Line that disgorges a stream of Swedish immigrants along bottom of mural, among them the brigade emblem carrying a huge tube of paint; large portrait to right heading procession is of Joe Hill (1879–1915), Swedish-born songwriter for Wobblies (International Workers of the World), judicially murdered; behind him a banner: "Hay una fuerza que a la tierra conmueve ¡Solidaridad!" (There is a force that moves the earth. Solidarity!); *center, in oval*: slave ships, one with the three crowns of the Swedish monarchy and interlaced Gs, to refer to King Gustav III (reigned 1771–92); the other with black slave emblem to refer to Sir John Hawkins, English naval commander (1532–1595); *below*: peaceful Indians in jungle.

Signed, lower right, with brigade emblem and "Anders Svensson, G[öran] Willgren, Olle Johansson, Rune Andersson."

2 x 5.5 m.

Other building exteriors

45 Horse-headed Güegüense dancer. Signed, below, "emilio" [González]. 1991. 3 x 1.5 m.

46 *Alambre de Púa* (barbed wire). Signed, below right, "Cony [Gómez] & emilio [González]." 3 x 1.5 m.

47 Semi-abstract biomorphic forms. Signed, lower right, "Ruth Mougel" (France). .5 x 2.5 m.

48 Cluster of doll's houses, with one in tree. Signed, below, right, "Cony [Gómez]." 1.5 x 2 m.

49 Biomorphic versions of Nicaraguan petroglyphs, with incised lines. Signed, below right, "Armando Mejía G[odoy], Agosto 4 1991." 2 x 6.5 m.

50 "Sublimuis Deus [*sic*]." Mother, holding golden ball, and child, flanked by mythic figures. By Juan José Robles (Honduras). 1990. 3 x 8 m.

51 Woman's head (ceramic), fragment of mural from facade of Casa Nacional de AMNLAE, in Managua. By ENAPUM-DAS. Made July–August 1983. Destroyed September 1987 (see no. 108).

Lit. (whole scheme, overview): Vidaluz Meneses, "Las Obras de Arte del Centro de Espiritualidad 'Oscar A. Romero,'" *Amanecer*, no. 79 (August–November 1992): 53–54.

52

Escuela Nacional de Artes Plasticas (National School of Plastic Arts)

52 Satirical-historical-political map of the world composed of a mélange of stereotypes—historical, cultural, and political—with an emphasis on the political and on imperialist oppression. Detail shows Central America, with Sandino and helmeted soldier in dark glasses. Northern coast of South America, with figures, arms upraised to connote resistance, McDonald's arches, priest with cross. Off Caribbean coast, conquistador ship, firing cannon against natives, who respond with arrows. Cuba is filled with palm trees, out of which poke a large (Castroite) nose, mouth with cigar, and beard; smoke from cigar blinds soldiers emanating from Florida; beside them, Martin Luther King, other blacks. Over Mexico, Zapata, "Tierra y Libertad" banner, and conquistadores fighting Indians.

Signed "Autor: Brigada Internacional de Artistas de Jönköping, Suecia," composed of Rune Andersson, Jan Björkman, Olle Johansson, Li Kioko, Anders Svensson.

Photo 1987. Whole map about 3 x 3 m. Canvas. First shown in Jönköping and Göteborg, April–May 1984. Present location unknown.

Escuela Nacional Policial Walter Mendoza M. (National Police School, Carretera Sur, 11.5 km.)

Library, exterior wall

53 Police helping peasants, (A) teaching them to read; peasant, left of window, holds book inscribed "El Origen de la familia, Propiedad Privada, y el estado—Engels Marx" (The Origin of the Family, Private Property, and the State); seated figures are practicing writing revolutionary terminology; *right*, workers and soldiers.

Signed "Brigada Muralista Felicia Santizo Panamá '79."

3 x 6 m. (less window).

53a

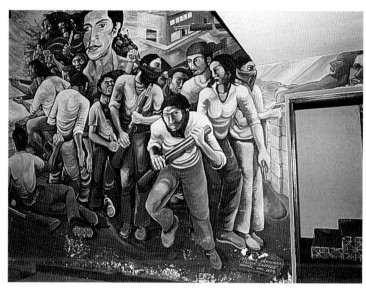

54

Conference Room

54 Fighters, male and female, at barricades, armed with knives, pistols, and shotguns, surge around a portrait of Walter Mendoza, wrapped in a red and black flag. The reclining figure, far left, about to throw a "contact bomb" (homemade grenade) wears cleated soccer shoes. Signed, bottom right, on stone, "Brigada Muralista 'Felicia Santizo' Panama, Nov. 1979." 3.5 x 3.5 m.

Former tennis court

55 *Left*: Group of guerrillas standing over a recumbent U.S. Marine, holding a knife at his throat; similar theme to right. Mural roughed out only. 3 x 6 m.

In storage

56 Three movable panels: Blond U.S. marines cut down by guerrillas, General Santos López and Sandino, Pedro Altamirano and another general. Originally panels may have numbered five or six. Each 3 x 1.5 m.

55

56

La Esperanza

Podium for cultural center (never built)

57 Murder and resurrection of Archbishop Oscar Romero. Seen through window of church, a soldier flees; Romero, in martyr's red, by the altar where he was saying mass when shot; mourning woman; Romero resuscitated, arms outflung; mass grave surrounded by mourners; peasants saluting Romero with signs: "If they kill me, I will rise again in my people" and "Romero of Central America lives among us." Inscribed, below right, "24 de Marzo de 1984."

By Maximino Cerezo Barreda.

3 x 10 m. Curved, deteriorated. Sketch for the mural is now in Romero's tomb in San Salvador.

Lit.: *El Tayacán* 3, no. 92 (17–23 March 1983): 6–7 (source of reproduction).

Gutiérrez, Miguel

Escuela María de los Angeles Larga Espada (named after adolescent martyr)

58 Four multicolored faces, indicative of different races. By Orlando Letelier Brigade. 1980. 3 x 10 m.

59 Profile of face, and arm holding forth book (inscribed "ABC"), against a sunburst. By Orlando Letelier Brigade. 1980. 3 x 9 m.

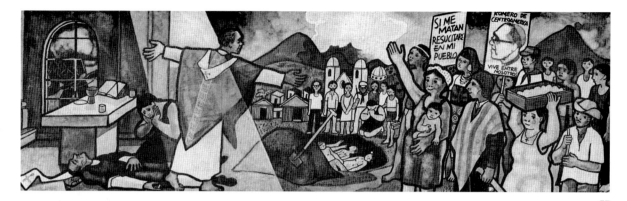

57

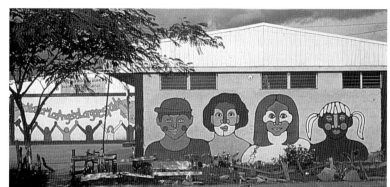

58

60a

Hospital Infantil Manuel de Jesús Rivera "La Mascota" (Children's hospital, named after a child martyr [1966–1978])

Playground

60 Animal fantasy, with Lenin fishing. *From far left*: Elephant's tusks (A) are black, green, and gold (colors of the African National Congress); figure (she is Earth) holds trunk of tree; golden hair flows through tree branch (a) into lake, where fishes (B) hold books by Karl Marx, Malcolm X, Carlos Fonseca; Lenin (C); *behind*, green hills shaped like woman's breasts, reclining face (mouth and nose visible); trumpet-horned rhinoceros (D) marks reach of woman's other hand.

Signed, left, on pillar: "Para los Niños de Palestina, Mike Alewitz—1989. Asistencia Claudio Rocha ASTC, Ventana." Sponsored by ASTC (Sandinista Association of Cultural Workers) and Ventana (New York).

2 x 21 m.

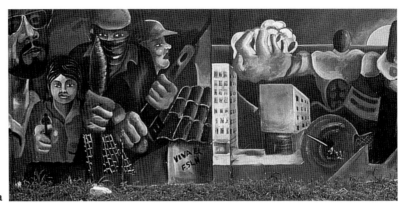

61a

62

Hotel Camino Real area, Carretera Norte (North road)

Former Tecnisa Garment Factory (Complejo Camilo Ortega), now a print works

61 Helmeted conquistador (A) brandishing cross-handled dagger; horses, church, native with club; (B) Sandino, peasants, one with rifle, death's heads, weapons, U.S. flag; (a) Carlos Fonseca, armed Sandinistas, production. By the Mexican artist Guerrero. 3.5 x 24.5 m. Destroyed about 1984.

62 Portraits of Simón Bolívar, Sandino, and Carlos Fonseca. Signed, top left, "Guerrero." 3.5 x 7 m.

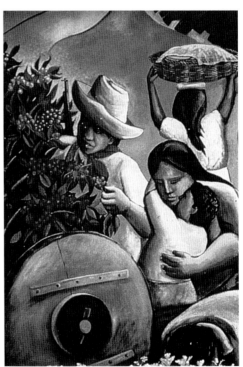

65

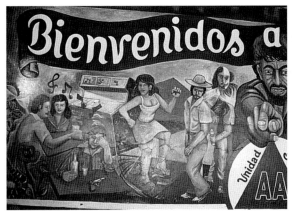

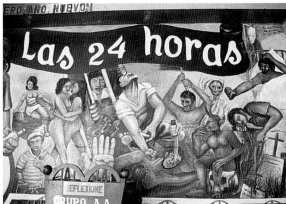

66a 66b

Instituto Nacional de Energía (INE)

63 Village life, electrical pylons, Sandino, children, dove, Rigoberto López Pérez, Carlos Fonseca, agriculture and industry. By the workers of INE (National Energy Institute). About 1984. 3.5 x 14 m. Very crude.

Larreynaga

In patio by church, below stage platform

64 *La Solidaridad es la ternura de los pueblos* (Solidarity is the affection of peoples). Hands clutching guns reach toward rainbow. In sky, *right*, "Despues del primer paso no pararemos de andar jamás" (After the first step we will never stop).

Signed "Brigada Rodrigo Peñalba ENAP [National School of Plastic Arts] 1983." Designed by Sergio Michilini.

Lit.: reproduced in progress, Michilini p. 32.

Mercadito San Juan, Centro Comunitario Roger Deshon Argüello

65 *Levantando la producción* (Raising Production), in five sections, including scenes of picking coffee, loading bananas.

By Boanerges Cerrato, Leonel Cerrato, Francisco Rueda, John Pitman Weber (United States), and Daríon Zamora. Sponsored by ASTC (Sandinista Association of Cultural Workers).

6 x 15 m.

Lit.: *Community Murals* (Spring 1985): 11, with photo of whole; "Muralista, norteamericano, y amigo de la humanidad!" *El Nuevo Diario* 24 January 1985 (the headline plays upon the Sandinista anthem, which characterizes yanquis as "enemies of humanity").

Mercado Oriental

Alcoholics Anonymous Center

66 *Interior: Bienvenidos a las 24 horas* runs across top. *Left:* (a) Contrast of (legitimate) pleasure and alcoholic degradation: music, dance, companionship in a disco; man sitting with pistol and bottle before him; figure (to right of dancers) in alcoholic stupor; *center:* (A) man, bottle in hand, challenging spectator. *Right:* (b) Homicide, prostitution, lesbianism, jail, drug addiction, suicide, murder, death, devil amid the flames of hell. Two serpents, one below and another, *far left*, among roses.

Signed, top right, "Ricardo Morales / Martin Espinoza NIC 1990."

2.5 x 8 m.

68a

68b

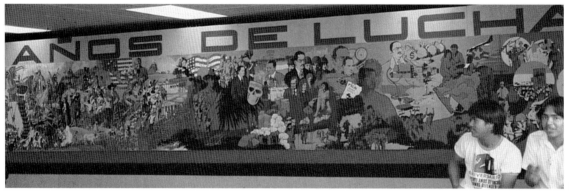

68c

68d

68e

68f

68i

68g 68h

68j 68k

67 *Exterior:* Woman with book; alcoholic with bottle. 1 x .5, 1.5 x 2.5 m.

Mercado Roberto Huembes

Panels in entrance to temporary exhibition of documentary photographs entitled "Twenty Years of FSLN Struggle" (July 1981)

68 History of Nicaragua. The indigenous people (A, d), drawn in the style of, and with motifs from, pre-Columbian art, shown suffering and enslaved; the conquistadores (e), clerical and military, loot, kill, and destroy. A cross (a), formed of spears and swords and documents (used to justify conquest), is enwreathed with serpents sacred to the conquered. 17th to 18th century: (f) British pi-

rates, bringing African slaves, attack the Spaniards from the Atlantic coast. Below, the native Indian continues to plough his field of maize; large figure in blue coat and broad hat (g) probably represents British plantation owner; William Walker, filibuster from United States (depicted as an older man; he was thirty-two in 1856 when he invaded Nicaragua), carries the manacles of the slavery he sought to reimpose as president of the country. A railway line snakes from a map of Central America superimposed on the U.S. flag, past symbols of wealth and luxury and a portrait of Cornelius Vanderbilt, who presides over scenes of cotton and coffee harvest, carried on the railways and ships he owned; Sandino (i), backed by a sun breaking through a U.S. flag; U.S. soldiers, guerrillas. (B) Poet Rigoberto López Pérez assassinates Anastasio Somoza I at a banquet in León (1956). Above, bust of his successor and son Luis Somoza, who stepped down in 1963 to install as interim president René Schick, represented here as a glove puppet in the hand of another son, Anastasio Somoza II, true power in the land as head of the National Guard, shown as a marionette of United States—he stands left of skull marked "Democracia," for fraudulent democracy of Somocista regime—and again, to right of assassination and Luis, surrounded by guards. Anastasio II had himself elected president in 1967; held that office until 1979. Somocista regime: (C) Naked woman and jailed figure over large red

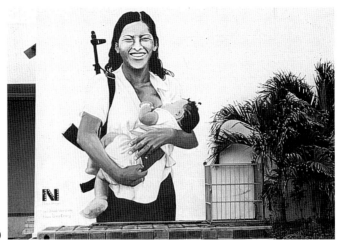

70

blot (whose upper edge forms silhouettes of National Guard), which bleeds over landscape with guerrillas. Blonde woman portrayed centrally above blot is Nicolasa Sevilla, who led a female storm troop under Somoza; Carlos Fonseca with FSLN "Ideario Politico"; (e) Anastasio Somoza II, with money bags; crumbling building and construction refer to 1972 earthquake; image suggests Somoza profiting from disaster (see p. 4). FSLN militants below; (j) map of FSLN strategy for pincer movement on capital; Somoza cracks; (k) Triumph of Sandinistas; scenes of reconstruction, symbol of literacy campaign.

Artist(s) and present location unknown.

Panels totaling about 1 x 8 m.

Inside market: five major murals

69　Three murals of village life by the primitivist Manuel García, each 4 x 4 m. Artisans at work, geometrically stylized view by Mexican assistants of Arnold Belkin, 1987, 3 x 5 m. (reproduced); women market vendors, with lines by Rubén Darío beginning "El corazón del cielo late" and ending "En nosotros corre la savía / Del universo" (The heart of heaven throbs, . . . the sap of the universe runs in us), by the Mexican Luis Felipe de la Torre, 1987, 6 x 6 m. The last, destroyed 1994.

Metrocentro

Wall facing crossroads

70　Woman suckling child, with gun over her shoulder—based on well-known photograph, copied as far away as Belfast, Ireland, where it forms the centerpiece of a mural entitled *Nicaragua Must Survive* (reproduced in Bill Rolston, *Drawing Support: Murals in the North of Ireland* [Belfast: Beyond the Pale, 1992], pl. 110)—signed "N Nueva Imagen. Foto: Orlando Valenzuela / Pintura Chico Emery." 3.5 x 3 m. Destroyed about 1990.

Monseñor Lezcano

Restaurant en Segovia, patio

71　Musicians, volcano, peasants carrying fruit on a pole that rests on their shoulders. Signed, bottom left, "[Camilo] Minero 1988." 2.5 x 5.5 m.

Casa Ben Linder, Fundación Nicaragüense por Desarollo Comunitario Integral (FUNDECI, Nicaraguan Foundation for Integral Community Development, supported by Episcopalian and Methodist churches in United States): three murals depicting the life of Ben Linder

72　*Facing street:* Before a primitivist village landscape, children with grasshopper; people building houses; children following Ben Linder

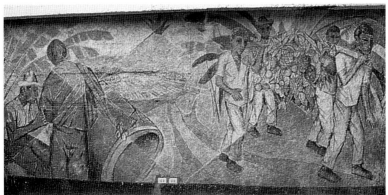

71

72

as a clown on a unicycle (perhaps a reference to the occasion when during a measles vaccination campaign in the village of El Cúa, Linder drew spots all over his body, juggled four balls, and rode his unicycle down the village's one dirt street to the clinic, to the amazement and delight of the children); *right*, going to school under a mango tree.

2.5 x 8 m.

Color reproduction: *Masaya sin Fronteras* 1, no. 2 (January–March 1993): cover.

73 *Courtyard*: In a whirlwind from western United States, a vision of Linder (born in Oregon) as a boy with his father watching an electrical storm; he decides to become an electrical engineer; the profession is inscribed on the knapsack behind him as he stands (now a university graduate) on a cliff speaking to a cloud/grasshopper, which, according to a poem about Linder by Michelle Najlis that influenced these murals, is called good luck and hope (a common symbolism for grasshoppers in Nicaragua). In the Najlis poem Ben asks where hope is found. The grasshopper answers, "In Nicaragua," warning him that it is also where people with hope get killed.

2.5 x 4 m.

73

74

74 *Courtyard:* In San Juan del Bocay, Matagalpa region, Linder observes the electrical light he has brought to a house. *Top right*, a grasshopper above a madroño tree cries, and tears slide down a rainbow to Linder's grave, where flowers bloom (Najlis's poem is called "His Name is Rainbow"; Linder was murdered by contras, along with two Nicaraguan co-workers, at a hydroelectric plant near San Juan del Bocay on 28 April 1987; he was twenty-seven years old).

2.5 x 5 m.

Signed, bottom left (on no. 72), "Thelma Gómez F[lores], Freddy Gaitán [Esconcio] Nic., 12/92."

Finished early 1993.

Casa Ave Maria, patio

75 *The Visitation*, or, *Under the Volcano. Left* (a): Virgin Mary greets her cousin Elizabeth, each with her miraculous baby ("two unborn liberators") leaping in her womb. The basket of fruit on Elizabeth's head refers to the Gospel phrase "He has filled the hungry with good things" (*Luke* 1:53). A rosary of polygons with symbols of the sacrifices women have made in the social struggle; the polygons above are in gold leaf; *center, top row*: portraits of Blanca Aráuz, wife and collaborator of Sandino; Arlen Siú; Luisa Amanda Espinoza and María Zuniga, early martyrs of revolution; Nora Astorga, the Judith, as she was called, who trapped a Somocista torturer after luring him to her bed (after the United States refused to receive her as ambassador, she was made ambassador to the UN), who died of cancer at thirty-nine; patriot and singer Norma Elena

75a

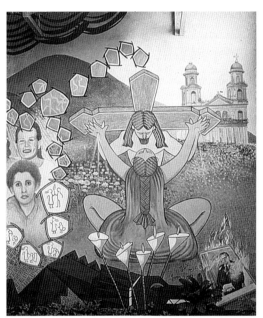

75b

Godea; *bottom row:* Casa Ave María workers: Maryknoll Sister Rita Owzarek; Anglican medic Dorothy Granada; social programs co-ordinator Mirium Lazo Laguna; human rights and social worker Sister Mary Hartman; Florentina Pérez, mother of martyr María Zuniga and herself a heroine; and Dora María Téllez, former comandante and minister of health, now a member of the National Assembly; *right* (b) Christ on the cross leans forward to kiss his mother, who sits with legs parted. Her hands share his wounds. *At far right,* a photograph of the last Somoza, burning in its frame, and the ruined cathedral swarming with triumphant revolutionaries—both motifs, based on famous photographs by Susan Meiselas, illustrate the Gospel verse "He has put down the mighty from their seat and has exalted the humble and meek" (Luke 1:52). Lily-candles behind Mary; and running the length of the whole mural, below, the dragon of Revelation, signifying (according to Grant Gallup) militarism and economic privilege. A volcano behind spouts lava.

Signed, bottom right, with four signatures/initials of Grupo Artistico Contraste. Names of women portrayed are inscribed on the wall to left of mural. Sponsored by the Reverend Grant Gallup of Casa Ave María, a U.S. Episcopalian-supported center, to whom the above interpretation is mainly indebted.

Inaugurated 19 July 1992. 4 x 8 m.

Lit.: *Tampa Tribune* (Florida), 10 January 1993, commentary p. 1; *Anglican Advance* (Chicago) 106, no. 1 (February 1993): 20.

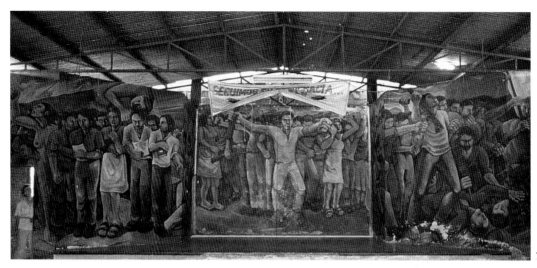

76a

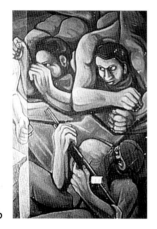

76b

77

Nicarao

Community Center

76 Insurrection. *Left:* Mass of figures with tools and books; *center:* Angry protest; *right:* (A, B) Barricade, with guns, pistols, grenades, and machete. Figure at extreme right holds dagger at throat of fallen National Guardsman. Black and red flag above.

Signed, bottom left, "Vitch Ortega Santizo 17 Oct. 1980 . . . [p]oder popular" (popular power). By Felicia Santizo Brigade (Virgilio Ortega alone, his last mural on this campaign).

4 x 15 m. Seven-sided mural, an inverted U whose arms splay out from center. Paint peeling at bottom and upper-right corners. Restored 1994.

78

79a

79b

Las Palmas

On wall around home of former president
Daniel Ortega

77 *Mural de la Dignidad* (Mural of Dignity).
The work of a dozen Nicaraguan artists, the
mural was an effort to prevent the mayor of Ma-
nagua from knocking down the wall. A dozen dif-
ferent designs, none overtly political, several in
the primitivist style, including Festival in León
(reproduced), signed, upper right, "Olga Mar-
adiaga Z[uñiga], León (S) Nicaragua 90." 3 x 5 m.

June 1990–July 1991. 3 x 75 m.

Print shop, exterior

78 Women and men printing; *behind*, children
reading. Two abutting walls, by Giancarlo Splen-
diani (Italy), with students of ENAPUM-DAS. In
true fresco, 1987. 3 x 4, 3 x 1 m. Destroyed 1994.

Pancasán

Escuela Radiofónica de Nicaragua (German-
supported Radio School of Nicaragua, for instruction
in agriculture), lobby

79 View (a) of hilly countryside of Segovias (Ve-
necia, Estelí, is intended), with project for drink-
ing water and latrine depicted; woman on steps of
house in foreground is reading *La Voz del Cam-
pesino*; inside house, peasants with textbooks (one

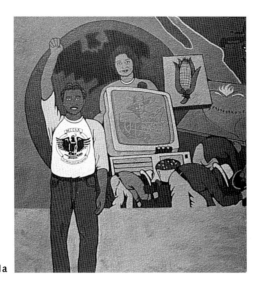

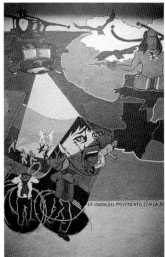

81a 81b

of them real, glued on); (b) peasants watching an educational film. The mural incorporates three steel pilasters, two erased by the design, the third illusionistically enhanced as part of the painted interior of the house.

By Federico Matus, assisted by Ricardo Gómez.

February 1990–February 1991. 2.5 x 1, 2.5 x 3.5 m.

Plaza España, Parque de las Madres (Mothers' Park)

Teachers' Union Building and Móngalo School

80 *Dawn. Center:* Against a huge flourishing chilamate tree (a real one grows opposite), child and adult being taught to write by literacy campaign workers. Child writes "La Solidaridad es la ternura de los pueblos" (Solidarity is the affection of peoples), on a sheet of paper resting on a larger book open at a page inscribed "Después del primer paso no pararemos de andar jamás" (After the first step we will never stop)—Ricardo Morales Avilés; *left:* a mass demonstration with children in the foreground and banners behind them saying "Solo La Unidad nos hará fuertes y respetados—ANDEN" (Only Unity will make us strong and respected—Nicaraguan Teachers' Association), "Marcha por la Dignidad," "Muerte

al Somocismo," "Operación Justicia," and "F.S.M.N." (Federación Sindical de Maestros Nicaragüenses, Federated Union of Nicaraguan Teachers). A building behind is marked Escuela Emanuel Móngalo; *right:* digging; picking cotton and coffee; music. In background a figure paints "Solidaridad" on pink banner that winds across whole mural, starting in blue and white and becoming red and black over school.

Signed, far left, " 'El Amanecer' Mural hecho en solidaridad por el grupo Placa-Nica de San Francisco de California: Juana Alicia, Miranda Bergman, Ariella Seidenberg, Arch Williams; Artistas Nicaragüenses: Hector Noel Méndez, Nohelia Cerrato, Boanerges Cerrato, Vicente Cerrato, Pablo Paisano, Rosa López Hernandes, © 1986." By 1992, very faded; reconstituted and signed, bottom right, "Reconstituido por Leonel Cerrato, Vicente Cerrato, David Kunzle, Orlando Pastora, Pablo Paisano Feb. 1993."

Lit.: "Cuatro Pintores de EE UU nos regalan enorme mural, Pinceles contra la injerencia," *Nuevo Diario,* 28 September 1986.

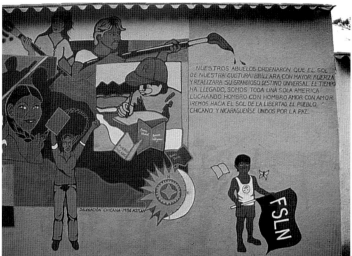

81c

Former Sandinista Youth Building, rear wall

81 Chicano-Nicaragua solidarity, depicted against the background of a map of southern Mexico and Central America. *Left* (a): Youth wearing T-shirt inscribed MEChA (Movimiento Estudiantil Chicano de Aztlán, Chicano Student Movement of Aztlán) and motto "La Unión hace la fuerza" (Union gives strength) around emblematic eagle. Behind him, a circle bearing the stylized eagle emblem of the United Farmworkers Union (UFW); TV screen saying "Sandino presente en Aztlán," with portrait of Sandino surmounting map of United States, the seven southwestern states claimed for the mythic Chicano homeland of Aztlán marked in blue; above TV, portrait of Dolores Huerta, founder and vice president of the UFW; farmworkers in field; maize cob symbol, flaming heart with thorns (popular Chicano religious symbol); *center* (b): armed police/immigration helicopter arriving from north, beaming searchlight down on undocumented workers, who flee through barbed wire back into Mexico and Central America; Face of frightened child; (A) pre-Columbian figures and motifs; Latinas / Chicanas holding braids of hair, with cala lily; below them, a dark-complexioned girl representing Nicaragua's Atlantic coast; *right* (c): literacy. Defiant figure brandishing book "Dios y Hembra" (God and Female); boy writing, with books marked "Pueblo Chicano," "Jaime W[h]eelock Raices Indígenas" (*Indigenous Roots [of the Anticolonialist Struggle in Nicaragua*, 1980]), and "Rubén Darío"; sun/moon with four compass points; *above*, figures brandishing pen and paintbrush like great pikes; *below*, small boy bearing FSLN flag (his head was defaced in 1990 [see figure p. 15], since restored), with lines above that translate: "Our forefathers ordained that the sun of our culture shine with greater force and realize its grand universal destiny. The time has come, we are all one single America struggling shoulder to shoulder, love to love, we will move toward the sun of liberty. The Chicano and Nicaraguan peoples united for peace."

Inscribed, below, center, "La Unión del Movimiento [Chicano] con la Revolución," and, right, "Delegación Chicana 1986 Aztlán [added later], pintado por Carlos Callejos, Barbara Carrasco, Yreina Cervantes, Kathy Gallegos, Francisco Letelier, Brigada Orlando Letelier." Mural was executed July 1986, with the help of a number of Chicanos and others from Southern California, and in consultation with the Nicaraguan artists Leonel Cerrato and Raúl Quintanilla.

82a

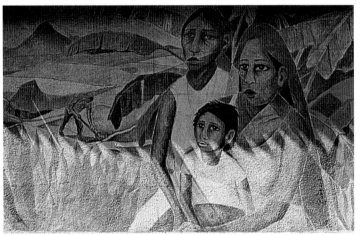

82b

Next to Chicano solidarity mural (no. 81)

82 Salvadoran Solidarity: (A) Peasants, pre-Columbian sculpture, contrasting profiles of indigenous brown face and ancient Greek type; outstretched arm of struggle; (a) bust portraits of Carlos Fonseca, comandante Ana María, Farabundo Martí, and Sandino (*above*); (b) landscape with fire, and peasants (Salvadoran refugees?). (Comandante Ana María [Ana Mélida Montes], second-in-command of the Fuerzas Populares de Liberación in El Salvador, was assassinated in Nicaragua in 1984. Farabundo Martí was an associate of Sandino but, unlike Sandino, a Communist, leader of the insurrection in El Salvador

until his execution in 1932. The current liberation front in El Salvador is named after him.)

By Camilo Minero, a Salvadoran refugee.

About 1987.

Plaza España area

"El Chipote," former military base and secretariat of FSLN National Directorate, perimeter wall

83 *Side wall:* Literacy, cotton, corn, coffee; *main wall:* Nicaraguan and FSLN flags; Somocista plane and tank; FSLN guerrillas; (a) Carlos Fonseca, Sandino's guerrillas in black and red bandanas, U.S. marines in helmets, seen from back, shooting; (b) slain peasant; Rigoberto López Pérez; "Seal of Sandino" motif (see figure

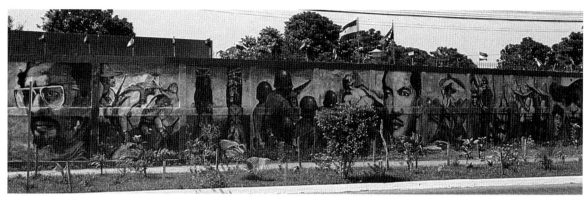

83a

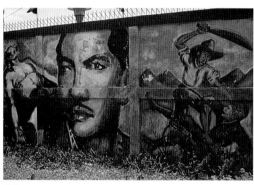

83b

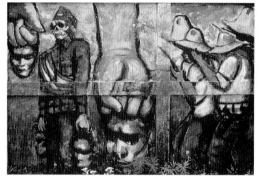

83c

p. 3); (c) skull-headed U.S. soldier, draped in
U.S. flag, carrying severed heads of Nicaraguan
opponents (motif based on photograph, re-
produced in Black 1988, p. 44); either side of him,
enlarged details of carrying hand and severed
head; Sandino's peasant guerrillas; (A) Sandino
with faces of other Nicaraguans.

A (pre-existing) plaque, incorporated to right of
portrait of Sandino, reads: "Secretaría de la Direc-
ción Nacional Conjunta 'El Chipote.' La causa
del F.S.L.N. es la causa de los explotados y
oprimidos que lucharon por hacer nacer la revo-
lución en nuestra patria. Patria Libre o Morir. Jor-
nada Heroica de Pancasán. Cte Germán Pomares
Ordoñez. 1967 1979" (Secretariat of the Joint Na-
tional Directorate "El Chipote." The cause of the
FSLN is the cause of the exploited and oppressed
who struggled to give birth to the revolution in
our homeland. Free country or death. Heroic
Day of Pancasán . . .).

By Róger Pérez de la Rocha and others.

August/September 1979. Deteriorated, painted
over circa 1983.

Interior wall of "El Chipote"

84 *Un solo ejército . . .* (A Single Army). Portraits
of Rigoberto López Pérez, Germán Pomares,
Sandino, and others, with women in uniforms,
and a base formed of barricade blocks. Orlando
Letelier Brigade. July 1980 (destroyed). Lit.: *Com-
munity Murals* (Fall 1981): 8, with photograph.

Former Mural School (ENAPUM-DAS, then part of
Ministry of Culture building complex, now Sports
Institute; premises currently occupied by Sculpture
Department of National School of Plastic Arts),
corridor, twenty-five artworks on walls

85 Flowers, signed "B[eatrice] Wild" (Ger-
many), 1986, 2.6 x 1.1 m.

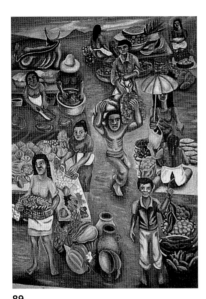

89

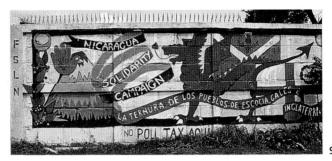

91

92a

86 A wheel, placed above a hilly green land-scape, is divided into eight segments showing various cultural activities of Mongolia. Signed "N. Sanchir, Mongolia 1985" (artist was Mongolian minister of culture). 2.6 x 1.9 m.

Lit.: Design is visible in Michilini, p. 44.

87 Woman giving birth, signed "Cecilia [Salaverry] Nic '87." Fresco. .9 x 2.4 m.

88 "Poema con dos figuras," signed "Daniel Hopewell." Also by Oman Díaz? Fresco, 1989. 2 x 2.6 m.

89 *El Mercado*, signed, "Autor Oman Díaz. Colaborado: Daniel Hopewell." 1987. 1.9 x 2.6 m.

90 *The Muse of Art Guiding the Young Painter.* Tall Roman-draped figure with hand, holding a scroll, on shoulder of smaller figure, looking at mural-within-mural (wisdom derived from murals?), signed "G[iancarlo] Splendiani" (Italy). First true Fresco in Nicaragua, 1985. 1.9 x 2.6 m.

"El Chipote," adjacent to wall of no. 83

91 Inscribed "Nicaragua Solidarity Campaign. La Ternura de Los Pueblos de Escocia, Gales y Inglaterra" (Affection of the peoples of Scotland, Wales, and England) unwinds on a scroll, from symbols of Nicaraguan coffee, bird, and volcano to the heraldic dragon of Wales and the flags of Scotland and England. Below, "No Poll Tax aquí" (referring to unpopular British tax, withdrawn after massive protest). Scroll appears to run into a multicolored snake, which unwinds past a spiraling sun under the (1990 electoral) slogan "Ganamos todo será mejor" (We won/win; all will be better); this segment is signed, at left, "Comité Français de Solidarité Nicaragua Libre," and, at bottom, "Shrunkel 90."

92b

93a

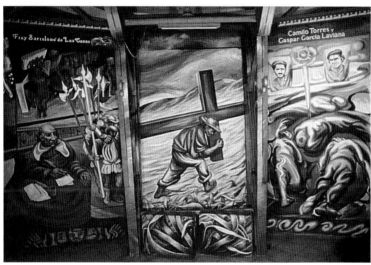

94a–96a

Riguero

Iglesia Santa María de los Angeles, fifteen murals, *History of Nicaragua: Reading from entrance toward altar*, nos. 92–98, left to right, north wall; nos. 99–106, right to left, south wall. Names and phrases italicized are inscribed above artwork.

92 Polychrome sculptures over entrance: Priest, (a) the goddess of maize Xilonem; *Tamagastad* and *Cipattonal* (Zipaltoval), creators of heaven and earth; (b) goddess of fertility (woman in labor); priest. .55–.65 m. high. Lit.: reproduced in color in Michilini, pp. 26–27.

93 (A) Native leader *Diriangén* and (a) conquistador *Gil Gonzáles Davila*, armored on horseback, with features of Anastasio Somoza II, who transfix each other with lances. 2.6 x 2.3 m.

94 *Fray Bartolomé de Las Casas*, writing letters protesting torture of Indians (depicted above). 2.6 x 1.5 m.

95 Peasant bearing the cross "through the paths of exploitation" in the colonial era. 2.6 x 1.5 m.; plinth .7 x 1.3 m.

96 Portraits, drawn to resemble posters, of the Colombian sociologist, revolutionary, and priest *Camilo Torres* (1929–1966) and the Spanish-Nicaraguan priest and poet *Gaspar García Laviana* (1941–1978), fixed on arms of cross, whose bloodied base pierces one of several corpses of anonymous martyrs, that "illuminates the world." 2.6 x 1.5 m.

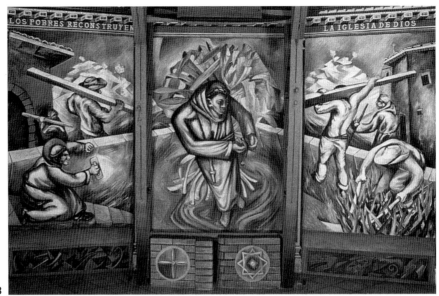

98

97 *Luis Alfonso Velásquez: David contra Goliat.*
The famous child martyr (see figure p. 47), who
lived in the Riguero barrio, with musicians
behind him, fearlessly confronts three-headed
armed beast (Somoza's thugs). 2.8 x 2.8 m. *David
and Goliath* is the title of a book (1987) about
Nicaragua and the United States by William I.
Robinson.

98 *S. Francisco: The Poor Rebuild the Church of
God.* St. Francis following God's order to rebuild
his church. In three parts: *left,* St. Francis work-
ing as a mason; *center,* St. Francis holding a
guardabarranco (national bird of Nicaragua);
right, people build, with St. Francis in middle
ground. 2.8 x 5.3 m. Done in high-relief colored
clay.

99 *Cacique Nicarao,* the indigenous philoso-
pher chief, surrounded by tropical, "paradisaical"
vegetation. 2.6 x 2.3 m.

100 *Mons[eñor] Antonio De [sic] Valdivieso,* op-
posing heavily armored landowner, who rides his
horse over the corpse of a peasant. Antonio Val-
divieso, bishop of León, 1544–50, was the first
bishop martyr of Latin America. 2.6 x 1.4 m.

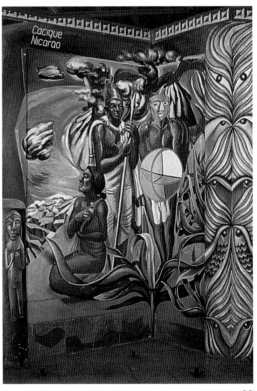

99

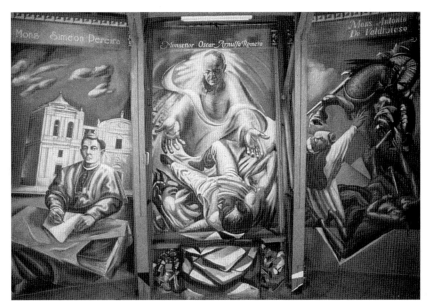

100–102

101 *Monseñor Oscar Arnulfo Romero.* The arch-bishop of San Salvador, "San Romero de América," a collar of blood around his neck (referring to his assassination by the Salvadoran military in 1980), reaches out compassionately over the body of a dead youth, representing the Salvadoran people. 2.6 x 1.5 m.; plinth .9 x 1.0 m.

102 *Mons[eñor] Simeón Pereira* (1863–1939; bishop of León), shown writing in protest of U.S. invasion in 1920s, with church of León in background. 2.6 x 1.35 m. Lit.: Reproduced in Michilini, p. 38.

103 *Sandino: La historia de las hormigas* (The Story of the Ants, a reference to Sandino's saying that after his death, the ants [the people] would leave the earth to enjoy his posthumous victory). Sandino stands to right with Nicaraguan flag; Carlos Fonseca to left, with FSLN flag; children, one of them wearing the revolutionaries' Güegüense theatrical mask, rush up a roadway paved with "Somoza stones." On a reproduction included in a set of five cards published by ACRA, entitled ¡Sé tú solidario tambien!, this painting is credited to Maurizio Governatori. 2.8 x 3.3 m.

104 *Azarías Pallais*, anticapitalist, anti-imperialist poet and priest, who died in 1954. 2.8 x 1.7 m. Reproduced in color in Michilini, p. 51.

105 The Annunciation, polychrome high relief sculpture. 2.8 x 1.5 m. Reproduced in color in Michilini, p. 51.

106 The *Barreda* couple, "*Somos Christianos . . . Somos Revolucionarios.*" Felipe and Mary Barreda, husband and wife, picking coffee and defying the contras. (They were tortured and murdered in January 1983, saying the words quoted above. See the biography by Teófilo Cabestrero [Managua: Tayacán, 1984].) 2.8 x 3.6 m.

107 The Resurrection (*over altar*). *Below, left*: the liberation of women; *center* (B), the people carrying the cross ("of imperialist oppression"), *foremost*, a man wearing a Sandinista military jacket; *right* (b), mothers bearing photographs of heroes and martyrs; *above, left*: sugar harvest; *center* (A), resurrected Christ, with stigmata, wearing

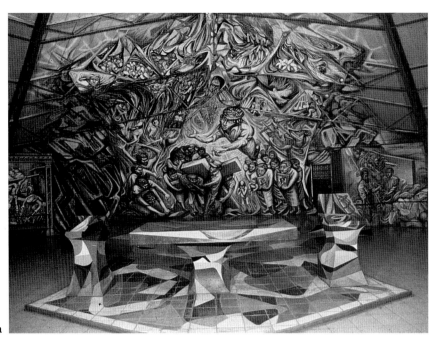

107a

Nicaraguan peasant headband; *right*, the joy of children; *toward ceiling*: dove of peace, (C) tropical nature ("an earthly Nicaraguan paradise"), Atlantic coast, *sacuanjoche*, coffee, cotton, sugar, maize, night and day (masks). 150 sq. m.

Most paintings by Sergio Michilini, who directed the project. Other painting, ceramics, and decorations by Giancarlo Splendiani and Maurizio Governatori (no. 103). Ceramics by Gianni Berra. Architectural advice by Clementino Sartori. With the collaboration of twenty-two Nicaraguan students and four foreign students. Project of ENAPUM-DAS. Sponsored by Associazione Italia Nicaragua Ancona, Centro Documentazione America Latina—Varese (Italy), MLAL (Movimiento Laici America Latina) Roma, ACRA (Associazione di Cooperazione Rurale in Africa e America Latina) Turin (Italy). Commissioned by parish priest Uriel Molina

July 1982–July 1985. 680 sq. m. complex of decorations, mainly acrylic paint on plywood, with ceramic sculpture and found objects.

Lit.: Kunzle 1989; Pérez Díaz, pp. 26–31; Michilini (measurements and passages in quotation marks are from this little book, which includes

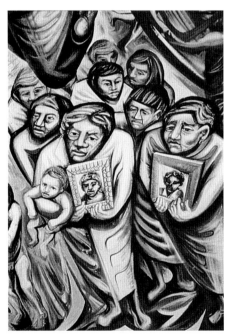

107b

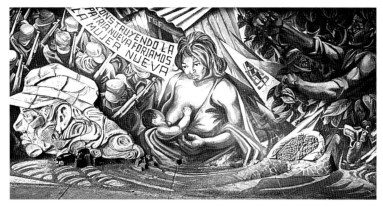

108a

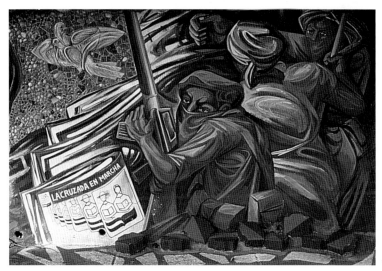

108b

many excellent color plates, details, photographs of decorative segments and other parts not reproduced here, ensemble views, and a rejected design of 1982, p. 36; this text incorporates Pérez Díaz; reviewed in *Ventana*, 9 September 1989, 12); "Un Arte Integrado" (interview with Michilini), *Nuevo Amanecer Cultural*, 27 June 1985).

A photographed list published by the Ministry of Culture and preserved in the Michilini-ACRA archive, "Recopilación de Articulos . . . ," dated 1 May 1987, includes thirty-three items relating to this cycle from the Nicaraguan press (nearly half of them from *El Nuevo Diario*), ten from Italy, and five others.

San Juan

Casa Nacional Asociación de Mujeres Nacional Luisa Amanda Espinoza (AMNLAE, Headquarters of the National Women's Association).

108 *Woman in the Construction of the New Nicaragua.* Head of woman (a) in uncolored clay relief; armed, massed women; woman seated, suckling infant, with banner "Construyendo la patria nueva forjamos la mujer nueva" (Building the new fatherland, we forge the new woman). Hut marked TGF and flag marked JPS (Jornadas Populares de Salud, Popular Health Campaign). Woman with pistol at hip picking coffee; (b) dove of peace over mosaic ground; women wearing black and red bandanas over faces, defending a

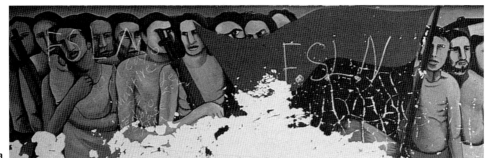

109a

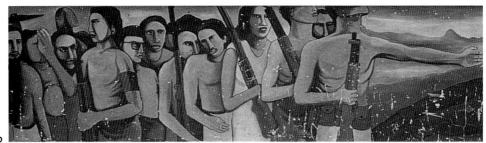

109b

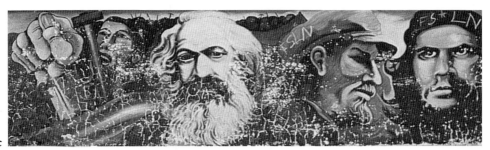

109c

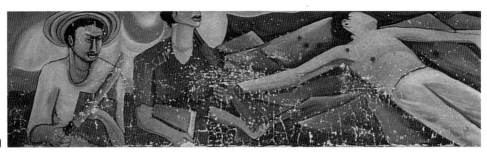

109d

109e

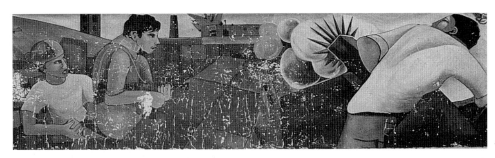

109f

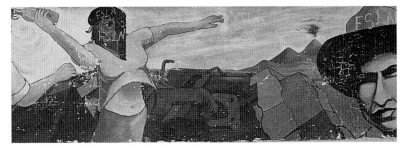

109g

barricade, whose stones painted red and black, become three-dimensional and real, spilling into real street. A page of a book is headed "La Cruzada en marcha" (The [literacy] crusade on the march).

Signed, lower right, "Brigada Muralista Rodrigo Peñalba Agosto 1983" (Sergio Michilini and members of the ENAPUM-DAS; first public work of Mural School).

Destroyed 4 September 1987; clay head, bottom left, salvaged and placed in Centro Espiritual Monseñor Oscar Arnulfo Romero (see no. 51).

Lit.: Pérez Díaz, pp. 21–22, with letters protesting destruction and before-and-after photographs, p. 33; Michilini, p. 44; *El Andamio* 1 (November 1987): 14.

Santa Ana

Carretera Sur 8 km., former barracks, exterior wall, two-part mural

109 (a, b) Two dozen armed figures, including a mother and baby, with FSLN flag; (c) portraits of Marx, Lenin, Che; (d) combatants with machete, rifle, and books; (e) slain figures on barricade; shooting pistols at barricade; (f) mortar; (g) woman throwing Molotov cocktail; portraits of Sandino, (A) Germán Pomares, Carlos Fonseca, and Faustino Ruiz.

Signed, far right, below Pomares and Fonseca: "Brigada muralista Felicia Santizo, Panamá Oct. 1979" (see figure p. 74).

1.5 x 25 m. "FSLN" later graffitoed on hats of Lenin, Che, Sandino, and Pomares.

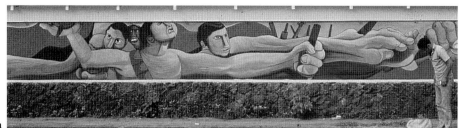

110a

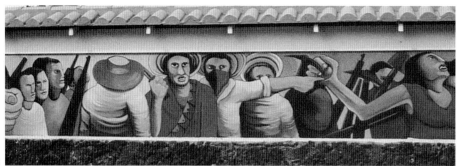

110b

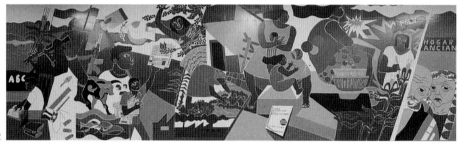

112

110 Figures of men and women at barricades with (a) immensely elongated arms, reaching, (b) pointing, preparing to throw grenades. Signed, far left, below, "Brigada muralista Felicia Santizo Panamá Sept. 1979."

Sotelo, Casimiro

Instituto Nacional Rigoberto López Pérez (primary and secondary school), opposite INE (National Energy Institute), vestibule

111 Figures carrying Nicaraguan and FSLN flags, machete, gun, and torch (which illuminates book with portrait of Rigoberto López Pérez) surge forward; *above, left*: an eagle with U.S. dollar bills in its beak, toward which Sandino points

from behind a mountain marked FSLN; *to right*: learning to write, picking coffee, portrait of Carlos Fonseca with dove of peace, construction.

Signed "Por David Fichter de Cambridge, Massachusetts. En solidaridad con Nicaragua libre. Patria libre o morir. 1984."

3 x 4 m.

Lit.: *Community Murals* (Summer 1984): 12–13.

Tenderí, Colonia

Instituto Nacional de Seguro Social y Bienestar (INSSBI, social security headquarters), auditorium, Modulo E

112 *La Revolución.* Literacy, soldiers with guns, Nicaraguan flag, oxen and fishes, newsboy (see figure p. 11), picking coffee, planting, "CDI"

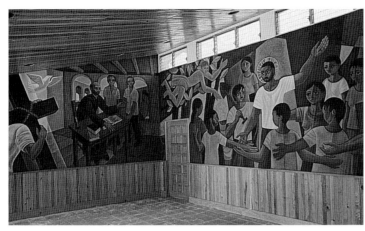

113–114a

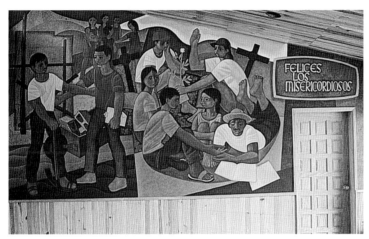

115

(Centro de Desarollo Infantil), mothers with children playing, FSLN flag, maize, old people before "hogar de ancianos" (old people's home). Signed, bottom left, "Diseño Original—A[lejandro] Canales, Colaboradores F. Canales, P. Matute, Patrocinado: INSSBI. Título: Revolución 1982—NIC." 2 x 10 m.

Universidad Centroamericana (UCA), a Jesuit institution.

Chapel, three walls, center and right continuous

113 *Left:* St. Ignatius of Loyola, seated, with book inscribed "Elegir para en todo amar y servir (Choose to love and serve in all), with Juan Ramón Moreno Pardo, professor of theology, and

Ignacio Ellacuría Beacoechea, rector of the University of Central America, two of the six Jesuits who, with their cook and her daughter of sixteen, were killed by the Atacatl battalion on 16 November 1989 at the University of El Salvador. Sign to left near figure carrying cross: "To the greater glory of God" (see also no. 36).

114 *Center:* Jesus as peasant, teaching peasants.

115 *Right:* People building, planting, a flower, and reading. Sign to right: "Happy are the merciful."

Signed "[Maximino] Cerezo Barreda 91."

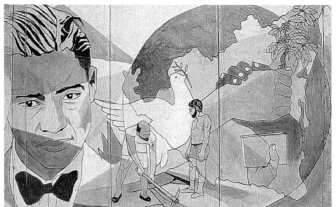

117

Universidad Centroamericana district

Asociación (now Escuela) de Artistas de Danza (dance association, now school of dance)

116 *Exterior:* El Güegüense (popular festival). Signed, top left, "L. Sáenz 89" and, below right, "Realizado por la brigada de arte publico Monumental 'Rubén Darío.' " Sponsored by Instituto de Cultura. 4 x 4 m.

117 *Inside, over stage, left wall:* Sandino, men digging, dove, light and dark hands clasped over map of Nicaragua, coffee, and book; *right wall:* Carlos Fonseca, Nicaraguan figures, dove. Signed "[Camilo] Minero '89." Painted for festival celebrating El Salvador and Frente Farabundo Martí de Liberación Nacional (FMLN). 3 x 22.5 m. On wood panels. Destroyed 1992.

Centro de Investigación, Promoción y Desarollo Rural y Social (CIPRES, Center for Rural and Social Research, Advancement, and Development)

118 Allegory of the primacy of agriculture (and the art of painting) over computerization (a pick smashes computer screen). Computer keyboard spells out "Aquí no se rinde nadie [No one surrenders here]. 1979–1987." *Bottom right,* twenty lines in favor of campesinos by Gaspar García Laviana from his *Cantos de Amor y de Guerra* (Songs of Love and War), beginning "Yo sé, y sé que estos versos" (I know, and I know that these verses). 4 x 3 m.

Instituto Centroamericano, Centro de Descapacitados (Center for the Disabled), entrance

119 *Rompiendo Barreras* (Breaking the Barriers). Peasant Christ surrounded by handicapped persons. Signed, bottom left, with three signatures and "Contraste 1993." 1.5 x 3 m. All four walls of the auditorium at this center are decorated by Grupo Artistico Contraste with pre-Columbian figures as handicapped people.

Universidad Nacional de Ingeniería Simón Bolívar, Escuela de Architectura (School of Architecture), exterior

120 Playing basketball, planting trees, scientific research, the New Man, soldiers with grenade launcher and artillery, before mountains. Stripes of Sandinista and Nicaraguan flags wrap from mural around balcony, upper left. Nude figure representing New Man holds paper saying, "No puede haber arquitectos [q]ue piensan como revolucionarios y no actúan como tales" (There can be no architects who think like revolutionaries and do not act as such).

By Federico Matus and students of School of Architecture

1989. 5 x 5 m.

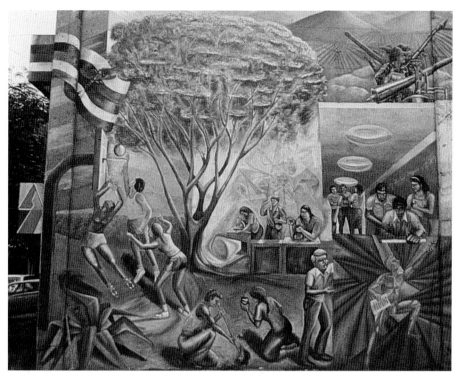

120

Universidad Nacional Autónoma de Nicaragua (UNAN)

Aula principal (main auditorium)

121 *Far left:* Guerrillas entering Cathedral Square (19 July 1979), arms aloft; a fist breaking chains, which continue to right. Three portraits fixed separately on pilasters: Rigoberto López Pérez, Sandino, and Carlos Fonseca; *far right:* gathering of militants, with banners, books, pencils, T-shirts marked MOA (Milicias Obreras Alfabetizadoras [Workers' Literacy Militias]). Older woman writes, "Día de la alfabetización. Mi nombre es Narcisa Cruz López, aprendí a leer gracias a la Revolución Sandinista. Sandi[no] aye[r], San[dino hoy . . .]" (Literacy Day. My name is Narcisa Cruz López; I learned to read thanks to the Sandinista Revolution. Sandino yesterday, Sandino today . . .). See figure p. 35.

By students of the university. Covered in recent years with a curtain.

Universidad Politécnica (UPOLI), courtyard

122 Dove, coffee, Carlos Fonseca among people, male guerrilla, fist over sun. 2 x 15 m. Very crude.

123 Symbols of learning and the arts; UPOLI XX ANIVERSARIO NOVIEMBRE DE 1987," on banderole. Lesson with teacher writing, "Si la patria es pequeña, un[o] grande [l]a sueña (If the homeland is small, one dreams it large—Rubén Darío). Sandino-era General Santos López (as an old man, surviving into FSLN days), male and female guerrillas, female guitarist, dove, planting coffee. 2 x 22 m. Crude.

Signed, upper right, on no. 122, "Diseño y Dirección: Camilo Minero," followed by ten names of students in advertising design from the university and two names of students who restored the murals.

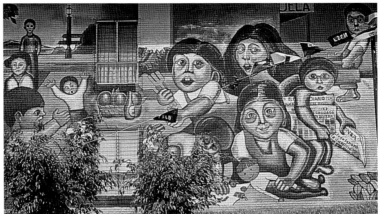

124

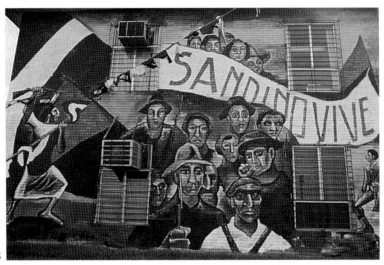

125

Zumen

Ministerio de Educación, Complejo Camilo Ortega,
(Ministry of Education, Camilo Ortega complex)
Plaza Angela Morales Avilés

124 Children playing; *far right*, child carrying
shoe-shine box and child selling the three daily
newspapers of Nicaragua, *El Nuevo Diario*, *Barri-cada*, and *La Prensa* (see figure p. 11). By César
Caracas. 6 x 13 m.

125 "Sandino Vive" on banner, surrounded by
armed figures and bust-length portrayals of Nic-araguan types. By César Caracas. 6 x 10 m.

126 Portrait of teacher martyr Angela Morales
Avilés, cut out of styrofoam, positive and negative,
set on concrete block, about 3 x 3 m., used to
mark name of square (see p. 61). About 1980–81.
Destroyed circa 1990.

Achuapa

Casa Cultural

127 Guerrillas; peasant with sword slaying prostrate figure ("Seal of Sandino" motif); Somoza's tanks and helicopters; harvesting fruit and vegetables; farmer behind oxen plowing. By Romel Beteta, with Pablo Hernández and Sergio Serrano, sponsored by ACRA, the Italian Third World development organization. 4 x 12 m.

Asturias

Military Base

128 Lookout tower, four sides with four portraits: Rigoberto López Pérez, Miguel Angel Ortéz, Carlos Fonseca, and Sandino. Total 1.5 x 6 m.

129 Medical Post, four walls: (a) Soldiers with automatics and grenade launchers chasing contras; (b) mother clasping child; work of woman and peasants; defense, production. Total 3.5 x 21 m.

Both by Federico Matus (his first major independent work), with ENAPUM-DAS.

1985. Dismantled.

Bluefields

Note: Most public art in Bluefields predating 1988, including one long mural, was destroyed in the hurricane of that year. Only various primitivist murals now remain (at the Moravian College, the Colegio San José, and the Carmelite Nursing School), of idyllic local lagoon landscapes. The only mural group in town is named Gremio de Pintores "June Beer," after the internationally known painter, who died recently; it is headed by Alerton Gómez. The Reggae Center is decorated with symbols and cartoons on themes of contraception, AIDS, and Rasta religion (1992).

130 The port has a billboard with a monument to the condom.

131 Fishing, triumphant (black) man, Sandino in sun, housing. By Leoncio Sáenz, about 1984, 2.5 x 7.5 m. Destroyed. Local blacks demonstrated in opposition to this painting, objecting to being shown as subject to (and adoring) Sandino-sun; an accommodation was reached after discussion, but the mural, said to be in poor condition, was painted over.

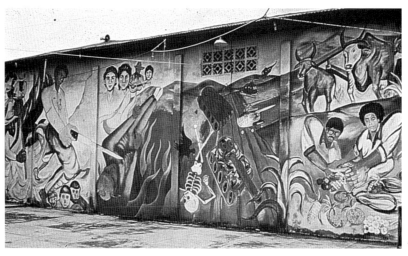

127

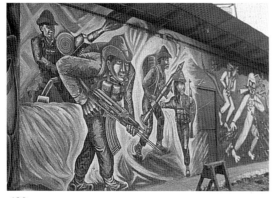

129a

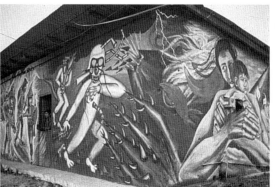

129b

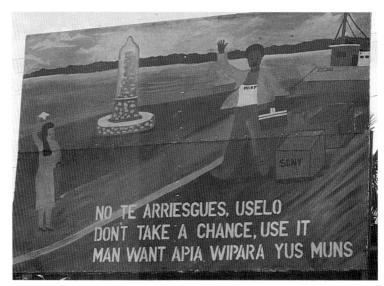

130

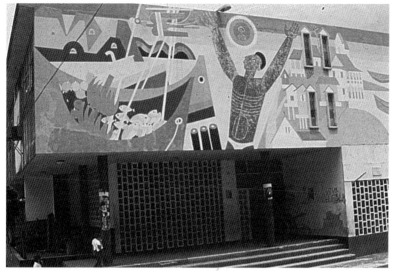

131

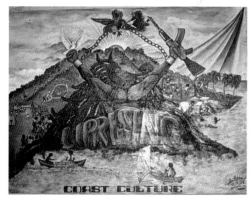

133

132 Fishing, mining, harvesting bananas (copied from a poster). About 1981, 3.5 x 3 m.

133 *Uprising:* Title appears large on black Rasta-haired figure, dove perched on left hand and gun in right, rising out of the sea, brandishing chains, against a sunrise, and hill landscape filled with local life. Fishing in foreground and words "Coast Culture."

Signed, bottom right, "Milton Hebbert [local, black artist] 19/5/84 Bluefields Nic."

2 x 2.5 m., on canvas. Formerly in Centro Cultural (destroyed by hurricane); now in a private house next to Centro de Investigaciones sobre el Desarollo de la Costa Atlántica (CIDCA, Research Center for the Development of the Atlantic Coast). Design and title based on Bob Marley album cover, with chains, gun, and other details added.

134 "Vencimos, somos libres, jamás volveremos a ser esclavos" (We won, we are free, we will never be slaves again) over fists breaking chains. "FSLN." About 1981. 3 x 4 m. (See figure p. 7.)

135 "We want to learn to read and write. Just waiting for you, brothers. National Literacy Crusade, Ministry of Education" (in English); literacy statistics, under landscape of poverty. About 1980. 3 x 9 m.

136 *Heroes en el Combate Heroes en el Trabajo* (Heroes in Combat, Heroes in Work): Three hands, one light and two dark, reach for composite landscape with ploughing, factory buildings, jungle, fishes, roadway, and cattle, all set against a rising sun. To left, "F.S.L.N." To right, "ERA 80" (signature?).

Lit.: Color reproduction in Ernesto Cardenal, *Unser Land mit den Menschen die wir lieben* (Wuppertal: Hammer Verlag, 1980), p. 43.

Boaco

Jefatura Departamental de Policía, wall facing park

137 Literacy theme, with book "Pobres de Campo, Uníos" (Poor of the fields, unite); agrarian reform; production; milk; theodolite; woman with paper inscribed "Ser culto es liberación" (To be educated is liberation); cutting barbed wire signifying latifundio; pregnant woman in eyeglasses (social services).

By Felicia Santizo Brigade of Panama.

2/2.5 x 11 m. Extremely deteriorated.

Hotel Sobalbarro, facing park

138 Conquest of Indian; bishops and military figures; local fiesta and church of Boaco. Signed "[César] Caracas 80-22-2." 3 x 3.5 m.

Chinandega

Cine Noel, exterior wall facing Parque Santa Ana

139 Women in uniforms fighting in mountains; mothers grieving; dove; campesinos raking fields. Above, row of martyr portraits, identified as "Cra Silvia Marlene Ramírez, Cro Roberto González G., Cra Alba Ruth Hernández, Cmdte [Comandante] Germán Pomares O., Cra Miriam Tinoco, Cro David Martínez, Cra María del Pilar Gutiérrez, Cro Bernardo Andino" ("Cra" means compañera, or female comrade, "Cro," compañero, or male comrade).

Signed, bottom right, "En Solidaridad con el pueblo de Nicaragua, Priscilla Proudwoman Stadler, Jennifer Bowen [both from United States]—Junio 1985, C.P.C. [Popular Center for Culture] Chinandega."

2.5 x 5 m. Very crude.

Gas station opposite church.

140 Music, insurrection, literacy; sport, defense. Signed, bottom right, "Movimiento Cultural Leonel Rugama, Célula de pintores EDWIPA Tayamo."

3 x 9 m. Very crude. Painted over with advertisements, 1990–92.

Ciudad Sandino

Carpentry Workshop

141 "Taller Carlos Nuñez Téllez de Carpinteria y Jugueteria" (Carlos Nuñez Téllez carpentry and toy workshop) is inscribed on a wooden jigsaw puzzle being completed on the wall of the workshop by a child using a crutch. The workshop itself is shown under construction (by Danish volunteers); in it are people in wheelchairs at work. They are mostly Nicaraguan war disabled but include a legless Dane called Jasper; *above:* carpenters appear to be building the real roof; *center:* tools and toys are painted illusionistically as if on recessed shelves. "Viva el FSLN" is written under eave; paintings of children continue along bottom of side wall to right.

By Colectivo Boanerges Cerrato (Daniel Hopewell and Janet Pavone).

About November 1991. 4 x 5 m.

Colegio Edgar Talero Vélez, exterior wall on Los Cabros park

142 "La revolución cumple con la educación popular" (The revolution offers popular education) runs above scene of learning; Sandino; Carlos Fonseca; picking coffee; literacy statistics. 3.5 x 11 m.

Wall facing Los Cabros park

143 "La Alfabetización una realidad . . . [painted out] en Ciudad Sandino" runs under large portrait of Carlos Fonseca with sunrise behind (portrait now obliterated), over crowd raising books in triumph. 2.5 x 7 m.

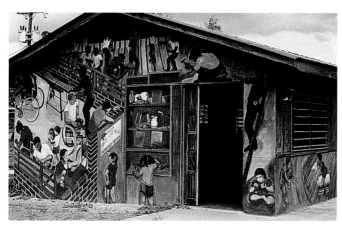

141

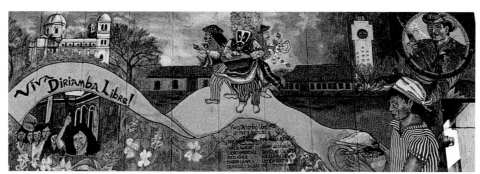

147

Corinto

Casa Cural, Plaza Central

144 "A la hora de alfabetizar con Cristo hemos de estar" (In the literacy campaign let us be with Christ) runs above a landscape showing Christ resurrected, with literacy workers (brigadistas) walking toward mountains. 2.5 x 8.5 m.

Colonia Liverpool, private home, road to Chinandega

145 "Corinto hermanada con Liverpool, Inglaterra" (Corinto twined with Liverpool) runs above landmarks of Corinto, rising sun, and landmarks of Liverpool. *Below, center:* "Estas casa fueron construidos por la primera brigada de Liverpool en Nov. 1989" (These [five] houses were built by the first brigade from Liverpool).

According to the owner of the house, Evarista López, the brigade included two Liverpudlians called William and David.

2 x 8 m.

Diriamba

Casa de Cultura

146, 147 Culture and production in Diriamba. *Left wall* (no. 146): Diriangén (native Nicaraguan chief, after whom town was named), "Toro Gaucho" dance (with colorful costumes and horse masks); cows grazing in flower-strewn meadow. 4 x 12 m.; *right wall* (no. 147): local church, militants amid flowers, "Toro Gaucho" dancers, roundel with Sandinista soldier, figure cutting leather band that unfurls to left, where "Viva Diriamba Libre!" is inscribed. 4 x 12 m.

Signed, center, below, on right wall, " 'Viva Diriamba Libre' 1985. Un mural diseñado por Rikki Asher, Marvin Campos, Angela Mathews. Pinturas: Marcia Aguílar, Silvio Ambrogi, Rikki Asher, Marvin Campos, Francisco Salinas Cruz, Roberto Cruz, Douglas Granja, Angela Mathews, Leticia Ruíz N., Silvia Zuñiga."

Lit.: *Community Murals* (Winter 1987): 9–10.

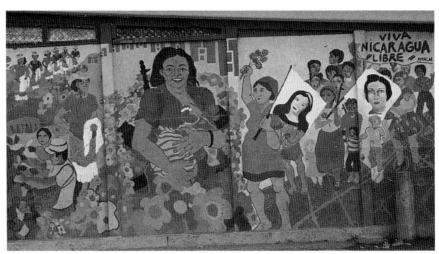

148a

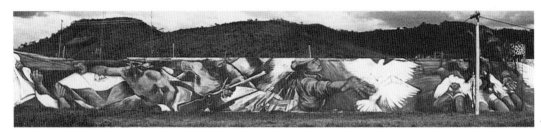

150a

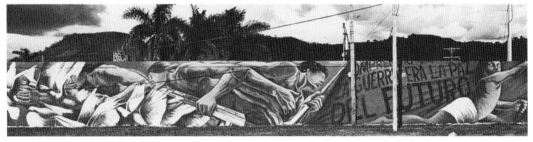

151a

Casa AMNLAE (Women's association building)

148 (A) Women and a man marching in a surround of flowers, with a placard reading "La Solidaridad de Mujeres" (The solidarity of women); (B) women in fruit market; women flying over fields; harvesting coffee and carrying white towels; (a) woman with gun on shoulder, suckling an infant; women marching, carrying large photographs of Arlen Siú (?) and another woman martyr; children carrying banner "Viva Nicaragua Libre AMNLAE."

Signed, bottom left, "Artifact '86" (Carla Nemiroff, other women from Montreal, and local women).

4 x 24 m.

Diriomo

Centro Recreativo Marcelo Campos Flores (a sister-city project with Solothurn, Switzerland, and Kaiserslautern, Germany), exterior wall

149 Fight at the barricades, triumph, literacy, coffee, harvest, defense, basketball, literacy, dance music, lakeside repose with sunset. Above "Patria, Paz y Futuro para esta juventud vencedora" (Fatherland, Peace and Future for this victorious youth). Directed by Isaias Moraga of Diría. 3.5 x 20 m.

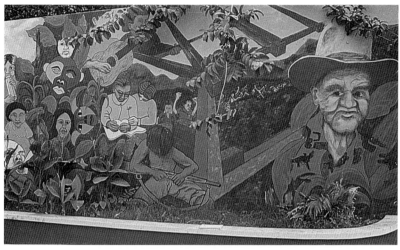

152

Estelí

Base Militar Regional "El Quiabú," exterior wall

150 *Left of entrance:* Grasping flags of FSLN and Nicaragua, bare-chested indigenous figure; (FSLN) fighter with gun and Sandinista soldier releasing doves, which are received (A) by young girls; *background*, barely discernible, Five Volcanoes (Nicaraguan national emblem). 4 x 42 m.

151 *Right of entrance:* (A) Portraits of Germán Pomares, Carlos Fonseca, and Sandino; (B) eagle felled and bloodied by doves released by bare-chested combatants (C); child being swept off to right bearing red flag inscribed "Comprendió que la guerra era la paz del futuro" (He understood that the war was the peace of the future—a line from a song by the Cuban musician Silvio Rodríguez). 4 x 50 m.

By Colectivo Boanerges Cerrato.

October 1989–22 April 1990.

Casa Gobierno (town hall)

152 Sandino, coffee production, literacy, oral vaccination, colorful masks, volunteers in the coffee fields (background); portrait of local personality. By Ilona Sturm and John Watkins (United States), Ramón C. S. 2.5 x 12.5 m.

Casa Juventud Sandinista (Sandinista youth center)

153 Portrait of Che Guevara, flanked by flags of FSLN and socialism. Inscribed "Che Comandante, Vos Sos el camino, Nosotros los caminantes" (Commander Che, you are the way, we are the wayfarers; see figure p. 61). Signed, right, "For the Cuban internationalists, Mike Alewitz '88." 3 x 4 m. Destroyed.

Centro Pastoral "El Despertar" (The Awakening), Comunidad Eclesial de Base (Christian Base Community), Barrio Juana Elena Mendoza

154 (A) Portrait head of Juana Elena Mendoza, martyr of barrio; Gaspar García Laviana, with guitar; (a) head of Archbishop Oscar Arnulfo Romero; head of Fermín Orozco (green and blue); (b) the Barreda couple (blue, below "Despertar"; see no. 106); bust of Edi Hernández, of base community (green); mother with cross and torch (behind, representing mothers of martyrs); man casting golden coffee beans that fall to the

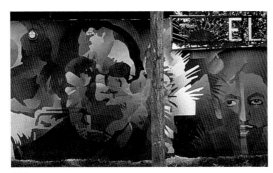

154a

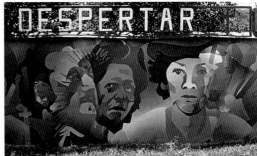

154b

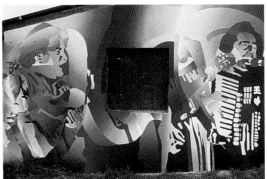

154c

head of José Benito Escobar; (c) Carlos Mejía Godoy, half-length with guitar, and Luis Mejía Godoy, with accordion (latter two are musicians with Mancotal group).

By Roberto Delgado.

July–September 1989. 2.5 x 18 and 2.5 x 9 m. (average height), painted on fiberglass cloth glued onto wall.

Centro Popular de Cultura Leonel Rugama

155 Corridor, Galería Héroes y Mártires: Portraits of heroes and martyrs of Estelí; that of the schoolteacher and poet Leonel Rugama, assassinated at age twenty, appears first (a), left, at end of corridor. By Roberto Delgado. Inaugurated 15 July 1989. Total painted surface about 3 x 60 m.

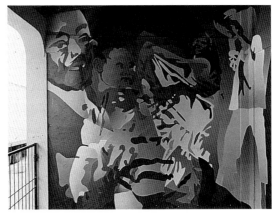

155a

156 Exterior wall: Figures behind a barricade, many seen from the back, armed with stones, rifles, pistols, machete, Molotov cocktail, and homemade grenade ("contact bomb").

Signed, lower right, "Obsequio de la brigada muralista Felicia Santizo . . . y la P.N.S. [Policia Nacional Sandinista?] en omenaje a [Estelí?] heroico y combat ——cia Estelí." 1980. 3 x 8 m. Restored by Colectivo Boanerges Cerrato and reinaugurated 17 July 1991.

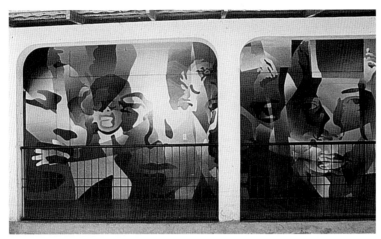

155b

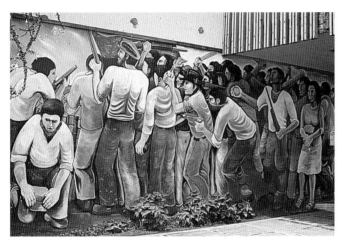

156

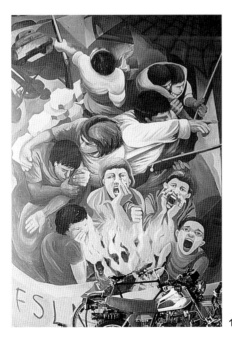

157

Centro de Salud (health center, donated by ACCA, Las Segovias, Spain; now the biggest health center in Central America) Seven murals, all in lobby except no. 163, which is in corridor.

157 "FSLN": Insurrection. 5 x 4 m.

158 "Sandino": Dr. Dávila Bolaños (after whom the Estelí hospital is named) tending the wounded. He was taken from the hospital while at work, with Dr. Selva and a nurse, and shot by the National Guard in April 1979. 5 x 4 m.

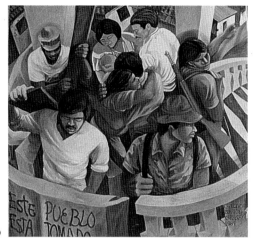

159

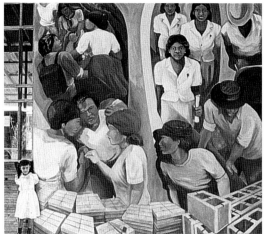

160

159　"Este pueblo está tomado" (this town [Estelí] is liberated). Rebuilding Estelí; meeting of mother and son returned from mountains; female soldier and male literacy/health worker (with knapsack) departing for countryside after the Triumph; health care. 4 x 4 m.

160　Nurses and doctor (intended as portrait of a Cuban volunteer) shake hands; *above*, volunteers for literacy campaign (one wears typical knapsack); construction workers building the center; *above*, nurses. 4 x 4 m.

161　"Nunca hubo tanta patria . . ." (Never was there so much patriotism . . .). Childbirth, with midwife, and childcare. 4 x 4 m.

162　". . . en un corazón" (. . . in a single heart [tenth anniversary slogan]). Natural medicine; oral vaccination for polio (a disease eliminated by the Sandinistas); traditional medicinal plants such as were studied by Dr. Bolaños are depicted: aloe vera (left), *zacate de limón* (behind woman), and *guayava*, whose leaves and bark, possessed of antiparasitic properties, are handled by the man. Both man and woman facing us are portraits of local "curanderos" (healers). The whole composition is mirrored twice in successively smaller versions, top left, as if to reincorporate actual wall, as painted, on the corner of the building. 4 x 4 m.

163　Boys in wheelchairs playing basketball. 4 x 3 m. (See figure p. 31). Signed (on no. 159) "Colectivo Boanerges Cerrato 1989." Executed December 1988–May 1989; hospital with murals inaugurated by Daniel Ortega, 16 July 1989, anniversary of liberation of Estelí.

Colegio (Instituto Nacional Francisco Luis Espinosa, named after a revolutionary priest who died in 1978), western exterior wall

164　*Left:* Sandino, backed by a group of his generals, headed by Miguel Angel Ortéz, stands over a coffin draped with a U.S. flag, loaded on a truck. A hand brandishes U.S. dollar bills; Somocista soldiers terrorize civilians, one of whom is behind bars; *center:* heads of Sandino, Carlos Fonseca (facing rising sun, to right); *below,* José Benito Escobar and Leonel Rugama. Vignette of fighting at barricade; *right (over entrance):* tilling the soil, one laborer standing, with knapsack, such as was carried by internationalist volunteers; Sandinista soldier; health and literacy.

Signed, bottom right, "Comité FSLN Estelí." By students of the school [and Bayardo Gómez].

1986. 4.5 x 16 m. By 1992 deteriorated and much graffitoed. Restored by Colectivo Boanerges Cerrato, 1993. Destroyed on order of school director, March 1995 (*Barricada,* 18 March 1995).

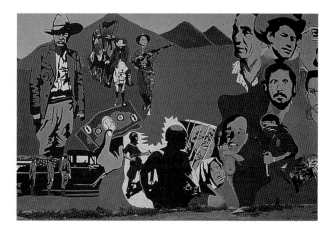

164

166a

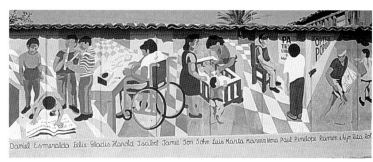

166b

Escuela Nicaragua (Spanish language school for foreigners; since May 1990, private house)

165 Portrait of Ben Linder, dressed as a clown, riding a unicycle and carrying a parrot (see also nos. 72–74).

Inscription covering half of mural: "El es la sonrisa en los niños que le vieron con su traje de payaso iluminando el futuro que juntos construimos en la nueva Nicaragua" (He is the smile in the children who saw him in his clown's outfit, illuminating the future that together we build in the new Nicaragua).

Signed, "For the Internationalists who gave their lives for Nicaragua, Mike Alewitz '88."

3 x 3.5 m.

INSSBI (Instituto Nacional de Seguro Social y Bienestar), two walls (with short connecting wall) facing regional social security office, continuous design

166 (a) Nicaraguan types, children with doves, boy sitting on *Barricada* newspaper (see also figures, p. 11), children in bird's-eye view, dancing a round. "Puertas Azules" (village near Estelí). Old lady with book "Con Sandino en Nicaragua

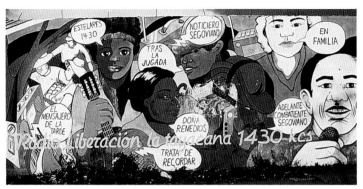

168

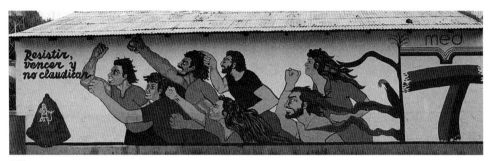

169

[by] C[arleton] Beals"; children playing; women planting coffee; on the beach; peasants with INSSBI identity cards; Tickets for INSSBI lottery (to help war orphans); (b) school bench; paper inscribed "El primer día que llegué a la escuela llegué con cien ganas de llorar" (The first day I came to school, I came overwhelmed with tears—Leonel Rugama); two men playing flutes; man in wheelchair mending a radio, women caring for children, optician, paperboy, inscription: "Problemas sociales, soluciones comunales."

Signed "Colectivo Ernesto Barrera Moto, El Velero." By Colectivo Boanerges Cerrato, with the help of a dozen local residents, their names inscribed below. Restored in 1992, with the words "Restaurado con el apoyo de la alcaldía municipal de Estelí y el INSSBI (Restored with the help of the Estelí municipality and the National Social Security Institute) por el colectivo Boanerges Cerrato y la brigada Carlos Nuñez Téllez (i.e. 31 children, whose first names are inscribed below).

December 1987–February 1988, 2.5 x 20, 2.5 x 2.5, 2.5 x 10 m.

Junta Municipal de Co-ordinación de las Ciudades Hermanas de Estelí (former sister-city office, now Ministerio de Gobernación of the UNO government)

167 (A–B) Tropical foliage, children drawing and peering through (real) windows; FSLN flag wrapping around window; (B–C) figures holding large banners marked "Bielefeld [Germany], Sheffield [England], Delft [Netherlands], Evry [Near Paris], Sant [*sic*] Feliu d[e Ll]obregat [near Barcelona]." By Colectivo Boanerges Cerrato. August–September 1989. 3 x 16 m., less windows.

Radio Liberación Building

168 Portraits of workers at radio station, with speech balloons containing the names of features and mottoes. By Colectivo Boanerges Cerrato in a "popular" style not typical of the artists, corresponding to popular style of radio. May 1988. 4 x 9 m.

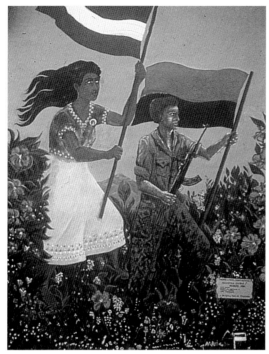

170

Wall on Main Street

169 "Resistir, vencer y no claudicar" (Resist, prevail, and never give in). Seven figures, young men and women, charging, fists raised; to right, seventh anniversary symbol and "MED" (Ministry of Education), over open book. 3 x 17 m.

Granada

Banco Nicaragüense area

170 *Mother and Son.* Woman bearing Nicaraguan flag and wearing AMNLAE button, and soldier (her son) bearing FSLN flag, amid flowers. Signed, lower right, "Madre e hijo, con s—— Nuestra patria Agosto 1984. Rikki Asher, Nicasio del Castillo M., Theresa Muñoz, Lynn Roberson, y los hijos y hijas de Granada" (Mother and son, with . . . our fatherland. . . . the sons and daughters of Granada). 4.5 x 3 m. Destroyed November 1991.

Casa de Cultura (cultural center supported by Swedish sources)

171 *Patio: Granada Histórica 1524–1989.* Virgin Mary "Auxiliadora"; cannon; locomotive; old buildings; Yegüita dance. Signed by ten local artists. 3 x 9 m.

172 *Inside:* Rubén Darío, full length, as poet laureate, amid mythic, literary, and historical allusions. Executed for Darío centenary. Signed by ten local artists, dated on scrolls in upper corners "1888, 1988." The earlier date is that of Darío's first major published work, *Azul.* 2.5 x 5 m.

CBS (Comités de Base Sandinista) Jabonería Prego, Sandinista Base Committees Prego soap factory, on road to Masaya. Two murals: no. 173 painted over no. 174

173 Malinche tree; (a) skull-headed orator-puppet wearing U.S. flag tie, with toad (popular denigration of Somocista) on shoulders, astride Nicaraguan; (b) machinery (for soap manufacture) amid figures firing automatic rifle and slingshot; Sandino; soap worker handling soap bars on conveyor belt; above him, copy of *Barricada* newspaper with headline "Solidaridad"; washing clothes; voting (reference to 1984 elections); street scene.

Signed, left, under flowers and parrots: "Al pueblo de Nicaragua libre y los trabajadores de esta jabonería Prego: Este mural es un regalo de la Brigada Artistica de Artes para una nueva Nic-

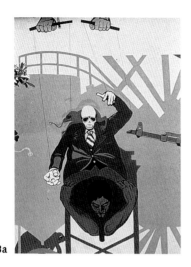

173a

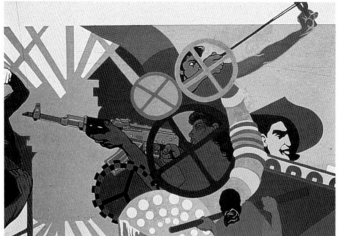

173b

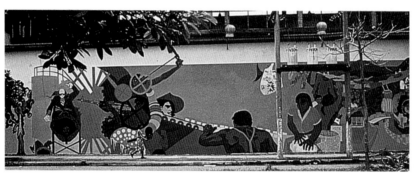

173c

aragua de los Estados Unidos. Estamos aquí invitados por el Ministerio de Cultura y los Centro Populares de Cultura 23 Agosto 1984. Pintado por Natasha Mayers, Janet Braun Reinitz, Judy Branfman, David Fichter, Jorge Alejandro González, Johny García Chamorro, Claudia Licett, Rivero Mejía, Paul Morales, Jaibo——'Cultura es Fusil artistico de la revolución' " (To the people of free Nicaragua and the workers of this Prego soap factory. This mural is a gift of the Arts for the New Nicaragua Art Brigade from the United States. We are here invited by the Ministry of Culture and the Popular Centers for Culture 23 August 1984. Painted by. . . . "Culture is the artistic gun of the revolution").

2.5 x 22 m.

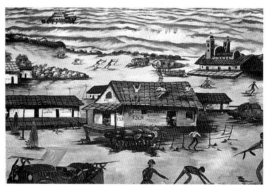

174

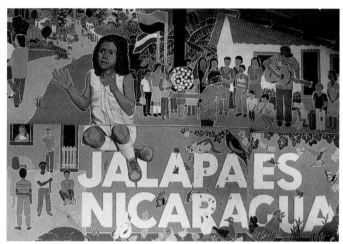

175a

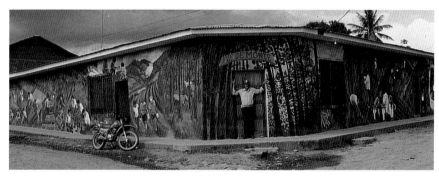

176a

174 Primitivist mural, in four contiguous sections. *Left*: Landscape with peasants, landscape with bust portraits of Sandino and Fonseca; *center*: fighting the National Guard by the lakeside, around house graffitoed with FSLN slogans, and Granada cathedral; *right*: street, landscape, lake and sunrise.

Circa 1981. About 2.5 x 20 m. Painted over with no. 173.

Jalapa

Biblioteca, Sala Infantil (children's library)

175 "Jalapa es Nicaragua" inscribed, very large, right (a). Children reading, oxen drawing cart by coffee plantation, birds, iguana; children playing and dancing; dove; village life; (A) ice-cream vendor; Nicaraguan and FSLN flags, music, children's games. By Daniel Hopewell and others.

November 1985–January 1986. 4.5 x 13 m.

Pié de Monte Reforestation Project (Dutch funded), opposite police station. Three contiguous walls

176 *Left* (A): Children learning how to plant trees and make fences from live trees; cattle grazing among trees to show compatibility of growing trees and raising cattle; cutting wood for fuel; women grafting trees. 3 x 20 m.; *center, around entrance* (a): trees, with sign "Pié de Monte." 3 x 3 m.; *right* (B) selective cutting of trees, oxen pulling logs, portable sawmill at work, furniture workshop, co-operative nursery. 3 x 20 m.

By Daniel Hopewell

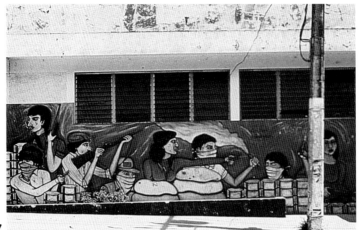

177

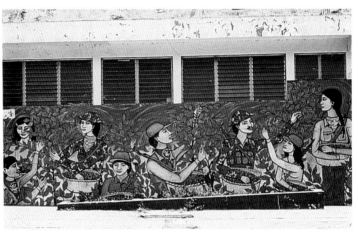

178

Jinotega

Juventud Sandinista (Sandinista youth building, former Somocista jail and torture center)

177 *Below, left wall:* Fighting at barricades. Inscribed, right: "Con Paco y Georgina." 2 x 7 m.

178 *Right Wall:* Picking coffee. 2 x 9 m.

Signed, at right: "J. [Paul] Atamian L (or S?) [Jan] Duplisea 21.9.86" (United States).

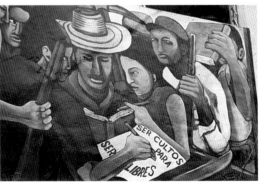

179

179 *Above, left wall:* Portrait of Germán Pomares, row of armed revolutionaries, bust length; peasant writing "Ser cultos para ser libres" (Be educated to be free).

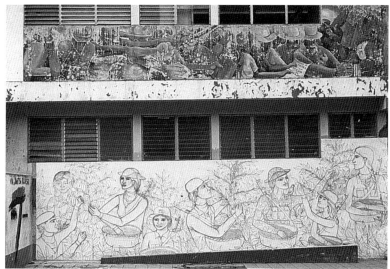

180a/178

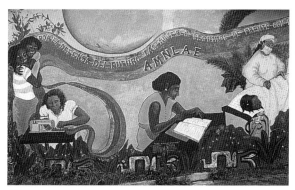

181a

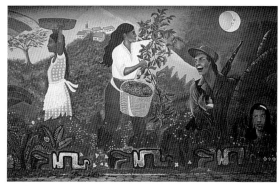

181b

180 *Right wall:* (A) Figure with huge mallet; (B) arms reaching with clenched fists, weapons.

By Felicia Santizo Brigade, Panama. Painted over about 1986 when much deteriorated.

Jinotepe

AMNLAE (former women's association building, now a Shell station)

181 Women at work: (A) Embracing a child, sewing an orange and blue banner that extends over two-thirds of mural, inscribed "Por la defensa del futuro las mujeres seguimos de frente con el frente" (For the defense of the future we women go forward with the Front (FSLN); with book;

(a) nurses apparently making holes through a sheet, under which a woman lies; (b) picking coffee; in uniform, with gun and baby. At bottom, row of pre-Columbian motifs.

Signed, bottom center, left, " 'Mural a AMNLAE a Jinotepe.' Por Marcia Aguilár, Rikki Asher [United States], Marvin Campos, Ana Graz——, Roberto Hern——, Marco ——, Maria ——, Theresa Muñoz [United States], Lynn Roberson [United States], ——isco Za——a, ——os de Jinotepe ——o—— Balmas, Salinas, ——n Braun 1984."

4 x 15 m. Very deteriorated.

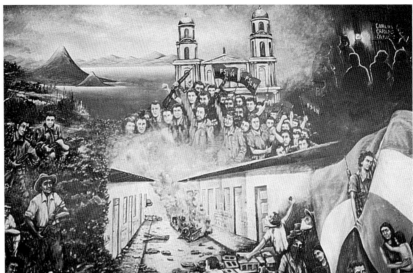

182a

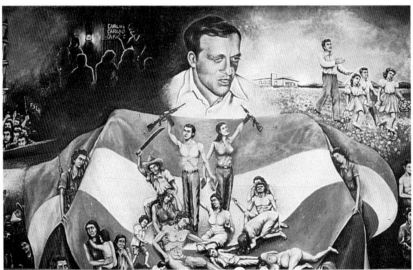

182b

Escuela Normal Ricardo Morales Avilés, Auditorium

182 *Heroes and Martyrs:* (a) Fighting in jungle
and streets; graffiti on houses; (b; *above, left*) adult
literacy; (*center*) tableau, mourning the tortured;
(*above*) portrait of Ricardo Morales Avilés (born
in Diriamba, 1939; arrested in 1968 and tortured;
died in combat, 1973); (c) better future through
science and medicine; (*below*) disabled soldiers
soldering; picking coffee; cutting bamboo;
(*above*) the fine arts; portraits of Sandino (*far
right*) and Carlos Fonseca (*far left*).

"Dedicamos este trabajo a nuestros Heroes y mar-
tires, Fuente eterna de inspiración en el amor y la
defensa de la Patria [We dedicate this work to our
heroes and martyrs, everlasting source of inspira-
tion in the love and defense of the fatherland].
Jinotepe 15, Sept. 81. S. Zuñiga G. [director of
mural, a local painter, now deceased], Marvin
Campos CH. [assistant]."

5 x 15 m., including bottom two feet of mural
obscured by stage.

160

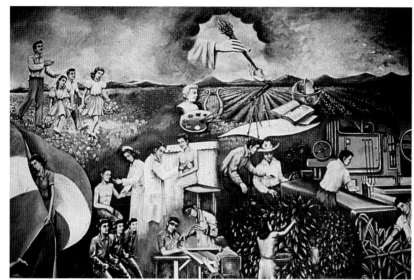

182c

Juigalpa

Base Militar "La Colina" (contains a small patio with seats, credited as an "architectonic, plastic, and pictorial complex" to ENAPUM-DAS)

183 *Inside auditorium:* Landscape. 5 x 6 m.

184 *Exterior of auditorium, facing patio:* Landscape with contras, descended from a helicopter; a beheaded woman tied to a tree, and a peasant about to bury her. By Ricardo Gómez. About 3 x 5 m.

Both circa 1985.

Casa de Apoyo a Los Combatientes (combatants' support agency)

185 Carlos Fonseca; Rigoberto López Pérez, flanked by FSLN militants and soldiers; and Sandino with five of his generals, in landscape. Signed: "Julio Madrigal (Dir), Ayudantes [assistants] Teofilo Madrigal, Felipe Oporta, Román Suárez 1988." 3 x 35 m.

Centro de Ancianos (old people's home, 32 km. from Juigalpa on road to Rama)

186 *Rio Rama sobre Ramas:* Hurricane, reconstruction, the god Nexacual, planting crops. Signed, bottom right, "Escuela de Muralismo, Julio Madrigal, Donaldo Robleto, Mario Martínez 1988." 3.5 x 14 m.

Centro Escolar Pablo Hurtado

187 Landscape with portrait of Professor Pablo Hurtado, and Indians. Signed, "Equipo: Napoleón Ugarte, Ulice Urvina, Teófilo Madrigal, Julio Madrigal." [1986/87] 4 x 7 m.

188 On Pabellón (Pavilion) Gregorio Aguílar Barca. Landscape with portrait of Gregorio Aguílar Barca, Indian symbols. Signed left: "Equipo Ulice Urvina, Napoleón Ugarte, Teófilo Madrigal, Julio Madrigal." [1986/87] 3.5 x 5 m.

Centro Popular de Cultura, interior

189 Monumental (4 x 3 m.) portraits of four local celebrities and Rubén Darío; river landscape with portrait of Vicente Hurtado Morales ("El Catarrán"), a popular toreador, on horseback. By Julio Madrigal and local children.

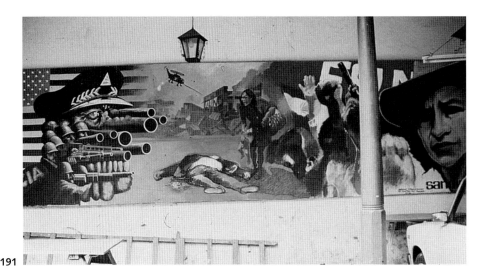

191

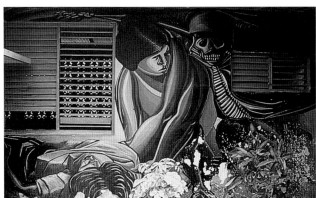

192

ENABAS (Empresa Nacional de Alimentos Básicos, National Basic Foods Corporation)

190 Agricultural scenes. By Julio Madrigal, Teófilo Madrigal, Ulice Urvina, Carlos Montenegro. 1989. 4 x 4 m.

León

Asociación de Artistas Plasticas de la Región 2, Workshop and Gallery

191 Monstrous head, in military hat, formed by soldiers and cannon, with "CIA" on shoulder and a swastika in the eye, backed by a U.S. flag, confronts ruined buildings and protesters, one of them lying dead in the center, others raising fists, backed by FSLN and Nicaraguan flags; ruined buildings in street behind; Sandino far right.

Signed, lower right, "Brigade Internationale des Peintres Anti-fascistes, 1 x 78" (1 October 1978). On canvas, brought to León by this group in 1983, destined for Contemporary Art Museum. Brigade may be French-Canadian.

1.5 x 6 m.

Casa Comunal, Reparto William Fonseca

192 *Left wall: Repression.* Woman and child bending over dead body; a death's head in a National Guard helmet looms over them. Design is worked around windows.

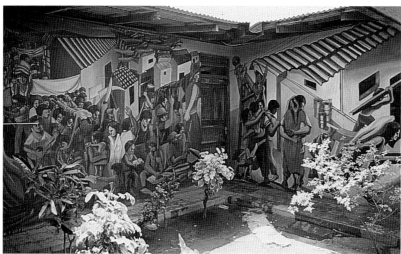

193a–194

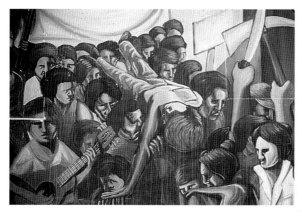

193b

193 *Center wall: Insurrection.* Militant figures in procession on a village street bearing dead body in a manner reminiscent of that in D. A. Siqueiros's *Strike in Cananea* (1957, Chapultepec Castle); children distribute pamphlets; books; weapons; guitar.

194 *Right wall: Reconstruction.* Embracing couple; building a house.

Signed (on separate wall): "Junta Comunal del reparto William Fonseca. Organismo Olandés de Solidaridad Utrecht-León, ENAPUM-DAS, CPC [Popular Center for Culture] León, y Taller Juvenil CPC, Jovenes y Niños de la comunidad William Fonseca [eight names follow], Taller Ju-

venil del CPC [eight names] 1987. Aquí no se rinde nadie!!! Agosto 26/87" (Community council of William Fonseca district. Dutch committee for Solidarity Utrecht-León, ENAPUM-DAS, CPC León, with its youth workshop, youth and children of the William Fonseca community . . . , CPC Youth Workshop . . . 1987. Here no one surrenders!).

By Daniel Pulido

Inaugurated 14 September 1987. Each 3 x 6 m. Very freely painted, in the manner of Siqueiros.

Lit.: *El Andamio* 1 (November 1987): 11–12.

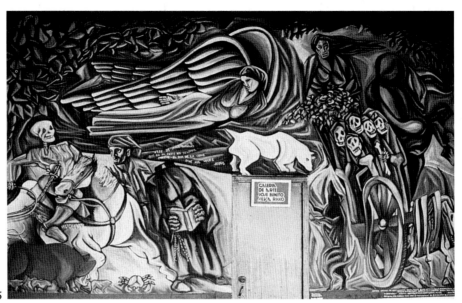

196

Centro Popular de Cultura, Galería de arte José Benito Silva Ricco (holds donations of about 15 artists from around the world)

195 *Festival Day.* Signed, bottom right, "Día de fiesta, Mayo, 89—D. Pulido, Talamuro Nicaragua." 1.5 x 8 m.

196 Algunas Leyendas de León (Some Legends of León): Chancho Bruja (pig sorceress); Punche de oro (golden crab); Arrechevalo (Death on horse); El Duende (prankster); Fraile sin Cabeza (headless friar), saying "Vete de aquí Satanas / que in mi parte no tendras / porqué el día de la cruz / dijé mil veces Jesús" (Get thee behind me Satan. Thou shalt have no part of me, for the day of the cross I said a thousand times Jesus); Cadejo Blanco (white dog); Cadejo Negro (black dog); La Voladora (flying woman); La Cegua (= Ciega, blind woman), top, with blown hair; Carreta Nagual (cart of Death / sorcerer); Toro cacao o encantado (cocoa = colored or bewitched bull).

Signed, bottom right, "Participaron Kerwing Vázquez, Gerarda Hoogland [Netherlands], Daniel Pulido, Apoyo CEDAL (Varese, Italia), CPC [Popular Center for Culture] León. Proyecto:

Diez murales para León en conmemoración del V Centenario de la conquista de America." Signed, by door, "Talamuro, Nicaragua, Agosto–Oct./89," and "Apoyo Talamuro-Italia/CPC León."

8 x 4 m., less door. An inscription was added to both nos. 195 and 196 after the Managua murals were destroyed in 1990: "Este mural fué declarado patrimonio cultural y artistico de la nación por ley no 90 de Abril/90" (This mural was declared cultural and artistic patrimony of the nation by law no. 90 of April 1990).

197 *Side entrance, Tradiciones de León:* "Tambureros, Enano Cabezón, Fanalero, Gigantona [wearing sash inscribed 'Reyna Mariso'], Coplero, Pepe Chineado, Yeguïta, Toro Guaco, Toro Encohetado, Gritería. Diseño: Olga Maradiaga. Colaboró: D[aniel] Pulido. Marzo/91." Three walls: 2.5 x 5, 2 x 3.5, 2 x 3.5 m.

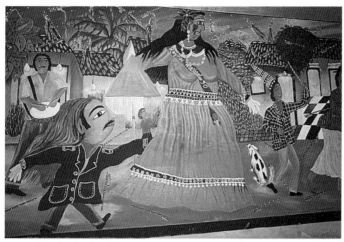

197

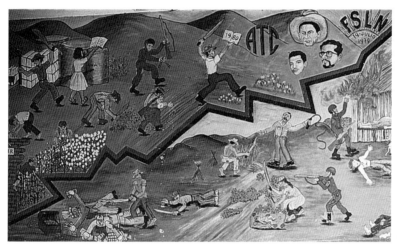

199a

Casa Regional de la AMNLAE Martha Mercedes Reyes Pérez

198 *U-shaped recess:* Two huge trees at corners, a tamarind of Subtiava and a *sacuanjoche*, on whose complex exposed root system are small photographic portraits, fixed to the wall, of thirty-five local young women martyrs. Signed, on right wall, "Teresa Soardi 1989" (Italy). 6 x 3.5, 3 x 2.5 m.

Central Sandinista de Trabajadores (Sandinista labor union headquarters), meeting hall

199 Composition divided diagonally by a jagged red and black line, the new Nicaragua above, Somocista Nicaragua below. *Above line, from left:*

Child care (SIR = Centro/Servicio Infantil Rural), productive agriculture, literacy, Rigoberto López Pérez, Sandino, Carlos Fonseca, FSLN. *Below and right:* (A) Somocista soldier setting fire to thatched hut; pregnant woman lying on bench; malnourished children; peasant wearing Sandinista neckscarf, lying bleeding; (B) peasant with machete striking recumbent bodies (Seal of Sandino motif) of an Uncle Sam figure and Anastasio Somoza II, who lies on, and bleeds over, a U.S. flag. Both clutch dollar bills within reach of a chest full of gold coins.

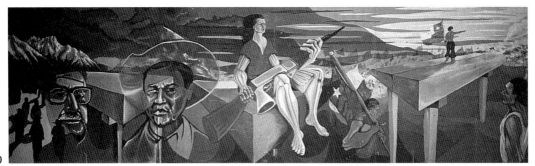

200

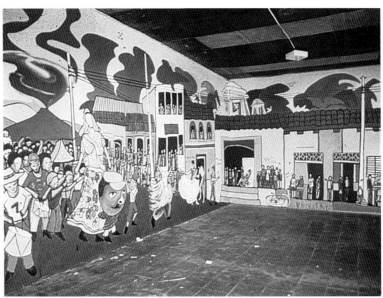

201

Escuela Militar Silvio Mayorga, vieja carretera de León 63 km. (Silvio Mayorga Military School [now abandoned], 63 km. from Managua on old road to León, Salvador Allende auditorium)

200 Cordillera of Andes, silhouettes of campesinos, transparent portraits of Allende and Sandino; skeletal woman (= patria) with huge automatic; figures bearing Chilean flags (to symbolize march of people to victory). By Victor Canifrú, with Alejandra Acuña Moya. Circa 1984. 2 x 6 m. Housepaint on plywood panels.

Hospital, Centro de Atención Psico-Social Alfonso Cortes, two large walls

201 Volcano, La Gigantona, popular festival, bull, dances. By Daniel Pulido, doctors, and patients. 1987. 4 x 8, 4 x 6 m.

Hospital Escuela Oscar Danilo Rosales, vestibule

202 *Left* (a): Tutelary spirit reaches over Somoza-era health care: paunchy doctor clutching money walks toward specters, turning his back on woman with sick child; revolutionaries with guns, one loading a mortar; *center* (b): revolutionaries entering Managua in triumph; hand cradling maize, holding cob like grenade (the cob connotes defense, production, autonomy, and the corn festivals organized by the Ministry of Culture in spring 1981, after the United States banned wheat shipments); health and literacy workers in the countryside; behind their outstretched arms, scene of medicines being delivered by boat to remote region, now beneficiary of a health center;

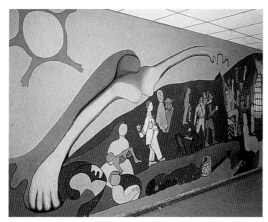

202a

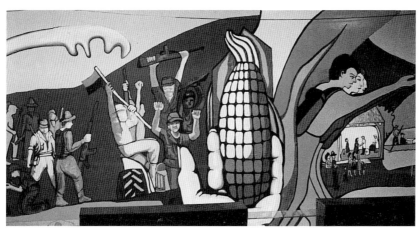

202b

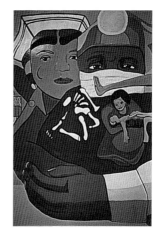

202c

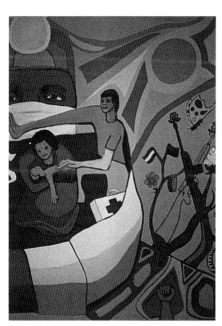

202d

right (c): doctor and nurse embrace woman holding sick child, who is touched by a figure (d) fending off death; a tree and a gun sprout flowers; cotton, and butterfly.

Signed, center right, below; "A los trabajadores de la Salud Grupo Mural CPC León 30-7-81" (To the Health workers . . .). Overall design by Eva Cockcroft (United States), from themes and visual ideas supplied by members of Popular Center for Culture, León: José Anton, Maria Lourdes Centeno, Franco Fonseca, Balthazar Gutiérrez, David Kunzle, Maria Loaiga, Marvin López, Javier Mendoza, and Orlando Pastora (organizer and colorist).

3 x 14 m.

Lit.: *Community Murals* (Fall 1981): 9; Cockcroft and Kunzle, 1982.

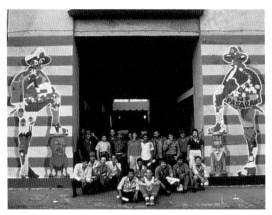

203–204

Parque de Bomberos (fire station), entrance on street

203 Silhouette of Sandino (attitude is that of a famous photograph of him), his body made up of Nicaraguan symbols and the word "Democracía," his foot resting on a canine Somoza figure.

204 Same silhouette, made up of symbols of resistance and the phrase "No pasarán" (They shall not pass), foot resting on crouching figure of Uncle Sam.

By Mike Alewitz.

Each 4.5 x 2.5 m. Much deteriorated. Restored 1993.

Plaza Héroes y Mártires, opposite cathedral, embracing monument to heroes and martyrs

205 *Our Land Is Made of Courage and Glory* (title is a line by Rubén Darío). On two walls, a desert landscape (like that surrounding León, the result of centuries of deforestation), inscribed with dates and symbols marking epochs of Nicaraguan history.

Left wall, 1492 (A): Nicaraguan pre-Columbian sculptures and local petroglyphs like those in Juigalpa museum; (a) Spanish and native arms and religious symbols, marking conquest; (b) cross floating in air (shadow added to produce this effect in response to local bishop's objection to cross lying in dirt); footsteps left by native warriors. 1856: Pile of stones records those thrown by national boy hero Andrés Castro, with guns, footprints, stones, and (B) cannon marking the invasion by William Walker and battle of San Jacinto where he was defeated; photograph of General Benjamín Zeledón, with map dated 10 August 1912 showing the line of opposition to

invading U.S. marines (he was killed in combat 4 October that year).

Right wall: 1912 and 1926 (dates of U.S. invasions): Shadow of Sandino, with inscription, traced in sand, "Nuestra tierra está hecha de vigor y de gloria" (Our land is made of vigor and glory). 1956 (C): Pistol with which Rigoberto López Pérez shot Anastasio Somoza I in León lies atop letter addressed by López Pérez to his mother, 9 September 1956, with scroll of his violin nearby (pistol, letter, and violin scroll survive in museums). 1959 (c): Stone with León University emblem; blood-drenched flags of Nicaragua and the university, and objects referring to the 23 July massacre of students in León. 1961: Manuscript of book by, and eyeglasses of, Carlos Fonseca; barbed wire cut through (alluding to protest by Indians of Subtiava, León, against seizure of their lands). Insurrectionary period (d): Tank of National Guard, stones of barricade, (e) homemade hand grenades, cartridges; surviving end of horse from Somoza equestrian statue, drum, Güegüense masks. A happier future: In green pasture two children, leaving the desert (of the past), run with blue and white kite (Nicaraguan flag) aloft, toward lake with volcano in background.

Signed, right, "Grupo de Muralistas Hamburgo-León. Sönke Nissen, Klaus Klinger, Rafael Flores, Balthasar Gutiérrez, Jorge Tovar y Carlos Pineda. Nov. 1989–Ene 1990." A collaboration of the Hamburg-León sister-city project. The same group did a companion mural in Hamburg

205a

205b

205c

205d

205e

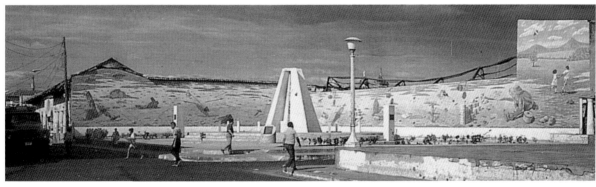

205f

(August–October 1989), sponsored by the Referat für Kunst im öffentlichen Raum (Commission for Art in Public Space) of the Hamburg cultural authority, on the theme of the relations between Hamburg as a First World and León as a Third World city.

5 x 34, 5 x 48 m.

Lit.: *IKA, Zeitschrift für Kulturaustausch und Kulturkalender Dritte Welt*, no. 41 (February 1991): 16–21, which gives title of work; same (or similar) text in *Papel Mural*, no. 1 (1991?): 12–19. Eight picture cards of the León and Hamburg murals were printed (no printer or publisher named), with credit to Flores, Gutiérrez, Nissen, and Klinger.

Plaza 23 de Julio, five murals, left to right

206 *Todo será mejor* (All will be better; FSLN electoral slogan 1989–90) runs vertically, *left*; FSLN fighting National Guard, with banner "No más Somoza"; human pyramid celebrating victory, topped by figure with FSLN flag; other figures marching with banners "UNEN [Unión Nacional de Estudiantes Nicaragüenses]," "Conectate al futuro" and so forth; figures in wheelchairs playing basketball; *below*: studying, playing, classical dancers, volunteers picking coffee.

Signed, bottom right, "Participantes: Gera[rda] Hoogland [Netherlands], Kerwing Vázquez, Carlos Alberto, Daniel Pulido, Noviembre 8 de 1989. Talamuro Nicaragua" (with Sandino hat logo).

7 x 6 m.

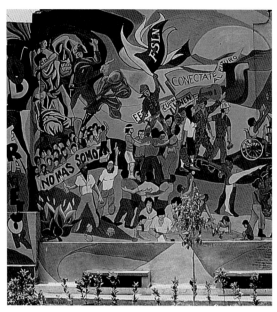

206

207 " . . . Este es el gobierno de 'reconciliación nacional' " (This is the government of "national reconciliation"). A dragon spews scrolls bearing various political and social accusations against the new government (elected February 1990).

3 x 22 m. Black and white.

208 Fists and gesturing dark, light brown, and pink hands; Nicaraguan and FSLN flags. Inscription: "Estamos contra 4 siglos y medio de agresiones extranjeras de las cuales mas de 1 solo coresponden a agresiones Yanquis—Cte Carlos Fonseca Amador" (We are up against four and a half centuries of foreign aggression, more than one [century] of which is yanqui aggression). Horse's skull (of U.S. imperialism).

Signed "Talamuro Nicaragua Dic. 30 1989" (with Sandino hat logo).

3 x 20 m.

209 Colored ribbons radiating from globe; dancing figures, one with colored balloons. Signed, bottom right, where paint is peeling, "[. . . Tal]amuro Nicar[agua]." 5 x 18 m.

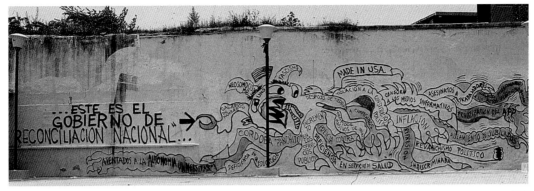

207

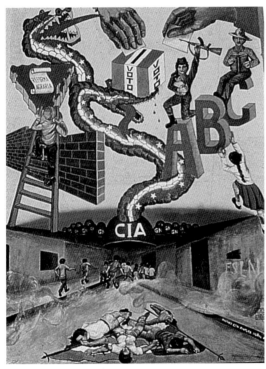

210

210 *Below:* Pile of bodies (photo circa 1984, now with much paint loss) representing students massacred 23 July 1956; gunsmoke, figures fleeing down street (paint loss), at end of which a row of National Guard helmets surrounds a much larger CIA helmet. From it rises a green two-headed snake with red, white, and blue stripes and white stars, one head depressed by a ballot box into which hands place ballots, the other head flicking its tongue at a voting hand; *to left*, man building the new Nicaragua, with wall and outline map of country inscribed "Reforma Agraria"; *to right*, large letters ABC (for literacy campaign) supporting female figure, with rifle aloft and baby, and male figure reading.

Signed right: "Pintado por el Taller Toribio Jérez y pintores Norteamericanos en solidaridad con Nicaragua CPC [Popular Center for Culture] León." By Arts for the New Nicaragua (Joel Katz, Susan Greene).

7 x 5 m.

Lit.: *Village Voice*, 23 October 1984, reproduces mural, with incorrect caption, in article by Lucy Lippard, "Planting Art in Nicaragua."

213

Taller de Bicicletas "La Hermandad" (Bicycle repair shop, run by handicapped)

211 Bicyclist in landscape, mechanic above, at work on bicycle. Sponsored by ORD (Utrecht). Design by Gerarda Hoogland (Netherlands), painted with help of Monique, Kerwing Vázquez, Carlos Pineda.

Union Nicaragüense de Agricultores y Ganaderos (UNAG, Nicaraguan farmers' and cattle ranchers' association), Escuela Agropecuaria (Agrofishery school), near railway line, outside town (funded by ACRA, the Italian Third World development organization)

214

212 Dining room (*exterior*): Family and dog near banana fields; fallen victim, streaming with blood, embraced by a comrade, while another, to right, holds a paper inscribed "No somos aves para vivir del aire, no somos peces para vivir del agua, somos hombres para vivir de la tierra— Bernardino Díaz Ochoa" (We are not birds who live in the air, we are not fishes who live in the water, we are men who live on the earth). Cotton, corn, oxen ploughing.

By Daniel Pulido and ENAPUM-DAS.

3.5 x 19 m.

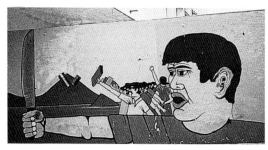

215

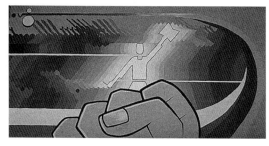

216

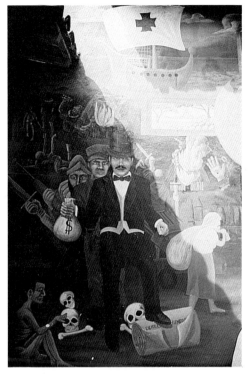

217

213 Auditorium (*interior*), *left:* Soldier, woman, and man (with guitar) in field filled with white flowers; *right:* family group in cornfield; *center:* before a smoking volcano in the background is a chalkboard, illusionistically incorporated into painting. On right reentrant wall around window, used as if it were a table, a peasant receives his "Título de Propiedad" (property title).

Signed, "ENAPUM-DAS Nicaraguïta." By Leonel Cerrato with Colectivo Boanerges Cerrato.

2 x 6 m.

214 Offices: Abstract design running over corner of room, creating optical illusion.

Signed, bottom right, "Escuela Nacional de Arte Publico Monumental 'David Alfaro Siqueiros,' y Taller juvenil 'Toribio Jérez' del CPC [Popular Center for Culture] de León—Anabelly Espinosa, Alexis Hernández, Heberto Montoya, Marvín

Sánchez, Byron Centeno, Flavio Javier Castillo, Daniel Pulido. Nic. 9/19/86." By Sergio Michilini with ENAPUM-DAS.

2 x 7.5 m.

Universidad, Edificio Ciencias Basicas (Basic Sciences Building; complex contains several other small, militaristic murals). Two murals commemorating the literacy crusade

215 Large-headed figure holding out machete; behind, figures brandishing books, against a lake and mountain with Nicaraguan and Sandinista flags. 3.5 x 10.5 m. Very deteriorated.

216 Clenched fist against the silhouette of a worker in the literacy campaign that is refracted in a spectrum of colors, with the book and pencil he holds outstretched in each hand changed successively into a wrench, a machete, a rifle (*above*), and a hammer, a guitar, and so forth (*below*). 3.5 x 7 m.

Executed 1979–80 (First post-Triumph murals in León).

Masaya

Bufete Popular (food program organized by Christian Base Communities), entrance corridor

217 *Tragedia y Esperanza de Indoamérica* (Tragedy and Hope of Indo-America): Below stormy sky, Spanish conquest bringing torture and destruction, death and hunger, in exchange for gold; *foreground:* the capitalist triumphs, backed by the military and his predecessors, the conquistadores; through a cross, symbolizing hope and peace, glimpses of an idyllic landscape representing environmental recovery; at the foot of the

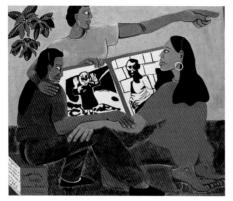

218

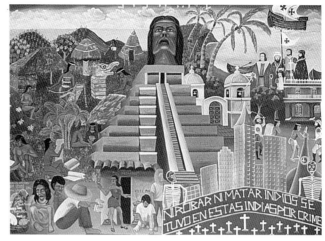

221

cross, the "figura pasionaria" of a native woman, symbol of humanity and the suffering of woman (according to painter's interpretation); *right*: a woman and a child embark on the road to a sunny future, gazing at symbols of the good life, and bad life (drugs, alcoholism).

Signed, top left, "Thelma Gómez Flores, Freddy Gaitán Esconcio Nic. 10/92."

3.5 x 3.5 m.

Centro Deportivo de los Trabajadores Sandinistas (Sandinist Workers' Sports Center), basketball court, three murals: *Todo será mejor* (All will be better)

218 Nicaraguans look at album of photographs of Nazi concentration camp victims and embrace each other to symbolize alliance against all oppression. 4.5 x 5.5 m.

219 Defense of cultural heritage: dance and theater; Nicaraguan and FSLN flags; music, armed defense. 4.5 x 11 m.

220 Shoemaking (local industry) and design and construction of houses; botanical research (*right*); the dawning of the new age (*center*). 4.5 x 5.5 m.

Signed, at left, "Colaboración de Claudio Oviedo R., Martin Chávez R., Roberto Bermúdez R., César García R., Erick Valle S., Renatha (Renalba?) Martínez S., Dragon Dance Theater, Worcester, Vermont, U.S.A. 05682," and, on no. 219 (*left*), "por Sam Kerson, G. Roy Levin." Theme proposed by Fernando Paladino, head of Cultura y Deportes del Comité Zonal del FSLN, Masaya, and Dr. Rammel Martínez. Sponsored by Dragon Dance Theater, directed by Sam Kerson.

Inaugurated 28 February 1990.

Industria Nacional de Clavos y Alambre de Púas Silvio Renazco (INCA, national nail and barbed-wire factory)

221 Oficina de sindicato (union office): Social degradation: prostitution, alcoholism, hunger, beggar holding U.S. fruit juice can as alms bowl. *Above*: indigenous craftspeople at work; pyramid surmounted by chief Diriangén; church; lakeside with arrival of conquistadores, enslavement of natives; *below*: skyscrapers arising from a banner held by skeletons inscribed "Ni robar, ni matar indios se tuvo en estas Indias por crimen" (Neither to rob nor to kill Indians was taken in these Indies to be a crime); seventeen crosses, each marked with the name of an indigenous people exterminated.

223a

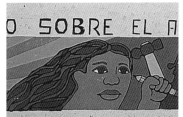

223b

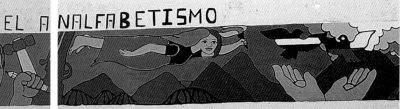

223c

223d

Signed, bottom left, "Fundación Artistas Unidos (FAUN) 1992 Thelma Gómez F[lores], Madel, Freddy Gaitán E[sconcio], César Gaitán, Romulo Gaitán V, Mauricio López, Rene Mercado 1992, Marvin Kelly."

3 x 3.5 m.

222 Auditorium/cafeteria: Celebration of factory against background of factory buildings in use. *Right:* Workers hang banner "Los Proximos 500 años serán nuestros" (The next 500 years will be ours). Signed, right, with same names as no. 221, less César Gaitán, plus Luán Gaitán and Daniela Sandoval. 1.5 x 6.5 m.

223 Courtyard: *Territorio victorioso sobre el analfabetismo* (Country victorious over illiteracy) runs over length of mural. Dove, star, face; figures raising machete, breaking chain; ("19" means 19 July), working at a machine, practicing writing (these four figures, painted by factory workers before the Chileans arrived, are in a local primitivist style; the rest of the mural is painted in the characteristic Chilean manner—see p. 66); woman with raised pencil, hammer, gun; figure in red and black with torch floating over mountaintops; hand releasing doves colored like Nicaraguan and Chilean flags; mountains with Nicaraguan and FSLN flags.

Signed, bottom right, with the logo of Orlando Letelier Brigade, "Chile VII [Aug.] 80."

2.5 x 30 m. Ordered destroyed by new government; saved by workers and twice restored by them.

230

Mercado Colonial (colonial market), four interior walls

224 Pre-Columbian and folkloric motifs, masks, flowers; "Muerte al yanqui invasor"; portraits of Rigoberto López Pérez, Carlos Fonseca, and Camilo Ortega Saavedra, slain brother of Daniel Ortega.

Nindirí, Park

225 Indian huts, Indian chief Niquirano; Ye-qüita dancers in *baíle de los negritos* (dance of the little dark ones), in front of erupting volcano; church. Represents fiesta patronal of Santa Ana. By Omar Calero of Monimbó, done in June 1988 in commemoration of *repliegue táctico*.

226 "Bienvenidos al III Aniversario de nuestra revolución—Masaya" on a banner held over a street with barricade. 1982. 2 x 3.5 m.

227 Sandino and dove before rising sun, and ploughed field; *below*: row of hands holding rifle, book, pencil, machete, guitar, hammer, and shovel. About 3 x 3 m. Lit.: Color reproduction, Sheesley p. 7.

228 Sea, landscape, village life. In primitivist style, 4 x 13 m.

229 Sandino, militants with red and black FSLN banners, fourth anniversary logo, Carlos Fonseca. About 1983. 3 x 10 m. Very crude.

230 Female head with bird; hair flows into mountains behind houses with arcades, each with a silhouetted figure, one with a basket, one seated (working?), one with a gun; *to left*, "Madre tu heroísmo sustenta la moral del combatiente" (Mother, your heroism sustains the morale of the combatant); *to right*, shadowy landscape with cross (martyr's grave). By (or in style of) Alejandro Canales. 3 x 12 m.

Matagalpa

Casa Materna Mary Ann Jackman (outside barrio Guanuca, a service for high-risk pregnant women sponsored by Nicaraguan Federation of Professional Workers Associations [CONAPRO], with financial support from various solidarity groups in the United States)

231 *El Nacimiento* (The Birth): *Left:* Corn and coffee harvests; above, petroglyph of Ixchel, the Maya moon goddess of birthing; *center:* portraits of Mary Ann Jackman (Nicaraguan social worker active with FSLN, killed at age 27 in a traffic acci-

231

dent), holding child with a comb in his hand; *behind her, to right*, Nora Astorga (see no. 75); portraits of locals; *above*, birth and doves, new day; *right:* women with fruit: "El sabor de la vida" (The taste of life).

Signed, bottom right, "William Hernández, R[osa] A. Oviedo 23/06/91, J. E. Nuñez," initials of Pablo Danilo Téllez(?). By Grupo Artistico Contraste.

Lit.: Porfirio García Romano, "Pintando el interior del vientre," *Barricada*, March 19, 1993; set of picture cards with four different details in color published by Ann Arbor [Michigan] Medical Aid Project.

Centro Popular de Cultura Carlos Arroyo P.

232 Nicaraguan arts and culture: music, painting, children, weaving, picking coffee. Inscribed, below, right: "Con la esperanza de alcanzar la paz, los trabajadores de la cultura de la región seis, y el comité de solidaridad Arte Para la Nueva Nicaragua de los Estados Unidos, como un esfuerzo conjunto, dedicamos este mural a la amistad entre nuestros pueblos" (In the hope of achieving peace, the cultural workers of region six and the solidarity committee Arts for the New Nicaragua from the United States, in a joint effort, dedicate this mural to friendship between our peoples); inscribed, right: "C[oop]erativa Daniel Teller Paz" (presumably a coffee cooperative).

By Rikki Asher and others.

3.5 x 12 m. Destroyed 1991/92.

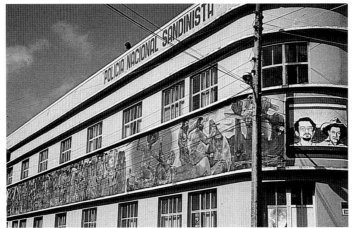

233a

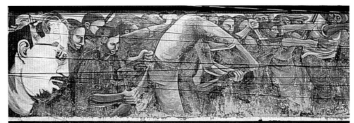

233b

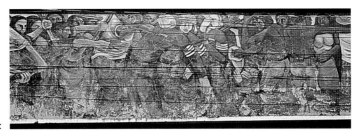

233c

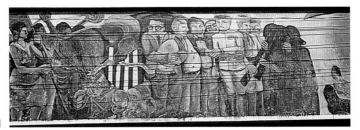

233d

233e

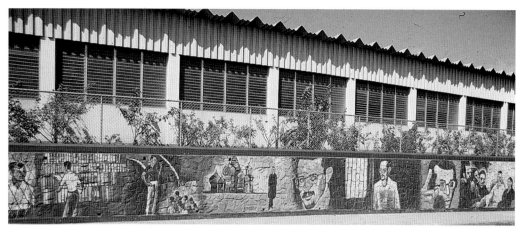

Former Policia Nacional Sandinista

233 Carlos Fonseca (b); group of angry people, armed mostly with knives, attack (c) U.S. marines (flags on sleeves), who fall back in defeat. Another group of civilians, led by (d) a woman with a red flag, confronts Anastasio Somoza I (in glasses, clasping money bag) and other caricatured Somocista types; they shake hands with a general (perhaps U.S.) accompanied by armed soldiers and black-hooded figures. The two groups are separated by a red and white striped shield, crossed by a scroll inscribed "Doctrina Monroe. Imperio Yanki," and a pile of skulls; (e) a peasant kneels over a recumbent U.S. marine (Seal of Sandino motif); FSLN guerrillas shoot from behind a barricade; (a) *on corner:* raised fists, machete, and other tools; portraits of Carlos Fonseca and Sandino.

Signed, lower right, "Obsequio de la brigada muralista Felicia Santizo de Panamá, y la policia sandinista del pueblo . . . enero 1980" (Gift of the Felicia Santizo mural brigade of Panama, and the Sandinista police of the people).

3 x 27 m. Quickly faded; destroyed by 1986 (photo 1981).

Wall along a main street

234 Life of Carlos Fonseca Amador: Birthplace in Matagalpa; running errands as a boy; studying; addressing students; in Moscow; portrait; in jail; portrait with speaking gesture; with other FSLN members; FSLN combatants in the mountains hunted by Guardia. About 1984. 1.5 x 22 m. Faded and painted over by 1988.

Wall facing main street

235 Between a nuclear power station inscribed "Abajo la energía nuclear" (Down with nuclear energy) and high-rise buildings marked Shell, Phillips, "Poder de Multinacionales" (Power of Multinationals), a mass of demonstrators with banners bearing slogans, including "Reagan asesino," "Solidaridad Internacional." Landscape behind with Dutch windmills.

Signed, bottom left, "Saludos de Holanda en lucha" (Greetings from Holland in struggle).

About 1981. 4 x 4 m. Very crude style. Destroyed.

Ocotal

On wall facing park

236 Hybrid Uncle Sam—military figures, each with death's head, sit on bags of dollars; combatants struggle and die; building being bombed from the air; three-quarter-length portrait of San-

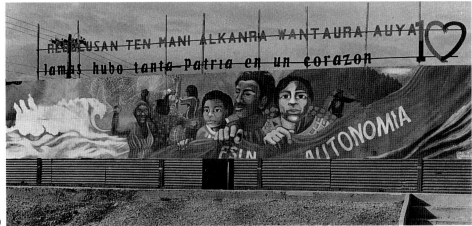

240

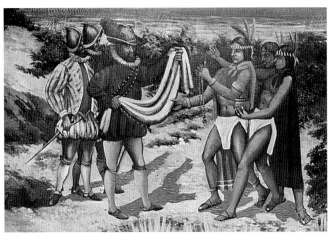

242

dino's Colonel Rufo Marín, who died in the attack 16 July 1926 (see no. 237); Sandino; fighting guerrillas and screaming civilians. A large block-lettered inscription below read "Digale a mi general que muero como yo quería, peleando contra los Yanques. Crel Rufo Marín" (Tell my general [Sandino] that I die as I wanted, fighting against the Yankees).

Painted by Spanish brigade.

About 3 x 9 m. Plaster fell off about 1986. Repainted with design based on famous photograph of the captured U.S. pilot Eugene Hasenfus, that was in turn painted out by the new owner of the house.

237 Bombing of Ocotal, with the words "Aquí fué el primer ataque aereo en picada" (Here was the first aerial dive-bombing attack [in history]), referring to the U.S. bombing of civilians at Ocotal 16 July 1926 (see also no. 236). Destroyed (see figure p. 2).

Pearl Lagoon

Primary school

238 "We want peace. Bushman—surrendering is your only salvation." Words appear, in English, to left. Dove of peace; nine arms, black and different shades of brown, reach from different communities of Pearl Lagoon to unite in center. "Bushman" means contra. About 1985.

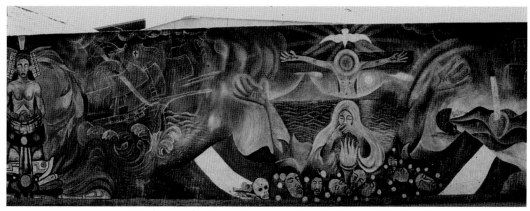

243

Puerto Cabezas

Plaza Central

239 *Autonomía Ya* (Autonomy Now): Title appears on a banner streaming behind diverse ethnic groups of Nicaragua, with economic activities (fishing, agriculture, mining) and representations of Pacific coast peoples: Caribe, Sumo, Mesquito, and Rama.

By Reinaldo Hernández, assisted by Florencia Artola. Sponsored by the government.

1990. 4 x 15 m. Partially destroyed in storm, 1991.

Lit.: *La Prensa*, 15 February 1990, p. 1.

240 Representatives of the Atlantic coast peoples hold a banner marked "FSLN . . . Autonomía." Above, in letters cut out separately, "Rebocusan ten mani alkanra wantaura auya" and "Jamás hubo tanta patria en un corazón" (Never was there so much patriotism in a single heart, in Miskito and Spanish).

Signed, bottom right, "Colectivo Boanerges Cerrato 1988," for first anniversary of Atlantic coast autonomy (September 1988). About 2 x 12 m. On zinc panels.

Rivas

AMNLAE Center, inside

241 Battle of Emanuel Móngalo against William Walker in Rivas (1857). Signed "Edgardo Aguílar, Alvaro Valdéz." 1989? 4 x 5.5 m.

Road to San Jorge, 2 km. from Rivas

242 At historic marker where, in February 1522, the "glorious cacique" (chief) Nicaragua (= Nicarao) met the Spaniard Gil González Dávila; conquistador offers cloth in exchange for gold ornaments. (For a historical account see Tomás Ayón, *Historia de Nicaragua*, vol. 1 [Managua, 1956], p. 155.) Signed, bottom right, "L. Manzanares, 92 NIC." 3 x 8.5 m.

Calle Central, opposite AMNLAE center.

243 Life on earth begins; conquistadores arrive, impose Christianity, and bring death, over a Nicaraguan flag; dead U.S. marine, with knife piercing heart; modern city high-rises, technology of future. Signed, bottom right, "Hecho por [done by] Gustavo [Javier Gómes] Segura, Difón, Humberto Bello, Manuel Palacio." 1989. 4 x 19 m.

Gymnasio Umberto Méndez, rear exterior wall, near park

244 *El Futuro está en nuestras manos* (The Future Is in Our Hands): (a) Jaguar petroglyph pat-

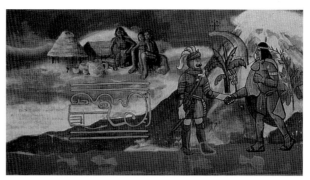

244a

tern below natives with pottery, near huts; Friendly native chieftain (Diriangén) greets conquistador (see no. 242); (b) armed native chieftain looks up toward future, in bust portrait of Sandino; woman, with automatic rifle on back, suckling baby (based on no. 70) and holding copy of the new constitution (promulgated 9 January 1987); head of Carlos Fonseca above sunrise; armed peasant ploughing with oxen; (c) young peasant learning to write, blended into volcano; guerrilla crouching with bazooka behind shield; woman with FSLN flag; priest with eucharistic cup; figure with rifle and flaming torch represents William Walker, who, when defeated in Rivas (in 1857), set fire to the town. A building in Rivas, as it exists still, is shown burning, with armed figures.

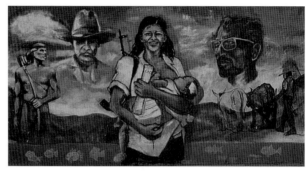

244b

Below, left, under title: "Mural por el Centro Popular de Cultura Dir. José Cruz Hurtado Nuñez. Arte para la Nueva Nicaragua, Brigada de los Artistas de los Estados Unidos Angela Mathews, Whiting Tennis, Phillip Danzig of 'Wet Paint,' Artistas locales Gustavo Javier Gómes Segura, Gerardo Aguilar, Rivas 17 de Enero 1987 / ¡Aquí no se rinde nadie! [Here no one surrenders]."

3.5 x 17 m.

Lit.: *The Montclair Times* (N.J.), 16 July 1987, p. A18.

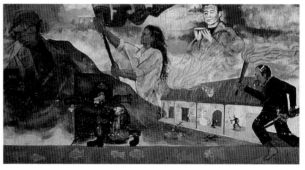

244c

San Benito

Billboard at crossroads

245 The words "Via crucis por la paz y la vida" (Stations of the Cross for peace and life) occupy most of reverse of billboard; on pictorial side, "Por la paz y la vida" recurs on facade of church (*right*), past which a large crowd of people, bearing crosses and wearing white headscarves, file in procession, leaving mountains on the left, and meeting soldiers in the distance; *center foreground:* three bishops, gesticulating toward the procession, stand wrapped in a U.S. flag; *foreground, right:* figures tearing down a barbed-wire fence.

By Artifact (see no. 148).

About 1981. 4 x 12 m. Much deteriorated below. Destroyed 1994.

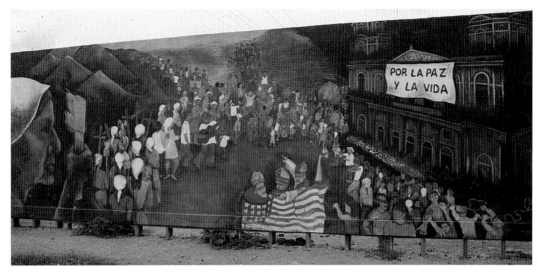

245

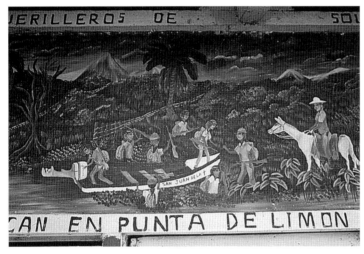

247

San Carlos

Hotel Mirador, former fortress guarding river, four murals in primitivist style

246 "Preparasión [*sic*] de guerrillos en Solentiname para asalto cuartel San Carlos del 13-10-77" (Solentiname guerrillas prepare to assault the San Carlos barracks) .5 x 2 m.

247 "Los guerrilleros de Solentiname se desembarcan en punta de Limón el 13 de Octubre del 77" (Solentiname guerrillas disembark at Punta de Limón) .5 x 2 m.

248 "Asalto Cuartel San Carlos Octubre del 77 (assault on San Carlos barracks). José A[rana, artist]." .5 x 2 m.

249 "Retirada (Retreat). Miriam Guevara [artist]." .5 x 2 m.

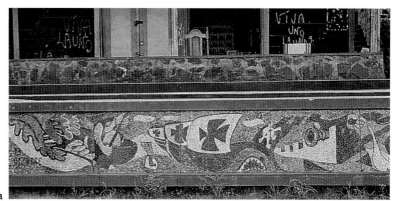

250a

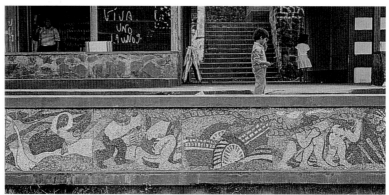

250b

Riverfront

250 History of San Carlos: (a) Indigenous man in boat, fishing; arrival of Spanish ships; shark; Castillo de Concepción, Río San Juan, cannon and fist (reference to Rafaela Herrera, young daughter of local commander who had fallen sick; she took over for her father and beat off the British, represented here by flag with skull and cross-bones). (b) Fishing; long whip of slavery over naked natives, with steamboat referring to Vanderbilt's transoceanic route through Nicaragua. (c–d) Death (Somoza era), insurrection, independence, literacy, "[ref]orma [agr]aria."

Signed, bottom right, "ENAPUM-DAS 1987." Design by Sergio Serrano. Executed for the tenth anniversary of the seizure of the Somocista barracks 13 October 1977 (date inscribed far left).

1 x 16 m. Mosaic, made of local stone.

On wall near riverfront, two primitivist landscapes

251 Shooting at plane from hilltop; blond man is Eugene Hasenfus, U.S. citizen captured by Sandinistas in 1986, while running guns for contras. 2 x 2 m.

252 Cattle, peasants on (school) bench, "Carlos Fonseca" on blackboard. 2 x 2 m. Signed "Tema Defensa, Producción, alfabetización. Elba Jímenez." About 1987.

Basketball Court

253 Filled with Sandinista logos; one painting of captured U.S. mercenary Eugene Hasenfus.

Centro Cientifico Cultural, Auditorium

254 Soldiers on watch; ferry approaches harbor; fishermen; women washing clothes; mother

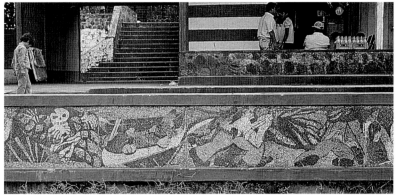

250c

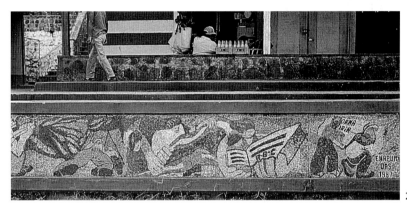

250d

embraces son; doctor attends a family; architect Martín Guido studies building plans (for development of San Carlos); reading lesson; man with guitar; man building wall from local volcanic rock.

By Leonel Cerrato and students of ENAPUM-DAS.

1987. 3 x 12 m.

Lit.: Lynn Anderson, "Public Art of Nicaragua," Master's thesis, University of California, Los Angeles, 1992, p. 44.

San Miguelito, Río San Juan Department

Centro de Salud (health center)

255 Circular design: lakeside; health and literacy programs; corpse of Somoza. Primitivist style. By Frida Weisz (Germany), with local artists, circa 1990.

Sébaco

Escuela Primera de Julio

256 Sandino, "1 de Julio," triumphant guerrilla, construction (Danish volunteers shown), education, ploughing, children flying kites. FSLN and Danish flags. Signed (on blackboard in center), "Jorma, ——, Karl Aage, Susanne O., Finn, Christiane, Johnny, Thorhil, Karen Merete, Susanne P., Trank (?), 27-2-88," the Danish volunteers who built the school. 3 x 9 m. Destroyed 1992.

257 Eagle, and (Viking) dragon wrapped around a (pre-Columbian) pyramid. Signed, left, "Syntese 1988" (Denmark). 3 x 9 m. Destroyed 1992.

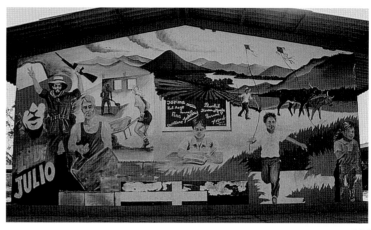

256

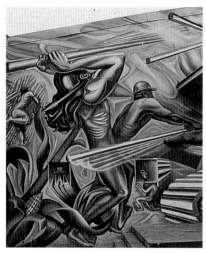

259a

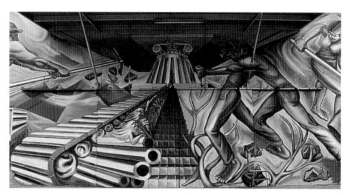

259b

Solentiname

Church

258 Various primitivist decorations.

259c

Tipitapa

Fabrica Química Borden (Borden chemical factory)

259 *Defensa y lucha de los trabajadores contra el imperialismo* (Defense and struggle of workers against imperialism): (a) Naked indigenous figure aims lance at (A) monstrous eagle, bearing U.S. flag on wing, that is bringing (or being consumed by) raging flames. Another figure behind him on left wields a hoe against conveyor belt, in which

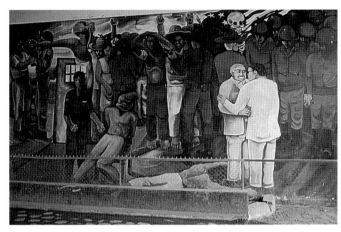

260a

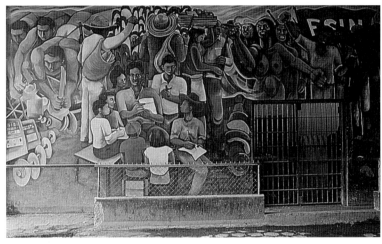

260b

crushed workers lie, and against the pillar of imperialism (a reference to the White House in Washington, according to publicity; see Lit.), which supports the real roof; *right* (c) Bare-chested workers attack the base of same pillar; rocks, bare branches, barren soil represent aridity of workers' lot; (B) woman hoeing and man cutting weeds with machete; *sacuanjoche*; (e) doors, *center*, are painted so that when open they match design (legs of right-center figure move to fit figure to his right).

By Federico Matus (design) assisted by Reinaldo Hernández. Sponsored by factory and Mario Bolaños, commander of military unit to which Matus was assigned at time of painting (1986), the

Brigadas de Lucha Irregular Miguel Angel Ortéz ("BLI-MAO" appears in a real box on wall, lower left), other aid from ENAPUM-DAS.

6 x 18 m.

Lit.: "Obra Monumental de Cachorros," *Barricada*, 22 December 1986; English translation in *Community Murals* (Fall 1987): 10.

Centro Penitenciario Jorge Navarro ("model prison"), covered entrance to courtyard (mural reads chronologically from right to left)

260 *Right wall* (a): A. Somoza II and prison director (both dressed in white, the latter, with fair hair, smiling broadly) embrace before serried ranks of National Guard commanded (or advised) by fair-haired marine, who stands before a

187

U.S. flag and pointing skeleton. To their left, a group of peasants have been seized; one (A), seated and hooded, is being tortured with an ice pick and brass knuckles. (Tomás Borge, who had been imprisoned here, identified the director as Colonel Nicolas Valle Salinas, who was not, however, fair-haired.) Above the torturer, (B) a female allegorical figure, hair aflame, thrusts a rifle into the hands of a group of FSLN combatants; *left wall* (b) FSLN militants, with naked female allegorical figure holding torch. Literacy, harvesting corn and fruit. Farmers with hammer, sickle, and machete. Broken plough, electronic instruments (superseding manual labor?).

Signed "Brigada muralista 'Felicia Santizo' 17-Oct 80 PMG[C?]"

Each wall 4 x 6.5 m.

Tonalá, near Puerto Morazán.

Health Clinic

261 *From top:* The breast is better than the bottle; dangers of diarrhea and dehydration; woman suckling child, reading self-help medical manual ("Where there is no doctor"); sign "No animals allowed in house"; "Literacy and Health" logo, boy reading health manual from *biblioteca popular*.

Inscribed at bottom "Municipal de Morazán—Ciudad de Bristol, en celebración 10 aniversario."

Painted in association with Bristol, England's link with Tonalá/Puerto Morazán, by Chris Collett of Bristol and Julio Emmanuel.

3 x 1.5 m.

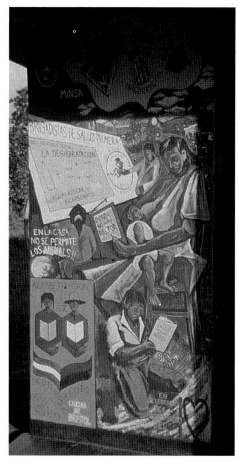

261

Waslala

Church of the Immaculate Conception, built 1988–89, interior

262 *Pediment over entrance:* Classroom with older children and teacher (self-portrait of artist) holding book "Historia de Ni[caragua]." On chalkboard "A-B-C. Queremos la paz" (We want peace). Older couple, *left:* a Brazilian priest (in yellow) talking to campesino. Signed, below chalkboard, "Pantoja." 1.5 x 7.5 m.

263 *Right:* Six women working manual/pedal sewing machines and cutting cloth. 4 x 4 m. (irregular).

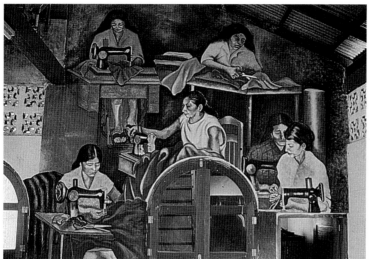

263

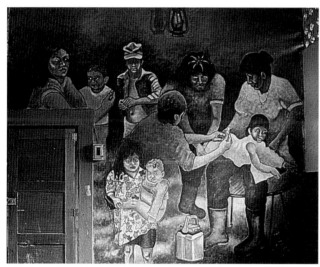

267

264 *Side walls:* Fourteen Stations of the Cross (Via Crucis), copied from traditional compositions.

265 *Altar wall, left:* Peasants ploughing with oxen; wheat above. Signed, bottom right, "Pantoja 90." 3.5 x 3.5 m.

266 *Center:* Appearance of Christ to disciples after Resurrection; doubting Thomas on right. Women and children not mentioned in Bible are included, and a relaxed, friendly atmosphere reigns. 3.5 x 8 m.

267 *Right:* Children being vaccinated (homage to 200 health workers in municipality). 3.5 x 3.5 m. (less door).

268 *Pediment above altar:* Campesina with large family (according to parish priest, she refers to Immaculate Conception); *left:* local bishop Salvador Schlaefer (from Wisconsin); (*in yellow*) parish priest Father Enrique Blandón, baptizing a Brazilian woman, prior to her becoming a nun;

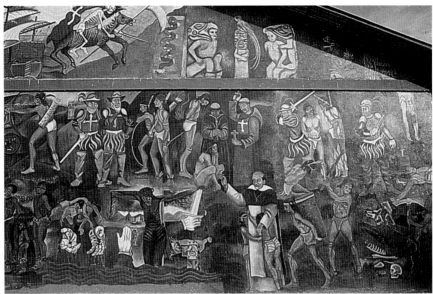

269–270a

Nicaraguan Teodora Chavarría; and (*in orange*) Lodia Furlani, Delegate of the Word; *right:* local carpenter Salomón planing (homage to local industry). 16 x 1 m. (triangular).

All by local artist Francisco Pantoja.

Inaugurated April 1990.

Church of the Immaculate Conception, exterior, east wall

269 *Pediment:* On scroll: "1492 Año del Descubrimiento y esclavitud indígena" (Year of discovery and native slavery). Spanish galleons disgorge apocalyptic Death in red cape with white cross, onto continent identified by Quetzalcóatl, symbol of indigenous independence, and other pre-Columbian figures, including Xilonem (maize goddess) and quetzal (bird). 2 x 16 m. (less corners).

270 *Main wall, top, from right:* Conquistadores torture and execute natives; friars forcibly convert, hang, and burn natives; native chief Diriangén, with bow, treats for peace with Gil Dávila González and another conquistador (both wear beards; all the Spanish in this mural wear a con-spicuous green cross on the chest); natives fight with bow and spear against firearms of mounted enemy; a Spanish soldier (b) lies dying, fodder for an approaching vulture. *Main wall, below:* Indians defend themselves against wolves; Bartolomé de las Casas protects Indians, one laboring; Christ crucified on a cruciform window that reveals an erupting volcano behind and is flanked by fire and bloody sword; corpses and bloody hands flow into a red river, which drenches native symbols; African slaves chained neck and foot; stylized maize; Monseñor Antonio Valdivieso (protector of Indians); native sculptor, with more native artifacts marking landscape to left, past door; *beyond door* (A): a Christian cross with broken chain hanging on it; armaments from both sides lie unused; one (indigenous) hand gives seeds of maize to another (the world). An open book reads "Agradecimiento o Indignación? 70 millones de indios asesinados durante la conquista española" (Gratitude or indignation?

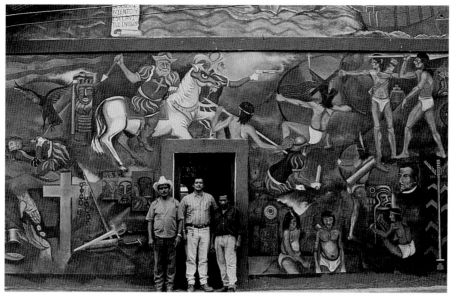

270b

Seventy million Indians murdered during the Spanish conquest).

Signed, top right, "Colaboraron en este mural Los cros(a) M.A.H.L. Gladys Aráuz, Carlos Siles, [Francisco] Pantoja." Painted by Francisco Pantoja in a novel technique of acrylic mixed with linseed oil and turpentine. In a cruder style than interior murals, to correspond with crudity of events.

January–April 1992. 4.5 x 16 m.

Lit.: *Nuevo Amanecer Cultural* (Managua), 13 June 1992.

Bibliography of Frequently Cited Works

Ashton, Dore. 1988. "Every Grain of Sand: Notes from a Visit to Nicaragua." *Arts Magazine* (April): 37–39.

Barnett, Alan. 1984. *Community Murals: The People's Art.* Cranbury, N.J.: Associated University Presses.

Black, George. 1988. *Good Neighbor: How the United States Wrote the History of Central America and the Caribbean.* New York: Pantheon.

Borge, Tomás. 1981. *Los Primeros Pasos: La Revolución Popular Sandinista.* Mexico City: Siglo Veintiuno.

———. 1986. *Nicaragua: Justicia y Revolución.* Caracas: Centauro.

Burns, E. Bradford. 1987. *At War in Nicaragua: The Reagan Doctrine and the Politics of Nostalgia.* New York: Harper and Row.

Chomsky, Noam. 1988. *The Culture of Terrorism.* Boston: South End.

Cockcroft, Eva, and David Kunzle. 1982. "Report from Nicaragua." *Art in America* (May): 51–59.

Craven, David. 1989. *The New Concept of Art and Popular Culture in Nicaragua since the Revolution in 1979.* Lampeter (Dyfed, Wales, U.K.): Edwin Mellen.

———. 1990. "The State of Cultural Democracy in Cuba and Nicaragua during the 1980s." *Latin American Perspectives* 17 (Summer): 100–119.

Kunzle, David. 1978. "Art of the New Chile: Mural, Poster, and Comic Book in a 'Revolutionary Process.'" In Henry Millon and Linda Nochlin, eds. *Art and Architecture in the Service of Politics.* Boston: MIT Press.

———. 1984. "Nicaragua's *La Prensa*: Capitalist Thorn in Socialist Flesh." *Media, Culture, and Society* 6:151–76. Also in Armand Mattelart, ed. 1986. *Communicating in Popular Nicaragua,* 55–69. New York: International General.

———. 1989. "Revolutionary Resurrection: The Church of Santa Maria de los Angeles, and the School of Public Monumental Art in Managua, Nicaragua." *Latin American Perspectives* 16, (Spring): 47–60. Short version in *Zeta* 2, nos. 7–8 (July–August 1989): 101–6.

Laduke, Betty. 1983. "Nicaraguan Mural Painters: Hilda Vogl and Julie Aguirre." *Off Our Backs* 13 (9 October): 11–12.

Sergio Michilini, *L'occupazione del tempio: Le pitture murali della chiesa S. Maria degli Angeli, Managua-Nicaragua*, Milan: ACRA, 1989.

Pérez Díaz, Mayra Luz, and Dolores G. Torres. 1987. "El Arte Mural en Nicaragua." *Encuentro* 32 (September–December): 13–33.

Rolston, Bill. 1991. *Politics and Painting: Murals and Conflict in Northern Ireland.* London and Toronto: Associated University Presses.

Sheesley, Joel. 1991. *Sandino in the Streets.* Bloomington: Indiana University Press.

Sklar, Holly. 1988. *Washington's War on Nicaragua.* Boston: South End.

World Encyclopedia of Naive Art. London: Brocken.

Artists' Biographies

Artists listed are those who painted three or more murals, including foreign-born artists long resident in Nicaragua.

Julie Aguirre. Born 1954. Self-taught, starting 1973. Husband, a painter, was killed in fight against Somoza. Has exhibited all over the world. Primitivist whose specialty is life of Nicaraguan women.
Bibl.: Laduke 1983; *World Encyclopedia of Naive Art*, p. 91.

Maximino Cerezo Barreda. Claretian priest born in Spain, 1932, living in Latin America since the 1970s. More than a hundred murals in churches, auditoriums, and parks in Brazil, Colombia, El Salvador, Mexico, Nicaragua, Panama, Peru. Now in Peru.
Bibl.: *Nuevo Amanecer Cultural* (Managua), 4 May 1991.

Alejandro Canales. 1945–1990. Major one-man show, Düsseldorf, 1987. Murals in Seattle; Eugene, Oregon; Düsseldorf, Klagenfurt, and Vienna. Thirty-five group and individual shows, many prizes. See *Nuevo Amanecer Cultural* (Managua), 7 March 1990, pp. 7–8.

Victor Canifrú. Born in Chile, 1951. Worked with Ramona Parra Brigades in Chile. Left for Costa Rica after coup (1974), and thence (27 July 1979) for Nicaragua. Known as a singer, in partnership with Alejandra Acuña Moya, a fellow Chilean and participant with Ramona Parra Brigades, who also helped on several murals.

Leonel Cerrato. Born 1946, Estelí. Farmhand at seven years. First schooling and pair of shoes at twelve years. Director, ENAPUM-DAS 1985–88. In France he has done fourteen murals to date: in Evry, Lille, Marseilles, Montpellier, Paris (metro), Rennes, Saint Amand, Seclin, and Terrasson; in Austria, he has done murals in Graz, Klagenfurt, Salzburg, 1989.

Colectivo Boanerges Cerrato. Named after brother of Leonel, who died in 1990 at age twenty-seven. All studied and worked with ENAPUM-DAS. They formed the collective on leaving the school and reside in Estelí.

Cecilia Herrera, born, studied, and taught in Argentina; arrived in Nicaragua, 1987. Graphic designer with Press Department in Nicaragua. Murals in Germany, December 1991–March 1992.

Daniel Hopewell, born in 1958 in London, where he studied art. Worked as freelance graphic designer, including two years in Australia and New Zealand. Arrived in Nicaragua 1985, via Cuba. Mural in Cuba.

Janet Pavone (Barrenechea), born in New York City (her father worked on WPA murals in the 1930s). Trained in Boston; spent seven years in Italy. Arrived in Nicaragua in 1985. Mural in Cuba.

Manuel García Moia. Born in Masaya, 1936; studied under Rodrigo Peñalba from 1959. Exhibitions in Latin America, West Germany, France, former USSR. Murals in Copenhagen (prize) and in West Germany, 1981, and East Germany, 1985.
Bibl.: *Nicaráuac* 12 (April 1986): 173; *World Encyclopedia of Naive Art*, p. 254.

Olga Maradiaga. Primitivist painter of León; three murals in Germany, thirteen in Holland.

Federico Matus. Born 1966, student at ENAPUM-DAS, 1985–88; student, then instructor (1990), National School of Plastic Arts; School of Architecture 1987–92. Military service, 1985–87. Murals in Germany 1992. Collaborates with Reinaldo Hernández.

Sergio Michilini. Born in Italy, 1948. Trained at Academy of Fine Arts, Florence. Various murals and public sculptures in Varese province, Italy (1971–88); Livorno, Italy (1983); Coyoacán (1984) and Mérida, Mexico (1993). Arrived in Nicaragua, 1982; has worked there since 1984. Founded ENAPUM-DAS. Coordinator of ACRA (Italian Third World rural development organization).

Camilo Minero. Born in Zacatecoluca, El Salvador, 1917; studied in El Salvador and Mexico. Exhibitions worldwide. Professor of Drawing and Painting in Escuela Nacional de Artes Graficas, University of El Salvador. Murals in Mexico, El Salvador, and Cuba, and six in Nicaragua, where he resided as a refugee from 1980 to 1990, when he was expelled.

Daniel Pulido. Born in Bogotá, Colombia, 1956. Expelled from Escuela de Arte, Bogotá, 1982. Many murals in Colombia, destroyed. Targeted by death squads. Arrived in Nicaragua, 1984. Worked with ENAPUM-DAS. Many murals in Holland and Germany, 1990–92.

Leoncio Sáenz. Born in Dalxila, Matagalpa, 1935, of Mayan descent. Studied at National School of Fine Arts. Several murals destroyed in 1972 earthquake. Exhibited in Latin America, former USSR, and Bulgaria.
Bibl.: *Nicaráuac* 3 (December 1980): 31–52, 174–79.

Hilda Vogl. Born 1930. Self-taught primitivist, started painting at age forty-six. Exhibitions worldwide.
Bibl.: Laduke 1983; *World Encyclopedia of Naive Art*, p. 600.

Photographic Credits

APSNICA (Steve Kerpen), Introduction, pp. 2, 50; 6A, 6B, 20A, 20a, 20b, 65, 125

Miranda Bergman, 9B, 9b

Judy Branfman, 173a, 173b, 173c, 203–204

Mike Alewitz, 60A, 60a, 60B, 60C, 60D

George Black, Introduction, p. 21

Eva Cockcroft, Introduction, p. 3; 20a, 21, 58, 100–102, 108a, 108b, 109a, 196, 210

Chris Collett, 261

Patricia Mathes Cane, 18A, 18B

Roberto Delgado, 154A, 154a, 154b, 154c

Felicia Santizo Brigade, Introduction, p. 74; 165, 166a, 166b, 167A, 167B, 167C, 179, 180A, 180B, 215

David Fichter, 160

Peter Hammer Verlag, Introduction, p. 68

Daniel Hopewell, 175A, 175a, 176A, 176a, 176B, 240

Klaus Klinger, 205f

Sergio Michilini (photographers J. A. Gómez and M. Moghesen for murals 92–107), Introduction, p. 47 (no. 97); 92b, 93A, 93a, 94A, 94a–96a, 96A, 97, 98, 100–102, 106, 107a, 107B, 107b, 120, 127, 129a, 129b, 201, 212, 213, 214, 251–252

Tony Miramonte, Introduction, p. 16

James Prigoff, © 1995, 1A, 1a, 1b, 3a, 3b, 3c, 3d, 3g, 3i, 3j, 4, 5, 12b, 15, 31a, 32b, 54, 61A, 61a, 61B, 62, 76A, 76a, 76B, 76b, 112, 113–114a, 133, 151A, 155b, 161, 162, 170, 193a–194, 200, 234, 260A, 260a, 260b

Daniel Pulido, 22

Padre Gabriel Rodríguez Celis, 17

Syntese (Flemming Vincent), 24a, 24b, 24c

Carol Wells, 3A, 3B, 3C, 3D, 3E, 3F, 3G, 6a–7a, 6C, 7A, 7B, 7b, 80

All other photographs are by the author; all posters reproduced in the Introduction are from his collection.

Index

The mural numbers that follow pages in index entries refer to black-and-white as well as color illustrations unless a letter is attached: lowercase for black-and-white, capital for color.

Composition The text for this book is 10/16 Electra, with Syntax Bold display type. The type was set by Keystone Typesetting, Inc. Scans and color separations were made by Integrated Compositions Systems.

Manufacturing The paper is 80# Mountie Matte recycled, with printing and binding by C. J. Krehbiel Co., through Sandler/Becker, Inc.

At the University of California Press, the designer was Nola Burger, and the editor was Stephanie Fay. Production was coordinated by Lillian Robyn.